AN AMERICAN RENAISSANCE
PAINTING AND SCULPTURE SINCE 1940

D1517703

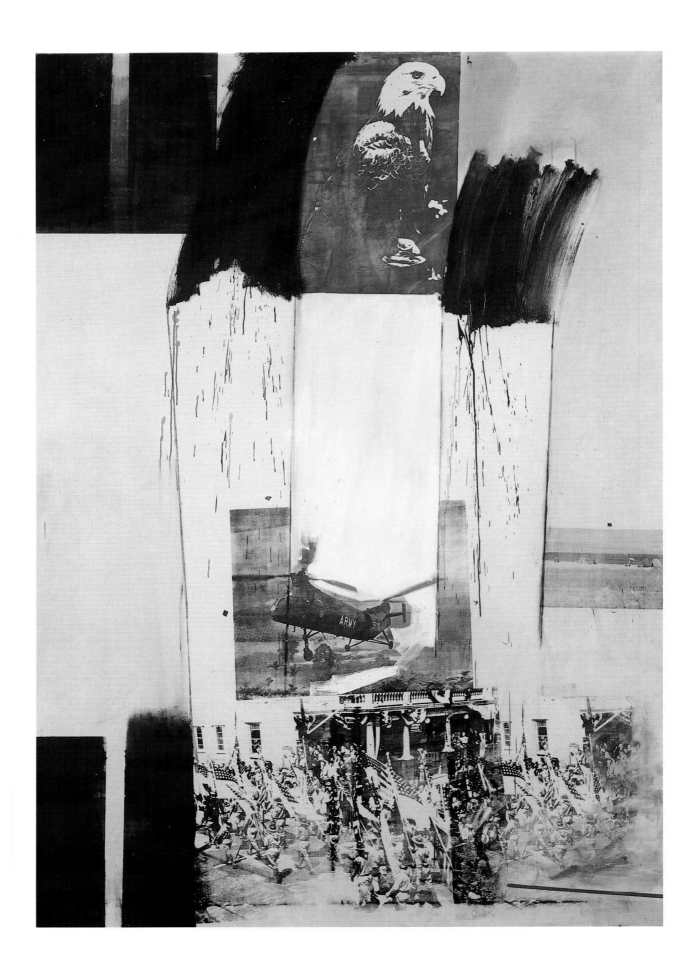

AN AMERICAN RENAISSANCE
PAINTING AND SCULPTURE SINCE 1940

Edited, with an Introduction, by
Sam Hunter

Essays by
Malcolm R. Daniel, Harry F. Gaugh,
Sam Hunter, Karen Koehler, Kim Levin,
Robert C. Morgan, and Richard Sarnoff

Museum of Art, Fort Lauderdale, Florida
With support from American Express Company

Abbeville Press Publishers New York

This catalogue was published on the occasion of the exhibition "An American Renaissance: Painting and Sculpture Since 1940," Museum of Art, Fort Lauderdale, Florida, January 12–March 30, 1986.

The exhibition and catalogue were made possible by a generous grant from American Express Company on behalf of American Express Travel-Related Services, Fireman's Fund Insurance Company, and American Express Bank Ltd.

Front cover: Andy Warhol, Mona Lisa (detail), 1963. Acrylic and silkscreen enamel on canvas, 128 x 82". Blum-Helman Gallery, New York.

Back cover: Frank Stella, Brazilian Merganser, 1977–80. Aluminum and mixed mediums, 120 x 84". Collection Martin Z. Margulies, Miami.

PLATE 1 (frontispiece): Robert Rauschenberg, Kite, 1963. Oil and silkscreen on canvas, 84 x 60". Collection Mr. and Mrs. Michael Sonnabend, New York.

Editor: Bitite Vinklers
Designer: Angelo Bucarelli
Printed in Italy by CO. GRA. FO.
Technical Supervision: Overseas Services

Library of Congress Catalogue Card Number: 85-52251

CONTENTS

ACKNOWLEDGMENTS

As the exhibition director, I wish to express my warm appreciation for the generous support and enthusiasm of the numerous museums, foundations, and private individuals, including many artists, who are listed among the lenders. The exhibition would not have been possible without their cooperation, and their enthusiasm made the rather daunting task of organizing such an ambitious project in a very short space of time a distinct pleasure despite the inevitable pressures. Actually, it seems that a whole new generation of contemporary art zealots has arisen among collectors, curators, and other professionals in the art world, and they are far better informed as to stylistic nuance and detailed studio activities of even the most reclusive or mythic contemporary creators than my own generation of critics and historians has been. The levels of energy, optimism, concern, and information this new and interesting group of *cognoscenti* has generated in the current art world make the organization of a show of this scope and magnitude feasible in a relatively short time and highly instructive. Their cooperation was indispensable.

At closer hand, I wish to thank George Bolge for placing his staff at my disposal for the complex tasks of organizing a major exhibition, and for his wise counseling in our many conversations. Elliott and Bonnie Barnett gave unstinting support to this project from its inception, and Mr. Barnett's faculty for generating not only enthusiasm but also the generous patronage which the exhibition project required has been exemplary. It should remind all of us in the art world that corporate patronage and communal participation are as essential for the artist in achieving public meaning as his private creation.

Finally, I wish to thank my assistant, Julia Hicks, a Princeton University undergraduate, efficient and responsible beyond all reasonable expectations, for handling so flawlessly the routine but no less essential curatorial chores of the exhibition.

Professor Sam Hunter
Director of the Exhibition

F O R E W O R D

Since this exhibition marks a new beginning for the Museum of Art, the subject "An American Renaissance" is an especially fitting one. The panoramic sweep of the exhibition, covering a period of immense change in American art, is well matched by the grand scale of the Museum's new exhibition space.

Americans, as a whole, should be proud of sharing in a culture that has produced the diversity of expression reflected in "An American Renaissance." At the same time, the people of Broward, Dade, and Palm Beach counties, and all of Florida, should take pride in the community spirit that has brought the new Museum of Art into being and made an exhibition of this dimension possible.

American Express believes in contributing to the quality of life of the communities where our customers, associates, and shareholders live. As a company, we have long had a vital presence in the tri-county region, and we are pleased to join in presenting this very special exhibition.

Our sincerest appreciation goes to Elliott Barnett and the dedicated staff at the Museum of Art. Mr. Barnett's vision and tireless efforts in realizing this dream are an inspiration to us all.

James D. Robinson, III
Chairman and Chief Executive Officer
American Express Company

THE NEW MUSEUM OF ART

Welcome to the reopening of the Museum of Art! Through the Museum's exhibition "An American Renaissance: Painting and Sculpture Since 1940," you are present at the coming of age of South Florida; you are here because of a spirit and an attitude toward a way of life that are positive and will contribute to America of the next century.

South Florida represents the natural evolution and progression of the filling out of the American continent. It is the last corner of our nation that became affected by growth, and it is now implementing its development. We are coming of age. Florida is one of the key states in terms of population, growth, and expansion. It has an energizing economic force, and its business, financial institutions, and news media are highly regarded. Its cities are developing and growing. Its institutions are becoming strong.

Thus, it is fitting that South Florida celebrate this beginning of its achievement with the Museum of Art. In so doing, we continue what has always marked man's best evidence of his contribution to civilization and culture—the visual arts. The testimony of the best of the past that we can observe today is in its artifacts, from Greek statues through Oriental figures; Pre-Columbian and Aztec gold; the Renaissance works of Michelangelo and Botticelli; the Impressionists and Fauvists; and now the American Abstract Expressionists and their heirs.

Museums have always symbolized and measured the achievement of culture; perhaps that explains why the America of today is deliberately building new museums across the breadth of the country. Perhaps we cannot state positively what will survive from our times, but we do believe that art museums will house the contents of what survives. We note that the quintessential American half century, 1950 to 2000, has contributed significantly to the history of art. We are certain that it will be from the architecture and the art of this period that America will be remembered, counted, and considered.

South Florida, Broward County, and Fort

Lauderdale are all very proud of this contribution—a new Museum of Art, designed by one of our country's most distinguished architects, Edward Larrabee Barnes, presenting the works of the greatest of America's artists of the period of America's most significant contribution to the visual arts.

We are grateful to the American Express Company for its forward-thinking and very generous gift that made this exhibition possible. The county government, through its Tourist Development Council and Broward County Arts Council, funded the exhibition with an additional gift.

We welcome you!

Elliott B. Barnett
President of the Board of Trustees

Like so many active and progressive cultural institutions, the Museum of Art mirrors its times and the generosity of its dedicated supporters. The ideas, ambitions, and tastes that shaped its development over the past quarter century have come from a large and diverse group of inspired and devoted citizens of Fort Lauderdale and Broward County, a region whose vital growth, energies, and aspirations made it possible for us to expand our goals and inaugurate this magnificent new modern building. With the encouragement, support, and expert counseling of many concerned individuals—collectors, art specialists, generous benefactors, and enterprising trustees—the Museum has now become a significant cultural force in the state of Florida.

The Museum has built, over the years, outstanding if rather specialized art collections in which we can all take pride. Obviously, among the leading American and European museums there exist many superior encyclopedic collections that can boast of greater artistic resources. Their treasures have been accumulated over centuries of active patronage. No museum, however, surpasses our comprehensive survey of "Cobra" art, the most significant collection of postwar European Expressionist art held by a public American institution.

After twenty-eight years of encouraging the public to visit our "pocket" museum, we are now entering a dramatically expanded new facility—mainly, because our audience has outgrown the old, familiar quarters. A more mature and sophisticated public now demands not only artistic quality that can withstand high standards of critical scrutiny, and far more ambitious programs, but also visible public amenities. None of these could be attained without significant enlargement of our permanent and temporary galleries, and of the public spaces in the lobby and the restaurant; the addition of our fine new auditorium; and the expansion of other vital areas required for the Museum's technical operations.

Meeting the needs of our public has always been the implicit justification for our acquisition,

exhibition, and educational policies. The Museum was founded on the assumption that art is inseparable from goals of public education, and thus the Museum of Art has addressed itself to a large and diverse constituency: to the family at home, to the student in the classroom, to the artist in his studio, to the dedicated scholar, and to the connoisseur—to the uninstructed as well as the culturally aware, all of whom are made welcome by our active staff docents. For these reasons we have managed to attract an audience on a scale once undreamed of, and its gratifying support has emboldened us to move forward even more adventurously.

For the Museum of Art, modern art has already proved its centrality to our culture and to our lives. Indeed, it has taken its rightful place in the great pageant of American history. Today modern, post-modern, and contemporary art in America continues to move forward dramatically, bringing forth vital vanguard innovators and sustaining powerfully independent visual traditions, unique in the world. For the grand opening of our new galleries, we are fortunate to continue a productive association with an old friend and colleague, Professor Sam Hunter of Princeton University, the celebrated art critic and educator who is familiar to you for the numerous exhibitions he has organized in this museum over the past several years. His inaugural exhibition, "An American Renaissance: Painting and Sculpture Since 1940," sets an impressively high standard in quality and scope, and it also presents us with a unique opportunity to reexamine the very considerable postwar achievement of American art.

A century ago, Matthew Arnold, the English critic and high priest of European cultural authority, disdained to be impressed by American progress, material wealth, and power, insisting we consider our cultural shortcomings before congratulating ourselves on our affluence and opulence, commercial success, and the quest for the beautiful and sublime. As Professor Hunter notes, during one of Arnold's visits to these shores, he rather peevishly dismissed American achievement in commerce and the arts: "Do not tell me only of the magnitude of your industry and commerce; of the beneficence of your institutions, your freedom, your equality; of the great and growing number of your churches and schools, libraries and newspapers; tell me also if your civilization—which is the grand name you give to all this development— tell me if your civilization is *interesting*."

Surely the arts of this century have dispelled Arnold's rather donnish and restrictive views of

the vital and original American contribution. Yet we have little reason to lapse into complacency today, in the media age, when the sheer volume of art-as-entertainment and works of embarrassing shallowness compete vigorously for the public imagination. This is the challenge to which we must continue to address ourselves in every generation: the discrimination of excellence is the serious work of public education as we explore together the changing meanings, values, and ideology of the art and architecture of our age, keeping in mind their historical roots and social base as well.

With Edward Larrabee Barnes's splendid new building finally in operation, and with the installation of this exciting and comprehensive survey of perhaps the most significant artistic episode in modern American history, the serious but also pleasurable work of our Museum has begun anew. We are at last in a position to meet the challenge and high expectations of a rapidly growing, culturally alert constituency in South Florida whose steadfast support and trust in our judgment have made this bold cultural initiative an irreversible reality.

George Bolge
Executive Director
Museum of Art, Fort Lauderdale, Florida

PAINTING AND SCULPTURE SINCE 1940: A SYNOPTIC HISTORY

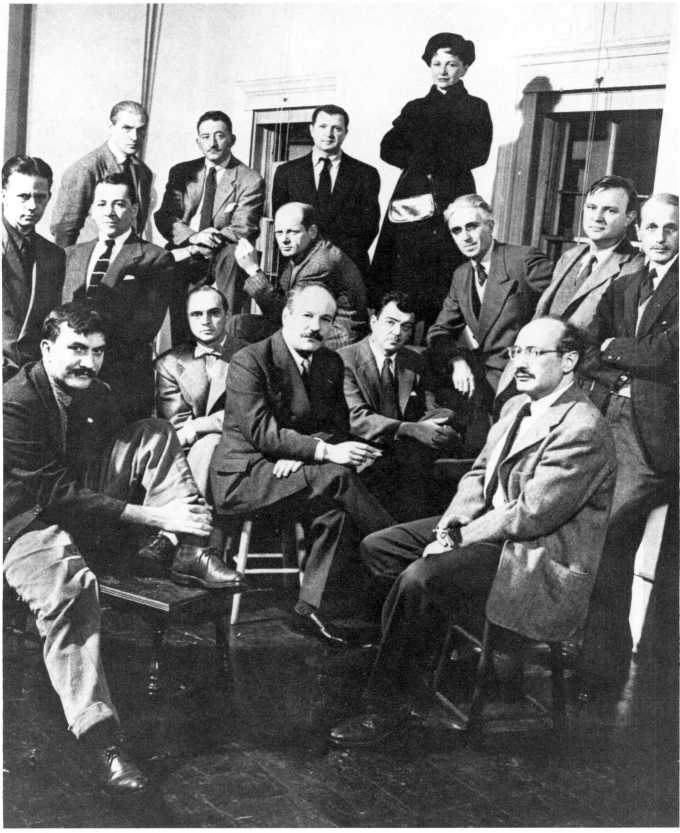

Figure 1. The so-called "Irascibles," 1951. Left to right: (top row) Willem de Kooning, Adolph Gottlieb, Ad Reinhardt, Hedda Sterne; (center) Richard Pousette-Dart, William Baziotes, Jackson Pollock, Clyfford Still, Robert Motherwell, Bradley Walker Tomlin; (bottom row) Theodoros Stamos, Jimmy Ernst, Barnett Newman, James Brooks, Mark Rothko. Photo: Nina Leen, *Life*.

POSTWAR AMERICAN ART AND THE MODERN HERITAGE

Sam Hunter

The triumphant return of American Art to the consideration of the engaging enterprises of our national life has aroused the indignation of various disgruntled factions. The most vociferous outbursts have issued from the sore throats of the cosmopolitan painters of New York, but the people of America are no longer heedful of the wants of dying modernists.... The whole trouble with America, in aesthetic matters, is her tolerance. She has been, until recently, so gullibly tolerant of imported cultural fetishes that she has remained in colonial bondage to moldering European abstraction.

Thomas Craven, "Nationalism in Art,"
Forum and Century, June 1936

One has the impression—but only the impression—that the immediate future of Western art, if it is to have any immediate future, depends on what is done in this country. As dark as the situation still is for us, American painting in its most advanced aspects—that is, American abstract painting—has in the last several years shown here and there a capacity for fresh content that does not seem to be matched either in France or Great Britain.

Clement Greenberg,
"The Situation at the Moment,"
Partisan Review 5, January 1948

I believe a renaissance exists today which is felt and shared by all. There is the birth of a new spirit and a new significance of form. There is a vitality and beauty in art today as penetrating and all embracing as has ever existed.

Richard Pousette-Dart,
talk at the Boston Museum School,
Boston, 1951

Kim Levin and the other contributors to this collection of essays have made it clear that today we cannot fairly assess the strength and range of world art of quality by limiting our account to events in America or to a specifically American art, if, indeed, there is such a thing. The current art scene is thoroughly diverse—stylistically, ideologically, and geographically. With the recent emergence of strong "schools" of painting and sculpture in Germany and Italy especially, Ms. Levin's epithet "global regionalism" wisely suggests how far we should go in defining national styles, in regard to both American and European art of the past decade.

Nonetheless, the idea of framing the events and personalities in American art over the past half century in terms of a new national self-consciousness and group identity, and, further, as a distinct and definable rebirth of creative energies, seems useful and warranted. The familiar term "renaissance" in this context has served mainly the nineteenth-century Golden Age of American literature. We should, of course, avoid imposing on the visual arts of the twentieth century a false unity or a collective purpose where none exists. And since the idea of a regrouping of energies and the rebirth of creative talent was first effectively given voice by the Abstract Expressionists, or the New York School, we must also guard against some of their early messianic rhetoric and exaggerated sense of their destiny.

Curiously, many of the Abstract Expressionists resisted the image of a "school" or a "rebirth," even as other individuals within the group publicly expressed a sense of collective style and purpose. In fact, one of the strongest assertions, and the one most frequently made, about this individualistic group is that no meaningful generalization or common denominator can contain its diversity. Each artist insisted on his individuality, his uniqueness, and it may even be that this anarchistic unwillingness to allow critics and curators to collectivize passionately held convictions and idiosyncrasies was itself American, in its anti-authoritarian stance and as an admission of some community of interests. Though all the Abstract Expressionists wanted to use personal intuition to make something new, distinctively American yet universally valid out of the modernism inherited from Europe, each sought to avail himself of an infinite set of options, and each strained for his own direction. As the critic Harold Rosenberg noted, "Painting became the means of confronting in daily practice the problematic nature of modern individuality."[1]

In his essay, Harry Gaugh makes another

essential point that helps explain the paradoxical defensiveness and ideological arrogance of the New York School artists. Only in the late fifties did they "achieve" significant serious international recognition and wide public success. Before then, what we now eulogize retrospectively as a "triumph" of American art, to use Irving Sandler's epithet, was treated by the popular press with disdain. In 1949 a Jackson Pollock exhibition was headlined in a popular weekly as "Jack the Dripper." Like so many other emerging vanguard movements of this century, Abstract Expressionism existed mainly underground in its rude beginnings and suffered the fate accorded its lively and controversial predecessors—popular and art-establishment reactions ranging from indifference to open hostility.

In any case, the phrase "American Renaissance" still has a certain ring, an acknowledged lineage, and a historically specific reference. It came into general use in the visual arts about 1880 and was understood to describe not simply a rebirth but, perhaps even more interestingly, a concerted communal effort to model American public life on the antique cultural ideals of Athens and on the Renaissance ideals of Florence and Rome. This late-nineteenth-century American Renaissance was political, civic-minded, and intensely nationalistic, freely appropriating images and symbols from past civilizations to create in specific art works allegories to support the new sense of our Manifest Destiny as a great power, and also to convey a new image of public life, embodied in elegant parks and malls, neoclassical architecture, and other amenities, including such a flood of heroic Beaux-Arts statuary that the art historian Milton Brown was prompted to call it "an orgy of plastic commemoration." Between the two world wars, these grandiose and dated allegories of great deeds and national heroes, immortalized in imperishable stone and bronze, slipped into senescence. Their iconography was a casualty of changing times, much as their *pompier* styles were made obsolete by the modernist revolution in artistic tastes.

A few decades earlier, the English critic Matthew Arnold had been a much-admired model for cultivated and literate Americans. He impressed on them the importance of forming and sustaining an educated cultural elite which, he insisted, would soon be called upon to act as the "saving remnant" of traditional authority in a

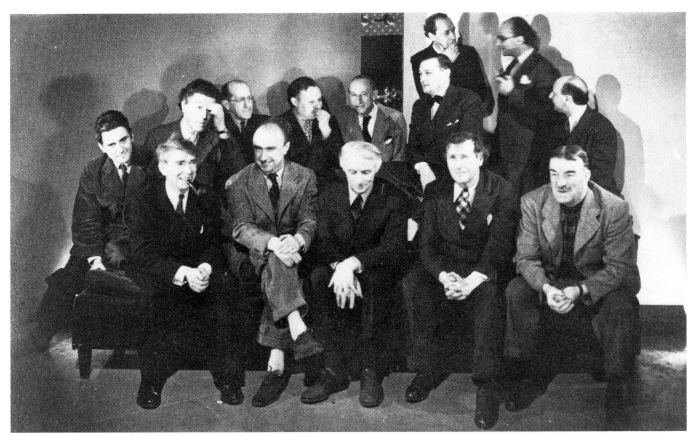

Figure 2. A group photograph of European artists who lived in America during World War II. From left to right, front row: Matta Echaurren, Ossip Zadkine, Yves Tanguy, Max Ernst, Marc Chagall, Fernand Léger. Second row: André Breton, Piet Mondrian, André Masson, Amadée Ozenfant, Jacques Lipchitz, Eugene Berman. Top row: Pavel Tchelitchew and Kurt Seligmann. Photo: George Platt Lynes.

world beset by forces of social change and anarchy. No matter with what terrors democratization threatened our political and social life, the "saving remnant" could be counted on to preserve "the best that has been thought and said in the world." [2] Arnold also had the temerity to challenge the putative civilized values of the brash New World, caught up in an expansionist fever and a self-congratulatory mood in 1880, at a time when the country was as proud of its philanthropies and cultural progress as it was of American material affluence:

Do not tell me only of the magnitude of your industry and commerce; of the beneficence of your institutions, your freedom, your equality; of the great and growing number of your churches and schools, libraries and newspapers; tell me also if your civilization—which is the grand name you give to all this development—tell me if your civilization is interesting.[3]

Americans went to school with European culture and society, but in a dark and self-deprecating mood. In his early novel of 1877, *The American*, Henry James's self-conscious hero Christopher Newman learned to his dismay, as he stood before the old masters in the Louvre, the mortifying truth that "Raphael and Titian and Rubens were a new kind of arithmetic, and they inspired our friend, for the first time in his life, with a vague self-mistrust."[4]

Still, the reverence for European culture in the 1880s also impelled America to self-discovery, and then to creating a more distinctive culture of its own, as part of the quest for a national identity. It also encouraged a fresh appreciation of the virtues and uses of our heretofore disdained provincial past. And so the cultivated and artistic American's view of himself shifted dramatically away from the plaintive and self-pitying cry of Henry James's cultural innocents, excluded from European tradition and artistic achievement, and condemned forever to some purgatory of shallowness, as recorded in his story "The Madonna of the Future":

We are the disinherited of Art. We're condemned to be superficial! We're excluded from the circle! The soil of American perception is a poor little barren artificial deposit! . . . An American, to excel, has just ten times as much to learn as a European! . . . We lack the deeper sense! We have neither taste nor tact nor force! . . . How should we have them? Our crude and garish climate, our silent past, our deafening present, the constant pressure about us of unlovely conditions, are as void of all that nourishes and prompts and inspires the artist as my sad heart is void of bitterness in saying so! We poor aspirants must live in perpetual exile![5]

But after this anguished *cri de coeur*, even James began to tire of his romantic fascination with effete European manners and noblesse oblige, as he felt the prestige and allure of the Old World

wearing thin. He took a fresh look at the American condition, reappraising its rootlessness, eclecticism, and freedom from constraining traditions, and found it a positive thing and perhaps even a providential blessing. In a letter to a fellow countryman he confessed his change of heart:

We young Americans are (without cant) men of the future.... We are Americans born.... I look upon it as a great blessing; I think that to be an American is an excellent preparation for culture. We have exquisite qualities as a race, and it seems to me that we are ahead of the European races in the fact that more often than either of them [sic] we can deal freely with forms of civilization not only our own, can pick and choose and assimilate and in short (aesthetically and culturally) claim our property wherever we find it.[6]

John La Farge expressed similar sentiments in discriminating between American and European artistic moods without falling into the trap of self-denigration: "We are not as they are—fixed in some tradition; and we can go where we choose—to the greatest influences, if we wish, and still be free for our future."[7]

There are fascinating cultural parallels with these nineteenth-century experiences in the artistic odyssey after World War II, as members of the New York School progressed from provincial

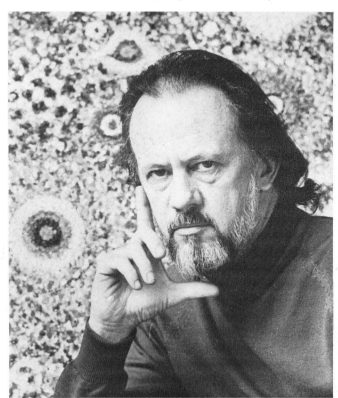

Figure 3. Richard Pousette-Dart.

isolation and innocence to the heady new sense that they were capable of sharing international responsibility for the fate of vanguard culture,

following the turmoil of the war in Europe. And there exist still other compelling reasons for describing the unprecedented flowering of American artistic talent and energies in this period and since as a rebirth, not least among them the fact that the artists themselves (*vide* Pousette-Dart) and critics of the period so felt and judged it. It is also useful to recall how the critic F.O. Matthiessen used the term "renaissance," when there might exist some doubts as to an anterior *naissance*. In defining a previous Golden Age in American literature, from Emerson to Whitman, he observed that such a phenomenal burst of creativity could best be described and understood

not as a re-birth of values that had existed previously in America, but as America's way of producing a renaissance, by coming to its first maturity and affirming its rightful heritage in the whole expanse of art and culture.[8]

To bring together these loose cultural threads of the American and modern heritage into a more meaningful pattern in our own period, beginning with the forties and the fifties, we can, in fact, produce proof positive and identify any number of extraordinary and representative works of art as acknowledged masterpieces, works of originality and imaginative power, which came into being at a historically specific moment. The oeuvre exists, it has been catalogued and classified in private and public collections and in innumerable scholarly studies and exhibition catalogues. This definable, concrete body of work has also created an extensive and continuing body of serious critical literature.

In this exhibition, Clyfford Still's brilliant untitled painting; Arshile Gorky's exquisite and poignant late work; David Smith's bold and blunt sculpture, demonstrating a perceptible vernacular, nativist assimilation of the great and familiar European Constructivist traditions; and Hans Hofmann's equally extraordinary synthesis of national and international sources, including influences as diverse as Cubist planar structure and Matisse's exquisite chromatic sensibility—all these are but a few incontrovertible signifiers, among the many remarkable expressions of individual genius, of a sustaining, if variously inflected, common sensibility.

Nearly 170 years had passed after Americans won their political revolution before they waged and won an aesthetic revolution, which finally enabled American art to throw off its shackles—provincialism, overdependence on European sources, an indifferent or even hostile public—and to liberate itself into a quality and expressive force equal to or exceeding that of modernist art produced anywhere within the period. Indeed, few would argue that the painting

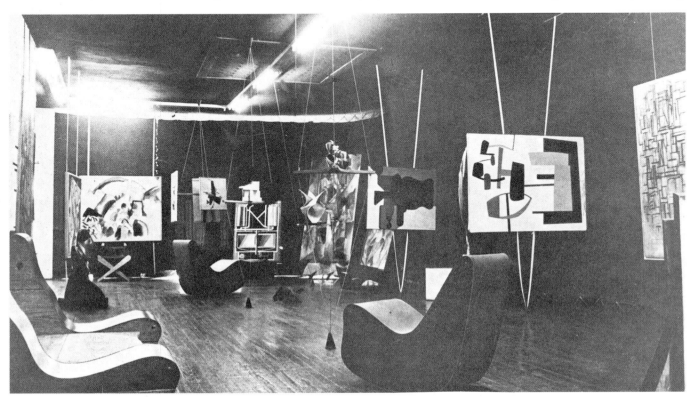

Figure 4. Art of This Century Gallery, New York, 1942.

and sculpture to emerge from the so-called New York School was, from the mid-1940s to the end of the 1960s, the foremost artistic phenomenon of its time, a reality that virtually transferred the center of the art world from Paris to New York.

Tempered by the struggle of surviving the Great Depression as well as the hostile barbs directed at international modernism, issued by such writers as Thomas Craven, the artists who became the pioneers of the New York School brought forth works that, by virtue of their highly original, monumentally scaled synthesis of modernism's great trends—Cubism, Expressionism, and Surrealism—represented an art of truly heroic grandeur. In time this art would leave little doubt about its power and importance, its legitimacy as successor to the best in European modernism, and the genuine Americanness of its vigor, boldness, and simple integrity.

The inspiration and formative influences for this extraordinary flowering of American genius were many and various, and they have been set forth frequently in the expanding literature on the movement. The decline in the momentum of European innovation and catastrophic public events on the Continent seemed to have had the paradoxical effect of releasing powerful new energies among young American artists. For a moment, it even seemed as if the main impulses of modernism had been repatriated and driven underground in this country, for the emerging American vanguard drew support and inspiration, in its complex beginnings, from direct contact in New York during the war years with a number of Europe's leading artists and intellectuals (figure 2). Léger, Tanguy, Mondrian, Breton, Ernst, and Matta, among others, maintained warm and influential relationships with many of these young Americans, and bridged the intimidating distance between them and advanced European art. A number of the European artists showed regularly at Peggy Guggenheim's Art of This Century Gallery (figure 4), and it was there that the pioneer American Abstract Expressionists Pollock, Rothko, Still, Hofmann, Motherwell, and Baziotes had their one-man shows, between the years 1943 and 1946.

As is well known, the decade of the fifties brought the expansive triumph of the New York School, a flowering of American artistic genius of international dimensions almost immediately acknowledged in advanced European criticism and sustained by admiring followers abroad, which was a shocking reversal of the customary current of transatlantic artistic influence for per-

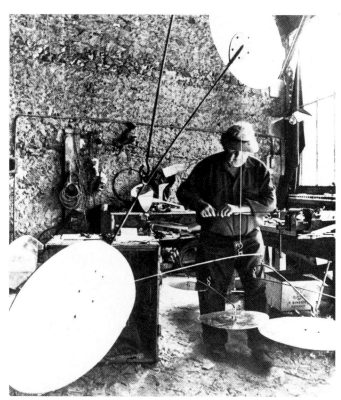

19

Figure 5. Alexander Calder at work in his small studio at Saché, France, 1972.

Figure 6. David Smith in his studio, Bolton Landing, New York, 1962. Photo: Ugo Mulas.

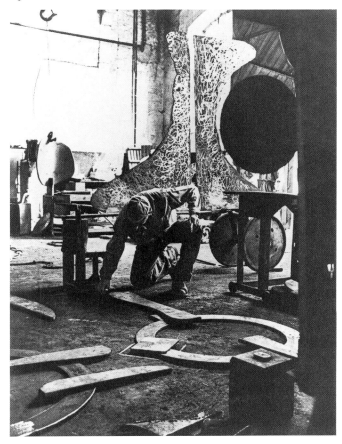

haps the first time in American cultural history. Alternatively known as Abstract Expressionism and, in a more specialized application, as Action Painting—a term conferred by Harold Rosenberg's famous essay of 1952—the New York School had by the end of the decade attained a collective coherence and a self-confidence that astonished even its most fanatical partisans. In a discerning if faintly ironic appreciation of the new movement, the art historian Robert Goldwater wrote in 1960:

> Not only is there the New York School that has burst into popularity, influence and affluence; not only has it had time to flower, to grow from indifference to prominence, from oppression to dominance; but it has also had time to change and develop, evolve and alter and expand, to spread and succeed, to attract followers and nourish imitators. It has lived a history, germinated a mythology and produced a hagiology; it has descended to a second, and now a third artistic generation.[9]

The adamant and defiant spirit of the pioneer generation of the New York School was captured in a famous group photograph (figure 1) of the so-called Irascible Eighteen, which included many of the leading new avant-garde artists. Pollock, de Kooning, Rothko, Newman, Still, Reinhardt, Motherwell, and others posed together to protest against the policies of The Metropolitan Museum of Art in 1951, and were recorded for posterity in the pages of Life magazine. Their look of stubborn determination gives one some sense of the fierce pride and tenacity of purpose of this first generation of Abstract Expressionists.

Professor Harry Gaugh's instructive and delightful essay bridges the period in which

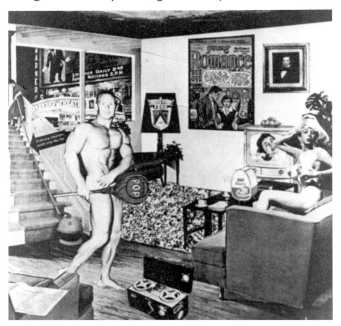

Figure 7. Richard Hamilton. *Just What Is It That Makes Today's Homes So Different, So Appealing?*, 1956. Collage, 10¼ x 9¾". Collection Mr. Edwin Janss, Jr., Los Angeles.

modernist Americans such as Stuart Davis and Alexander Calder assimilated the radical forms of European modernism, adapting Parisian strategies to their own particular sensibilities, and the advent, development, and decline into mannerism of Abstract Expressionism. The other distinguished contributors to this catalogue have picked up the narrative thread and continued with the new dialogue between American art and the objects, signs, and technology of the environment, as a new generation of artists in the sixties turned away from the subjective idealism of the Action painters to a new kind of subject matter. It was invariably topical, rooted in ordinary life and mass media, and intentionally banal in imagery and surface. This emerging generation of Pop artists, and their influential precursors, Rauschenberg and Johns, had taken flight from the heroic commitment to abstraction and the elitist posture of the Abstract Expressionists. Their dissenting position and fresh imagery led ultimately to the heresy of Pop Art.

Pop Art actually began in England in the late 1950s as an involvement with popular culture, almost a decade before it was associated with a distinctive artistic style or method. At least one American, R.B. Kitaj, chose to reside in England permanently at the beginning of this period, creating perhaps a more esoteric and literary variant on what was soon to be identified with a peculiarly American style of brashness and heroic scale. Pop Art originally grew out of discussions and exhibitions held at the Institute of Contemporary Art in London by a number of artists, critics, and architects who called themselves the Independent Group. Urban folklore—popular culture and its visual embodiment in advertising imagery and signs—became the obsession of the group. In 1956 it held an exhibition at the Whitechapel Art Gallery in London called "This Is Tomorrow," which showed a series of contemporary environments developed from photographs of architecture and the vernacular imagery of the advertising world. Richard Hamilton contributed a small collage that later became justly famous as the Pop Art forerunner (figure 7), although it was unknown by the Pop artists in America, who arrived at their styles independently some years later. Hamilton's collage, entitled *Just What Is It That Makes Today's Homes So Different, So Appealing?*, shows, in a modern interior, photographs of a muscleman and of a pin-up girl wearing only a hat, with the male figure holding a large lollipop on which the word "POP" is inscribed in bold letters. It is also crammed with

the icons of the consumer world—a tape recorder, canned ham, a television set, a comic-book cover, a Ford advertisement, and a vacuum cleaner—and reflects postwar Britain's nostalgic admiration for American material prosperity and technological progress.

In 1962 there was an even more influential exhibition, in the Sidney Janis Gallery in New York (figure 8), which was entitled "New Realists" and combined leading European New Realists (among them the Frenchman Arman, who later became an American citizen) and the American Pop artists Warhol, Segal, Dine, Lichtenstein, and many others. In his regular *New Yorker* art column, Harold Rosenberg noted that the controversial exhibition "hit the New York art world with the force of an earthquake."

The Pop artists were roundly censured for their artistic iconoclasm, and bore the brunt of almost hysterical criticism by defenders of "high" art who felt that fundamental aesthetic and moral issues were at stake. They rebuked the rude and dissident young not only for their flirtation with the visual signs and imagery of popular culture, but for their seeming acceptance of related commercial values and indifference to a rampantly consumerist society which their art appeared to celebrate. Divisive and impassioned arguments about issues of art and life, and about popular sources in a shallow Pop environment, roiled in the early years of the sixties, as the potent and controversial new movement began to establish itself.

While the initial reaction of the cool second-wave New York School to Action Painting came in the form of Pop Art—by an extension of as well as a departure from the gesturalism and inclusiveness of de Kooning—another branch of the same generation expressed its detachment by rejecting de Kooning totally and by turning to Pollock. But the Pollock they saw was not an artist of spontaneity, ambiguity, and complexity; rather, he was the creator of the single, clear, all-over, "holistic" abstract image. The younger artists of this bent also found inspiration in the non-painterly styles of the Color Field painters, mainly Newman, Rothko, and Reinhardt.

For ideological support, they could also turn to the New York critic Clement Greenberg, who, like John Cage, had ties to Black Mountain College in North Carolina, that mecca of the American avant-garde in the 1950s. As defined in a series of articles and reviews beginning as early as 1939, Greenberg's aesthetic held that "modernist" painting, from the time of its inception in Impressionism, had an overriding desire to become "pure," meaning that its creators had always sought, and should continue to seek, an art based, with increasing exclusivity, on those properties that are uniquely and irreducibly its own: color and the two-dimensional surface, or plane, on which the medium is applied. Thus, Greenberg rejected de Kooning's "painterly painting" because its tactility and value contrasts must inevitably create illusionistic space and therefore work against pictorial flatness. Prompted by this

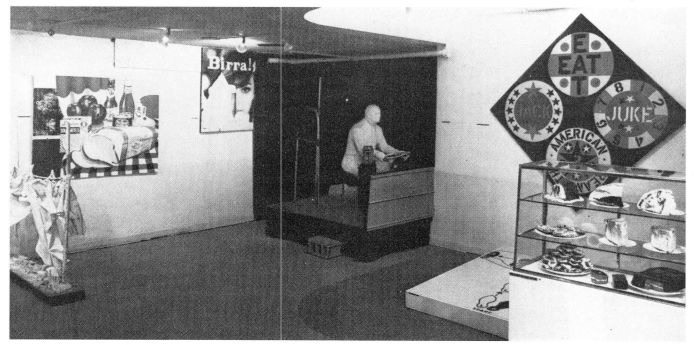

Figure 8. Installation of the "New Realists" exhibition, the first Pop Art group show, at the Sidney Janis Gallery, New York, 1962.

rationale, Greenberg also dismissed Cézanne and the Cubism that this master had inspired; an influential essay of the early sixties urged progressive painters to rediscover Monet, long ignored because of his presumed lack of structure, and to see the late water-lily pictures as a prophecy of contemporary Color Field Painting.

By the mid-1960s the simplifying spirit that arose in rebellion against Action Painting had grown so dominant and progressive that it produced what came to be known as Minimalism. In keeping with the major objectivist trends of the period in both abstraction and imagist art, the new term implied two concepts, decidedly different from one another but joined in a kind of obverse relationship. On the one hand, there had been the extreme and reductive formalism of the Post-Painterly Abstractionists, who, as Clement Greenberg prescribed, sought to purify painting of everything but its irreducibly essential properties.

On the other hand, simplification had been urged by the composer John Cage and expressed by the Neo-Dadaist Pop artists in the form of the use, in high art, of objects from everyday life with minimal or no modification imposed upon them by the artist. When initially absorbed into current usage, however, Minimalism stood for reductive form beyond anything seen before in the New York School; it was an "ABC Art," as Barbara Rose called it, "whose blank, neutral, mechanical impersonality contrasts so violently with the romantic, biographical Abstract-Expressionist style which preceded it that spectators are chilled by its apparent lack of feeling or content."[10] Robert

Morris's first New York one-man exhibition in 1964, with its array of bland geometric forms in gray (figure 10), exemplified Ms. Rose's terse commentary and also reflected the thinking of John Cage, a friend of the artist, who, probably as much as any single figure, influenced the striking shift in visual aesthetics. At this time, Cage summarized the Minimalists' paradoxical inspiration and their ironic vacuous effects with the aphorism: "I have nothing to say, and I am saying it."

And so it has gone, into the seventies and eighties, with new movements proliferating in dizzying profusion. Conceptual and Environmental art, as Robert Morgan points out in his commentary, developed directly from structurist and Minimal sculpture, stimulated by the revival of ideological preoccupations challenging the increasing commercialization and "commodification" of art by the expanding art world's support system of galleries, museums, and publications, in a period of competitive ardor among affluent collectors for vanguard art production. By the seventies there was a remarkable variety of vital new expression, as we entered a new age of pluralism, which the architectural historian Charles Jencks later described in a somewhat different context, with reference to "post-modern" architecture, as a period of "radical eclecticism."[11]

Today the range of expression in painting and sculpture extends from allusions to historical models "appropriated" with no apparent alteration except in context to a continuing if somewhat enfeebled purist, abstract impulse; from vernacular and primitivist styles to polished photo-

Figure 9. George Segal and Sam Hunter, outside Segal's New Brunswick, New Jersey, studio, 1984. Photo: Arnold Newman.

documentary and intellectually exacting Conceptual projects. We seem to have in the art world itself a good deal of the highly individualistic if self-centered and materialistic spirit of "the me decade" which is evident in other areas of high and low culture. And the mix of the two cultural standards, high and low, also continues to be a source of inventiveness and even of social affirmations, despite the continuing cold war, the menace of terrorism, and an imperiled environment.

Old formalist beliefs in the simple art object, or icon, as a basic, neutral, unchanging, and reliable source of meaning have been compromised almost beyond recovery by the exposure to new linguistic and structuralist viewpoints. Site works, "post-modernist" performance pieces, and Conceptual Art have all broadened the assault on the ideals of the sixties, as Ms. Levin so eloquently makes clear. Indeed, the intellectual vogue of semiology and "deconstructive" criticism argues for the right of the reader, or the viewer of art objects, to interpret and in effect to re-create the work before him. As the critic Stanley Fish recently wrote in a commentary that has been liberally applied to art objects, "Interpretation is not the art of construing but of constructing. Interpreters do not decode poems; they make them."[12] Nonetheless, innumerable works of quality even from the younger generation still persist in the reductive, late-modernist styles, despite the turn to vernacular idioms and an intense, if perhaps regressive, neo-expressionist revival on the one hand, and a more cerebral and conceptualized approach on the other. A radical eclecticism assumes that old hierarchies of dominant and subordinate styles have for the moment been abandoned.

In fact, the openness to a wide variety of styles and expressive moods is so striking, after the dominant and oppressive austerities of Minimalism in the sixties, that art today, in the process of change and détente, has found a new, more ebullient purpose in these neo-expressionist, primitivist, and imagist directions, exploring with a fine impartiality both figurative and abstract modes.

Another new and inescapable aspect of contemporary creation is the fascination with public violence. The political and environmental dislocations of the seventies and eighties, following the unsettling collapse of the American presence in Vietnam, and the collective insanity of the contemporary nuclear arms race have combined with millennial fears—recently *The New Republic* reminded us of "the looming presence of the magical year 2000"—to create a new and pervasive sentiment of public pessimism. The mood of disquiet and fatality has been reflected in the popularity and visionary character of the new expressionist wave in painting, and an increasingly receptive attitude in contemporary art generally to themes of violence. Millennial fears probably augmented the doomsday prognostications made by Jonathan Schell, and they may have intensified the exigent campaign of the antinuclear activists. Perhaps they even contribute to popular misgivings, amply supported by hard evidence, concerning the uncertain prospects of a stable international political life and the soundness of the ecology.

Responding to these sobering challenges,

23

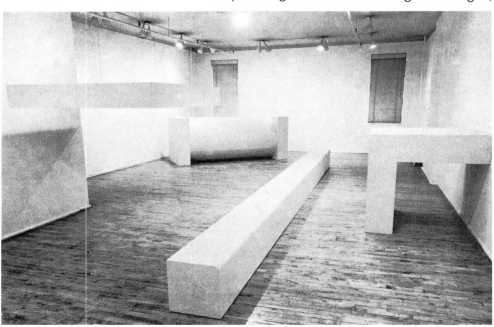

Figure 10. Installation of Robert Morris's one-man show of painted fiberglass structures at the Green Gallery, New York, 1964.

Figure 11. Frank Stella, 1984. Photo: Marina Shintz.

Figure 12. Nancy Graves, New York, 1983.

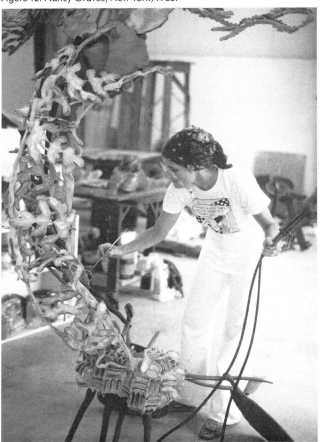

many young artists today have been openly repudiating modernist formal elegance and austerities and seeking dramatic new symbols. The new expressionist and fantasy arts resonate with desperation and a sense of vulnerability in the times, although at their best they also remain formally astute, rising above the more sentimental tendencies of a pictorial rhetoric of crisis and personal catharsis.

Despite the emergence of a number of major figures of extraordinary talent and powerful originality in the Neo-Expressionist and New Image styles—among them Borofsky, Schnabel, Salle, Longo, Rothenberg, and Jenney—we cannot say that any one stylistic mode yet reigns supreme. Different though they are in manner and vision, these artists all concern themselves with serious themes, including confrontation with the prospect of nuclear annihilation. This recent development of an art which openly embraces explicit and controversial social commentary, often with strongly moralistic overtones of some urgency, signals a shift in consciousness. Karen Koehler's essay on the ubiquity, and implications for art, of artists' preoccupations with politics and with social violence provides an eloquent commentary on the changing face and content of some of the best contemporary art.

Pluralism has in the eighties also encouraged compelling new kinds of abstract art, often framed in expressive baroque modes. Like Pattern and Decoration, it certainly reflects the influence of the mixed pictorial and environmental energies of Frank Stella's highly embellished, sprawling, three-dimensional constructions. The same tendency can be seen to spectacular effect in the work of Elizabeth Murray, who has achieved a highly original balance of vibrant color and interactive shapes that combine geometric and organic forms in multi-part, monumental scale. Sean Scully, working in a more restricted manner, which evolved from his controlled structures of con-tinuous parallel stripe paintings in the late seventies, has now wrenched new and more powerful dissonances from his previous formal strategies. He has thus managed to give a magical and primitivist cast to his recent three-dimensional, painted relief structures, with their contending, coarsely painted, warped bands of color arranged in irregular geometric structures on thick stretchers.

Another among the numerous talented women artists who have emerged in the past decade to energize the art of the eighties is Nancy Graves, who exploits direct-casting methods to

capture the textures of natural materials and then proceeds to assemble them in fantastical abstract forms totally alien to their original condition (figure 12). Her curious and personal amalgam of naturalism and personal fictions reminds us that the continuing effort to reconcile fact and abstraction, which so many commentators, from Emerson to Marianne Moore, have noted, seems almost endemically American.

Stella's recent work, which resembles Ms. Graves's colorful, intensely activated forms and prodigal energies, provides a vital bridge between the great achievement of postwar gestural abstraction, with which this exhibition begins, and the contemporary urbanist graffiti art represented by Keith Haring and Kenny Scharf. Some of the tensions of art and anti-art, high art and vernacular styles, are perhaps resolved by Stella's current work. His urbanist drives and obvious wish to force such associations through his art recall a similarly inspired synthesis of urban reality and the formal strategies of cosmopolitan modernism with which the story of the postwar "American Renaissance" commenced, nearly a half century ago, with the formation of the first New York School.

Some forty years after his first one-man show stunned the New York art world, de Kooning's contemporary work continues effectively to demonstrate his virtuosity and the relevance of his dense and complex style, which was the first, in the epic saga of American art history and theory, to combine suggestions of human anatomy and the life of the city. Jasper Johns's magnificent *Dancers on a Plane,* with its complex herringbone field of interwoven brushstrokes, also continues to assert a potent presence in the contemporary art world today, within a body of work that balances private and public realities in an unremitting tension.

Two such luminous examples of the late flowering of the "Old Masters" of American modernism, albeit separated in time by two generations, should redress any overriding concern with an obsessive "tradition of the new." That phrase was one of the taunting catchwords of Harold Rosenberg's radical critique of modern abstract painting, but it soon came back to haunt the older generation he championed, as the critical limelight shifted to younger talent. The truth is that major artists remain forces to be reckoned with, and many go on producing works of unassailable quality long after stylistic trends and fashion have moved on—and long after the older masters themselves are expected to remain either relevant or interesting.

In the effort to illustrate as many serious new developments in art as possible from a period of rapid change and a profusion of movements and counter-movements, depth was sacrificed for breadth, and each artist in the exhibition has been represented by a single example only. Some loss of historical continuity and a sense of impoverished representation in the case of major artists have inevitably resulted. Whatever may have been sacrificed in depth and coherence we hope will be offset by the Museum's good fortune in obtaining so many outstanding and rarely seen loans of high excellence. We were also pleased to find ourselves the recipients of an unforeseen aesthetic bonus, arising from the tactic of freely mixing styles and generations, without limiting individual artists to their most publicly familiar phases. Unsuspected affinities emerged from this extraordinarily diverse but representative cross section of modernist creation and sharply contrasting viewpoints. And these are embodied in works of quality which, more often than not, manage to elude classification and collapse distinctions between historical modern art and the evolving critique afforded by the most recent innovations in contemporary American art.

25

NOTES

1. Harold Rosenberg, *The Anxious Object* (New York: Collier, 1964), p. 40.
2. Matthew Arnold, "Numbers: Of the Majority and the Remnant" (1884), reprinted in Matthew Arnold, *Culture and Anarchy* (Cambridge, Mass.: 1960), p. 6.
3. Matthew Arnold, *Civilization in the United States* (Boston, 1888), p. 170.
4. Henry James, *The American* (Cambridge, Mass., 1970), p. 2.
5. Henry James, *Stories of Writers and Artists,* ed. F. O. Matthiessen (New York: New Directions, n.d.), "The Madonna of the Future," p. 21. Cited in *The Arcadian Landscape, Nineteenth-Century American Painters in Italy,* exhibition catalogue, University of Kansas Museum of Art, November 4–December 3, 1972, p. x.
6. James to Perry, quoted in Leon Edel, *Henry James, 1843–1870: The Untried Years* (Philadelphia, 1953), p. 265.

7. John La Farge, "The American Academy at Rome," The Field of Art, *Scribner's Magazine,* 28 (Aug. 1900), p. 254.
8. F.O. Matthiessen, *American Renaissance: Art and Expression in the Age of Emerson and Whitman* (New York, 1941), p. 5.
9. Robert Goldwater, "Reflections on the New York School," *Quadrum 8* (1960), p. 18.
10. Barbara Rose, "ABC Art," *Art in America,* vol. 53 (Oct.–Nov. 1965), pp. 57–69.
11. Charles Jencks, "Towards a Radical Eclecticism," *The Presence of the Past,* First International Exhibition of Architecture, *Corderia of the Arsenale, La Biennale di Venezia,* 1980 (Milan: Edizioni la Biennale di Venezia, Electa Editrice, 1980).
12. Cited in Sam Hunter, ed., *New Directions: Contemporary American Art from the Commodities Corporation Collection,* exhibition catalogue, Princeton, N.J., 1981, p. 10.

I
REAPPRAISING THE
NEW YORK SCHOOL

Harry F. Gaugh

Painting

William Baziotes
Ilya Bolotowsky
Stuart Davis
Willem de Kooning
Richard Diebenkorn
Sam Francis
Arshile Gorky
Adolph Gottlieb
Hans Hofmann
Franz Kline
Lee Krasner
Joan Mitchell
Robert Motherwell
Barnett Newman
Jackson Pollock
Richard Pousette-Dart
Ad Reinhardt
Mark Rothko
Clyfford Still

Sculpture

Louise Bourgeois
Alexander Calder
Joseph Cornell
Louise Nevelson
Isamu Noguchi
Theodore Roszak
David Smith

Recalling the "glory days" of Abstract Expressionism, Philip Guston has told how he and Bradley Walker Tomlin, with whom he shared a Greenwich Village loft during the late 1940s and early 1950s, once had dinner with Jackson Pollock. Late in the evening—the occasion was filled with art talk and booze—Pollock jumped up, grabbed a loose nail nearby, and hammering it into the floor shouted, "Damn it! If I say that's art, that's art!" Guston added that the outburst nearly scared the gentlemanly Tomlin to death.[1] Claiming the nail as art may now seem a nihilistic gesture looking back to Marcel Duchamp yet anticipating Joseph Beuys.

Guston told the story to illustrate Pollock's unpredictable, frequently abrasive nature and also to point out Pollock's intense commitment to art. It was a twofold commitment: to making difficult avant-garde art, and to living and working as an artist with little regard for polite sociability.

Of course, Pollock was not unique in pursuing his vision of art as an ethical force superseding aesthetics. Other first-generation Abstract Expressionists—Willem de Kooning, Franz Kline, Barnett Newman, Mark Rothko, Clyfford Still—pushed art beyond visual concerns to a rigorous way of life demanding total dedication with no guarantee of critical or financial reward. Perhaps Pollock summed it up best when he said, "Painting is my whole life."

For the Abstract Expressionists, a generation of artists who matured during and shortly after World War II, making paintings helped hold back the ominous "all-encompassing dark" described in 1955 by J. Robert Oppenheimer. Speaking in an existential tone of the increasing gap between art and science, Oppenheimer observed, "Never before today has the integrity of the intimate, the detailed, the true art, the integrity of craftsmanship and the preservation of the familiar, of the humorous and the beautiful stood in more massive contrast to the vastness of life, the greatness of the globe, the otherness of people, the otherness of ways, and the all-encompassing dark."[2] While referring neither to visual art in general nor specifically to contemporary painting, Oppenheimer had identified some of the touchstones of Abstract Expressionism.

Recently, however, it has become fashionable to challenge the artistic achievements and ethical foundations of Abstract Expressionism. The gauntlet that won the most notoriety was thrown in 1983 by Serge Guilbaut in *How New York Stole the Idea of Modern Art*.[3] Ingredients of

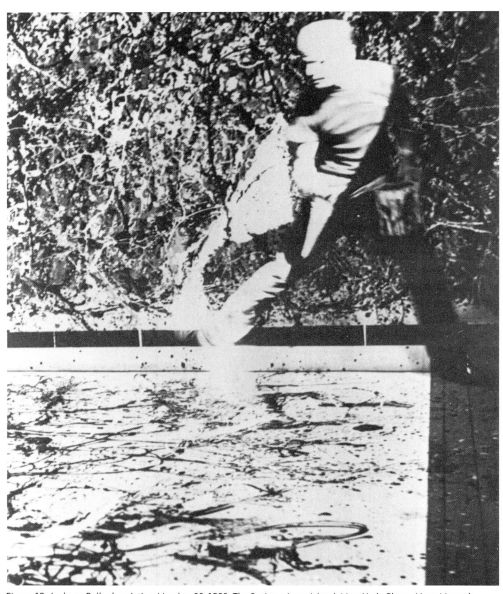

Figure 13. Jackson Pollock painting *Number 32, 1950*, The Springs, Long Island, New York. Photo: Hans Namuth.

28

Guilbaut's presumptive thesis make up the book's subtitle: *Abstract Expressionism, Freedom, and the Cold War.* As might be imagined, they do not mix well in this hermetic attempt to explain, in political terms, the emergence of Abstract Expressionism as a major art phenomenon. Desperate for a non-artistic context commensurate with the postwar political climate—characterized briefly by a Pax Americana and then by rampant anti-Communism—Guilbaut forces Abstract Expressionism into a neo-Marxist straitjacket. Unfortunately, in the process most of the art, such as Pollock's poured paintings of 1947–48, is excised from the illuminating context of artists' lives and interrelationships.

Writing in *The New Criterion* in 1985, Hilton Kramer exposed the bias of Guilbaut's wobbly intellectual construct and, referring to the "victory" for both Abstract Expressionism and Harry Truman in the 1948 presidential election, observed with commendable directness, "As art history, all of this is the sheerest rubbish, for it is history based on ideological scenarios that are completely removed from the real life of art. But it is, alas, the kind of rubbish that has now achieved a macabre intellectual legitimacy. Yet to write in this manner is to deny to art any significant role in determining its own history."[4]

Abstract Expressionism did not develop as a political phenomenon. Robert Motherwell zeroed in on this essential fact years ago, when he noted at the top of a now famous impromptu chronology of the New York School: "MORAL IDEAL: Mondrian; AESTHETIC IDEAL: A Looser 1911 Cubism; POLITICS: None—Hatred of W.P.A."[5] The glory days of Abstract Expressionism were not filled with revolutions to improve society, but with lonely struggles in the studio. There, artists confronted the dilemma of what art had been in Paris before World War II and what it might become in New York. To be sure, major European artists were already in New York, having arrived in the late 1930s and early 1940s: Chagall, Dali, Ernst, Léger, Lipchitz, Masson, Mondrian, Tanguy, Tchelitchew.

Perhaps in light of this exhibition, its chronological and stylistic range, it would be useful to ask: What *is* the legacy of Abstract Expressionism? Does it still add up to "The Triumph of American Painting" set forth by Irving Sandler in the title of his 1970 book? Is Abstract Expressionism viable as a movement for contemporary artists? Is the New York School, with its accommodation of multiple styles and ideologies—not to mention distinctly drawn personalities—

relevant to young artists in Manhattan, Newark, Chicago, Los Angeles, or, for that matter, in Tokyo and Berlin? Has Abstract Expressionism largely been locked into history, a fixture of the past, in spite of the fact that the first-generation painters de Kooning, Motherwell, and Pousette-Dart continue to work? (After all, Monet was still painting in an Impressionist style in 1926, nineteen years after Picasso gave up on *Les Demoiselles d'Avignon*.)

While younger artists may be inspired by particular Abstract Expressionists or their work, this does not necessarily mean that the movement as a whole conveys any broad meaning sociologically. Is there, for instance, anything today like The Club, that informal gathering of New York artists "formed to provide a place where [they]

Figure 14. Robert Motherwell, 1982. Photo: Renate Ponsold.

could escape the loneliness of their studios, meet their peers to exchange ideas of every sort, including tips on good studios and bargains in art materials (a perpetual topic)"?[6] Considering the "hottest" New York art at the moment—namely, that coming out of the East Village—any spiritual counterpart of The Club has been surpassed as locale for mutual support by non-art clubs, above all the opulent Palladium on Fourteenth Street with its frenetic synergism of music, light, dance, sex, fashion, and, not to be overlooked in the midst of such glamour, paintings by Keith Haring, Kenny Scharf, Jean-Michel Basquiat, and Francesco Clemente.[7] One wonders if Action Painting has been extended to action on the dance floor. Oppenheimer's "all-encompassing dark" has been technologically transmuted to

29

strobe lights and Dolby sound.

Naturally, some critics were already debunking Abstract Expressionism in the early 1960s. Abstraction per se was regarded as obsolete during the rowdy heyday of Pop Art. And several leading galleries, such as the Sidney Janis Gallery, shifted their primary interest away from abstraction. Significantly, in sculpture, abstraction was never overshadowed by Pop Art, although it developed a "cool" style all its own by way of planar or volumetric geometry. However, in spite of nay-sayers, abstract art has survived in painting and sculpture and, as exemplified by this exhibition, thrives because of such artists as Elizabeth Murray, Bryan Hunt, Judy Pfaff, and Sean Scully. Working in widely different modes, these artists are in generic terms descendants of the New York

halves, meld as a seamless wall, defying the all-encompassing dark Oppenheimer noted. As a historical aspect, moreover, Newman's unflinching ethical standard, against which both the artist and the viewer must measure their personal and professional *raisons d'être*, has had significant impact on younger visionary artists. To name only one: Brice Marden. Like Abstract Expressionism, Marden's painting affirms a complete meshing of moral/artistic attitudes.

Abstraction was by no means the dominant mode in American painting or sculpture before World War II. Art was rigorously figurative, and much of it was social realism. The Public Works of Art Project, which was begun in 1933 and was a predecessor of WPA's Federal Art Project, did not

Figure 15. Left to right: Barnett Newman, Jackson Pollock, Tony Smith, New York, 1951. Photo: Hans Namuth.

Figure 16. Franz Kline at the opening of his exhibition at the Sidney Janis Gallery, New York, March 7, 1960. Guests include Robert Goldwater and his wife, Louise Bourgeois; Ethel and William Baziotes; Mark Rothko; David Sylvester; and Willem de Kooning. Photo: Fred W. McDarrah, New York.

School.

The legacy of Abstract Expressionism, like that of any memorable art, is not limited to influence on later artists, but draws us again and again to itself. One can look, for example, at a first-rate Newman—such as *Onement VI* in this exhibition (plate 22)—and still sense "the integrity of the intimate, the detailed, the true art, the integrity of craftsmanship...." And, not incidentally, like many other Abstract Expressionist works that once seemed all raw energy and spit, *Onement VI* stands thirty-three years after its creation as an incredibly beautiful painting. Indeed, its radiant blue, and the laser-like zip, which does not actually split the canvas into equal

support artists working in an abstract style. Abstraction carried the implication of something un-American and maybe even subversive—something alien to the wholesome way of American life. And although abstraction was recognized by the Federal Art Project in 1935, "it still remained an unpopular and minority art."[8] The three major social realists, or regionalists, were Thomas Hart Benton (1889–1975), the outspoken teacher of Jackson Pollock; Grant Wood (1892–1941); and John Steuart Curry (1897–1946). They venerated American life by painting events, people, and geographical regions characteristic of no country save the Great Republic. Unlike the later Abstract Expressionists, they believed that through their art

they could improve the condition of man.

Born in 1882, Edward Hopper matured as a transcendent figurative artist between the world wars, yet remained apart from the prevailing social realism. His strongest work does not promulgate social change but, instead, fixes deeply personal, transient moments with dramatic lighting and unexpected compositional dislocations. *August in the City,* 1945 (plate 70), was based on a building with bay window and gothic doorway on New York's Riverside Drive,[9] and is remarkable for the integration of near-abstract forms, some planar, others tangibly volumetric. It may clarify the duality of figurative versus abstract modes in American art after World War II to note that Ilya Bolotowsky's *Grey and White* (plate 5) was painted in the same year, 1945.

Smith's *Circle and Ray,* 1963 (plate 2), offers a rewarding comparison with Bolotowsky's painting both in association of forms and vertical versus horizontal orientation. Also of interest as a historic parallel to Geometric Abstraction is Franz Kline's *Yellow Square,* 1952 (plate 22). Usually pigeon-holed as a free-wheeling gestural Abstract Expressionist fighting his way through black and white, Kline was repeatedly drawn to the open square as a central image for pared-down, tightly wound compositions. Compared to Bolotowsky's earlier geometric assemblage, Kline's *Yellow Square,* like Smith's sculpture, seems stripped to essentials, liberated spatially rather than locked into any preordained context.

A major artist working midway, as it were, between figurative and abstract modes was Stuart

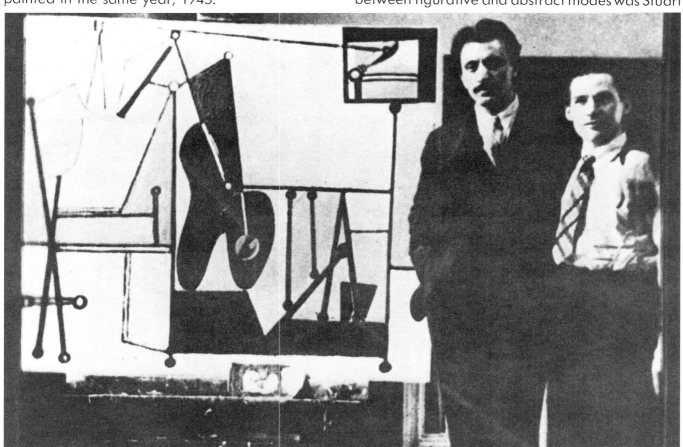

Figure 17. Arshile Gorky and Willem de Kooning pose in front of Gorky's *Organization,* 1934. Courtesy Elaine de Kooning.

As a representative of Geometric Abstraction, Bolotowsky points up the kind of carefully balanced obeisance to the right angle and its constituents—geometry as universal language— soon rejected by the New York School. At the same time, *Grey and White*'s primary shapes and colors, as if Mondrian had been dissected and rearticulated in a sculptural way, bring to mind David Smith, particularly his late painted pieces.

Davis. Indeed, he has recently been called "the most important American artist of the period immediately preceding the emergence of Abstract Expressionism."[10] Born in Philadelphia, he left high school to study with Robert Henri in New York, 1910–1913. When nineteen years old, Davis exhibited at the Armory Show (1913), of which he said: "The Armory Show was the greatest shock to me—the greatest single influence I have ex-

perienced in my work. All my immediately subsequent efforts went toward incorporating Armory Show ideas into my work.''[11] (Showing the great change in attitude by the time of World War II, no Abstract Expressionist would have felt and deferentially acknowledged such direct influence on his art from European modernism.) Most important for the young Davis was the breaking apart of form, characteristic of Cubism. His quasi-abstraction has a brassiness and boldness that some like to associate with the American pioneer spirit—pioneers either in covered wagons or New York studio lofts. Such romanticizing can be pushed too far, but Davis's non-finicky character is revealed through his art as surely as Hopper's withdrawn nature is through his. *Ultramarine,* 1943 (plate 4), is one of several "abstract land-

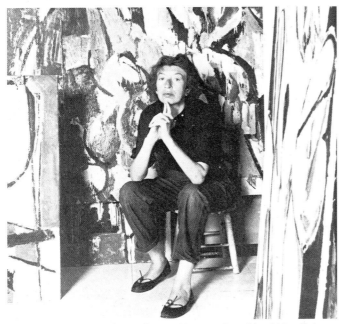

Figure 18. Lee Krasner in her studio, East Hampton, Long Island, New York, August 30, 1956. Photo: Sidney Weintraub/Budd.

scapes" whose solidly painted, interlocking shapes flatten space while simultaneously alluding, sometimes wittily, to a third dimension. Davis's tongue-in-cheek approach is also evident in the title—a pun on conventional seascape painting, the color ultramarine blue, and the many facets of marine life.

Among the earliest Abstract Expressionist paintings in this exhibition are Pollock's *Banners of Spring,* 1946 (plate 9), and Gorky's *Untitled,* 1943–48 (plate 10). Each displays a particularized idiom of organic form with ambivalent overtones located in fluctuating space. Yet, as with all Abstract Expressionist works, any formal analysis can reveal only one level of meaning, usually the most

superficial. Pollock's totemic personages, whose heads seem amalgams of bird/insect creatures and Picasso's art, line up across the canvas. In contrast, Gorky's forms are partially wrapped in an elegiac atmosphere heightened by warm browns, reds, and yellows. If a key to meaning in the Pollock is provided by the title's reference to spring, Gorky's painting must allude to a later season. And unlike Pollock's more easily recognizable figures, Gorky's clustering of hybrids is more complex and elusive in identity. Harry Rand notes in his enlightening study of Gorky that "symbols in various stages of evolution stud the painting, while the development of the work seems to have been arrested at a precarious moment. The opaque veil, which Gorky was so fond of using to unify his pictures, not only surrounds the forms but has begun to encroach on their outlines, disintegrating the integrity of the shapes.''[12] Tragic irony may be prescient here. Gorky was working on the painting near the time of his suicide on July 21, 1948.[13]

Unlike the sprawl of today's art world, the New York School was small. Most of the artists knew each other. Those as widely different in personality and style as Gorky and Davis were friends, at least for a while.[14] Gorky's close relationship with de Kooning is well known, as is de Kooning's friendship with Kline. Another well-documented artistic/personal relationship was that between Pollock and Lee Krasner. Pollock had exhibited a painting called *Birth,* ca. 1938–1941, in a 1942 group show at the McMillen Gallery, an interior design firm. Krasner's work was included, as were examples by Davis and de Kooning, along with works by Braque, Matisse, Modigliani, and Picasso. Because of the exhibition, Krasner looked up Pollock—she had first met him in 1936 at an Artists Union loft party. They were married in 1945. The Krasner/Pollock relationship has been thoroughly analyzed in the last few years—as has that between David Smith and Dorothy Dehner—and, undoubtedly, it was reciprocal in artistic terms. The nature and extent of that relationship is suggested when Pollock's *Banners of Spring* is seen beside Krasner's much larger *Celebration* (plate 13), a painting begun in 1957 and at that time entitled *Upstream II,* to be completed and renamed three years later.[15] Despite differences in scale and paint application, it is possible to sense a kinship between the two canvases. Each stands as a markedly frontal painting with overlapping forms bound together by strongly directional lines or bands. Curves dominate. Drawing provides the armature. More-

over, flanking elements direct one's attention toward a central being or entity. Hierarchy of presence and energetic circulation of movement are prime elements in each composition.

Celebration continues the Abstract Expressionist convention of working with full-arm gestures on wall-sized canvas, something Pollock had initiated in 1947 with the classical drip paintings. However, Pollock's use of the brush heavy with paint was never this extensive. For wall-sized canvases, rolled out on the studio floor in front of him, Pollock preferred dripping and pouring commercial oil, enamel, and aluminum paint from cans, using brushes and sticks to facilitate flow. Harold Rosenberg's concept of Action Painting immortalized—if overstated the significance of this technique—in his Art News article of September 1952. As a painting technique involving not only the artist's cerebral concentration, but total physical movement as well, it was succinctly described by Pollock in what has become another verbal monument of Abstract Expressionism: "When I am in my painting, I'm not aware of what I am doing. It is only after a sort of 'get acquainted' period that I see what I have been about. I have no fears about making changes, destroying the image, etc., because the painting has a life of its own. I try to let it come through."[16]

Although Pollock, Kline, Motherwell, and Newman made big paintings, they were surpassed in scale by the second-generation abstract artists Al Held, Gene Davis, Kenneth Noland, and, in figuration, by Roy Lichtenstein and James Rosenquist. The effect of such near-colossal painting—some of it billboard size—was easily intimidating. At times one had to keep backing away from a painting to scan its entire surface. (For example, a Held mural of 1969–1970 in the Empire State Plaza, Albany, New York, is 10 feet high and 90 feet long.) Abstract Expressionist works, on the contrary, tended to pull spectators into their ambience, much as Pollock had been in a painting while making it. One can test accessibility in terms of scale with Sam Francis's Persephone, or Painters Work in the Dark (plate 14), a 9½ x 19' black lattice work shot through with red, yellow, and orange. Francis's integration of color with black may exceed in emotional resonance the painting's sheer physical size.

Big yet intimate art has been widely recognized as an aspect of the New York School. Big not just in scale, but in undertaking: the desire, even compulsion, to take on major issues, such as the nature and means of art vis-à-vis the revolutionary European forces of Cubism and Surrealism.

Newman's Onement VI, Still's 1955-D (plate 18), and Motherwell's Wall Painting No. 4 (plate 8) manifest this characteristic. Motherwell's largest work to date is Reconciliation Elegy, 1978, a 12 x 40' canvas commissioned for the East Building of Washington's National Gallery. Actually constituting a wall of its own, this public work finds antecedents in image and impact in the more modest Wall Painting No. 4 of 1954. A continuum of intimacy extends through several Motherwell series—an ongoing legacy of Abstract Expressionism. In this regard, one is reminded that Motherwell once described the Abstract Expressionists as "the last romantics." Their closeness and respect for individuality as well as their willingness to do everything for art were conspicuous elements in this specific brand of romanticism tempered by World War II.

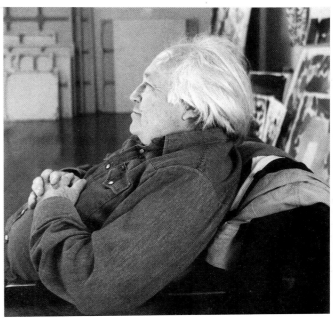

Figure 19. Sam Francis, 1983. Photo: Andre Emmerich.

During the 1950s, New York artists produced some of the most difficult—and violent—painting in the history of art, yet it remained rooted in this intimate, existentialist romanticism. De Kooning's Women (1950–53), his "urban landscapes" (1955–56), and Pollock's "black paintings" (1950–53) embody the violent aspect, a direct assault on preconceptions of subject, technique, and audience. Gottlieb's and Rothko's paintings, on the other hand, are less immediately wrenching in effect, but perhaps ultimately more difficult to assess, to measure against oneself.

In their maturity, at last free from the residual influence of Surrealism, Rothko and Gottlieb created some of the most demanding

Abstract Expressionist art. In Rothko's fields of color and Gottlieb's bursts, the artists wrestled with absolutes comparable on one level to the vastness of space, outer space, the light years between stars. Expressed in different ways and with strikingly different effects, Rothko's and Gottlieb's art, their refined but painfully elemental paintings, are eloquent attempts to embrace infinity. Again, romanticism. Who has made paintings with more soft-spoken but genuine integrity than Rothko? Who has grasped more oppositional forces than Gottlieb and yet welded them into artistic submission before our eyes?

In June 1943, Rothko and Gottlieb sent a letter to *The New York Times* replying to an article by the art critic Edward Alden Jewell. He had written that he could not comprehend work by the Federation of Modern Painters and Sculptors.

opening of a new museum but the persistence of "An American Renaissance" in painting and sculpture:

> 1. To us art is an adventure into an unknown world, which can be explored only by those willing to take the risks.
> 2. This world of the imagination is fancy-free and violently opposed to common sense.
> 3. It is our function as artists to make the spectator see our way, not his way.
> 4. We favor the simple expression of the complex thought. We are for the large shape because it has the impact of the unequivocal. We wish to reassert the picture plane. We are for flat forms because they destroy illusion and reveal truth.
> 5. It is a widely accepted notion among painters that it does not matter what one paints as long as it is well painted. This is the essence of academism. There is no such thing as good painting about nothing. We assert that the subject is crucial and only that subject-matter is valid which is tragic and timeless. That is why we profess spiritual kinship with primitive and archaic art.[17]

Figure 20. Willem de Kooning in his studio, The Springs, Long Island, New York, 1973. Photo: Hans Namuth.

Jewell had seen their annual show and stated that their art left him in "a dense mood of befuddlement." Rothko and Gottlieb, who belonged to the Federation, replied. They were helped by Newman, although he did not sign the letter, since he was not a Federation member. The document became the credo of Abstract Expressionism, and five of its points are worth citing within the context of a post-1984 exhibition celebrating not only the

The tone of the letter, especially these points, is assertive, even militant. To an extent this is due to the cause fervently supported by the artists. But the tone may also be due to their need to issue a manifesto against any critic's "dense mood of befuddlement."

The history of Abstract Expressionism must not be confined to tracing broad stylistic trends. Nor should it be limited to tracking down influences,

general or specific, from one artist to another. It must also point out that artists such as Rothko and Gottlieb in 1943 had to educate critics, the public, and museums about contemporary abstraction. Museums did not fling wide their doors, and admit American abstract art with open arms. Yet by 1950, even The Metropolitan Museum of Art had to face up to the importance of American modernism. The museum had been spending an average of $400,000 each year on acquisitions; of that, only about $10,000 went for contemporary work. Hoping to relieve the pressure from artists demanding that their work be seen, the Metropolitan held a giant competition of contemporary art. The show was open to all United States painters; $8,500 in prizes was offered. However, a group of fifteen artists protested, and were dubbed by *Life* magazine the "Irascibles."[18] They objected to the elaborate jury system set up to judge entries. Distressed by what had been intended as a benevolent gesture toward modernism, the Metropolitan's director compared the protesters to "'flat-chested' pelicans 'strutting upon the intellectual wastelands.'" Seventy-five other artists then attacked the "Irascibles" for going too far. At any rate, the Metropolitan had its show and the "Irascibles" won notoriety as the most forward-looking and vociferous New York artists at the time. Who got the prizes? Karl Knaths, Rico Lebrun, and Yasuo Kuniyoshi, all accomplished figurative painters reworking the innovations of Cubism and Surrealism. Taken for granted today, the acceptance of abstraction by museums was at first only reluctantly tendered and only after artists repeatedly demanded change. This is the personal political context of Abstract Expressionism: fighting to have one's art exhibited by museums and galleries, rather than working directly or indirectly for political candidates or causes.

Fortunately, the New York School was served by loyal and articulate writers. Earliest on the scene was Clement Greenberg, with reviews in *The Nation, Art Digest,* and *Partisan Review,* among others. Very perceptive of the new "American-type" painting, as he called it, Greenberg also became Pollock's chief defender, pointing out the artist's originality long before journalists paid him even disparaging attention.[19] Working for *Art News,* of which he became editor, Thomas B. Hess was another forceful spokesman for the New York School, with a particularly deep devotion to the art of de Kooning. Harold Rosenberg, in contrast, placed Abstract Expressionism in a broader, sociological perspective, yet was capable as well of sharp critical observations

about individual work. The art historian Leo Steinberg wrote persuasively in the mid-1950s about de Kooning, Pollock, Guston, and Kline. The poet Frank O'Hara, an editorial associate for *Art News* and a curator at The Museum of Modern Art, was another compelling voice helping to educate the general public as well as cognoscenti. Likewise, Dore Ashton, highly respected for her lucid, informative text *The New York School: A Cultural Reckoning* (1972), contributed reviews to periodicals and was art critic for *The New York Times* from 1955 to 1960. Without these dedicated advocates, who personally knew the artists they wrote about, Abstract Expressionism would have had even more difficulty winning a serious audience. One wonders if today there are comparable writers as thoroughly committed to championing current artists and movements.

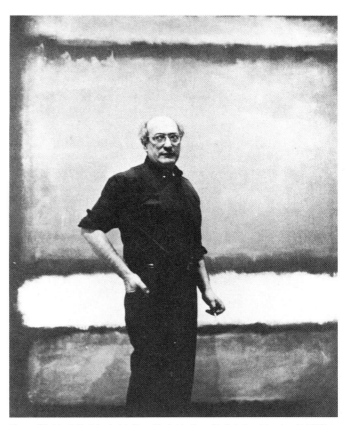

Figure 21. Mark Rothko in his New York studio with *Painting Number 7,* 1960.

Of course, sympathetic critics did not convince everyone of Abstract Expressionism's validity. In 1956, at a time when Pollock's art was being taken seriously by some mass media, *Time* christened him "Jack the Dripper."[20] The article was headed "The Wild Ones," an obvious reference to the 1954 motorcycle-gang movie *The Wild One* starring Marlon Brando. Interestingly, as early as 1949 *Life* had featured Pollock in a

large color spread entitled "Is He the Greatest Living Painter in the United States?"[21] In the long run, this publicity boosted the prices of paintings, but it also compounded Pollock's personal problems. It made him a New York star. Like de Kooning's later in the 1960s, Pollock's privacy was wrecked by his celebrity status. This was a serious problem thrust on several New York artists who became financially successful after years without recognition except from close friends, fellow artists, and a few intrepid collectors. How could one continue the lifestyle that had in the first place stimulated, or at least not interfered with, the strenuous activity of making art?

Sculpture was never as central to the New York School as painting, although sculptors were welcome participants in discussions at The Club and the Cedar Bar. Sculpture's unavoidable demands as a three-dimensional entity set it apart, literally, from much Abstract Expressionist painting; at the same time, an exchange of ideas between sculptors and painters did take place. As Greenberg observed in 1948: "Modernist sensibility, though it rejects sculptural painting of any kind, allows sculpture to be as pictorial as it pleases. Here the prohibition against one art's entering the domain of another is suspended, thanks to the unique concreteness and literalness of sculpture's medium."[22] He added that some of David Smith's pieces were strongly two-dimensional, sharing with painting that aspect of spatiality. Indeed, this became one of Smith's prime concerns, and he returned repeatedly to the possibilities of essentially two-dimensional constructed sculpture backed and flanked, rather than surrounded, by space. Such spatial reduction—as if depth had been steamrollered—determines the ambience for *Circle and Ray,* 1963 (plate 2), thereby denying a previous development of twentieth-century sculpture—namely, movement into actual space.

 With the imagination and technical skill of Alexander Calder in motorized pieces and free-floating mobiles, sculpture's kinetic potential had by the early 1930s become reality. Actual movement continued in Calder's work throughout his career, existing side by side with non-moving stabiles. But making sculpture physically move was not an overriding concern of most major sculptors after World War II. Such artists as

Figure 22. Louise Bourgeois, 1984. Photo: Robert Mapplethorpe.

Figure 23. Isamu Noguchi, 1984. Photo: Al Mozell.

Figure 24. Louise Nevelson, 1974.

Bourgeois, Nevelson, Noguchi, and Roszak did, however, share an interest in extending sculpture's look and meaning through a new combination of materials—some recently developed, some traditional—with direct, often stark, imagery.

Roszak's *Skylark*, 1950–51 (plate 12), points up a fusion of human and animal which interested artists at the time. A soaring yet standing predator, with possible links to public and private myth, this piece has forebears in Pollock's painting of the early 1940s and Smith's sculpture of 1947–49. Moreover, *Skylark* is related, through bird imagery, to Roszak's *Spectre of Kitty Hawk*, 1946–47, in The Museum of Modern Art. Both communicate awesome portent, ready to shred the air without warning. In this respect they reflect the destructive capability of flight developed on a grand scale during World War II; from the Spitfire to the V-2 to Enola Gay: death from the sky had been a threat since Guernica.

Equally disquieting though nonfigural is Louise Bourgeois's *Femme Maison*, 1981 (plate 26), an explicitly organic, even erotic, work. In this instance Bourgeois's technique is traditional, but her image is surprising and maybe shocking. In 1946–47 she produced a series of paintings with simplified outlines of women's bodies, their heads transformed into houses.[23] A long-lived symbol in Bourgeois's art, this conjunction of natural and fabricated forms functions less overtly in *Femme Maison*, yet endows the sculpture with ominous overtones. Although strictly speaking non-kinetic, the tubular shapes seem to pulsate and sway.

Above, the elongated house corresponds to a completely different standard of scale and proportion.

Two of the most accomplished and prolific sculptors in this exhibition, Louise Nevelson and Isamu Noguchi, while not actual members of the New York School, represent another aspect of first-generation Abstract Expressionism: creation of a total art environment. Manifesting itself in distinct ways, such a comprehensive purpose for art parallels in physical existence the intense emotional commitment of an artist dedicated to making art. Pollock stated that he was *in* a painting while at work on it. Both Rothko and Still preferred that their paintings be seen not individually, but as units contributing to a complete experience. Thus, the Rothko chapel in Houston and Still's gift of a body of his paintings to the Albright-Knox Gallery and, later, to the San Francisco Museum of Modern Art. In 1985, Noguchi opened a museum in Queens devoted solely to his work.

The *totality* of Abstract Expressionism—that union of art and ethics—is reflected also in the sculptural environments by Noguchi and Nevelson. While impossible to define it exactly, perhaps it can be glimpsed in Nevelson's *Mirror-Shadow IV*, 1985 (plate 17), a legibly structured black "wall" deliberate enough to challenge Oppenheimer's "all-encompassing dark" on its own ground. As Nevelson has put it, "Actually, I think that my trademark and what I like best is the dark, the dusk."[24]

NOTES

1. Guston, in an interview with the author, July 24, 1968, Saratoga Springs, N.Y.
2. Oppenheimer, "Prospects in the Arts and Sciences," reprinted in Whit Burnett, ed., *This Is My Philosophy* (New York: Harper & Brothers, 1957), pp. 104–113.
3. Translated by Arthur Goldhammer (Chicago: University of Chicago Press, 1983).
4. Kramer, "American Art Since 1945: Who Will Write Its History?" *The New Criterion*, Summer 1985, p. 4.
5. Reproduced with accompanying diagram in William C. Seitz, *Abstract Expressionist Painting in America* (Washington, D.C.: National Gallery of Art; and Harvard University Press, 1983), pp. 168-69.
6. Irving H. Sandler, "The Club," *Artforum*, vol. 4 (Sept. 1965), p. 29. See also "The Eighth-Street Club" in Dore Ashton, *The New York School* (Penguin Books, 1979), pp. 193-208.
7. For an appraisal of the East Village scene, including the Palladium, see Calvin Tomkins, "The Art World: Disco," *The New Yorker*, vol. 61 (July 22, 1985), pp. 64-66.
8. John Elderfield, "American Geometric Abstraction in the Late Thirties," *Artforum*, vol. II (Dec. 1972), p. 36.
9. Gail Levin, *Edward Hopper: The Art and the Artist* (New York: W.W. Norton and the Whitney Museum of American Art, 1980), p. 46.
10. John R. Lane, *Abstract Painting and Sculpture in America, 1927-1944* (Pittsburgh: Museum of Art, Carnegie Institute, 1983), p. 66.

11. Quoted in Henry Geldzahler, *American Painting in the 20th Century* (New York: The Metropolitan Museum of Art, 1965), p. 146.
12. Rand, *Arshile Gorky: The Implications of Symbols* (Montclair, N.J.: Allanheld & Schram, 1980), p. 168.
13. Ibid.
14. Gorky and Davis wrote articles about each other. A major reason their friendship disintegrated was Gorky's nonpolitical attitude toward art. Rand, pp. 4; 9, n. 11; 221.
15. Barbara Rose, *Lee Krasner: A Retrospective* (Houston: Museum of Fine Arts; and The Museum of Modern Art, New York, 1983), p. 114.
16. Quoted in Elizabeth Frank, *Jackson Pollock* (New York: Abbeville Press, 1983), p. 109.
17. *The New York Times*, June 13, 1943, sec. 2, p. 9.
18. "Irascible Group of Advanced Artists Led Fight Against Show," *Life*, vol. 30 (Jan. 15, 1951), pp. 34ff.
19. Greenberg, *Art and Culture* (Boston: Beacon Press, 1961). See particularly "*Partisan Review* 'Art Chronicle': 1952," pp. 146-153, and "'American-Type' Painting," p. 208-229.
20. *Time*, Feb. 20, 1956, pp. 70-75. Other "wild ones" discussed were Baziotes, de Kooning, Gorky, Gottlieb, Guston, Motherwell, and Rothko.
21. *Life*, vol. 27 (Aug. 8, 1949), pp. 42-44.
22. Greenberg, "The New Sculpture," in *Art and Culture*, p. 143.
23. Deborah Wye, *Louise Bourgeois* (New York: The Museum of Modern Art, 1982), p. 17.
24. Quoted in Jean Lipman, *Nevelson's World* (New York: Hudson Hills Press and the Whitney Museum of American Art, 1983), p. 61.

38

Plate 5
Ilya Bolotowsky
Grey and White, 1945.
Oil on canvas, 21 x 33".
Washburn Gallery, Inc., New York.

PLATE 6
Ad Reinhardt
Red, Green, Blue and Orange, ca. 1948.
Oil on canvas, 60 x 30".
The Pace Gallery, New York.

left

PLATE 7
Hans Hofmann
Pastorale, 1958.
Oil on canvas, 60 x 48".
Andre Emmerich Gallery, New York.

PLATE 8
Robert Motherwell
Wall Painting No. 4, 1954.
Oil on canvas, 55½ x 73¼".
Collection Elliott and Bonnie Barnett, Fort Lauderdale, Florida.

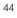
44

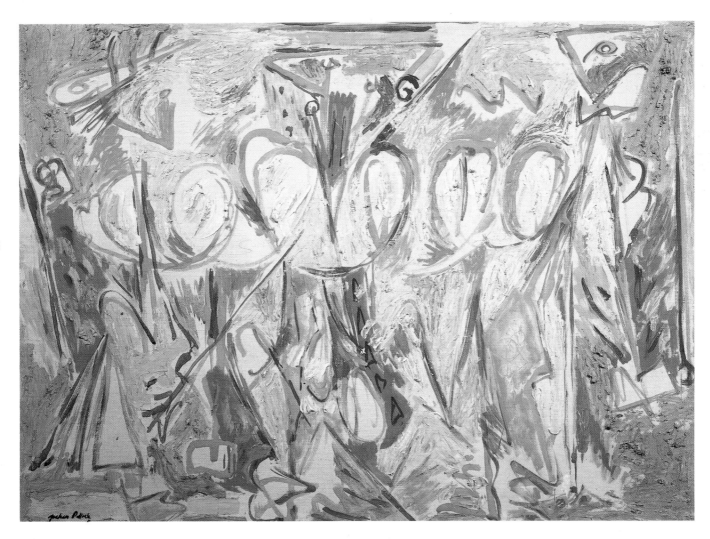

PLATE 9
Jackson Pollock
Banners of Spring, 1946.
Oil on canvas, 33 x 43".
Private collection, Connecticut.

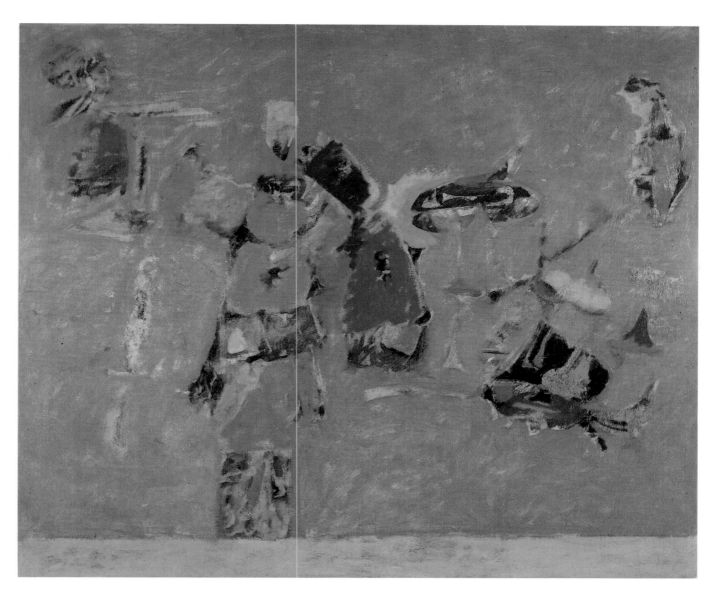

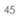

PLATE 10
Arshile Gorky
Untitled, 1943–48.
Oil on canvas, 54½ x 64½".
Dallas Museum of Art.

46

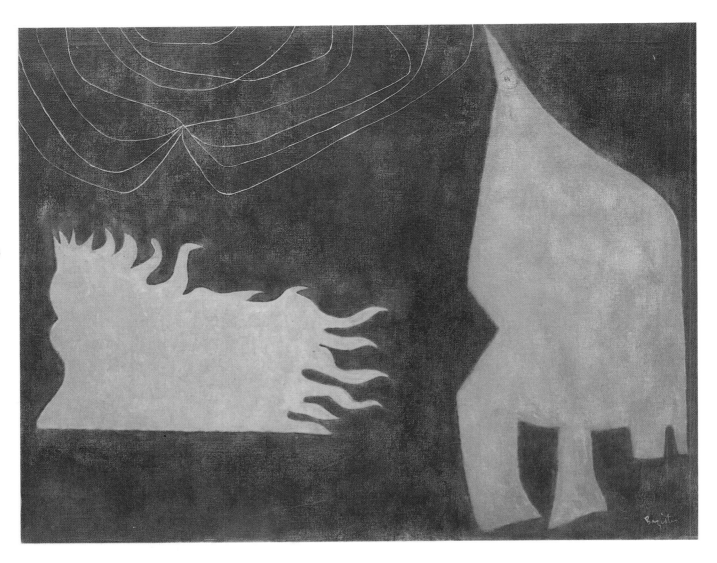

Plate 11
William Baziotes
Phantom, 1953.
Oil on canvas, 30⅛ x 37¾".
Blum-Helman Gallery, New York.

right
Plate 12
Theodore Roszak
Skylark, 1950–51.
Steel, 99 x 60 x 16".
Collection Mrs. Florence Roszak, New York.

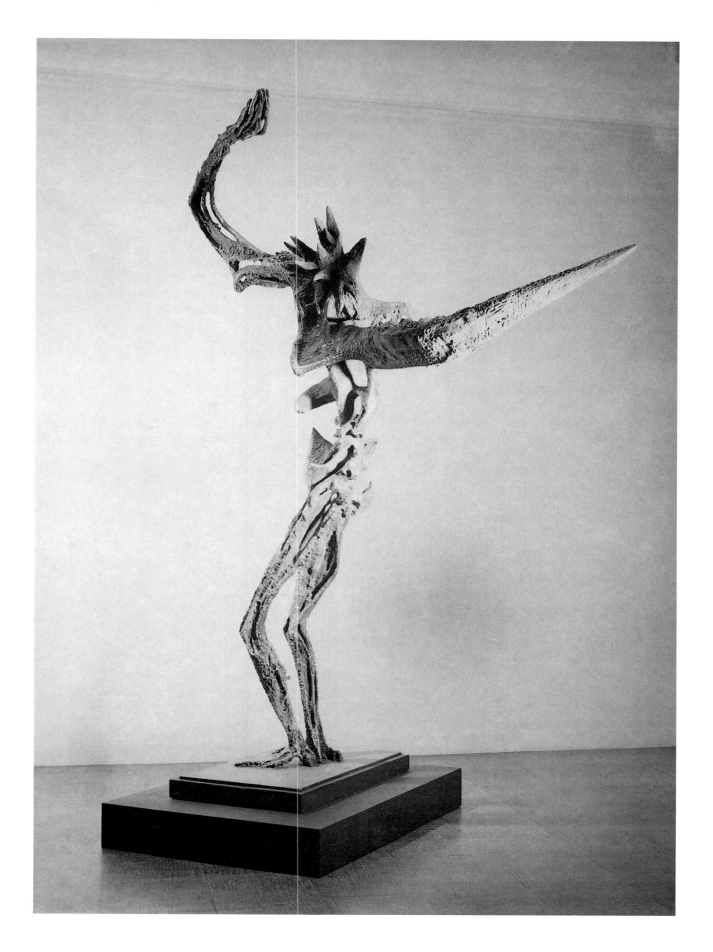

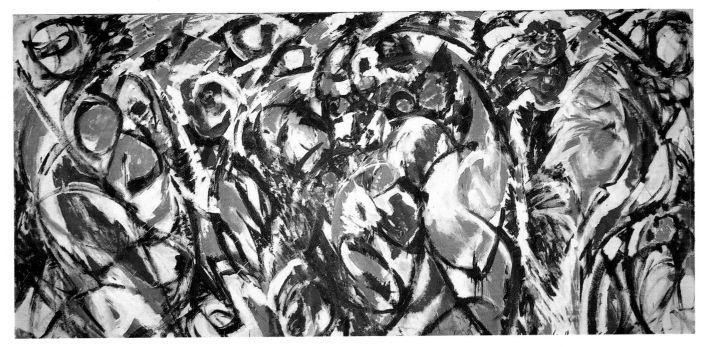

PLATE 13
Lee Krasner
Celebration, 1957–60.
Oil on canvas, 92¼ x 184½".
Robert Miller Gallery, New York.

PLATE 14
Sam Francis
Persephone, or Painters Work in the Dark, 1979.
Acrylic on canvas, 114 x 228".
Collection the artist.

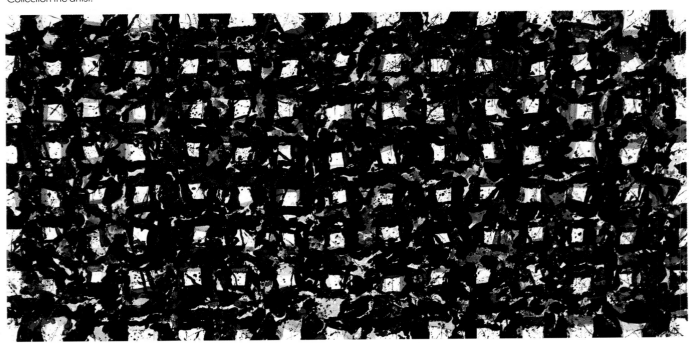

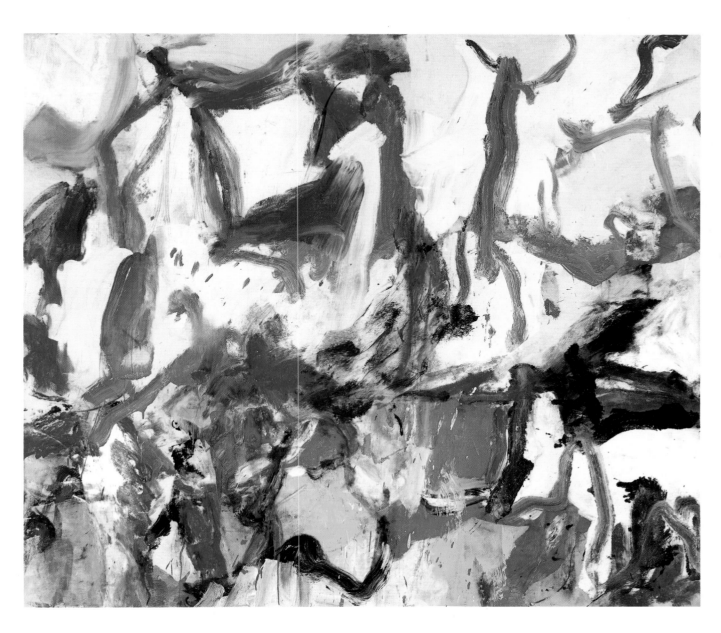

PLATE 15
Willem de Kooning
Untitled XV, 1975.
Oil on canvas, 77 x 88".
Xavier Fourcade Gallery, New York.

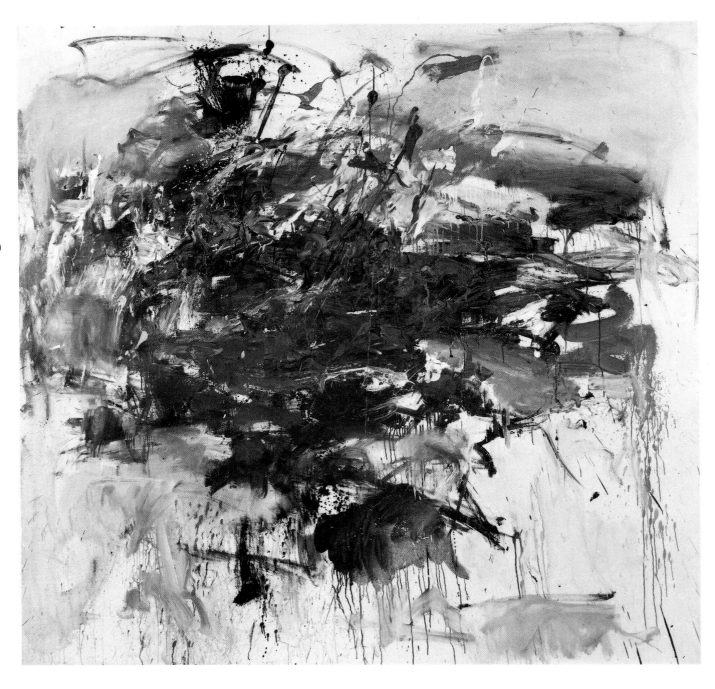

PLATE 16
Joan Mitchell
Flying Dutchman, 1961–62.
Oil on canvas, 78¾ x 78¾".
Xavier Fourcade Gallery, New York.

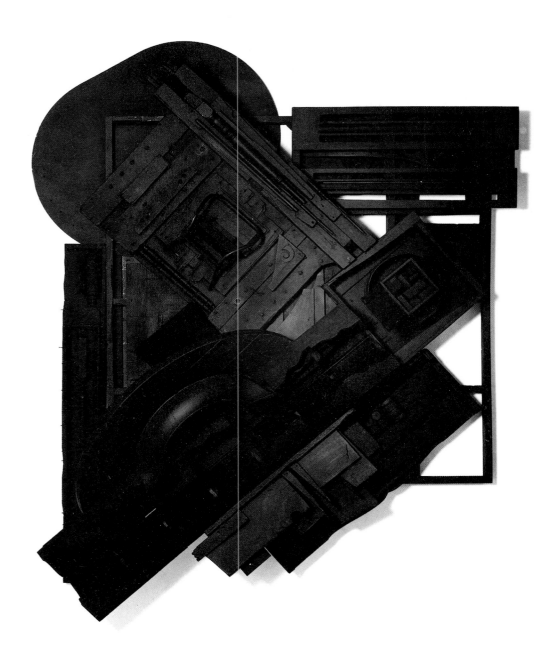

PLATE 17
Louise Nevelson
Mirror-Shadow IV, 1985.
Wood painted black, 105 x 128 x 33".
The Pace Gallery, New York.

52

PLATE 18
Clyfford Still
1955-D, 1955.
Oil on canvas; 117 x 111".
Marisa del Re Gallery, New York.

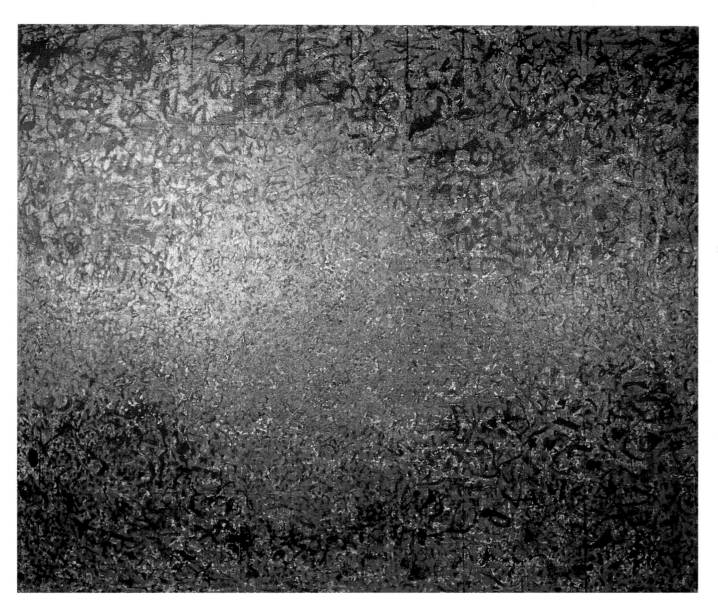

Plate 19
Richard Pousette-Dart
Presence, Genesis, 1975.
Acrylic on canvas, 96 x 111".
Marisa del Re Gallery, New York.

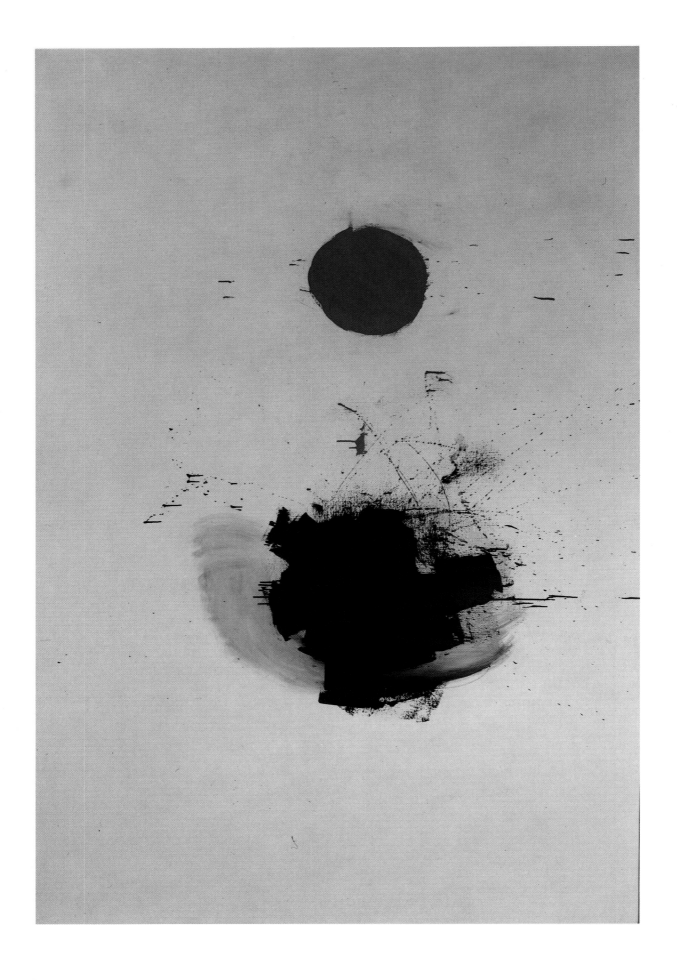

55

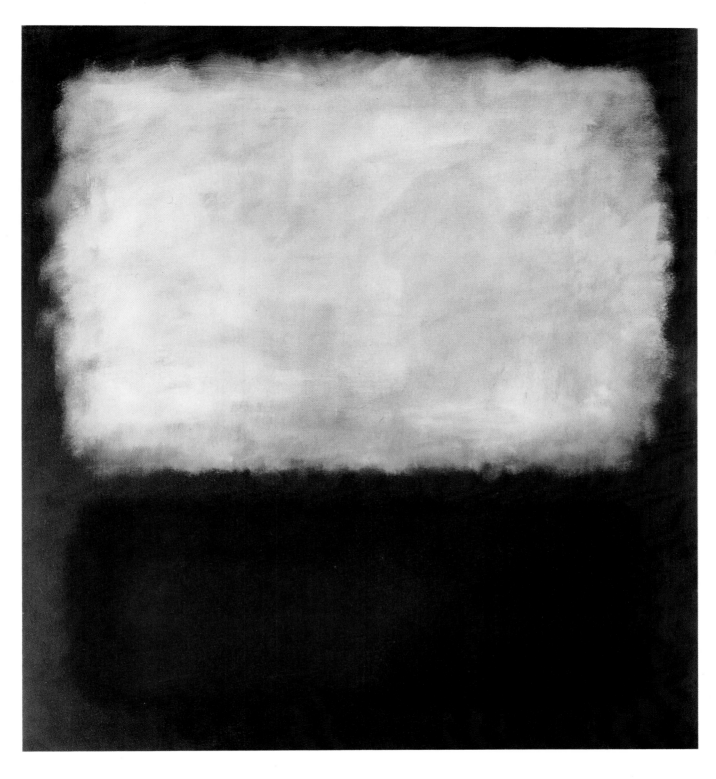

PLATE 20
Adolph Gottlieb
Collision, 1971.
Oil and acrylic on canvas, 90⅛ x 60⅛".
©1979 Adolph and Esther Gottlieb Foundation, New York.

PLATE 21
Mark Rothko
Blue and Gray, 1962.
Oil on canvas, 79¼ x 69".
Weisman Family Collection, Richard L. Weisman, New York.

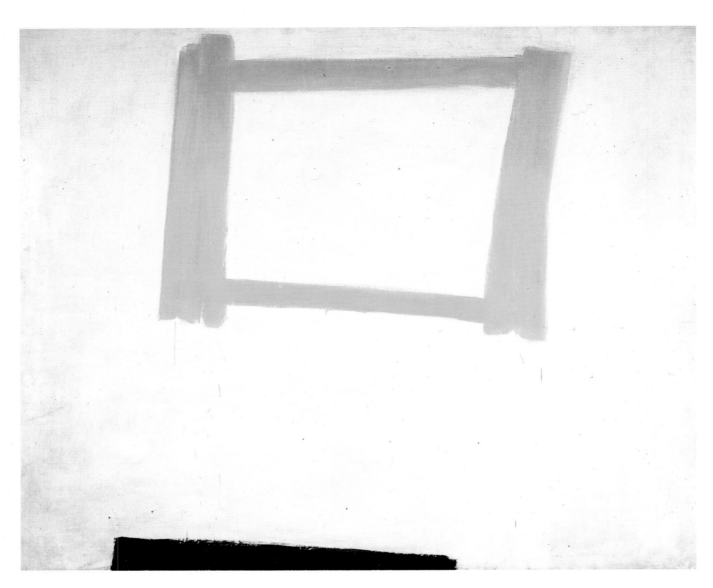

PLATE 22
Franz Kline
Yellow Square, 1952.
Oil on canvas mounted on Masonite, 64¾ x 78¾".
Collection Dr. and Mrs. A. Castellett, Darien, Connecticut.

PLATE 23
Barnett Newman
Onement VI, 1953.
Oil on canvas, 102 x 120".
Weisman Family Collection, Richard L. Weisman, New York.

58

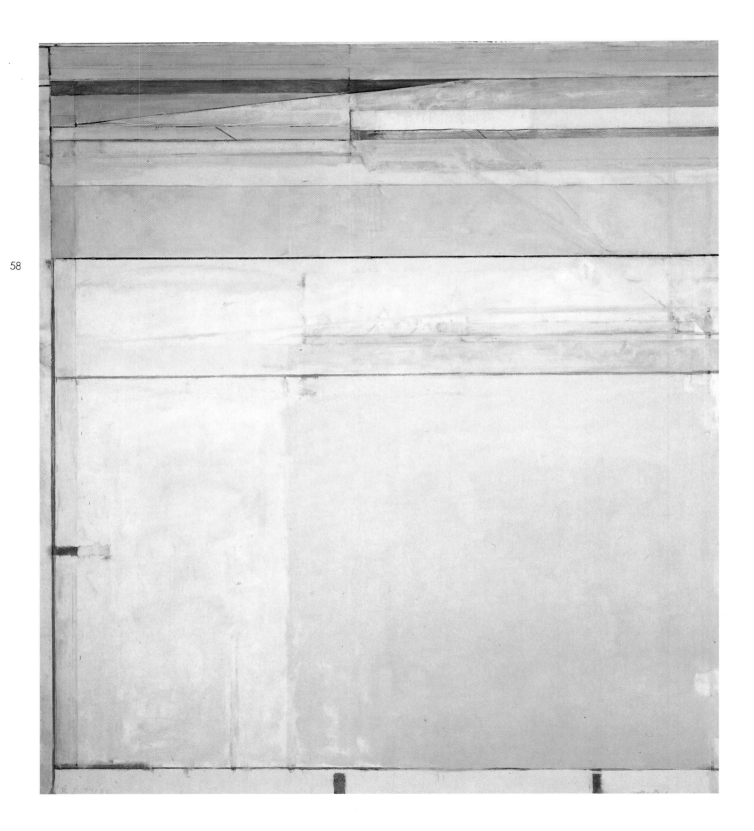

PLATE 24
Richard Diebenkorn
Ocean Park No. 118, 1980.
Oil on canvas, 93 x 81".
Collection Martin Z. Margulies, Miami.

right

PLATE 25
Joseph Cornell
Variétés Apollinaires (for Guillaume Apollinaire), 1953.
Box construction, 18¾ x 11⅜ x 4¼".
Castelli, Feigen, Corcoran, New York.

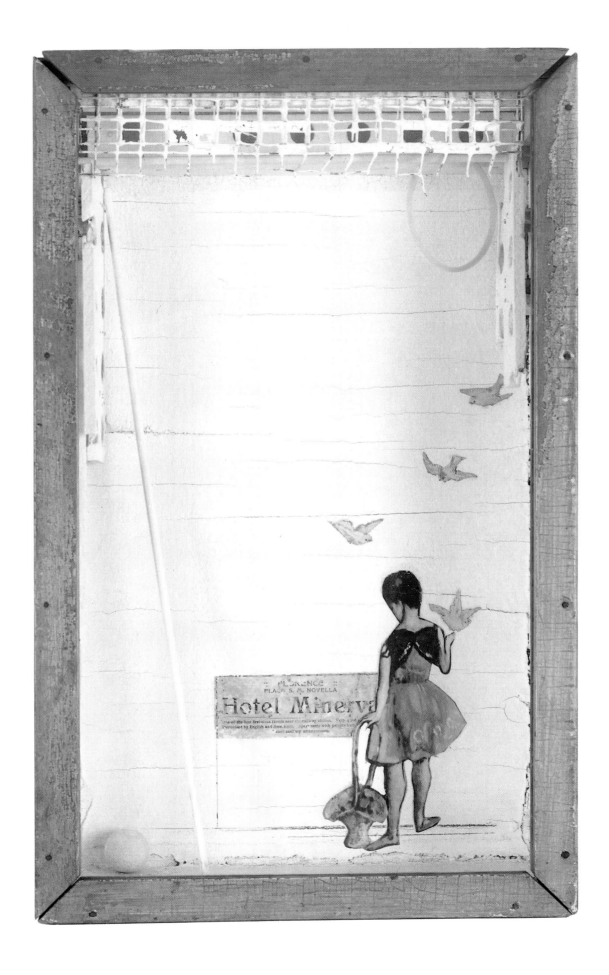

60

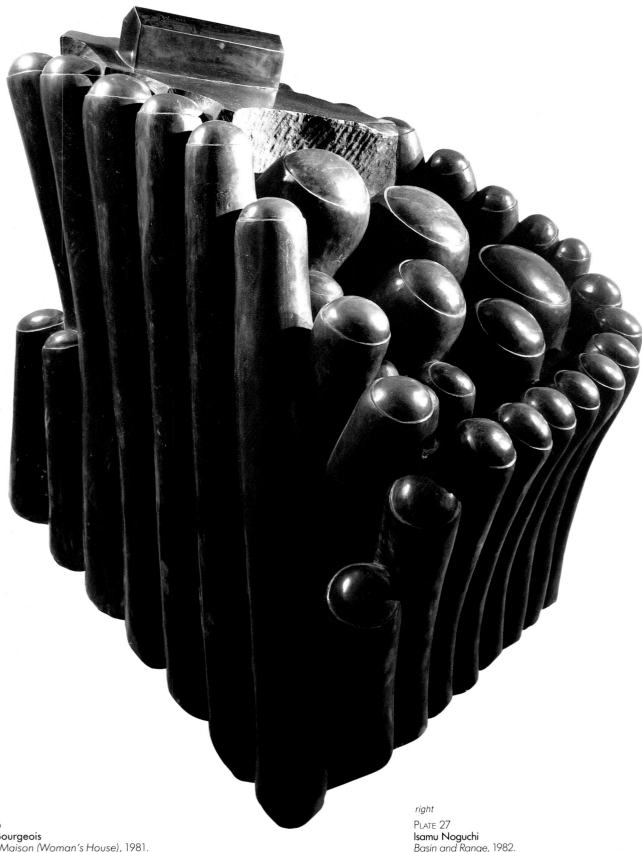

Plate 26
Louise Bourgeois
Femme Maison (Woman's House), 1981.
Marble, 48⅛ x 47 x 49⅞".
Robert Miller Gallery, New York.

right
Plate 27
Isamu Noguchi
Basin and Range, 1982.
Mihara granite, 17 x 14 x 49," with wooden pedestal.
The Pace Gallery, New York.

II
COLOR FIELD PAINTING, REDUCTIVIST PAINTING, AND MINIMAL ART

Robert C. Morgan

Painting	Sculpture
Helen Frankenthaler	Carl Andre
Sam Gilliam	Walter de Maria
Ellsworth Kelly	Michael Heizer
Morris Louis	Donald Judd
Robert Mangold	Joel Shapiro
Brice Marden	Tony Smith
Kenneth Noland	
Jules Olitski	
Robert Ryman	

Every important work of art can be regarded both as a historical event and as a hard-won solution to some problem. It is irrelevant now whether the event was original or conventional, accidental or willed, awkward or skillful. The important clue is that any solution points to the existence of some problem to which there have been other solutions, and that other solutions to this same problem will most likely be invented to follow the one now in view. As the solutions accumulate, the problem alters. The chain of solutions nevertheless discloses the problem.[1]

George Kubler,
The Shape of Time

For New York painters and sculptors, the decade of the fifties was characterized as one of considerable excitement, intensity, curiosity, and momentum. Critical attention had shifted from the great European art centers that existed before World War II to the New York Abstract Expressionists. Despite the controversial motivations that some historians have attributed to them,[2] de Kooning, Kline, Motherwell, and Pollock, especially, had found recognition for their daring departures from European abstraction by opening the way for bold experimentation on a monumental scale. The explicit turbulence of these painters' works was offset with the more subdued yet equally impressive "chromatic abstractions" of Barnett Newman and Mark Rothko, and the more eccentric tactile surfaces of Clyfford Still.[3] Having taken the lead from the European "automatist" Surrealists, Miró and Masson, and with the further catalytic inspiration of Arshile Gorky and the Chilean artist Matta, the American artists emphasized a display of emotional vigor through a directly visual and plastic means. Though often unwarranted and unkind, the notoriety inflicted upon these artists contributed a certain romantic aura—tinged with postwar angst, desperation, and violence—to the otherwise genuine intensity and intellectual integrity that informed their work.

After 1956, the year of Pollock's death, the manic novelty that had energized the New York School riding the crest of Action Painting—which Harold Rosenberg also characterized as "the tradition of the new"—gave way to another generation of painters, less engaged and less severe than their earlier counterparts. Sometimes known as the "second generation" group, these younger artists had already absorbed a great deal from looking at and reflecting upon early ventures into gestural abstraction. Remembering that art is, finally, a fundamentally personal expression—not a movement consciously predisposed to cultural politics or critical manipulations—several of these formally oriented artists under-

stood and accepted painting more as a problem-solving activity than as mystical effusion. It was this concern for "self-critical" activity in relation to painting that the critic Clement Greenberg championed in 1960:

I identify Modernism with the intensification, almost the exacerbation, of this self-critical tendency that began with the philosopher Kant. . . . The essence of Modernism lies, as I see it, in the use of the characteristic methods of a discipline to criticize the discipline itself—not in order to subvert it, but to entrench it more firmly in its area of competence.[4]

Greenberg observed the changes among painters in the New York School from the heyday of Abstract Expressionism—or Painterly Abstraction, as he preferred to call it—to the emergence of younger painters such as Helen Frankenthaler, Jules Olitski, Morris Louis, and Kenneth Noland. It

Figure 25. Helen Frankenthaler, 1981. Photo: Andre Emmerich.

was the young Frankenthaler who first impressed Greenberg with her staining technique which allowed vast areas of color to soak into the canvas. Another critic, Sonya Rudikoff, was also greatly impressed by Frankenthaler and described with insight her work during this period.

Variation and inventiveness always animate this painter's work: the experiment is never the same, which makes the work continuously interesting. Some pictures will show a close attention to edge and surface, others to the surface as against ranging spatial images. Calligraphy will work with thick color and wash-soaked canvas, or drip and spatter with massive directed forms, feathery line, stained or brushed color, with black, with unpainted areas.[5]

When Morris Louis and Kenneth Noland came from Washington, D.C., to visit Greenberg in April 1953, it was Frankenthaler's work that the critic urged them to see.[6] Louis was particularly taken by a painting, completed a year earlier,

called *Mountains and Sea*. The critic Michael Fried has remarked that what Louis saw in Frankenthaler's painting was an extension of Pollock, but with a more refined manner. Fried interprets the lesson Louis gleaned from this encounter as follows:

...what Louis may be said to have found in Mountains and Sea *were certain new, and hitherto unsuspected, possibilities for figuration—specifically, for combining figuration and opticality in a new synthesis of seemingly unlimited potential—which the staining of different colors (rather than just black, as in Pollock) opened up; and that it was the realization of these possibilities that liberated Louis' gift for color.[7]*

Frankenthaler's more recent works, such as *Nature Abhors a Vacuum*, 1973 (plate 30), carry a clear refinement of these earlier techniques of staining and calligraphy in relation to controlled modulations of shape and spatial openness. There is an implicit visionary response to nature in this painting that suggests an internalization of these forces at work in her own consciousness. The self-critical tendency which Greenberg had identified is apparent in Frankenthaler's dependence upon a lyrical manipulation of the color that does not deny the properties of its materiality; rather, the painting emphasizes the basic formal abstraction of the pictorial means according to subtle maneuvers which make her operation in the task nearly invisible.

The stained acrylic canvas by Morris Louis *Beth Lamed*, 1959 (plate 31), is one of his "veils" and predates *Nature Abhors a Vacuum*. In Louis there is a definitive synthesis between the color as a dominant figuration and the actual process used to establish its spatial presence. Because of the more rigid, systematic application of pigment employed by Louis, *Beth Lamed* carries less of the lyrical implication of Frankenthaler, offering a more formal/metaphysical dialectic between figure and ground. Here Louis has allowed the flow of the thinned washes of color to reveal itself through a monumental dark shroud which never denies the ultimate "flatness" of the surface despite inherent spatial tensions in shallow depth.

In a similar way, Jules Olitski's *Exact Origin* (plate 32) plays upon the tensions of subtle color gradation and the flat surface. Whereas Louis poured his pigment, Olitski sprayed it on canvas with an air compressor with an adjustable nozzle. The definition of the painted edges in Olitski's color field suggests a feeling of containment and an assertion of the painting's boundaries. Content in Olitski's paintings from the late sixties is minimal and, for the most part, entirely dependent upon mood as determined by the act of color perception. There is neither the abstract lyricism

of Frankenthaler nor the dialectical tensions found in Louis's later work. Olitski offers a field of color and a modulation of surface—a chromatic sensorium—without concreteness. Only the thinly striped demarcations at the edges identify or dictate the limits of the field. In 1966—the year that *Exact Origin* was completed—Olitski wrote the following statement for the catalogue of the international biennial exhibition in Venice:

What is of importance in painting is paint. Paint can be color. Paint becomes painting when color establishes surface. Where edge exists within the structure, it must be felt as an integral and necessary outcome of the color structure.[8]

Kenneth Noland concurred with Olitski's proposition two years later, in a conversation with the critic Philip Leider, when he said, "In the best color painting, structure is nowhere evident, or nowhere self-declaring.... The thing is to get that color down on the thinnest conceivable surface, a surface sliced into the air as if by a razor."[9] Noland's admonition may appear a bit extreme. From a technical point of view, it would seem that the task of achieving a true modernist "flatness" was a matter of measuring millimeters of pigment flush to the surface. When Noland states that painting is "all color and surface," what he means is that any concept of structure has to evolve from specific concerns about these visual parameters.[10] This would further imply that the figuration of shapes in relation to the field is secondary to the way the color harmonizes. The early target and chevron paintings give testimony to an extraordinary focus in this regard. Noland's *Across*, 1964 (plate 29), for example, represents one permutation in an extraordinary line of formal problem-solving. Although Noland rejects the notion of "systems" in relation to his work, there is an undeniable visual coherence in the evolution of his distinctive and changing emblematic structures and signs over the past twenty-five years.

Frankenthaler, Louis, Noland, and Olitski were all included in the 1964 exhibition "Post-Painterly Abstraction" at the Los Angeles County Museum of Art, organized by Greenberg. The purpose of this exhibition, as stated by Greenberg in an essay written the previous year, was to declare a more refined direction with regard to what he characterized as the "Tenth Street touch."[11] He was opposed to the kinds of stylization that had become evident in the New York School during the fifties.

What turned this constellation of stylistic features into something bad as art was its standardization, its reduction to a set of mannerisms, as a dozen, and then a thousand, artists proceeded to maul the same viscosities of paint, in more or less the same ranges of color, and with the same "gestures,"

into the same kind of picture. And that part of the reaction against Painterly Abstraction which this show tried to document is a reaction more against an attitude than against Painterly Abstraction as such.[12]

The term "Post-Painterly Abstraction" was adopted by Greenberg to give credence to the orientation of painters committed to the "self-critical" tendency in painting through attention to surface and color. For Greenberg, these four artists, among others, were making unique contributions to a new tendency in painting which emphasized the color field even at the expense of drawing in some cases. These artists were, in essence, getting to the core of painting by distancing themselves within the act of painting in order that the element on the surface—namely, the color—would show its own properties in a special way, without imposed markings.

Post-Painterly Abstraction and Color Field Painting are virtually synonymous in terms of historical evolution and formal orientation. Another painter included in the 1964 exhibition, though stylistically different from the previous four, was Ellsworth Kelly (plate 39). During the fifties, Kelly was in Paris on the G.I. Bill.[13] In contrast to the gestural abstraction so prevalent in New York, Kelly was developing a more geometric, reductive, and optical approach to the surface. Over the years he has experimented with a great variety of painterly formats, including irregularly shaped canvases and larger planar wedges cut from Cor-ten steel. Although Kelly has relied extensively upon brilliant color relationships, the crux of his overtly formalist attitude has been the control of his shapes as geometrically reduced elements in relation to architectonically defined surfaces. An early example is the painting Block Island No. 2 (1960), in which complex green-and-black interlocking shapes hover gently over a horizontal ultramarine rectangle. Dubbed a Hard Edge painter in the sixties[14] due to his insistence upon clean as opposed to rough edges in demarcating his shapes, Kelly has produced some of the most ingenious, subtle, and remarkable paintings in American art over the past four decades.

Al Held, who during the early sixties was also associated with the Hard Edge approach, uses geometric configurations which defy perspective in a charged existential manner. Whereas Kelly's untitled visually expansive wedge of steel (plate 39) is an ultra-reduced statement, albeit with a great complexity of issues to sustain it, Held's Rome II of 1982 (plate 44) is a spatially complex, optically active

Figure 26. Kenneth Noland, 1983. Photo: Marco de Valdiva.

66

configuration, with references to structural fantasy, somewhere between the mosque at Cordova and a Star Trek movie. Held's painting is also aggressively articulated in a strikingly illusionistic manner. This painting expands and contracts simultaneously, thus giving the definitive color beams a quality of suspension, an equilibration where the projecting elements are held in check by counterthrusts of equal intensity and visual power.

Other important artists of the American Hard Edge tradition are Jack Youngerman, who also worked in Paris during the fifties, and Leon Polk Smith. Both painters have made daring appropriations of natural shapes, often using nature as a source for their architectonic formats. Smith's reductive optical paintings of the early sixties, such as *Correspondence Blue Scarlet*,[15]

work is Minimal painting. Neither term is entirely accurate. Although Marden's encaustic paintings from the early seventies were primarily a dense layering of muted pigment, often revealing a rough edge of underlying color at the bottom, his more recent paintings have tended to embrace the post-and-lintel concept, sometimes associated with the tau cross.[16] In *Number Two* (plate 34), for example, there are three major sections to the surface, each demarcated by a modular lintel, running three-in-a-row across the top edge. The nine "posts" below are optically divided according to where they are placed in groups between the "lintel" sections above. The even modularity of these nine vertical panels and three horizontal panels gives *Number Two* the appearance of a form without a tampering with perspective and without hidden illusions. The look of Marden's

Figure 27. Ellsworth Kelly, 1982. Photo: Gianfranco Gorgoni.

attest to a mode of human perception that is perfectly in tune with the advances of recent technology.

Sometimes referred to as "monochromatic" painters, Brice Marden, Robert Mangold, and Robert Ryman are younger artists who all became prominent in New York galleries during the late sixties. Another epithet used to describe their

work has always been uncompromising in its frontality. The pictorial elements have the literalness of Minimal Art, particularly as they relate to the kind of repetition found in the sculpture of Carl Andre. This analogy is merely a formal one, however; Andre's ideological bent is vastly dissimilar from Marden's. The identification of color with the vertical and horizontal shapes in Marden's

Number Two is not at all related to the implicit industrial look associated with mainstream Minimal Art, but rather impinges upon the romantic sublime, more in the tradition of Barnett Newman's *Vir Heroicus Sublimus*. Marden has expressed a clear acknowledgment of nature in his work,[17] a reference antithetical to those of the more "epistemological" works of Andre, Judd, Morris, and others.

A similar problem exists in associating Robert Mangold's painting with Minimal Art. Since the early sixties Mangold has been dealing with the frontality of geometric surfaces in a highly reductive manner. If anything, the references in Mangold's work are more conceptual than Minimal.

> *I start first with an idea, a kind of structural idea, and it satisfies certain criteria that maybe I apply to ideas to decide what makes an idea a good one or a bad one. But there is nothing interesting for its own sake in the idea: it's the idea in the context of my work, and also in the size that I do it and in all the other decisions that are made in the doing of it.*[18]

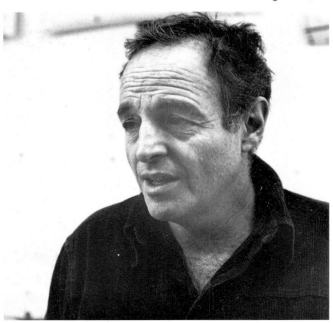

Figure 28. Al Held, 1976. Photo: Andre Emmerich.

Although Mangold studied with Albers at Yale, he has generally deemphasized the problem of color and has concentrated instead upon structure as it connects with the psychology of seeing. This delimitation in regard to the frontality of painting is in some ways related to the early work of Frank Stella, whose severely reduced construct in painting opened up considerable discourse as to the direction that abstract art might take, particularly geometric abstraction. Stella, however, was initially involved with modular positioning of elements in a serial pro-

gression. Again, his sense of repetitiveness in painting was not far removed from the alloy planes of Andre or the stainless steel boxes of Donald Judd. In each of these artists, a concern for modularity and anonymity was clearly evident. With Mangold, the concern was not with repetitions so much as permutations—subtle permutations of geometric surfaces, such as his early oil on wood painting, *Brown Wall* (1964),[19] in which an asymmetrical structure, actually composed of three equal squares, was divided in such a way as to assert an unequal distribution of surface weight. Later, in the early seventies, Mangold made a series of square paintings on canvas with incomplete circles drawn inside the squares. The fact that the circle within the square appeared irregular tested the viewer's ability to perceive why this was so. This propensity for the irregular and the asymmetrical is more than a visual/psychological concern. It is a personal account of how surface space is perceptually resolved in relation to what we know it to be.

In *Four Color Frame Painting No.1* (plate 33) Mangold asserts a more complex relationship of color, shape, space, and line; the superficial austerity of the painting has a tendency to give way to a decorative but more profound involvement with architectural space. What resonates from this ensemble of parts is that a deeply felt integration has occurred. The color is important; the blue and green values are muted, whereas the red and yellow are bright. The four "sides" to the open center progress in increments, perhaps in a serialized progression. Connecting these four color rectangles is a magnificent oval shape, reminiscent of Brancusi.[20] There is a perfection and grace about the oval that pulls the range of color values into a unity. The space within connects with the space outside in such a way that the architectural support is accentuated. Yet even with this free passage of optical movement there is a hovering, unprepossessing tranquillity.

Robert Ryman's paintings also show structural permutations that are subtly evocative. Ryman, whose intentions were defined in the early sixties, is primarily known for making white paintings—blank surfaces that strive to pull a psychological content from the viewer. Certainly their subject matter is "minimal," but the content is not. In one sense, the content is more agitated than in Mangold's paintings. One is reminded in such works as *Department* (plate 35), for example, of the presence of white noise. Without explicit subject matter, one tends to listen for something—a drone, a hum, an indication of static at the

periphery. The emphasis on materiality and physicality in Ryman's work does not permit much in the way of metaphor. These are stark, blunt paintings and very much an expression of a high-technology culture.

The phenomenon known as Minimal Art derives from four primary sources. One of these was the reaction against the aesthetic attitudes engendered in Abstract Expressionism and the formalist underpinnings of Color Field Painting. Even though the young artists of the early sixties who reacted strongly against the "excesses of deep subjectivity and allusive emotionalism"[21] associated with Abstract Expressionism were largely painters themselves, the positive thrust which emanated from their rejection of these attitudes came in the form of three-dimensional art. A second source was the revival of interest, particularly on the part of Andre and Stella, in the Russian Suprematists and Constructivists. Malevich's painting of 1913, in which he placed a black square on a square white ground may, in essence, be the first truly minimalist work of the modernist era. A third source was the ready-mades of Marcel Duchamp—an antecedent given some importance in the seminal essay on Minimal Art by Richard Wollheim in 1965.[22] Finally, the black paintings of Ad Reinhardt were a direct polemic repudiating modernist aesthetics and defined an extreme, purist position which was understood and acted upon by the mid-sixties as a logical antecedent to Minimal Art.

Minimal Art, known also as Primary Structures and ABC Art, articulated an important position in its advocacy of materiality, systems, seriality, and the removal of signs of the artist's hand as the tool by which art is made. Robert Morris, whose sculpture and writings espoused a new gestalt interrelation between literal objects and the space that contained them, wrote:

Simplicity of space does not necessarily equate with simplicity of experience. Unitary forms do not reduce relationships. They order them. If the predominant, hieratic

nature of the unitary form functions as a constant, all those particularizing relations of scale, proportion, etc., are not thereby canceled. Rather they are bound more cohesively and indivisibly together.[23]

The formalist critic Michael Fried took great exception to many of Morris's claims, arguing that "art degenerates as it approaches the condition of theatre."[24] What this means is that any art which does not adhere preeminently to the concerns of modernist self-critical posture, as deduced from the criteria of previously significant art, is outside the realm of qualitative meaning, and thus slides "towards some kind of final, implosive, hugely desirable synthesis."[25]

For Morris, Judd, and others, the distancing of their Primary Structures from any modernist

Figure 29. Brice Marden, 1985. Photo: Joe Maloney.

strategy gave testimony to the strength and significance of the work. Minimal Art, as it came to be known, could exist apart from aesthetic categories and definitions. One of the most notorious claims, often cited to describe this principle, occurred in an interview with Tony Smith:

Q: Why didn't you make it larger so that it would loom over the observer?
A: I was not making a monument.
Q: Then why didn't you make it smaller so that the observer could see the top?
A: I was not making an object.[26]

This statement was made as Smith was responding to a question about one of his early

69

three-dimensional pieces, a 6-foot steel cube painted black called *Die* (1962). Tony Smith had had a career as an architect for several years before turning to sculpture at the age of forty-eight. His first Minimal piece was *The Black Box*, completed in 1962. It was an irregular cube measuring 22½ x 33 x 25". This was followed the same year by a three-sided incomplete cube, set on three different axes, called *Free Ride*—named after Scott Carpenter's orbital flight[27]—and then *Die*. Architectural procedures were transformed by Smith for the making of sculpture. For example, instead of building the piece himself, he simply drew up the specifications and handed them over to a machine shop or a work crew. Rather than defining sculpture as expressive of something else, he considered it more in terms of its objectness—another great point of contention among formalist critics. Instead of taking organic shapes and materials and seeking their aesthetic resolution, he worked with modular units of structure in the same way that an architect might deal with masonry or prefabricated units; in other words, the system was worked out in the specifications long before the three-dimensional equivalent was realized.

In Tony Smith's *Throwback*, 1966 (plate 40), the precision mathematics of an architect are felt in the continuous dynamic cohesion of the elements, fabricated in steel and placed in a lateral orientation to the ground plane. Michael Fried's comment that Smith's sculpture belied a hidden "anthropomorphism" is not incorrect if one observes this piece closely.[28] At the same time, it virtually rejects the neo-primitivism recently emphasized at the exhibition on the relationship between modern and primitive art at The Museum of Modern Art in New York[29] that one might also find in the reclining figures of Henry Moore or the totemic figures of Jacques Lipchitz. *Throwback* is decidedly a piece with lyrical substance. It holds fast to its objective conception, yet manages to engage the viewer in what Barbara Rose once described as "rhythmic structuring."[30]

In contrast to the variation of linear movement in *Throwback*, Donald Judd's untitled piece of 1979, fabricated in Cor-ten (plate 38), is more characteristically Minimal. The six rectangular frames which constitute the piece are bunched together in such a way that their identity as a single unit of meaning is irrevocable. If one of the elements were removed, the piece would be destroyed. Judd's anti-art aesthetics plays upon the notion of context as the boundary which defines sculptural form. The serialized formation

of the elements does not progress in either direction; rather, each element is stable. Form and space interact through and around the location of the piece, thus creating a kind of presence without "aura." The work plays upon our industrial capacity to reproduce—to infinitely duplicate products—yet shows the moral force of decision-making that elevates our sensory and perceptual awareness beyond such material exigencies. Judd introduces a phenomenology of perception, an awareness of bodily self and all concomitant human frailties and fragilities, and shows them to be intrinsic to how we think, behave, and interact on all levels of human encounter.[31]

Probably the most important exhibition of work by these artists in the United States was "Primary Structures," held at The Jewish Museum in New York in 1966. One of the pieces which attracted a good deal of attention was by a young sculptor, originally from Quincy, Massachusetts, named Carl Andre. The title of his piece was *Lever*. It was a 400-foot lateral progression of firebricks stacked side by side, beginning at one wall and ending in the middle of the museum space. When asked about this piece, Andre replied: "All I'm doing is putting Brancusi's *Endless Column* on the ground instead of in the sky. Most sculpture is priapic with the male organ in the air. In my work, Priapus is down on the floor. The engaged position is to run along the earth."[32] This orientation was reiterated on a larger scale nearly a decade later in *Secant*, an outdoor piece made of Douglas fir beams placed end to end in an open field.

While the structure of Andre's projects, most notably his metal alloy planes, is mathematically precise, the content of his work may be characterized as loosely Marxist.[33] His ideological position, or "infrastructure," in dealing with units of constructive material is conspicuously related to industry, and especially to the industrial worker, the laborer who builds or "deconstructs" by adding or subtracting one element from another. He refuses the label of Conceptualist, though his ideas far exceed the visual complexity of his structures. In addition to his linear progressions of modular elements, he has also worked extensively with square plates of such metal as copper, zinc, aluminum, lead, magnesium, and steel. In his 12-foot-square floor installation *1981 Cu Fe* (plate 37) Andre has interwoven copper and iron plates. The physical sensation of walking on this base allows the viewer to become a participant. As with Judd, it is the functioning of the parts of the work in relation to the whole that defines the work

Figure 30. Frank Stella in his studio, 1967. Photo: Ugo Mulas.

Figure 31. Robert Morris, 1970. Photo: Ugo Mulas.

as a situational experience. Andre's unique contribution to sculpture is his insistence upon the lateral positioning of form, though upon some occasions he will resort to stacking wooden beams, usually as a way of redefining architectural space.

American Minimalism is a complex subject

and therefore requires much more discussion than is possible here. Artists such as Jackie Winsor, Richard Serra, Dan Flavin, Ronald Bladen, Bob Grosvenor, Sol LeWitt, Larry Bell, and John McCracken were all initiators of the development and evolution of this movement. Unquestionably it is more than "a minor movement...a slot in the debate about art,"[34] as the critic Robert Hughes once suggested. Some of these artists, such as Robert Morris and Richard Serra, have crossed over into other styles and categories or have since become involved with more topical subject matter.

Another aspect of this desire for extreme visual refinement should be noted; it is what the critic Robert Pincus-Witten has referred to as "post-Minimalism," but might be more accurately termed "meta-Minimalism." Two sculptors' work epitomizes this position, yet in unique and original ways. Michael Heizer, a sculptor and painter, became involved with Land Art or Earth Art during the late sixties, although he has continued working as a painter. Works such as *Double Negative* or *Circular Surface Planar Displacement* were monumental, temporal artworks, executed in the deserts of Nevada. In *Double Negative*, a rectilinear cut measuring 1,600 feet was moved across the edge of a canyon. The cut involved the removal of 240,000 tons of dirt.[35] Heizer's orientation toward natural earth and rock structures has been one of intervention, in which he tries to redefine the amorphous mass of material according to an ordering procedure and a displacement process.

In *45°, 90°, 180°* of 1985 (plate 41) Heizer constructed three cast bronze elements made to simulate chunks of cut granite held in place and contrasted with three highly polished pedestals. Heizer thus departed from his earlier, more direct, confrontation with the rawness of materials and has instead simulated this rawness while alluding to the concept of the traditional monument in Western culture. He still borrows heavily from the modular, serialized aspect of Minimal Art, yet there is an implicit sense of romanticism, a nostalgia for prehistoric monuments, such as the great Druid stones, thus giving the newer work a peculiar narrative quality. If *Double Negative*, a remarkable feat of process sculpture, can be compared to Action Painting, then clearly *45°, 90°, 180°* has links to the hard edge and gestural aspects associated with Color Field Painting. Heizer has the ability to evoke specific qualities from his materials, such as the varying textures and patinas of bronze, but in a less temporal way. Heizer is an idealist involved with the creation of

myth from the vestiges of history.

Until the late seventies, Joel Shapiro tended to work on a relatively small scale, in contrast to the more expansive tendencies of the earlier Minimalists. His sculpture from the early seventies is miniature in comparison. His forms have been consistently geometric and reductive, yet there is a lyrical element in the recent larger-scaled work that has emerged from the earlier cast-iron houses, bunkers, and chairs.[36] The figurative piece *Untitled* of 1985 (plate 42) is a delicately tuned work of choreography with five rectilinear elements poised in such a way as to suggest further movement. Earlier figurative works from 1980 had been constructed in wood; the more recent ones are cast in bronze. There is a certain elegance of placement in *Untitled*. The careful abutment of the elements suggests a continuity while concurrently allowing the parts a unique discretion. Because of the division of space, attention is detracted from the objectness of the

earlier pieces. Again, it is this lyrical sense of dance—the sense of a human sign—that gives Shapiro's essentially constructivist point of view significance.

Despite the different categories and intentions and critical observations described in this brief essay, there is a connecting link in these artists' work. That link is an obsessive quality in the treatment of the art object. To refine an object is not the same as reducing it, although the two processes have often been associated with each other. The desire among artists who emerged in the fifties and sixties to ferret out a specific plastic means where language finds an equivalence in visual objects constitutes a remarkable chapter in the history of modernism. It reveals an effort to give aesthetics tangible form in specific objects and to reinsert meaning into the materials and perceptions that evoke the shape of time at a historically specific moment.

NOTES

1. George Kubler, *The Shape of Time* (New Haven: Yale University Press, 1962), p. 33.
2. Michael Starenko, "Rear Window: Serge Guilbaut and the History of Abstract Expressionism," *Vanguard*, vol. 13, no. 9 (Nov. 1984), pp. 16–21.
3. Barbara Rose, *American Art Since 1900: A Critical History* (New York: Praeger, 1967), pp. 189–210.
4. Clement Greenberg, "Modernist Painting," in Gregory Battcock, ed., *The New Art* (New York: Dutton, 1966; revised, 1973), p. 67.
5. Sonya Rudikoff, "Helen Frankenthaler's Painting," in B.H. Friedman, ed., *School of New York: Some Younger Artists* (New York: Grove, 1959), p. 12.
6. Michael Fried, *Morris Louis: 1912-1962*, exhibition catalogue (Boston: Museum of Fine Arts, 1967), p. 26.
7. Ibid., p. 15.
8. Jules Olitski, quoted from *Catalogue of the International Biennial Exhibition of Art*, Venice, 1966, in Barbara Rose, ed., *Readings in American Art Since 1900: A Documentary Survey* (New York: Praeger, 1968), p. 172.
9. Kenneth Noland, quoted from Philip Leider, "The Thing in Painting Is Color," *The New York Times* (August 25, 1968), in Ellen H. Johnson, *American Artists on Art: 1940-1980*, New York: Harper & Row, 1982, p. 50.
10. Ibid., p. 50.
11. Clement Greenberg, "Post-Painterly Abstraction," exhibition catalogue (Los Angeles: Los Angeles County Musuem, 1964), in Rose, *Readings*, p. 170.
12. Ibid., pp. 170–171.
13. Rose, *American Art*, pp. 229–230.
14. Sam Hunter and John Jacobus, *American Art of the Twentieth Century* (New York: Abrams; and Englewood Cliffs: Prentice Hall, 1975), p. 377.
15. Ibid., p. 389 (illustration).
16. Robin White, "Interview with Brice Marden," in *View* (Oakland, Calif.: Crown Point Press, 1980), p. 15.
17. Ibid., pp. 12–13.
18. Robin White, "Interview with Robert Mangold," in *View* (Oakland, Calif.: Crown Point Press, 1978), p. 7.
19. Ibid., p. 4 (illustration).
20. In Robert Berlind's essay "Robert Mangold: Nuanced Deviance" (*Art in America*, May 1985), he interprets the oval in relation to the head of St. Dominic in Matisse's chapel in Vence. Berlind suggests that the colors used in *Four Color Frame Painting No. 1* are also

reminiscent of Matisse's later palette. I prefer to see Mangold's stasis of tension and balance more in line with Brancusi's aesthetic, particularly in such works as *The First Cry*, 1913. In Lucy Lippard's essay "Silent Art: Robert Mangold," in *Changing* (New York: Dutton, 1971), pp. 130–140, some of the qualities which I have suggested about the artist's work are in agreement with her comments.
21. Suzi Gablik, "Minimalism," in Nikos Stangos, *Concepts of Modern Art* (New York: Harper & Row, 1974; revised 1981), p. 245.
22. Richard Wollheim, "Minimal Art," *Arts Magazine*, vol. 39, no. 4 (Jan. 1965), pp. 26–32.
23. Robert Morris, "Notes on Sculpture, Part I," *Artforum* (Feb. 1966), in Gregory Battcock, *Minimal Art* (New York: Dutton, 1968), p. 228.
24. Michael Fried, "Art and Objecthood," *Artforum* (June 1967), in Battcock, *Minimal Art*, p. 141.
25. Ibid., p. 141.
26. Robert Morris, "Notes on Sculpture, Part II," *Artforum* (Oct. 1966), in Battcock, *Minimal Art*, p. 228–230.
27. Sam Hunter, "The Sculpture of Tony Smith," in *Tony Smith: Ten Elements and Throwback*, exhibition catalogue (New York: Pace Gallery, 1980), p. 4.
28. Fried, "Art and Objecthood," pp. 129-135.
29. The Museum of Modern Art, New York, *Primitivism in 20th-Century Art: Affinity of the Tribal and the Modern* (Sept. 27, 1984–Jan 15, 1985). William Rubin was director of the exhibition.
30. Barbara Rose, "ABC Art," *Art in America* (Oct. 1965), in Battcock, *Minimal Art*, p. 286.
31. Maurice Merleau-Ponty, "An Unpublished Text," translated by Arleen B. Dallery, in *The Primacy of Perception* (Chicago: Northwestern University Press, 1964), pp. 3–11.
32. Carl Andre, as quoted by David Bourdon, "The Razed Sites of Carl Andre," *Artforum* (Oct. 1966), in Battcock, *Minimal Art*, p. 104.
33. Andre described his relationship to materials and industrial work in a panel called "Art and Class Forum," Artists Space, New York, Apr. 9, 1976.
34. Robert Hughes, "The End of Modernity," the final episode in an eight-part TV series called *The Shock of the New* (1980), originally broadcast on PBS.
35. Gregoire Muller, *The New Avant-Garde* (New York: Praeger, 1972), pp. 29–31.
36. Maurice Berger, "Joel Shapiro: War Games," in Peter Frank, ed., *Re-Dact* (New York: Willis, Locker & Owens, 1984), pp. 16–21.

72

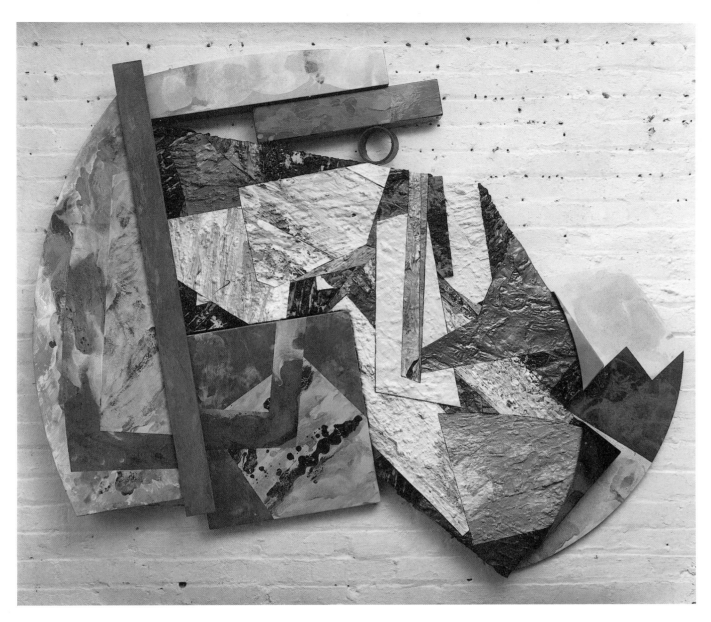

PLATE 28
Sam Gilliam
Like Today, 1985.
Acrylic on canvas with aluminum construction, 55 x 67 x 4".
Monique Knowlton Gallery, New York.

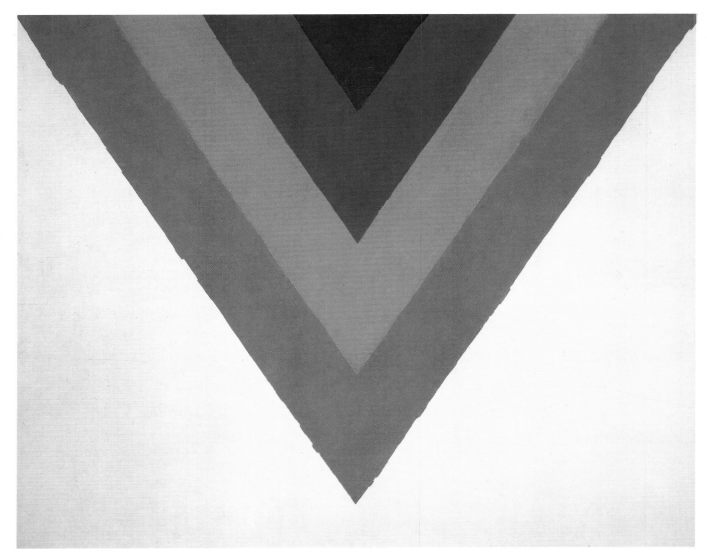

PLATE 29
Kenneth Noland
Across, 1964.
Acrylic resin paint on canvas, 97 x 126".
Andre Emmerich Gallery, New York.

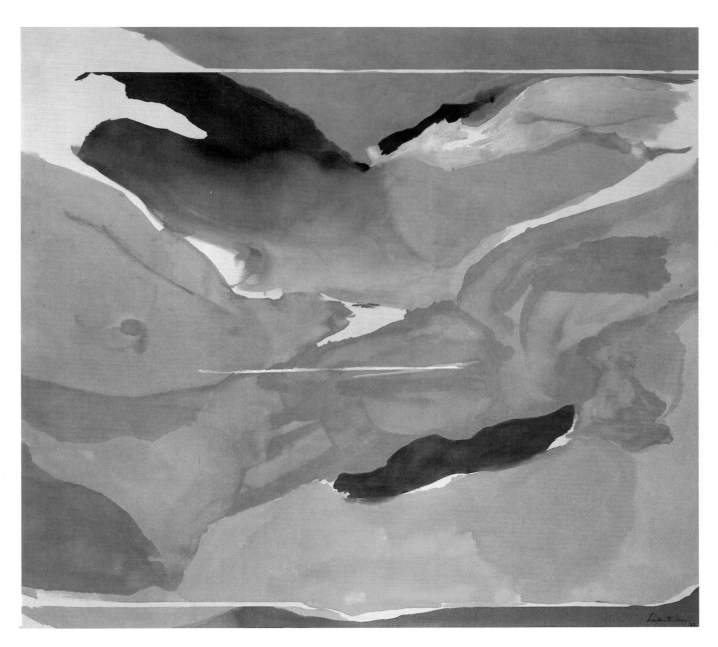

Plate 30
Helen Frankenthaler
Nature Abhors a Vacuum, 1973.
Acrylic on canvas, 103½ x 112½".
Andre Emmerich Gallery, New York.

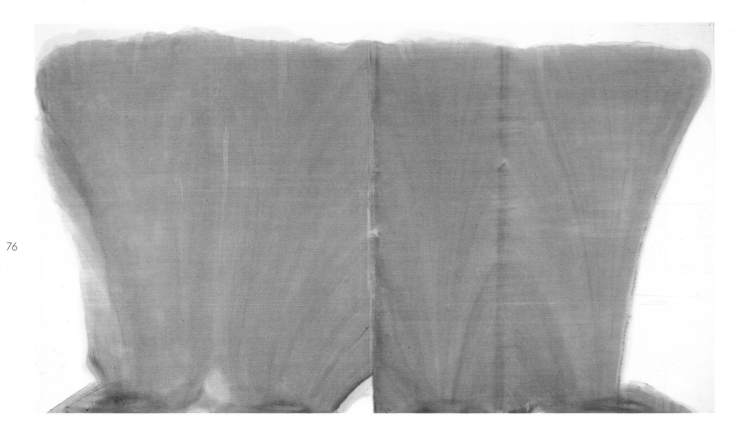

right

PLATE 31
Morris Louis
Beth Lamed, 1959.
Acrylic on canvas, 90¼ x 150".
Andre Emmerich Gallery, New York.

PLATE 32
Jules Olitski
Exact Origin, 1966.
Acrylic on canvas, 110 x 85".
Andre Emmerich Gallery, New York.

PLATE 33
Robert Mangold
Four Color Frame Painting No. 1, 1983.
Acrylic and pencil on canvas, 111 x 105".
Collection Martin Sklar, New York.

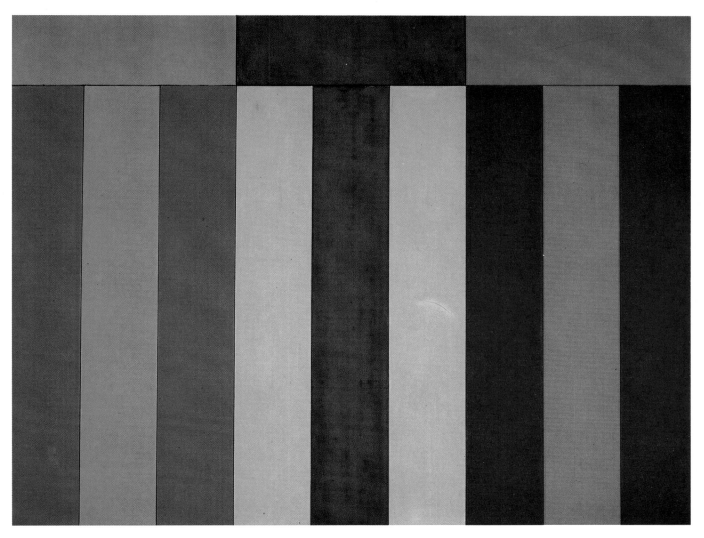

Plate 34
Brice Marden
Number Two, 1983–84.
Oil on canvas, 84 x 109".
Collection Martin Z. Margulies, Miami.

Plate 35
Robert Ryman
Department, 1981.
Oil on aluminum, 59¾ x 59¾".
Collection Rhona Hoffman, Chicago.

top
PLATE 36
Walter de Maria
The Square of the Large Rod Series, 1985.
Solid, custom-ground, and hand-polished polygonal stainless-steel
rods, 5-, 7-, 9-, 11- and 13-sided, each 52" long.
Xavier Fourcade Gallery, New York.

bottom
PLATE 37
Carl Andre
81 Cu Fe (The Net of Hephaestus), floor piece, 1981.
Copper and steel, 180 x 180 x ³⁄₁₆"; 41 copper plates, 40 steel plates,
each plate 20 x 20".
Paula Cooper Gallery, New York.

PLATE 38
Donald Judd
Untitled, 1979.
Cor-ten steel, 48 x 119 x 119".
Collection Martin Z. Margulies, Miami.

82

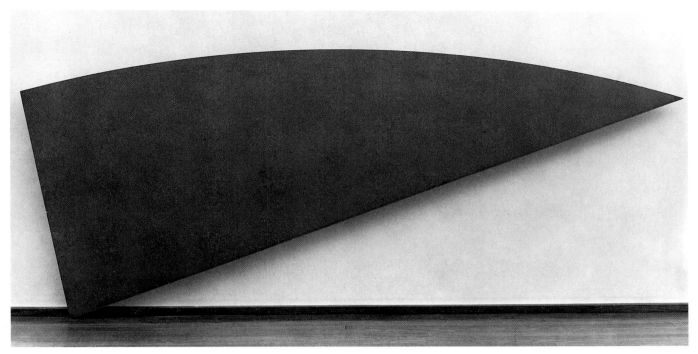

PLATE 39
Ellsworth Kelly
Untitled, 1983.
Cor-ten steel, 39⅜ x 94⅛ x ⅜".
Leo Castelli Gallery, New York.

PLATE 40
Tony Smith
Throwback, 1966.
Painted welded steel, 63 x 150 x 74".
Collection Martin Z. Margulies, Miami.

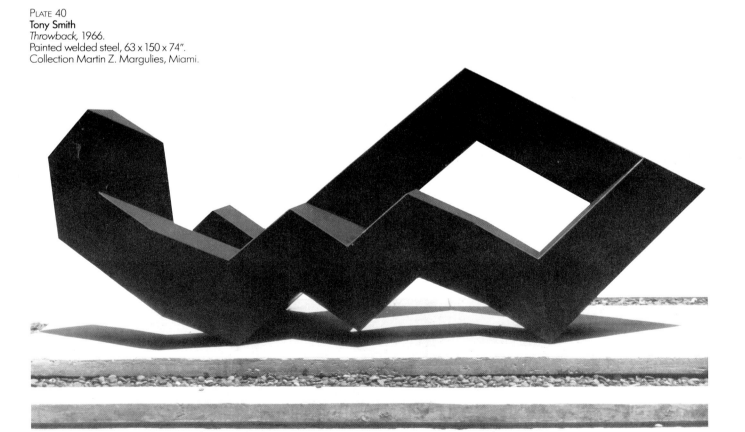

84

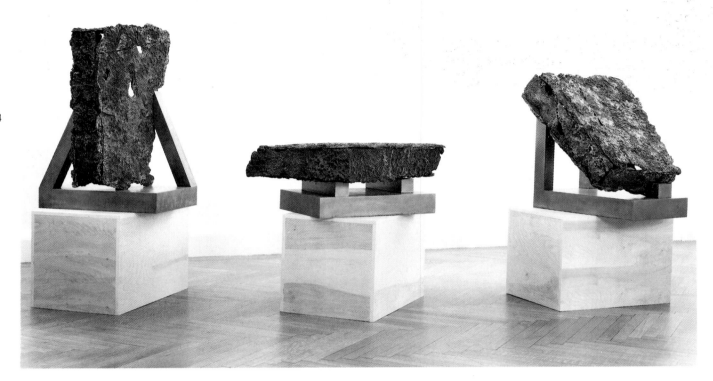

PLATE 41
Michael Heizer
45°, 90°, 180°, 1985.
Three elements, bronze,
45°: 31 x 29 x 31";
90°: 40 x 30 x 27";
180°: 15 x 21 x 37";
pedestals, 18 x 27 x 40".
Xavier Fourcade Gallery, New York.

right

PLATE 42
Joel Shapiro
Untitled, 1985.
Bronze, 117 x 133 x 72".
Paula Cooper Gallery, New York.

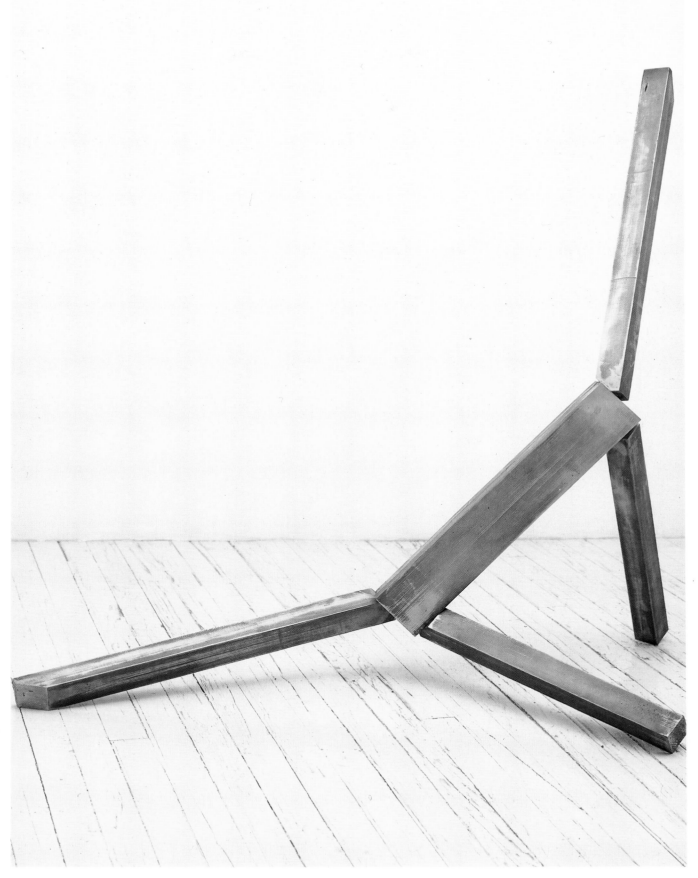

III
"THE RESPONSIVE EYE": ART OF LIGHT, PERCEPTION, AND MOVEMENT

Richard Sarnoff

Painting	Sculpture
Al Held	Dan Flavin
Robert Irwin	George Rickey
Agnes Martin	James Seawright

An exploration of the constituent elements of art has characterized much of the important work done by twentieth-century artists. The concentration upon color, plane, line, gesture, shape, and even frame defines a fair history of abstract painting. Similarly, the development of abstract sculpture can be identified through its formal properties. This rather clinical formalism does not hint at the individual and stylistic expression of nonobjective art nor address its philosophical and social underpinnings. Such an approach, however, can be useful as an armature when considering the work of contemporary artists who seek to expand their artistic horizons by exploring new materials and methods—new constituent elements. Light, perception, and movement are areas in which the American artists Al Held, Agnes Martin, Robert Irwin, Dan Flavin, George Rickey, and James Seawright have produced significant work in the past few decades, and whose concerns were first noted in the 1965 exhibition of optical art, called "The Responsive Eye," organized at The Museum of Modern Art in New York by William C. Seitz. With their vastly different approaches, these artists have systematically explored and secured new ground for art.

With the exception of Optical Art, there has been no movement or school associated directly with art of light, perception, and movement. (Various factions have been placed under the labels Minimalist, Conceptual, or technological art.) "Op Art" was mostly a journalistic phenomenon, with reviewers eager to find the next catch phrase after Pop Art. A style deriving from the Bauhaus investigation of color and the Hungarian-French artist Victor Vasarely, Op Art capitalized on the unstable optical effects created by juxtaposing high-intensity colors or contrasting mono-tonal patterns.

The American artists Larry Poons and Richard Anuszkiewicz created interesting work in this tendency in the 1960s. Yet Op Art never had the ideological or aesthetic strength of a "movement" and soon became a mannered style practiced by few artists. The art of light, perception, and movement certainly encompasses Op Art, and some of the characteristics of the style, such as its "systemic" approach, which consciously manipulates the eye and the mind of the viewer, can be generally ascribed to the artists discussed in this essay.

The high-romantic flourish of the Abstract Expressionist generation produced a fascinating fallout in the 1950s and 1960s. As described in other essays in this catalogue, the social irony and representational commitment of the Pop artists developed in reaction to the individual gestural hubris of the Abstract Expressionists. Yet the theatrical shock of grand scale and bold composition continued to be investigated, as in the post-Abstract Expressionist styles of Color Field and Hard Edge painting. Many of these paintings reflect a slowing down of gesture for lyricism or clarity, a concentration on shape and mass for structure or power. Al Held worked in the latter style, along with such contemporaries as Frank Stella and Ellsworth Kelly. Yet, whereas Kelly and especially Stella pioneered a Minimalist aesthetic with their bold, simple compositions in the 1960s, Held began to explore a complex geometrical illusionism, first in black outlines and later in stirring Op Art colors.

Al Held has said of his stylistic change, "I got frustrated at the notion of paintings getting simpler and simpler, so I developed this appetite for complexity. I wanted to put stuff back *into* my work."[1] Al Held's *Rome II* (plate 44) is an example of his latest style. He seems to be painting another universe, a weightless spectacle of myriad, interlacing geometric forms. Indeed the all-over field championed by Pollock and other Abstract Expressionists finds its equivalent in the rigid topology of Held's works. The colorful forms and spaces call to mind a geometrical labyrinth that may extend well beyond the canvas. Held places the viewer on a roller coaster of perceptual experience as the mind tries to reconcile the various shapes with one another. The earlier divergence from Stella has, ironically, come full circle—with Stella's recent work exploring in three dimensions a complex space similar to that of Al Held's illusionistic canvases.

Whereas Held orchestrates his work with dynamic composition and color, Agnes Martin chooses a subtler, more rigorous elaboration of the perceptual field. Martin began painting grids in 1962. The grid has an important history in twentieth-century art, beginning with Cubism and Mondrian. Even the Abstract Expressionists, notably Philip Guston and Ad Reinhardt, relied strongly on the grid to lend structure to their compositions. Agnes Martin paints and draws faint grids, sometimes with atmospheric traces of chalky color (plate 45). Martin's works are so Minimal that they are often classified with the work of Robert Ryman, who makes pure-white paintings.[2] While both artists employ extremely systematic, or "cool," techniques, the two diverge strongly in their impact on the viewer. Ryman asserts the physical fact of white paint on canvas

with clear brushstrokes and texture; Martin chooses a thin planar grid, giving the work an ethereal expression.

Trying to transform feeling into abstract form, Martin paints perceptual veils. Diffusing light and form, she evokes a plateau beyond experience but deriving from it: "Now let us turn to abstract response, the response that we make in our minds free from our concrete environment. We know that it prevails. We know that it is infinite, dimensionless, without form and void. But it is not nothing because when we give our minds to it we are blissfully aware."[3] So her paintings, existing at the very fringes of perception, require an intense commitment on the part of the viewer.

Martin moved to New Mexico in 1967 and ceased to paint for six years. She was upset at the misinterpretation of her work, with people pointing to the minor tremors and pauses in her lines as a significant expressive code, as if she were a gestural painter tracing a tiny grid. Thus, in 1973 she began to use a mechanized line and to make prints, which started to reflect the hues of New Mexico. She soon returned to making paintings with gesso and pencil as well. Agnes Martin has since continued to probe the grid composition, varying the compositional elements only slightly. Yet her work, if the viewer adjusts his perception to the quiet light of the paintings, has a remarkably broad range of expression.

Two other artists, Robert Irwin and Dan Flavin, have gone further than Martin in the diffusion of the art object, to the point of actually dematerializing it. Both artists work with light and space. Their works often have no specific dimensions, since the perceived light and altered space which constitute their art cannot be measured. Irwin has said, "All I try to do for people is to reinvoke the sheer wonder that they perceive anything at all."[4]

The New York artist Dan Flavin became interested in electric-light art while walking the corridors of the Museum of Natural History in New York as a guard. He called his first fluorescent works icons and became convinced that he had found a new medium of artistic expression: "The radiant tube and the shadow cast by its supporting pan seemed ironic enough to hold alone....It seemed to sustain itself directly, dynamically, dramatically on my work room wall—a buoyant insistent gaseous image which, through brilliance, somewhat betrayed its physical presence into approximate invisibility."[5] He soon discovered that fluorescent light could alter the appearance of a physical space, depending on placement.

Corners could be blurred; walls could be bent by our perception of light. Color too provided a fertile ground in fluorescent light—spaces could be made warm or cold, bright or somber.

In *Untitled* of 1980 (plate 96) blue, green, and pink fluorescent lights climb ladder-like in the corner of a room. This work takes on an almost architectural presence as it disintegrates/reintegrates the corner, altering the viewer's perspective of the room. Flavin's work cannot easily be classified as painting, sculpture, or even environmental art. People tend to participate in it by standing close and lighting themselves, their fascination balanced by a resistance to the new medium—familiar fluorescent light. What Flavin has done is to take one of the key components of art, light, strip away its normal context, and let it stand on its own. Flavin builds his own vocabulary of light, much as Martin does with her grids and Held with his playful geometric spaces.

Robert Irwin has composed art works out of space, angling and breaking specific areas with scrim or gauzy screen. Irwin began his experimentation with the limits of the art object in the late 1960s. An intellectually gifted California artist, he manipulated the art object, changing its shape, color, and lighting so that it would be perceived as a part of its surroundings. In his *Untitled* (plate 43) Irwin brought a large disk out from the wall and illuminated it from above and below with floodlights. This results in an ambiguity between the actual disk and its shadows. The curved edges of the disk disappear gradually as if melting into the environment. This can be seen as an artistic metaphor for Irwin's concern that art not exist in a vacuum but in the larger context of society and humanity: "It is a critical fallacy to imagine that 'art' could be satisfied with the in-itself as knowledge, while sparing itself the concerns and questions of its roots in the world."[6]

In the 1970s Irwin discarded the art object entirely, dividing space with scrim in site-specific works. A viewer's experience of the altered space is his experience of the art work. Art has melded completely with its environment. With the art object dematerialized to this extent, art can be as much a way of seeing as it is an object that is seen.

Like light and space, movement is a primary perceptual element. Kinetic art originated with Russian Constructivism, in the 1920s. The first major artist to devote himself fully to kineticism, however, was the American sculptor Alexander Calder. Irrepressible inventiveness and whimsy mark Calder's art, which often takes the form of mobiles. Recently, many artists have used move-

ment in their work; sometimes the movement is mechanical, sometimes natural, and sometimes it is generated by the viewer.

George Rickey has been creating mobile sculptures for thirty years. His three principal influences can be found in the work of Calder, the Constructivists Naum Gabo and Antoine Pevsner, and the brushed steel sculpture of David Smith. Rickey composes his kinetic sculpture from linear or planar elements, which are perfectly counterbalanced so that they move freely on one or more axes (plate 47). This allows a kind of scissoring choreography in the air. Rickey has described his development as a kinetic sculptor in this way: "I realized that if I were going to compose with movement, I must dispose of shape and reduce my forms to the minimum. So I soon reduced the components to lines—the simplest, just a strip— and I realized that I could make drawings in space, kinetic drawings in space with the strips."[7]

Rickey feels that kineticism is a new art medium, with its own structural concerns and its own range of expression. His art suggests not so much the tree as the moving of the branches, not so much nature as natural laws and forces. In this he continues the Constructivist tradition of searching for hidden order and harmony in our environment.

Coming from a quite different perspective but engaged in a related search, James Seawright builds machines and models using sophisticated electronic and mechanical means. Seawright's quasi-theatrical pieces have included a machine in which one element moves to "watch" another's changing pattern of lights. (Meanwhile, the viewer is watching this process of mechanized surveillance,

an irony with social and political overtones.) Seawright likens the creation of kinetic sculpture to the composing of a "pattern of phenomena," or to desired effects.

In *Mirror VII* (plate 48) the desired effect was to create a reflective surface that would duplicate the phenomenon of magnification without creating distortion. Thus, Seawright has constructed, instead of a curved mirror, a mosaic of precisely angled flat mirrors, calculated with the aid of a computer. Any image in front of the mirror is broken up and enlarged in crystalline fashion, which forces you to see yourself differently. This piece is passively kinetic; it relies on the viewer to create change. Seawright combines art and technology, as do artists working in areas as diverse as video art, photography, environmental art, and music. He states, "Art is, after all, only a record of people in a time, and this is the time of technology."[8]

The work of Held, Martin, Flavin, Irwin, Rickey, and Seawright represents such divergent approaches and such distinct results that certainly no one would call their art a school or a movement. Indeed, each artist's work is closely related to specific styles such as Minimalism, Conceptual Art, and Constructivism. Yet, together these artists illustrate an important technological aspect of the art of our time, employing novel materials and methods. The hard-won battles of earlier plastic styles influence newer ones. The artists discussed here pioneered in or perfected the use of light, perception, and movement. Their developments will certainly play a strong role in the unforeseen art forms of the future.

NOTES

1. Al Held, interview with Stephen Westfall, *Art in America*, vol. 73 (June 1985), pp. 113–121.
2. Dore Ashton, "Agnes Martin and...," in *Agnes Martin: Paintings and Drawings, 1957–1975* (London: Arts Council of Great Britain, 1977).
3. Agnes Martin, "Notes from a Lecture at Yale University, 1976," in *Agnes Martin: Paintings and Drawings, 1957–1975* (London: Arts Council of Great Britain, 1977).
4. Lawrence Wechsler, *Seeing Is Forgetting the Name of the Thing One Sees: A Life of a Contemporary Artist—Robert Irwin* (Berkeley: University of California Press, 1982).
5. Dan Flavin, "...In Daylight or Cool White," in *Dan Flavin: Fluorescent Light* (Ottawa: Vancouver Art Gallery, 1969).
6. Wechsler, op. cit.
7. George Rickey, untitled essay in *George Rickey: Retrospective Exhibition, 1951–1971* (Los Angeles: Art Gallery, University of California at Los Angeles, 1977).
8. James Seawright, "Phenomenal Art: Form, Idea, Technique," in *On the Future of Art* (New York: The Viking Press, 1970), pp. 77–95.

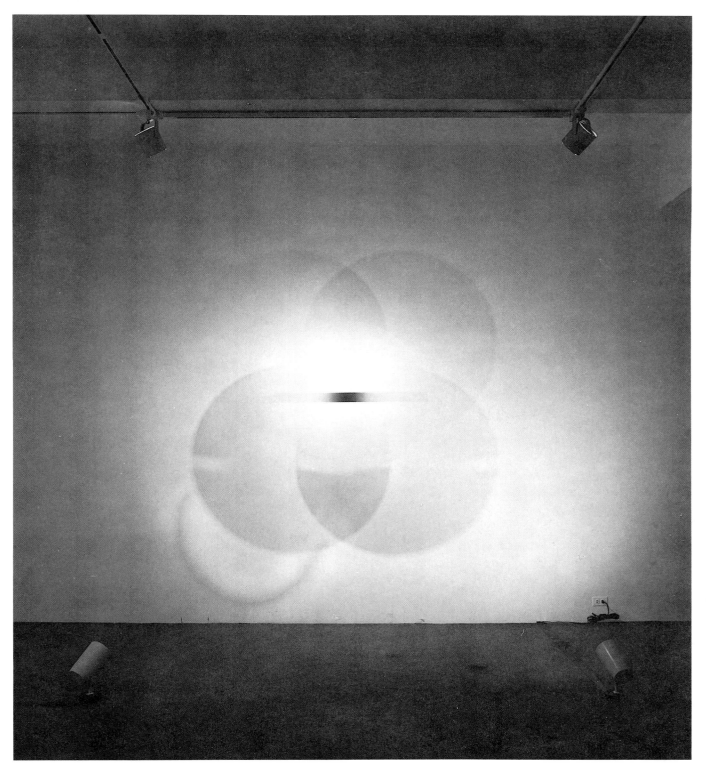

PLATE 43
Robert Irwin
Untitled, 1969.
Acrylic paint on cast acrylic, 54" diameter.
The Pace Gallery, New York.

Plate 44
Al Held
Rome II, 1982.
Acrylic on canvas, 108 x 216".
Andre Emmerich Gallery, New York.

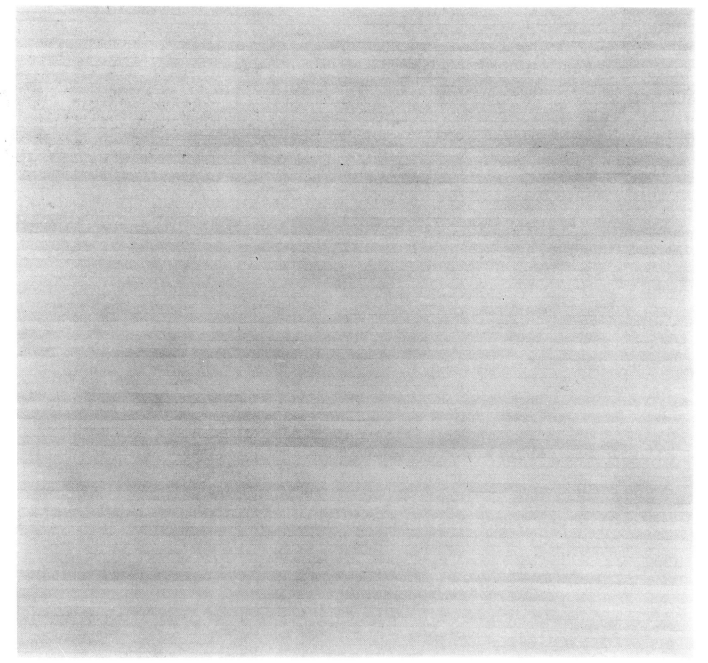

PLATE 45
Agnes Martin
Number 14, 1981.
Gesso acrylic and pencil on canvas, 72 x 72".
The Pace Gallery, New York.

far left
PLATE 46
Dan Flavin
Untitled, 1980.
Blue, green, and pink fluorescent light, 168 x 25".
Leo Castelli Gallery, New York.

near left
PLATE 47
George Rickey
Two Lines, Oblique, 1967. Executed in 1969.
Stainless steel, 25'h., 2/8.
The Lannan Foundation, Palm Beach, Florida.

PLATE 48
James Seawright
Mirror VII, 1985.
Fiberglass-reinforced cement and glass mirrors, 90 x 90 x 4".
Collection the artist, New York.

IV
THE OBJECT OF POP ART AND ASSEMBLAGE

Malcolm R. Daniel

Painting

Jim Dine
Red Grooms
Jasper Johns
Alex Katz
R. B. Kitaj
Roy Lichtenstein
Richard Lindner
Robert Rauschenberg
Larry Rivers
James Rosenquist
Ed Ruscha
Cy Twombly
Andy Warhol
Tom Wesselmann
William Wiley

Sculpture

Arman
Richard Artschwager
John Chamberlain
Mark di Suvero
Claes Oldenburg
George Segal

Though it is tempting to describe Pop Art as the assertive reemergence of objects and figures in the art of the late 1950s and 1960s, rising like a phoenix from the emotional fire of Abstract Expressionism, that would be to ignore the numerous instances which signal continuity between the generation of Pollock and de Kooning and that of Rauschenberg, Johns, Warhol, and Lichtenstein. Pollock had been drawn back to the human figure in the last years of his life, and de Kooning not only created a significant body of figurative work—his *Woman* series—but incorporated in his *Study for Woman* (1950) a collage mouth, cut from a magazine ad. On the other hand, we find in the work of Rauschenberg an expressive brushwork, in Johns a continued assertion of the flatness of the picture plane, in Warhol the painting process as an essential

Figure 32. Robert Rauschenberg, 1980. Courtesy Leo Castelli.

aspect of the work's meaning. The perspective from a quarter century later allows us now also to see aesthetic connections with the work of European Dadaists and with such Americans as Hartley, Demuth, and Davis, and to find personal and cultural meanings in Pop images which were once considered to be expressionless, if not nihilistic.

Despite such continuities, radical changes

did occur in the technical means and cultural reflections of art in the late 1950s and early 1960s, as young artists faced the problem of moving forward from Abstract Expressionism. The appropriation of images and materials from popular culture appeared to be one solution. On the basis of this connection the label "Pop Art" was coined by the British critic Lawrence Alloway, providing an all too convenient way of grouping together a score of artists with varying methods and aims. In the hands of different artists, for instance, use of objects from everyday life took a variety of forms: straightforward appropriation and presentation, contextualization, transformation, re-creation, and depiction.

The first works to signal a major shift from the aims of Abstract Expressionism and a new relationship between art and environment were the "combine paintings" of Robert Rauschenberg, the earliest of which date from 1953–54. Rauschenberg attached common objects to his canvases and incorporated printed materials in a collage manner amid dashes and splashes of oil paint. Though far from the characteristics which we associate with 1960s Pop Art, the "junk culture" aesthetic of these works constituted a new definition of appropriate subject matter and materials for art. The most important of the early combine paintings were shown in a solo exhibition at the Leo Castelli Gallery in 1957, and Rauschenberg was included in the 1959 Museum of Modern Art show "16 Americans"; it was in his statement for the catalogue of this exhibition that Rauschenberg made the much-quoted comment which seemed to stake out the territory for the new generation of artists: "Painting relates to both art and life. Neither can be made. I try to act in the gap between the two."[1] The combine paintings were placed in a historical context by inclusion in large survey shows of collage and assemblage, the most important of which was The Museum of Modern Art's 1961 exhibition "The Art of Assemblage." There Rauschenberg's combine paintings *Canyon* and *Talisman*, along with the work of Arman, Chamberlain, Johns, Kienholz, Samaras, and other young artists, were exhibited within the tradition of assemblage established by Picasso, Miró, Ernst, Dubuffet, and most importantly, Schwitters, Duchamp, and Cornell.

Consideration of the distinctions between art and life, and the conscious attempt to eliminate that boundary, found expression also in the Happenings of 1959–62. Kaprow, Oldenburg, Dine, and Grooms were the major participants in these quasi-theatrical events in which it was made

intentionally difficult to separate genuine action from acting. Again, Rauschenberg appears to have signaled the way with his long collaboration with the choreographer Merce Cunningham and the composer John Cage, beginning at Black Mountain College in the early 1950s.

Nearly all of Rauschenberg's work during the past three decades has incorporated objects or images from non-art sources. The actual incorporation of newspaper or other printed matter in his early work was replaced in later paintings such as *Kite,* 1963 (plate 1), by a photo-silkscreen process, allowing the artist to alter the size of the image and to repeat it on a single canvas or reuse it on another. Images of the eagle, the Vietnam War helicopter, and World War I soldiers appear in other Rauschenberg paintings of the period. Some of his works, such as *Canyon* and *Rebus,*

were Dada "readymades" rather than unique objects (indeed, Johns and Rauschenberg were dubbed "neo-Dadaists"). The triviality and apparent arbitrariness of Johns's subject matter clouded perception and discussion of formalist concerns—the ambiguity of actual and depicted surfaces, the tension between dictated form and free brushwork. Even in his paintings of the mid-1950s one can find the geometric structure and conceptual system which gradually displaced Pop subject matter as the principal force in such works as *Dancers on a Plane,* 1979 (plate 66).

By choosing as his subject flags, targets, and later maps, letters, and numbers, Johns was able to be depictive without resorting to traditional spatial devices. However, *Dancers on a Plane* is very much concerned with spatial perception. In speaking about a related painting with

Figure 33. Jim Dine and Judy Tersch in Dine's Happening *Car Crash* at the Reuben Gallery, New York, 1960. Photo: Robert R. McElroy.

have been shown to have complex iconographic or narrative meanings,[2] but many provide a rich field of detail which invites viewer interpretation in an inevitably personal manner.

Along with Rauschenberg, Jasper Johns was the primary artist challenging accepted norms of modernity and producing work which exercised power over younger artists. Despite the care and subtlety of Johns's encaustic technique, his early images of flags and targets were greeted (or scorned) by the public and critics as if they

the same title (1980–81, Tate Gallery), which bears the inscription "Merce Cunningham" as a dedication interwoven with the title at the bottom of the canvas, Johns stated that he was interested in the problem of expressing three-dimensional spatial relationships and movement in time (for example, that of the dancer) on a two-dimensional picture plane.[3] The work is not meant to be representational, although the size and proportions of the canvas, as well as the bilateral symmetry of the design, do evoke the figure. More

Figure 34. Jasper Johns. *Target with Plaster Casts*, 1955. Encaustic and collage on canvas with plaster casts, 51 x 44 x 3½". Collection Mr. and Mrs. Leo Castelli, New York (not in the exhibition). Photo: Rudolph Burckhardt.

100

Figure 35. Jim Dine. *Shoe*, 1961. Oil on canvas, 64 x 51½". (Not in the exhibition.) Private collection.

important is the sense of variation and continuity which Johns establishes in this and other paintings in his "cross-hatch" style. In addition to the central vertical division, the canvas is divided horizontally into four sections of equal size. The border between the two uppermost sections is marked by a change in color and direction of the red, yellow, and blue lines; between the central two sections the lines shift color only; between the bottom two, direction only. Spatial continuity is implied by the possibility of joining the top and bottom edges of the pattern (excluding the inscription), to form a bond in which neither the color nor the direction of line would change.[4] Wrap-around continuity in the other direction is implied as well, both by the second axis of symmetry which would be formed, and by the inscription at the bottom; the letters of DANCERS ON A PLANE and JASPER JOHNS 1979 alternate with one another, but both parts of the inscription begin to the right of center, run to the right edge, and continue at the left. The inscription reads:

ENRCJEORHSNOSN1A9P7L9AJNAESDPAE

with the letters of the title in red, yellow, and blue, and those of the artist's name and date in white; the letter E is split at the two ends. The eating utensils along the vertical edges of the frame in the Tate Gallery version were explained by Johns as relating to Tantric images of gods with many arms holding objects, but they must also be seen as part of Johns's own vocabulary of common objects.[5] It is also important to note that, like the appropriated designs of earlier work, the abstract pattern of cross-hatching which has appeared in his paintings since 1972 was itself a "found" image, triggered by a painted car which Johns glimpsed on the road.[6]

Of the younger artists coming into public view in the first years of the 1960s, Jim Dine most clearly carried forward the ideas developed by Rauschenberg and Johns. Though critics and gallery-goers may have viewed his early paintings as objective and impersonal presentations of arbitrarily chosen objects, this artist's images were always pregnant with personal meaning: "When I use objects I see them as a vocabulary of feelings," Dine has said.[7] The painted images of clothing which were dominant in his 1962 exhibition at the Martha Jackson/David Anderson Gallery, and which have remained an important part of his repertoire for more than two decades, often stand as surrogate self-portraits. The tools which are often depicted in his paintings, prints, and drawings and which are sometimes physically attached to his paintings recall his childhood

fascination with the stock in his grandfather's hardware store; the tools symbolize the full range of human emotions—some measure, some construct, some are violent, some are delicate instruments of balance.

In his works of the early 1960s Dine's brushy impasto comments with tongue in cheek on the art of the previous generation. Abstract Expressionists had abandoned representation in favor of abstraction, believing depiction of objects to be mere attention to surface, while expressive brushwork and evident process could be truer carriers of a personal and emotional content; the same rapid execution and thick impasto in works such as *Shoe* of 1961 (figure 35) seem to be Dine's way of proposing the reverse—that luscious paint handling may be beautiful surface, but that it is the common object described by that brushwork which carries a private symbolism, mythic presence, and expressive content. With increasing distance from the heyday of Abstract Expressionism, Dine's work has unified the potentials of painterliness and depiction. The figurative form and animated touch of *Blue*, 1980 (plate 67), imbue the trees with an anthropomorphic presence, sufficient to sustain Dine's interest in this subject through a large series of tree paintings. Of another work in the series Dine has said, "There may be a female form lurking in it. If such images do exist in my work it interests me. In fact, such mythological and psychological references, when they appear to me or to others, are wonderful gifts, bonuses."[8]

Along with Dine's solo show, the year 1962 saw debut solo exhibitions of Warhol, Lichtenstein, Rosenquist, Wesselmann, and Indiana—the core group of artists whose work constitutes the truly Pop style. In the same year European and American artists were shown side by side in the "New Realists" exhibition at the Sidney Janis Gallery in New York.

No artist more fully represented the Pop persona than Andy Warhol, rising to superstardom and captivating public attention like the Hollywood stars of his early canvases *Liz, Marilyn,*

and *Elvis.* Like almost all of Warhol's work after the 1962 *Campbell's Soup Cans, Mona Lisa* of 1963 (plate 58) uses a photo-silkscreen process, eliminating the artist's direct touch of paint brush to canvas and substituting instead a process which purports to be objective, detached, neutral. But the work actually agressively asserts the means of its creation, the uneven inking and awkward registration being intentionally visible, and the halftone dots of photo-mechanical reproduction being clearly shown—characteristics typical of Warhol's work. Further, the colors used—black, magenta, yellow, and cyan-blue— are those which the printer uses in four-color printing, and the arrangement of the Mona Lisa images on the canvas intentionally mimics that which might result on a waste sheet of paper used in testing a printed image. The subject of Warhol's *Mona Lisa*, then, is not Leonardo's painting, but rather its reproduction and the way in which our perception of a unique creation is affected by ubiquitous duplication. The related canvas *Thirty Are Better Than One,* with thirty Mona Lisa images, brazenly asserts (and necessarily calls into question) the typically American notion that more is better. While Duchamp's famous burlesquing of the *Mona Lisa* in his *L.H.O.O.Q.* must be seen as anti-art, irreverently mocking the high pretentions of art with base sexual innuendo, Warhol's *Mona Lisa* effects the opposite response by graphically showing how debased the image becomes through pretentious reverence.

Figure 36. Jasper Johns, 1981. Photo: Judy Tomkins.

Similarly, Warhol's *Disaster* paintings—including images of the electric chair, atomic explosions, horrifying car crashes, race riots, and Jacqueline Kennedy at her husband's funeral—are not intended as social commentary on the issues of capital punishment, nuclear war, or civil rights, but rather on the way in which our understanding of something as extreme as violent death is manipulated by constant repetition and by the anesthetizing screen of halftone dots in media images.

Similar concerns are found in the work of Roy Lichtenstein, who, without utilizing the techniques of mass communication, appropriated its style. He adopted as his own the black outlines, Ben Day dots, primary colors, and stylized forms of comic-book illustration and applied that style not only to adaptations of actual comic-book and advertising images, but also to the monuments and styles of art of the past. Speaking of the artistic influences on his work, Lichtenstein has pointed out that in the 1940s and 1950s in Ohio "most of what we saw was in reproduction. Reproduction was really the subject of my work."[9] The objective, mechanized look of Lichtenstein's art is itself a *tour de force* of painting, for unlike Warhol's photo-silkscreen images, this artist's technique is extremely traditional.

Like Warhol's *Disaster* series and his *Mona Lisa,* Lichtenstein's work ironically comments on the effect of ubiquitous reproduction on the genuine experience of emotion. Evoking the format of early Italian altarpieces, the *Eddie Diptych* (1962) presents the melodramatic artificiality which a media-saturated modern world perilously worships as truth. Those who considered such works to be a celebration of the banal missed the point of Lichtenstein's style. The Ben Day dots in his paintings mean "reproduced material, but I think they also may mean the image is ersatz or fake...it's a stamp of not being the real thing."[10] In an important document of the period, G. R. Swenson's interviews in *Art News* entitled "What Is Pop Art?" Lichtenstein pointed out that he was "not really advocating stupidity, international teen-agerism, and terrorism."[11]

Since the mid-1960s Lichtenstein has been superimposing his deceptively objective style onto images from earlier art, working his way successively through Mondrian, Abstract Expressionism, Art Deco, Impressionism, Cubism, Futurism, Surrealism, American Indian art, and German Expressionism. *Cosmology* of 1978 (plate 64) is one of his humorous tributes to Surrealism, incorporating forms and odd juxtapositions which seem to derive from that movement, and also

Figure 37. Jim Dine, 1984. Photo: Nancy Dine.

quoting his own work (for example, the entablature details on the right and the 1964–65 "sunrise" on the left). Such self-reference coupled with repeated male/female contrasts and a less direct use of specific visual sources than in his earlier works has prompted Donald Kuspit to suggest that Lichtenstein's Surrealist paintings are "tragicomic allegories, almost vaudevillian in method, yet pointed in their tension, in the unresolved dialectic of relationship they bespeak—whether it be between man and woman or artist and world," and that they make explicit a concern evident in all his work: "problems of creativity, the myth of the artist's transformation of raw, worldly material into a subjectively expressive image which articulates reality."[12]

James Rosenquist was one of the few Pop artists actually to have come out of an advertising background; he painted storage bins and gasoline tanks in the Midwest from 1952 to 1957, and then billboards in New York until 1960. Hoping to give his painting the same visual impact as advertising images, Rosenquist consciously adopted the colossal scale, intense colors, hard edges, and photographic modeling of billboard advertisements. Bizarre juxtapositions of objects as diverse as jet fighters and Franco-American spaghetti, and odd shifts in scale gave his early work a Surrealist montage quality. This effect has given way in Rosenquist's most recent work, such as *Eau de Monet* of 1985 (plate 61), to the interweaving of seemingly slashed images, in this case two partial faces and vegetation.

Tom Wesselmann not only appropriated the look and technique of advertising, but also the printed advertisements themselves, creating collage still lifes and background settings for his *Great American Nude* series from cut-out portions of subway posters and billboards. The photographic realism, subtly inconsistent perspective, hard edges, and oversized scale of Wesselmann's early collages give them a naïve quality which Wesselmann retained even in the masterfully painted oils which he began producing in the late sixties. From the first of his *Great American Nude* paintings in 1961, Wesselmann's canvases have incorporated a blatant eroticism; his nudes are often painted a single flawlessly smooth and pale color, with only the lips and nipples painted in luscious pinks and reds. The same idea was used in determining the irregular shape of some of his paintings in 1967 and again in the early seventies; the bottom and right edges of *Bedroom Painting No. 28* (plate 59) follow the silhouette of the torso and raised thigh of a reclining nude. Such toying

Figure 38. Roy Lichtenstein, Paris, 1984. Photo: Ulla Wolfender-Josephsson.

103

Figure 39. Andy Warhol. *Silver Disaster*, 1963. Oil and silkscreen on canvas, 42 x 60". (Not in the exhibition.) Collection Michael and Ileana Sonnabend, New York.

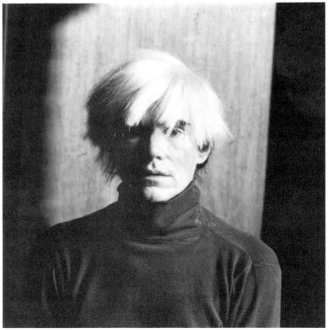

Figure 40. Andy Warhol, 1985. Photo: Richard Leslie Schulman.

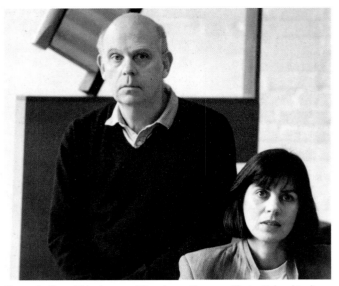

Figure 41. Claes Oldenburg and Coosje van Bruggen. Photo: Richard Leslie Schulman.

with perception of negative and positive shapes gives Wesselmann's canvases new formal properties and suggests that the erogenous is in the mind of the beholder. One of a series of paintings incorporating the nude and bedside paraphernalia, this was a commissioned work and includes the subject's portrait and silhouette along with objects which have become standard Wesselmann motifs—the lotion bottle, the rose, the lamp.[13]

Interest in printed matter took a different form in the work of Ed Ruscha (plate 57). Although his oeuvre includes depictions of buildings and objects, Ruscha's most unusual works are drawings, paintings, and prints of single words or short phrases. These are presented sometimes as trompe l'oeil configurations of spilled liquid or curling ribbons of paper and at other times as straightforward typography. According to the artist, the words are chosen for their appearance, sound, or spelling rather than for their dictionary definition or referential associations.[14] Ruscha echoes Johns's interest in numbers and letters, saying, "Words are the only thing that do not have a recognizable size, so I can operate in the world of no size."[15]

Eschewing legibility, and retaining only a gestural sense of personal handwriting, Cy Twombly's paintings diametrically oppose Ruscha's. In those instances where specific words are legible (usually words relating to ancient history and mythology) they are intended to evoke a host of associational meanings; in those where no words can be read, such as *Nina's Painting* (first version) of 1969-70 (plate 68), the mind still tries to decipher the marks and make visible the palimpsests. It is by this connection with writing that the trace of Twombly's brush or charcoal is set apart from that of the Abstract Expressionists, despite the obvious visual connections.

Among the sculptors of the period, the use of common objects found various manifestations. Perhaps the most direct sculptural use of objects came from the French artist Arman. A close friend and protégé of the artist Yves Klein and the critic Pierre Restany, Arman was a member of the Paris-based New Realists, a group contemporary with the American Pop artists and with similar objectives, but utilizing the material debris of society rather than its slick advertising images. Arman's work in the early 1960s directly connected the life cycle of objects with the range of human emotions. His *accumulations* of like objects raised questions of quantity versus quality (like Warhol's *Mona Lisa*), and his colères (smashed, sliced, and burned objects, including violins, statuettes, and typewriters, glued down in their fragmented state or embedded in polyester resin) demonstrate the connection between objects and emotions. The sight of an armchair being consumed by flames on an Amsterdam trash heap prompted Arman to create *Ulysses' Chair* in 1965, a half-burned chair whose decay seems arrested in a shell of polyester.[16] Only recently did Arman meet a founder capable of casting this "arrested catastrophe" in bronze. Preserved and presented like some Pompeiian relic, *Horizontal Catastrophe* (plate 53) is an ironically elegant sculpture, full of contradictions: the sofa is destroyed by fire, the sculpture born in fire (the molten bronze); the destruction of what appears to be a finely hand-crafted object (but which is in fact reproduction furniture) is expressed only through the most painstaking and complex craftsmanship of the bronze founder; a sculpture which evokes fear of nuclear holocaust (Arman's exhibition of this and similar objects at the Marisa

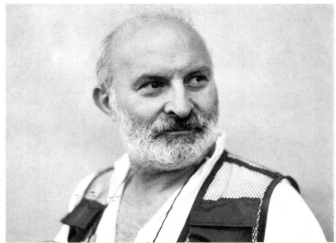

Figure 42. Arman, 1982. Photo: Cinquini.

104

del Re Gallery was entitled *The Day After*) does so through antique forms and classical mediums, rather than through twentieth-century technological images and methods.

Having been a major participant in the Happenings of the previous few years, Claes Oldenburg displayed his painted papier-mâché sculptures of oversized foods in his storefront studio, dubbed The Store, in December 1961 and January 1962. A strong element of humor has always been present in Oldenburg's sculptures, often as a result of absurd changes in scale and through incongruous pairing of object and material (for example, a typewriter rendered in limp vinyl, lettuce leaves in rigid papier-mâché). His drawings for proposed monuments include ideas for skyscraper-scale Good Humor ice-cream bars and baked potatoes for strategic sites in Manhattan, and a mammoth toilet float for the river Thames. While these drawings succeed as a result of exquisite draftsmanship and playful cleverness of concept, Oldenburg's executed large-scale public sculptures have a different character. Works such as the 100-foot-high baseball bat in Chicago, the three-way plug at Oberlin, the billiard balls in Münster, West Germany, and the flashlight in Las Vegas have a clean geometry of form which allies them more closely with the work of Minimalist sculptors than with their object models; they succeed as monumental sculpture rather than as humorous novelty. *Cross Section of a Toothbrush with Paste, in a Cup, on a Sink: Portrait of Coosje's Thinking—Model*, 1982 (plate 65), designed for a site at the University of

Hartford, shows just such a tendency toward the abstract. The "Coosje" in the title is Oldenberg's collaborator since 1976 on large-scale works, Coosje van Bruggen. Oldenburg has written:

> [Coosje] was responsible for the idea of the cross-section which gave the work its special identity. In fact, she has applied to the sculpture her approach to any subject as reflected in her writing style: an analytical approach cutting through a context to reveal the relation of its parts.[17]

The sculpture shows the effect of two parallel blades making a "slice" through the

Figure 43. George Segal in his studio, 1985. Photo: Wendy Worth.

cluster of toothbrush, paste, and cup, as well as the sink on which they are standing. The proposed 23-foot-high work was rejected by the executive committee of the University of Hartford, but has since been permanently installed in front of the Haus Esters in Krefeld, West Germany. Like the form itself, the use of the primary colors red and blue, along with white, calls to mind the aesthetics of Constructivism and the trivialities of American life.

In a somewhat similar vein, Richard Artschwager's sculpture hovers disconcertingly on the border between Pop Art and Minimalism; much of his "furniture" has the character either of chairs and tables reduced to their generic and most anonymous form or of highly rational and mathematical sculptural forms. Reversing the Dada technique of giving high-art status to mass-produced functional objects, Artschwager creates art works which could conceivably serve a utilitarian purpose. The machine-made look of his Formica furniture and the naïveté of the painted pattern on *Flayed Tables*, 1985 (plate 54), are both completely *faux* and once again call forth the oft-cited Pop conflation of art and life.

George Segal's use of common objects—often architectural elements, as in *Blue Girl in Front of Black Door*, 1977 (plate 63)—has been to create a setting for his plaster figures. Alloway has eloquently described the contrast between the rough (almost painterly) white plaster figures of Segal's 1960s work and the objects which surround them, commenting that the "handmade plasters are corporeal presences in an ambiance defined by ready-made objects."[18] Although his work often speaks of the relationship between man and the man-made environment, Segal's sculpture is distinguished from most Pop Art precisely because of its spiritual expressiveness. In the 1960s Segal's figures were created by molding plaster-soaked canvas over a model, and the resulting shell bore features which were less distinct than an actual cast would be, yielding "everyman" rather than portraiture. In the early 1970s Segal changed his technique, now making a cast of the interior of the plaster-bandage shell, yielding an image far more lifelike in its detail; the art historian Sam Hunter has suggested that it was this increased realism of form which prompted Segal to compensate with highly intense and artificial coloration, as in *Blue Girl in Front of Black Door*.[19]

For other sculptors of the period, the connection between the products of society and the products of the artist was not one of imagery or emotional association, but rather one of materials. Underlying one's perception of John Chamberlain's sculpture (plate 51) is the knowledge that its raw material was junked automobile fenders (once destined for the dump but here given second life in the realm of high art). The forms deceptively appear to have been determined by the arbitrary forces of the wrecking ball and metal compactor. In truth, the materials have been "manipulated and re-used, restructured, repainted, sandblasted, fooled around with and carried around for years,"[20] their assemblage a matter of "squeezing and hugging . . . fit and balance."[21] Although the tension thus created between junk materials and elegant or monumental forms parallels the Pop Art issues of art versus life and unique versus mass-produced objects, Chamberlain's work is more appropriately judged by formal criteria, having more aesthetic connection with the paintings of the preceding generation of Abstract Expressionists than with the contemporary painters of Pop images. Chamberlain acknowledges the important influence of de Kooning and Kline, not only in his work's formal characteristics, but also in his working method, which relies on experimentation and intuition rather than premeditation and design.

A similar relationship between found materials and abstract form exists in the sculpture of Mark di Suvero (plate 52). The monumental sculptures which were shown in his first solo exhibition at the Green Gallery in 1960 were constructed of rough, weathered wooden beams, a barrel, heavy rope, and chain; later work incorporated truck and tractor tires, pipes, metal beams, and steel cables. Contrasting with the rugged industrial character of the materials, di Suvero's work shows a delicate and sometimes playful sense of balance; in some works massive elements hang in perfect equilibrium, moving with a push from the wind or offering the spectator a ride on a seat, log, or rope. In the 1970s di Suvero's use of steel I-beams ordered from the mill instead of found in the junkyard accompanied an aesthetic shift away from the gesture of Kline and toward the geometry of Constructivism and its modern progeny, but the contrast between strong materials and perfect balance remained. Unlike other sculptors, who make a small maquette and rely on a fabricator for construction of the actual sculpture, di Suvero has maintained a total involvement in his sculpture: he improvises and designs as he works.

No sculptor has succeeded in incorporating more of the details of everyday life and popular culture in his art than Red Grooms. After partici-

pating briefly in the Happenings of the early 1960s Grooms moved on to produce caricature-like sculptural installations of quotidian subjects, as in *The Discount Store*. In 1974, with the collaboration of his wife, Mimi Gross, and a crew of engineers, electricians, painters, fabric sculptors, and carpenters, Grooms set out to re-create lower Manhattan in his zany but true-to-life style. The project, entitled *Ruckus Manhattan*, comprised the monumental and the mundane—the World Trade Center towers (30 feet high) and a graffiti-filled subway station, the Stock Exchange and alligator-infested sewers. Among the city landmarks represented in *Ruckus Manhattan: Girls, Girls, Girls* (plate 49) was New York's famous 42nd Street, with a wall-size fabric and foam rubber triptych, showing a pair of pimps, a pair of policemen, and a pair of prostitutes, each duo sharing a single pair of legs. The work is a blaze of gaudy colors and patterns, shiny fabrics, alluring signs, and humorous details.

New York's low life has also been a source of images for Richard Lindner. *Hello*, 1966 (plate 60), features a typical Lindner woman—a futuristic savage sex goddess (which one critic called a "Venus in Vinyl"[22]), her telephone an erotic weapon. Born in Hanover, West Germany, in 1901, Lindner grew up in Nuremberg and was in Berlin during 1927–28—"a fantastic city... full of decadence and meanness. It was lurid and perverted and marvelous."[23] In Munich until 1933, and in Paris after that, Lindner had direct contact with Schlemmer, Duchamp, and the Dadaists. "My work is really a reflection of Germany of the '20s... on the other hand, my creative nourishment comes from New York, and the pictures I see in American magazines or on television."[24] With its sources in American popular culture, its poster-like form and color, and its blatant eroticism, Lindner's art naturally rose to prominence during the Pop period. However, it can also be seen as a demonstration of the connections between Pop and previous art styles.

Temporal distance has allowed us to consider more carefully the form and iconography of individual paintings and to place Pop Art in broader social and art-historical contexts. Lichtenstein's 1964 statement has proved true: "Since works of art cannot really be the product of blunted sensibilities, what seems at first to be brash and barbarous turns in time to daring and strength, and the concealed subtleties soon become apparent."[25]

NOTES

1. Robert Rauschenberg, statement in Dorothy C. Miller, ed., *16 Americans* (New York: The Museum of Modern Art, 1959), p. 59.
2. Charles F. Stuckey, "Reading Rauschenberg," *Art in America*, vol. 65 (Mar.–Apr. 1977), pp. 74–84; Kenneth Bendiner, "Robert Rauschenberg's 'Canyon,'" *Arts*, vol. 56 (June 1982), pp. 57–59.
3. Richard Francis, "Jasper Johns," in *Tate Gallery Illustrated Catalogue of Acquisitions, 1980–1982* (London: Tate Gallery, 1984), p. 145.
4. For an analysis of the structure of Johns's cross-hatch paintings and for their relationship to the Dada game "Exquisite Corpse," see Michael Crichton, *Jasper Johns* (New York: Harry N. Abrams and Whitney Museum of American Art, 1977), pp. 59–62.
5. Francis, p. 146.
6. Crichton, p. 59. Johns is quoted as saying: "I was riding in a car, going out to the Hamptons for the weekend, when a car came in the opposite direction. It was covered with these marks, but I only saw it for a moment—then it was gone—just a brief glimpse. But I immediately thought that I would use it for my next painting."
7. Jim Dine, interview with John Gruen, 1966. Quoted in John Gruen, "Jim Dine and the Life of Objects," *Art News*, vol. 76 (Sept. 1977), p. 38.
8. Jim Dine, statement, in Graham Beal et al., *Jim Dine: Five Themes* (New York: Abbeville Press; and Walker Art Center, Minneapolis, 1984), p. 126.
9. Diane Waldman, "Roy Lichtenstein Interviewed," in *Roy Lichtenstein* (New York: Harry N. Abrams, 1972), p. 25.
10. Jeanne Siegel, "Thoughts on the 'Modern' Period," reprinted in John Coplans, ed., *Roy Lichtenstein* (New York and Washington, D.C.: Praeger, 1972), p. 94.
11. G. R. Swenson, "'What Is Pop Art?': Answers from Eight Painters, Part I: Jim Dine, Robert Indiana, Roy Lichtenstein, Andy Warhol," *Art News*, vol. 62 (Nov. 1963), p. 25. Part II of the set of interviews included Stephen Durkee, Jasper Johns, James Rosenquist, and Tom Wesselmann, and was published in the February 1964 issue of *Art News*.
12. Donald Kuspit, "Lichtenstein and the Collective Unconscious of Style," *Art in America*, vol. 67 (May–June 1979), p. 105.
13. Slim Stealingworth [pseudonym of Tom Wesselmann], *Tom Wesselmann* (New York: Abbeville Press, 1980), p. 66.
14. David Bourdon, "A Heap of Words about Ed Ruscha," *Art International*, vol. 15 (Nov. 1971), p. 25.
15. Ibid.
16. Sam Hunter, "Arman's Apocalypse," in *Arman: The Day After* (New York: Marisa del Re Gallery, 1984).
17. *Claes Oldenburg* (Krefeld: Kaiser Wilhelm Museum, 1985).
18. Lawrence Alloway, "George Segal," *The Nation* (June 8, 1970), reprinted in Alloway, *Topics in American Art Since 1945* (New York: W. W. Norton, 1975), p. 183.
19. Sam Hunter, "George Segal's *Blue Girl on Park Bench*," *Art News*, vol. 80 (Summer 1981), p. 137.
20. Michael Auping, "An Interview with John Chamberlain," in *John Chamberlain: Reliefs, 1960–1982* (Sarasota: John and Mable Ringling Museum of Art, 1983), p. 18.
21. "Excerpts from a Conversation Between Elizabeth C. Baker, John Chamberlain, Don Judd, and Diane Waldman," in Diane Waldman, *John Chamberlain* (New York: The Solomon R. Guggenheim Museum, 1971), p. 17.
22. John Perreault, "Venus in Vinyl," *Art News*, Jan. 1967.
23. Dore Ashton, *Richard Lindner* (New York: Harry N. Abrams, 1978), p. 76.
24. Ibid., p. 77.
25. Roy Lichtenstein, address at the College Art Association annual meeting, Philadelphia, Jan. 1964, reprinted in Ellen Johnson, ed., *American Artists on Art from 1940 to 1980* (New York: Harper & Row, 1982), p. 103.

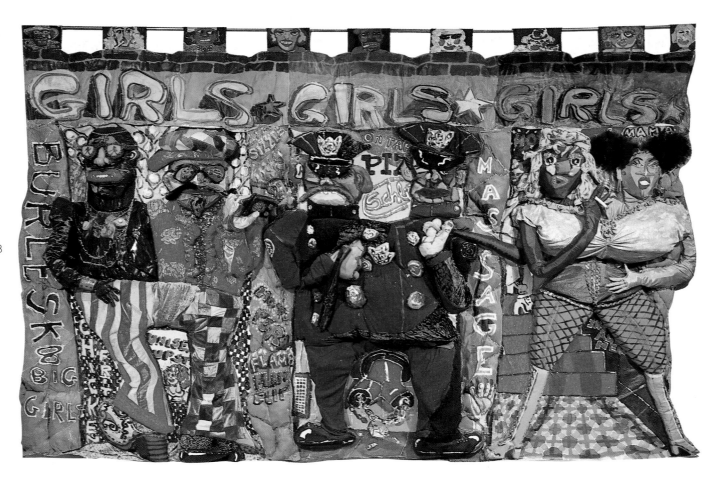

Plate 49
Red Grooms
Ruckus Manhattan: Girls, Girls, Girls, 1976.
Mixed mediums, canvas, fabric, 120 x 168½".
Marlborough Gallery, New York.

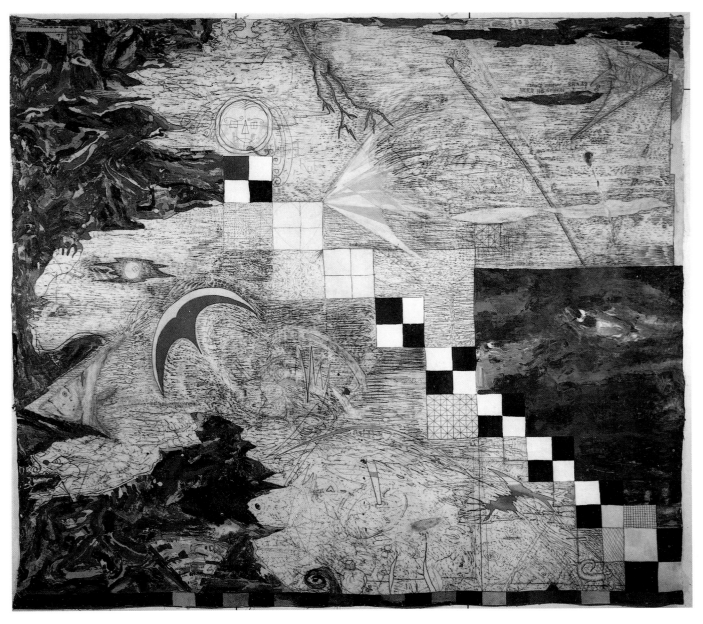

PLATE 50
William Wiley
Imp Your Deck Oration on the Level, 1983.
Acrylic and charcoal on canvas, 96 x 108½".
Collection Harvey and Judy Gushner, Philadelphia.

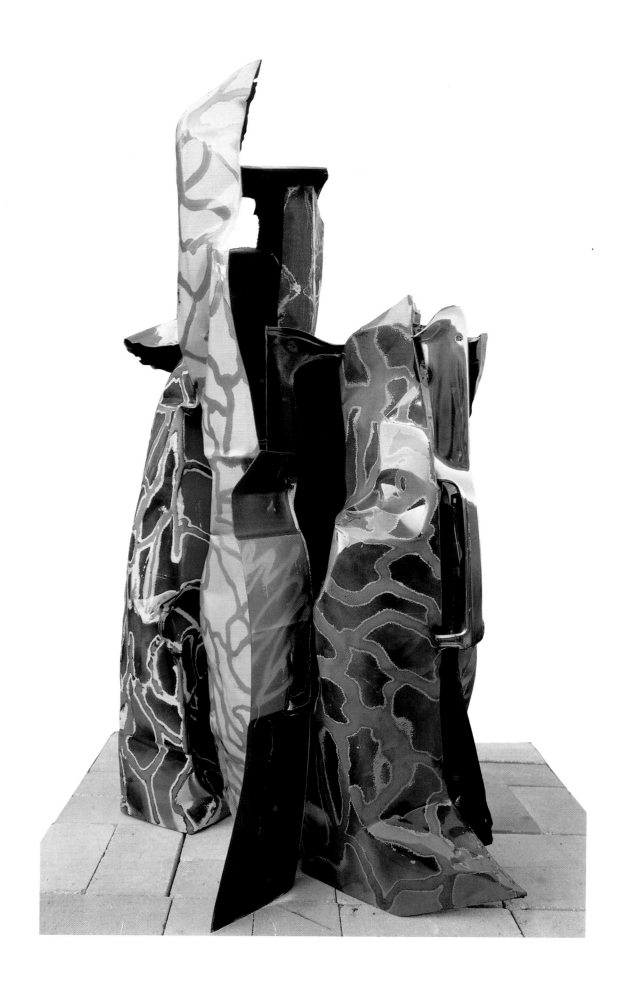

left

Plate 51
John Chamberlain
Lorelei's Passion, 1982.
Painted and chromium-plated steel, 84 x 60 x 35".
Xavier Fourcade Gallery, New York.

Plate 52
Mark di Suvero
Untitled, 1980–83.
Steel and stainless steel, 63½ x 64 x 59¾".
Oil and Steel Gallery, New York.

PLATE 53
Arman
Horizontal Catastrophe, 1982.
Burned sofa cast in bronze, 39¾ x 55 x 26".
Marisa del Re Gallery, New York.

right
PLATE 54
Richard Artschwager
Flayed Tables, 1985.
Polychrome on wood (open), 123 x 52½ x 18¼".
Collection Suzanne and Howard Feldman, New York.

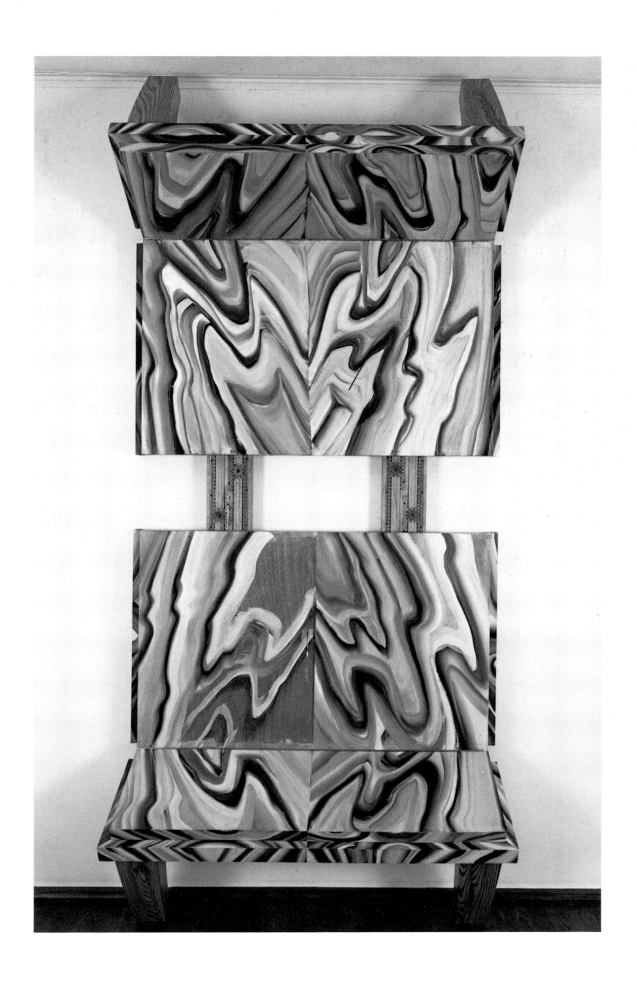

114

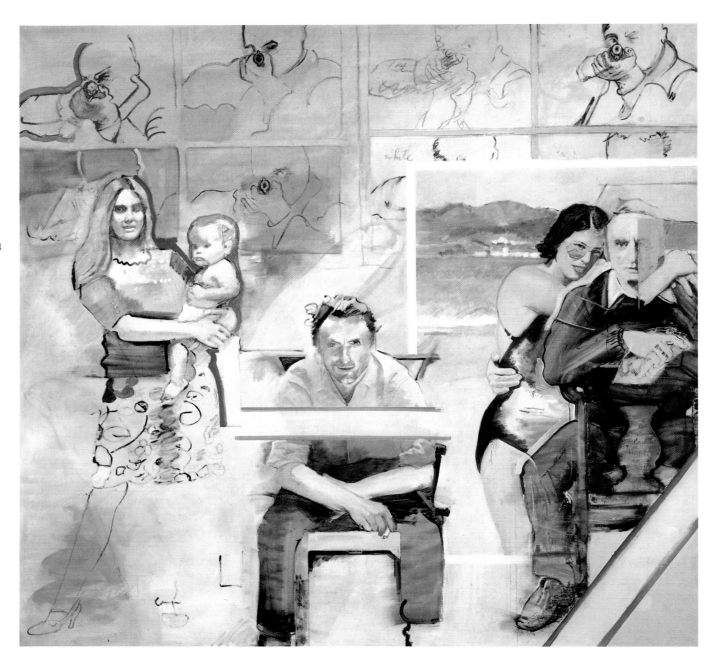

PLATE 55
Larry Rivers
The Continuing Interest in Abstract Art: Now and Then, 1981.
Acrylic on canvas, 76⅛ x 80½".
Marlborough Gallery, New York.

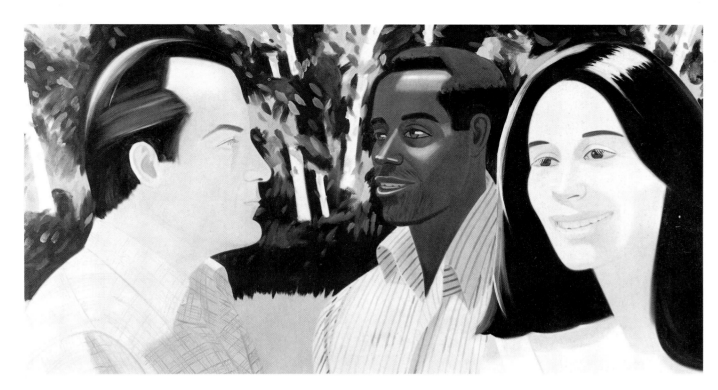

Plate 56
Alex Katz
Lawn Party, 1977.
Oil on canvas, 78 x 144".
Marlborough Gallery, New York.

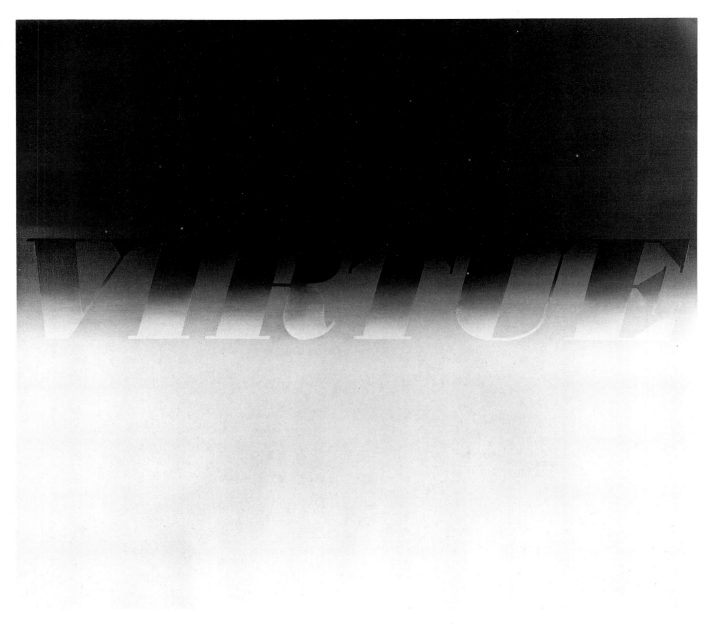

PLATE 57
Ed Ruscha
Virtue, 1973.
Oil on canvas, 54⅛ x 60".
Leo Castelli Gallery, New York.

right
PLATE 58
Andy Warhol
Mona Lisa, 1963.
Acrylic and silkscreen enamel on canvas, 128 x 82".
Blum-Helman Gallery, New York.

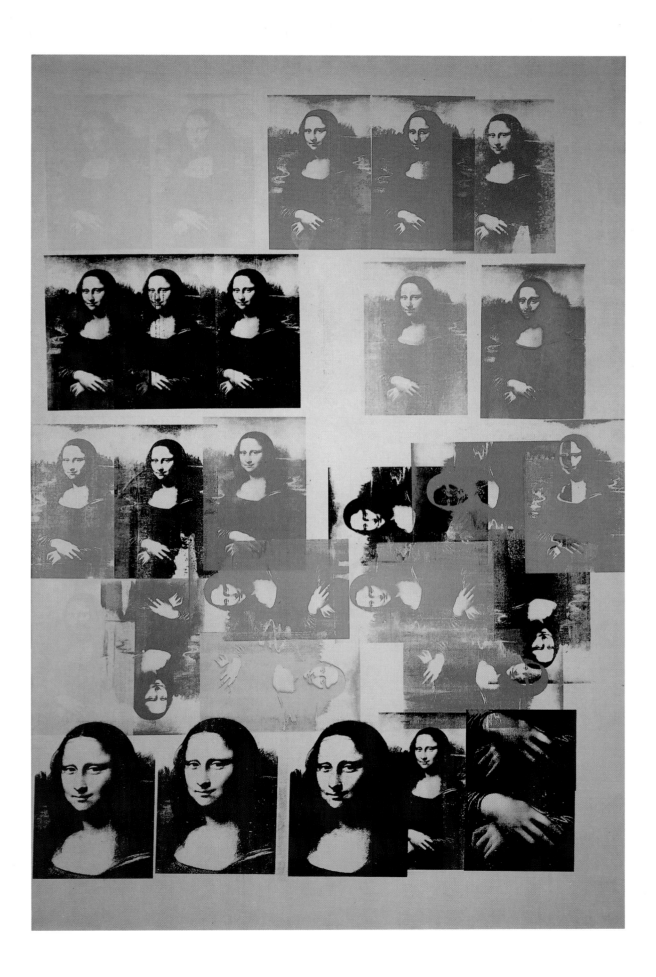

118

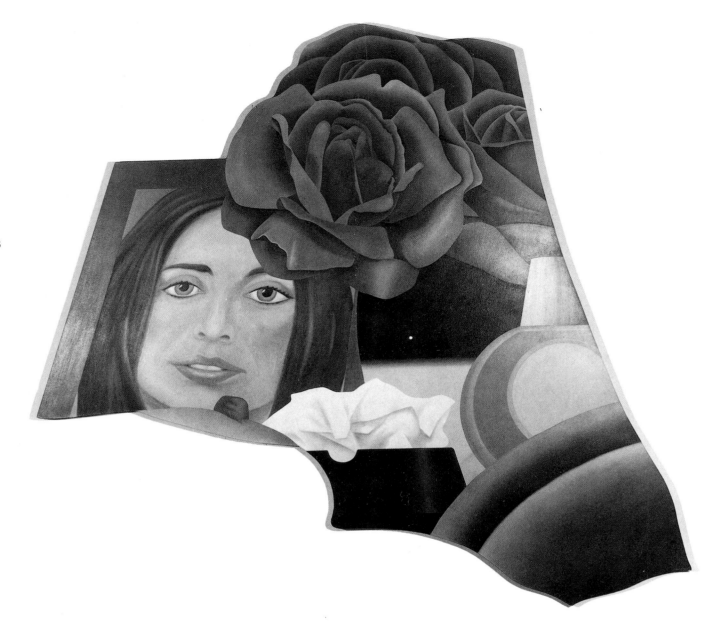

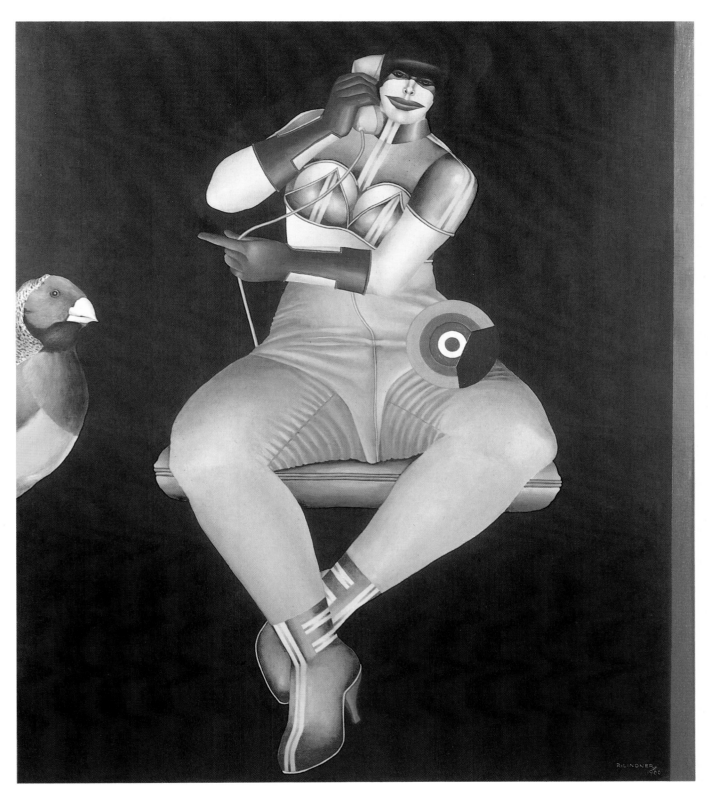

PLATE 60
Richard Lindner
Hello, 1966.
Oil on canvas, 70 x 60".
The Abrams Family Collection, New York.

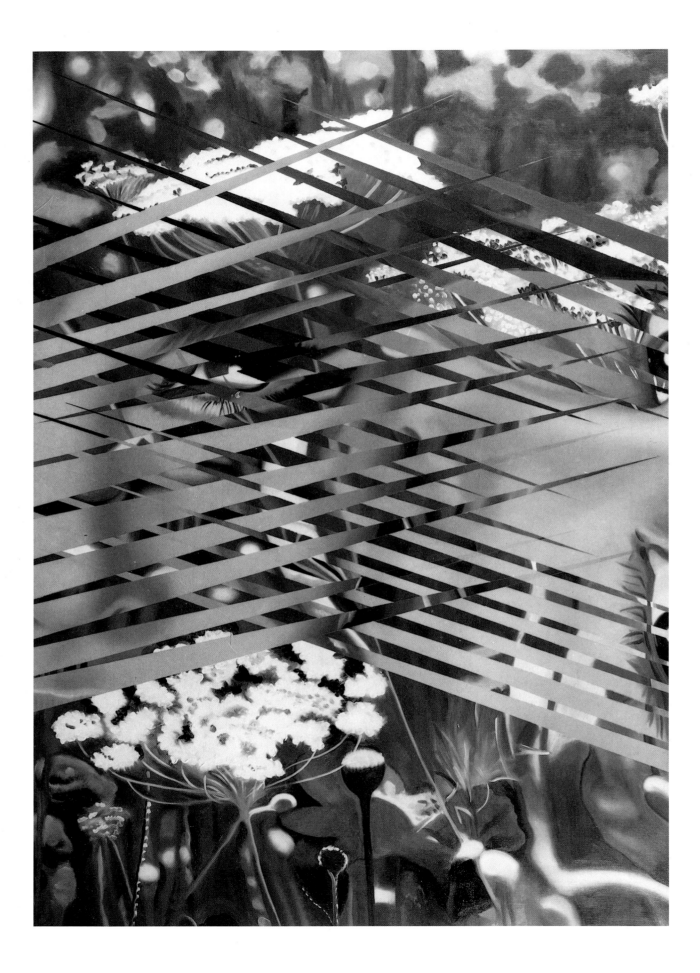

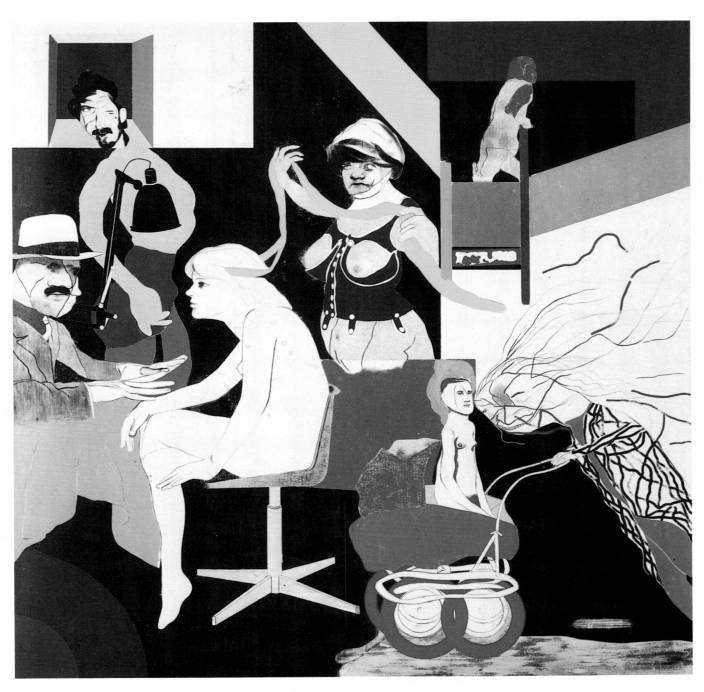

left

PLATE 61
James Rosenquist
Eau de Monet, 1985.
Oil on canvas, 78 x 54".
Mr. and Mrs. Martin Bucksbaum, Des Moines.

PLATE 62
R. B. Kitaj
The Ohio Gang, 1964.
Oil and crayon on canvas, 72⅛ x 72¼".
The Museum of Modern Art, New York, Philip Johnson Fund, 1965.

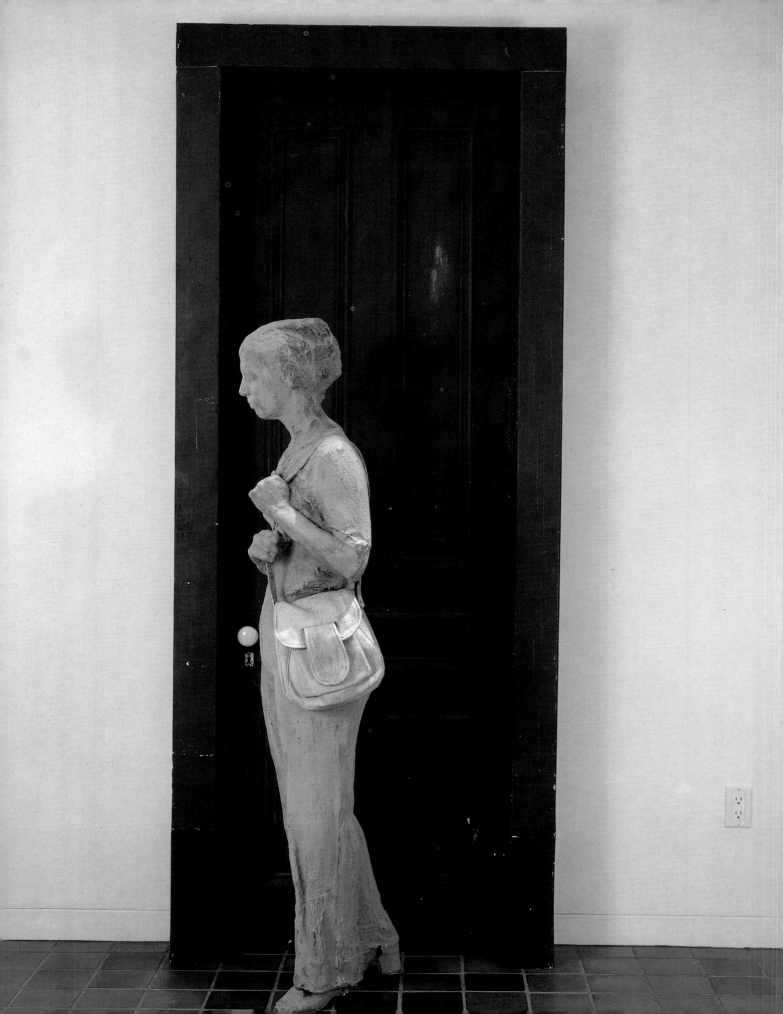

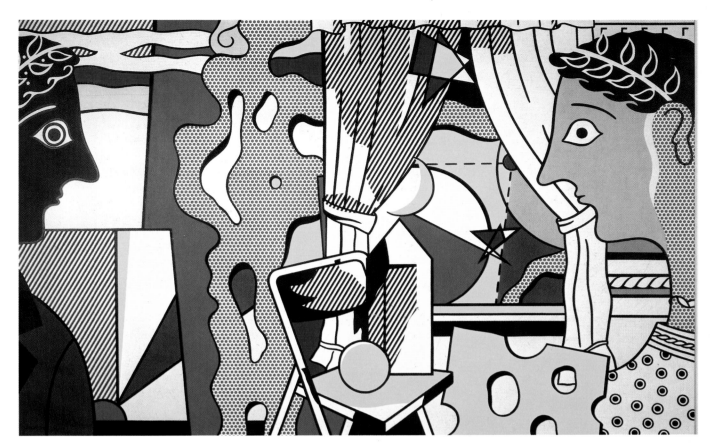

left

PLATE 63
George Segal
Blue Girl in Front of Black Door, 1977.
Painted plaster with wood and metal, 98 x 39 x 32".
Collection Leonard and Gloria Luria, Miami.

PLATE 64
Roy Lichtenstein
Cosmology, 1978.
Oil and magna on canvas, 107 x 167".
Private collection, New York.

PLATE 65
Claes Oldenburg and **Coosje van Bruggen**
*Cross Section of a Toothbrush with Paste, in a Cup, on a Sink: Portrait of
Coosje's Thinking—Model,* 1982.
Aluminum, painted with acrylic, 134¼ x 54¼ x 15⅛".
Leo Castelli Gallery, New York.

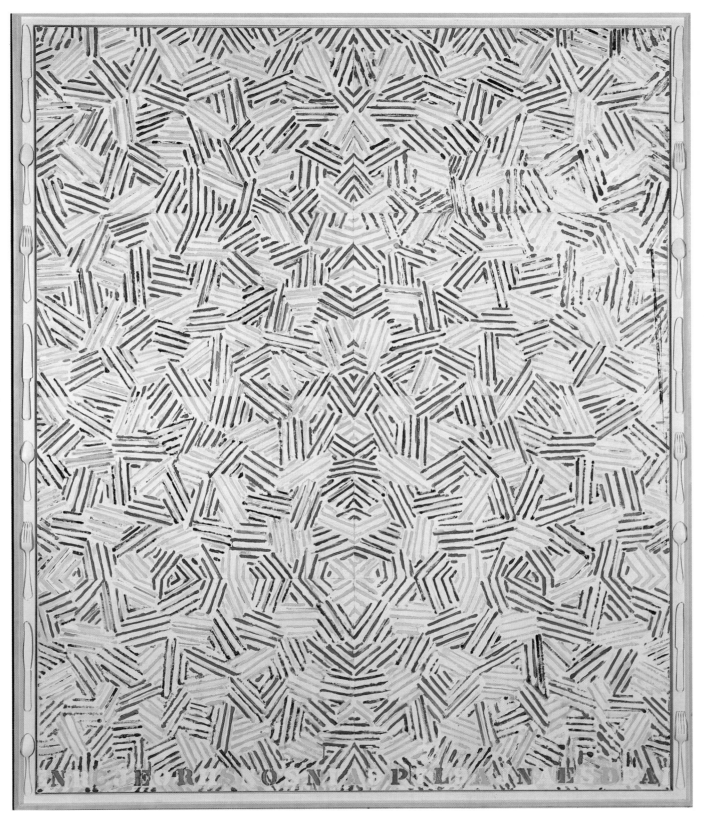

PLATE 66
Jasper Johns
Dancers on a Plane, 1979.
Oil on canvas with objects, 77⅞ x 64".
Private collection, New York.

PLATE 67
Jim Dine
Blue, 1980.
Oil on canvas, three panels, overall size 80 x 96".
The Pace Gallery, New York.

PLATE 68
Cy Twombly
Nina's Painting (first version), 1969–70.
Oil and graphite on canvas, 98½ x 118".
Collection Martin Z. Margulies, Miami.

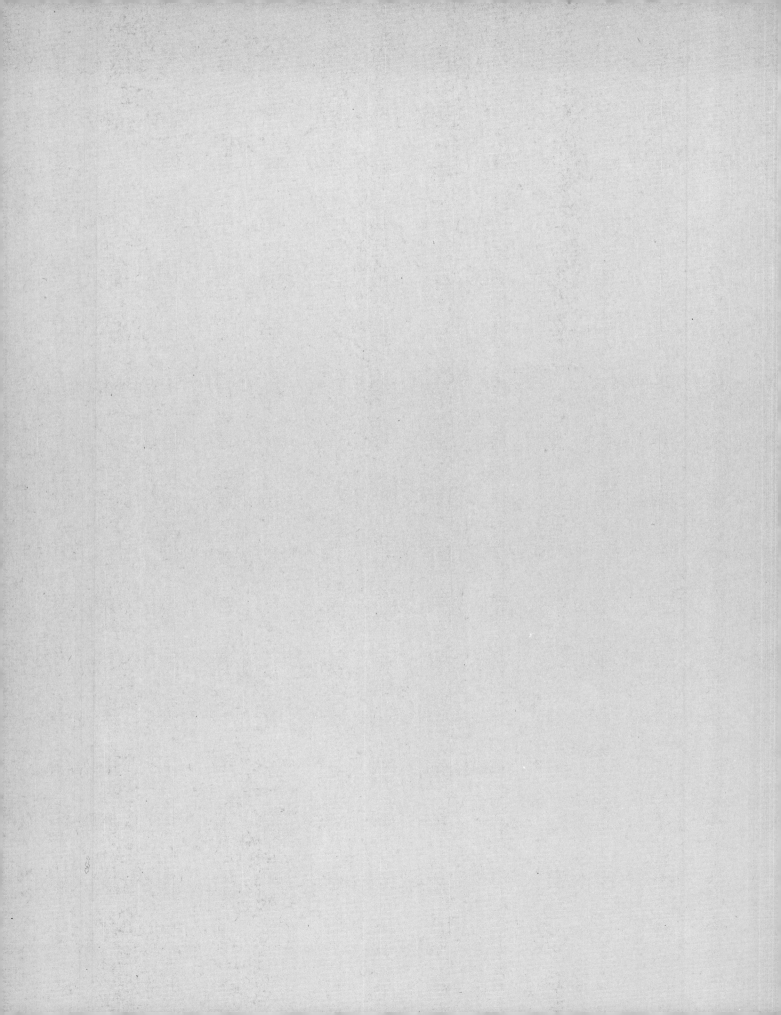

V
RETURN TO REALISM

Richard Sarnoff

Painting

William Beckman
Chuck Close
Richard Estes
Audrey Flack
Edward Hopper
Alfred Leslie
Philip Pearlstein
Neil Welliver

Sculpture

John Ahearn
Duane Hanson

One of the notable features of recent art is the renewed interest in figurative imagery, narrative content, and illusionistic space. The return of representation among avant-garde artists has prompted a general reevaluation of realism, so much so that even the academic realists of the late nineteenth century are enjoying a revival. This reevaluation of realism has brought realist painting and sculpture of the 1960s and 1970s, a period of relative critical neglect, into sharper focus.

For the first time since abstract art became a dominating concern, beginning with Cubism, painting and sculpture have progressed as much through the elaboration and extension of representational principles as through abstract formal interests. Realism and abstraction also no longer coexist in a dialectic of opposition. An examination of recent developments in representational painting and sculpture, however, yields an important framework from which to view contemporary art. At the same time, such a survey also offers the kinds of challenging insights and perceptual rewards we have become accustomed to in studying the abstract art of this century.

The American artist most closely associated with the realist tradition since 1920 has been Edward Hopper (1882–1967). In his paintings familiar settings reveal a profound, melancholy significance. Instead of choosing to depict the dramatic scenes of his realist predecessors in the eighteenth- or the late-nineteenth-century traditions, Hopper painted quiet views of ordinary American life with an intuitive voyeurism—a life observed in offices, homes, restaurants, and service stations. Yet his paintings approach the margins of poetic vision. He is as much a romantic as a realist in his depiction of the American scene.

We recognize Hopper's isolated figures as American loners despite (or, perhaps, because of) their stolid bearing and impassivity; even without human beings, Hopper's scenes can evoke the human presence. Particularly in his early work, Hopper subtly modulated the play between frontality and depth, and his masterful evocations of light and shadow give a special visionary cast to all forms. He is a poet of the void, and transmits a sense of emptiness which we all seem to feel when confronting the inescapable reality of a culture whose technological prowess is matched by the depersonalized individual beings who make the technology giant perform so efficiently. Hopper manages to describe the surfaces of American life with a stark, remorseless objectivity, and he characterizes its inner life with an equally potent, subjective honesty. On occasion, he has also created moods of sexual tension, evident in the barely visible configuration of the nude statuary in *August in the City*, 1945 (plate 70), which contrasts with the commonplace, desensualized externals of the rather dispiriting scene.

Hopper's long and consistent career continued and extended the American scene realism introduced in 1908 by the so-called Ash Can School despite the purges of modernism during the twenties. Realism later persisted in a variety of forms even in the heyday of Abstract Expressionism and Minimalism. Then, the 1960s saw its undeniable resurgence and reaffirmation in the recognizable commercial images of Pop Art. Although these images tended to be flat and standardized, inspired in most instances by consumer media or the ideographic emblems of popular culture, serious social themes and a methodical depictive technique made their way back into the mainstream of contemporary art. The artists considered in this chapter go much further toward a fully representational art, working diversely from a variety of models including life casts, urban scenes and photographs, and nature. Many of the artists began their serious realist explorations in the 1950s, and continued to pursue this alternative despite the prevailing critical emphasis upon purist and formalist values and abstract styles through the 1960s and even into the early 1970s.

The wide range of expression that contemporary realist, or representational, art has attained can be gauged by the work of nine selected artists of different temperaments and inclinations: Philip Pearlstein, William Beckman, Neil Welliver, Alfred Leslie, Richard Estes, Audrey Flack, Chuck Close, Duane Hanson, and John Ahearn.

Philip Pearlstein has been painting in a unique representational style for twenty-five years, first from nature and then from models in his studio. Actually, he considers the formal organization of his painting strictly in terms of abstract principles rather than representation: "It's the kind of structure that is not so different from the structure I read in the paintings of, say, de Kooning and Kline; just the way the forms move across the surface.... It's just the clash of the axes that the picture structure is based on—diagonal, opposing movements. And I translate that directly into the movement of the figure, how the models are posed, how they move against the pieces of furniture."[1]

Pearlstein's paintings, exemplified by *Two Nudes, Bamboo, and Linoleum*, 1984 (plate 78),

are complex figurative compositions. The formal qualities of the subjects are articulated with such remorseless precision that any consideration of the psychology of the sitter or the sensuous nature of the human form either pales or is deliberately aborted by cutting off the figures' visages. Many critics have misunderstood his work as deliberately portraying bloodless human beings, or clinical specimens—plastic automatons conveying a social commentary of alienation. Actually, Pearlstein paints desensualized figures because his studied perceptual detachment enhances the formal play and striking compositional structures that are central to his work.

His abrupt pictorial cropping, often of his gaunt figures' heads, provides a clue to the meaning of Pearlstein's art. He forces the viewer to concentrate on his painted figures as elements in a composition, not as unique living beings with distinctive personalities. Although physiology, attitude, and gesture may hint at their craggy characters, Pearlstein basically envisions his nudes as visual data to be composed into aesthetic configurations along with the structural forces of furniture and the rug and floor patterns.

Only through close and repeated viewing can the subtlety of Pearlstein's work become apparent. Once the viscerally disturbing aspect of a depersonalized model has been dispelled, the dynamic activity of the space and form become apparent. Slightly out of balance and from oblique perspectival angles, space takes on a Cubist orientation within a three-dimensional representation, sometimes seeming to cross the aesthetic barrier into the viewer's space. Tiny distortions in foreshortening and masterful framing heighten the overall transformation of the studio scene into Pearlstein's personal vision. With his terse language of realism Pearlstein manages to express inexhaustible variations of structural arrangement. His work thereby bridges, with power and vivacity, pure formal concerns and the exigent demands of an intense representational reality.

William Beckman provides a striking contrast to Pearlstein's rigorous stylized representation. Beckman handles his portraits and landscapes with the delicacy and sensuousness of a Venetian Renaissance master. His realism borders on the photographic in its nuanced surfaces and softened edges, yet Beckman paints only with a T-square. The flawless modeling, articulation of form, and delicate atmosphere give full play to the personality of the sitter, or the mood of the landscape, without sacrificing photographically minute detail. A sense of rightness and harmony pervades his landscapes just as surely as a physical and psychological presence characterizes the portrait subject. Beckman's subtly brilliant and brutally candid nude, *Diana* IV, 1981 (plate 77), offers the eye an exquisite delicacy of touch within the aesthetic conventions of traditional realist painting reminiscent of the great masters of Northern European Renaissance painting.

Neil Welliver paints almost exclusively from nature. Forests and streams at close quarters are his recent obsessive subject matter, and he paints them in a loose, almost impressionistic manner, suggesting an earlier apprenticeship in the de Kooning manner. He captures the immediacy of a forest glimpse as well as the enduring, pellucid light of Northern Maine. In the haunting *Final Venus*, 1984 (plate 72), a dense web of fallen and standing timber, the rocks, and the water provide an endless play of light, shade, and reflection, and, at a distance, a brilliant pink clearing in an opening has the symbolist, even spiritual, resonance of Caspar David Friedrich's romantic landscapes. Whereas Beckman perceives nature fastidiously, compulsively attached to detail, Welliver observes it directly, with an air of romantic embellishment. Welliver's unusual painting technique requires him to cover the canvas from top to bottom, registering so much vertical progress day by day. There are no preliminary sketches of the overall composition. He feels himself in deep and empathetic touch with his chosen scenes, revealing elemental forces through the specific sites he chooses to paint repeatedly, and, indeed, he has been known to focus for years on particular locations in the quest of their elusive *genius loci*.

Alfred Leslie shares Pearlstein's interest in the creation of unidealized, even brutal human figures, but Leslie's approach differs strongly in his injection of narrative content into his work. Leslie began his career as a most promising second-generation Abstract Expressionist, but soon began

Figure 44. Chuck Close at work in his New York studio, 1977. Photo: Heidi Faith Katz.

131

to experiment with loosely painted self-portraits, as early as 1960: "The adversarial position of 20th-century painting, which is what attracted me in 1946, seemed to have disappeared by 1960. And it seemed to me that within a framework of figuration, there was a way to renew painting."[2]

Confronting the tragic loss of his studio, which burned down in 1966, Leslie reevaluated his stylistic commitments and shifted abruptly to a crisp representational style. His compositions and theatrically illuminated pictorial effects are drawn freely from the history of art, and obviously rely most strongly on the conventions of Mannerist portraiture, Caravaggio, and the Spanish Baroque. Yet his subject matter remains startlingly contemporary, despite its clear historical sources. *Birthday for Ethel Moore,* 1976 (plate 73), combines old-master authority with an eclectic painterly talent to produce a work of haunting psychological intensity.

Leslie's art can be seen as an avant-garde variation on traditional genre painting, deliberately monumentalized. Once a filmmaker, Leslie blended his interest in the social narrative of the movie camera with his love of painterly virtuosity: "It was a matter of my trying to find subjects that were generally discredited...to take them and try to find truth in those subjects. I think there are truths in old people, truths to be seen in babies, nursing mothers, children and family life." [3]

Leslie successfully captures both the drama and ennui of contemporary life in unnaturally vivid images which often have a wrenching impact on the viewer. Their precision of form and almost photographic verisimilitude tend to obscure the bold massing of forms and a strong emotive impact. While Eric Fischl (plate 137) has explored sexual innuendo in his own unique manner, one senses that the complex interaction of Leslie's figure groupings may have provided some psychological hints for the younger artist.

The paintings of Pearlstein, Beckman, Welliver, and Leslie are realized through the direct observation of their subject matter. Other contemporary realists base their paintings on photographic sources without discernible aesthetic transformation, and they have been labeled Photo-Realists. In the 1970s, Photo-Realism achieved the status of a movement, with many practitioners as well as a fund of critical literature. The Photo-Realist style involves considerations of both technique and content. Paintings are derived from blown-up photographs registered photomechanically on stretched canvas by an opaque projector. These vague images are then meticulously transferred to the canvas, with an airbrush, to produce the shiny flat surface and the look which we associate with photographic prints on emulsified paper. Subjects have tended to be drawn from images of popular culture or an obsessive personal mythology—a potpourri of

Figure 45. Richard Estes in his studio, 1984. Courtesy Louis K. Meisel Gallery.

motorcycles, diners, candy bars, automobiles, neon signs, urban vistas vacant of human presence, symbolist *vanitas* still life, among others.

This literal, *trompe l'oeil* painting technique can be understood as an extension of Pop Art, reflecting the latter artists' concern for commercial icons and standardized surfaces as much as it mirrors the photographic reality to which it is more familiarly ascribed. Photo-Realism shows a similar sensitivity to the ubiquitous advertising media of our society, but it lacks the social irony or commentary, or even tragic themes, associated with Pop Art. Instead, images are presented for their inherent sensuous or allusive qualities, in stunning detail but without overt commentary. Although recently criticized as a somewhat empty style, Photo-Realism has facilitated a cross-fertilization between photography and painting. This dialogue plays an important role in today's art, and can be clearly seen in latter-day variations by such contemporary artists as Robert Longo, Jack Goldstein, Troy Brauntuch, and Cindy Sherman. In addition, there are a few Photo-Realist artists who have transcended any consideration of a group style.

Richard Estes had his first exhibition in 1963, after ten years of solitary painting. His work soon received wide attention and acclaim, which has not dissipated. His flawless technique combines the rigor of Photo-Realist transcription with the compositional and depictive skill of an intuitive painter (plate 72). The cityscape is Estes's primary subject, and it comes alive as never before—even though the artist prefers to work in rural Maine. He photographs a particular scene from a number of different angles and exposures, then painstakingly paints the scene in his studio using his various photographs as sources—subtly altering them, however, and recombining elements of the scene as he sees fit.

Compelled in his youth to work in a very small studio, Estes began to use photographs as his major visual source, and from them he surprisingly produced vast, wide-angle expanses of illusionistic space. Like a contemporary Canaletto he makes visible a scene so broad that the eye can hardly take it in, even peripherally. The distortions of peripheral vision disappear, however, in the sparkling clarity of every shining detail. He revels in the play of reflections—glass buildings, shop windows, and metallic surfaces which activate his glittering spaces more intensely than a single vantage point or fixed lens could possibly do. His carefully plotted perspectives and geometries call attention to the minute elements of the scene, all painted with equal emphasis, rather than to any particular focal point, and the multiple perspectives and deliberate ambiguities confer on his clinical precision a mysterious and often confusing multiplicity of densely layered visual detail.

Estes does not concentrate on figures. In fact, his cityscapes rarely have any noticeable

133

Figure 46. Audrey Flack with the painting *Baba*, 1984. Courtesy Louis K. Meisel Gallery.

human presence at all: "When you add figures, then people start relating to them, and it's an emotional relationship. The painting becomes literal, whereas without the figure it's more purely a visual experience."[4] Recent scientific inquiry has shown that humans do not "see" without the cognitive processes of identification and understanding going on concurrently. Estes seems to attenuate or deny this intellectual/visual coherence in his work. He can coax scenes of beauty from such unlikely sources as escalators and theatrical marquees, not because of the quasi-photographic rendition of the scene, but precisely because of his clarity of vision.

Unlike Estes, Chuck Close paints portraits with the direct aid of the camera. His gigantic frontal faces are rendered myopically, and in such high detail that individual pores and facial hairs can often be discerned. Lately he has used a room-sized camera housed at the Museum of Fine Arts in Boston to achieve a sharper focus and heightened contrast. The faces are enlarged from a gridded photograph, either monochrome or full color. Close creates his color portraits with a four-color overlapping process akin to offset printing, except that he makes each mark separately with an airbrush. This extremely time-consuming process results in monumental images with an extraordinary impact, since they can be viewed only intimately, at a relatively close distance.

The faces are so large and so detailed that they yield only abstract marks when observed closely. The process by which the image is made—thousands of separate, uniform marks—overshadows the representational content. *Phil* of 1983 (plate 75) becomes a processed abstraction of a particular face rather than a psychologically significant portrait of Philip Glass, the composer. Close's portraits are executed with such exactitude that, paradoxically, they become depersonalized abstractions. His vision is atomic—reality is revealed composed of tiny, uniform particles. Close has commented about his transformation of the face: "It's an intimate experience made large, or a large image filled with intimate information. What I wanted to do was make a very large, aggressive, confrontational image which would grab your attention at fifty feet and then suck you in to the point where at normal viewing distance you would scan the image for the larger relationships and experience up close the kind of intimate experience from tiny little pieces and the relationship among minutiae."[5]

Close has also explored variations of the process of photo-transferred portraiture, some-times leaving the execution of the image incomplete, and other times substituting different kinds of visual data for the airbrushed mark. In *Phil* he used paper pulp chips, closely scaled in tonal value, to serve as marks in depicting the black-and-white face. Close puts the same image, the same photographic source, through many processes and personally devised systems—airbrush painting, lithography, paper drawing, fingerprint marking, paper pulp. The shifts in process determine how the image is perceived, overshadowing the nature of the original source. His fascination with process allies him with various Minimal and Conceptual artists, even such radically different figures as Carl Andre and Sol LeWitt, for whom repetition and procedure are also of crucial importance, however.

Far from the cool clarity of Estes and the monumental atomism of Close we find the intimate paintings of Audrey Flack. She executes her complex narrative tableaux in hot colors, often leaving portions out of focus to reinforce a vague, romantic atmosphere. She paints exotic still lifes crowded with flowers, fruit, and ornaments of various kinds. Often, as in *Invocation* of 1982 (plate 74), the objects are associated with a theme such as gambling, women's toilette, or contemporary social commentary, including a powerful interpretation of the holocaust. The *vanitas* theme, of course, was a popular seventeenth-century obsession for painters, a visual reminder of mortal transience.

Flack has described her fascination with that particular theme: "I approve of sentiment, nostalgia, and emotion (three heretical words for modernism). I collect Spanish Baroque 'passion' art. I use *vanitas* symbols in order to increase communication on both conscious and subconscious levels."[6] She considers recognition of and emotional reaction to objects in a painting to be of paramount importance. The compositions are not unconsidered or hedonistic accretions of objects placed in a pleasing aesthetic arrangement. Rather, they are symbolic and carefully deliberated clusters of forms, where each has a specific meaning and reference.

Some can be recognized as pertaining to femininity—perfume, lipstick, beads, and jewelry—but everything has a sensual pleasure in both the nature of the object and its manner of painting: "An apple is never red enough, nor a sky blue enough,"[7] Flack has written. Sharp focus in some passages, blurring in others, and prismatic highlights in still others lift Flack's work from the neutrality of photographic transcription onto

another expressive level reflecting her passion and ecstasy in the act of painting.

Sculptors have approached the limits of representation through the technique of life casting. Two such sculptors are Duane Hanson and John Ahearn. Existing in three dimensions, their figures are often mistaken for living human beings. Life casts, of course, were pioneered by George Segal (plate 63), who molded plaster over his figures and often placed the white casts in realistic environments. His sculpture spoke directly to our sense of modern rootlessness and alienation, with an effect both humbling and chilling. Hanson and Ahearn have moved further, toward another kind of realism, by using a thin polyester fiberglass cast, which is then clothed and painted. Both sculptors create figures with expressions and poses that absolutely pinpoint character.

Trained in painting, Ahearn switched to filmmaking, and then became interested in casting techniques while creating monster faces for horror movies. His first experiments in this sculptural process retain some of the rhetoric and drama of the theater, but then he became involved with a specific neighborhood in the south Bronx, which is economically disadvantaged and has a large black and Hispanic population. Ahearn, an Irishman by origin, often working in collaboration with Rigoberto Torres, has since primarily drawn on subjects from this community—among these, the powerful, manly *Pedro*, 1984 (plate 76).

Ahearn's ongoing interaction with the Bronx community and his execution of a few public commissions have given the artist an "alternative" audience. The very people he casts have come to take pride in his art, and he has become something of a hero in the community. Ahearn's figures, often cut off at the waist, seem to grow playfully from the wall or the ground. Like alternative fashion models, the figures from the south Bronx radiate popular style and energy.

Ahearn's buoyancy contrasts strongly with the figures of Duane Hanson. Hanson, in the late 1960s, began producing figures with overt sociopolitical overtones—riot scenes, motorcycle accident victims, and the familiar American drum majorettes and football players. Soon he began to search for the true America, capturing housewives and workers in a "frozen moment." The melancholia which often characterizes Hanson's sculptural people, even his autobiographical *Self-Portrait with Model*, 1979 (plate 69), is intentional: "I think I must be a romantic, but we have to deal with the harsh reality of our industrial society. I'm interested in the tragic side of life."[8]

Hanson portrays people belonging to various economic groups, at various ages. As he concentrates on the skin, clothes, and other elements of external appearance, we observe another person intensively, more closely than we would dare look at a stranger. This forces us to be cognizant of the dehumanizing practice of type casting, which we go through individually and as a society. Hanson's work speaks to us so directly not because we see ourselves in it, but rather because we come to understand how we see other people, through stereotypical social models. The sculptures of Ahearn and Hanson approach reality so closely that the very fact that they are separate from reality becomes an edgy signifier of meaning.

The nine realist artists illustrated in this essay have contributed through their personal vision, not through their adherence to any standards of a preordained or stereotyped realism. The dialectic of realism and abstraction is finally falling away. After all, Mondrian, the ultimate abstract painter, wished to be understood as an artist who represented nature—not the visual appearance of nature but the forces underlying it. While de Kooning is considered the Abstract Expressionist *par excellence*, much of his work is based on the human figure. How do we view the recent work of Neo-Expressionism? Is it primarily abstract or representational? The language of painting and the language of sculpture now encompass both the representational and the abstract—that is, an imagery that is formally astute, and an abstraction that veers toward metaphor and symbolism. They can work separately or together in furthering personal expression, depending less on rigid theory or on canonical strictures than upon personal aesthetic choices.

135

NOTES

1. Philip Pearlstein, in Mark Strand, ed., *Art of the Real* (New York: Clarkson N. Potter, 1983), p. 96.
2. Alfred Leslie, interview with Stephen Westfall in *Art in America*, June 1985, p. 112.
3. Alfred Leslie, in John Arthur, *Realism-Photorealism* (Tulsa: Southwestern Art Association, 1980), p. 12.
4. Richard Estes, in *Richard Estes: The Urban Landscape* (Boston: Museum of Fine Arts, 1978), p. 22.
5. Chuck Close, in Kelly Wise, ed., *Portrait: Theory—Chuck Close* (New York: Lustrum Press, 1981), p. 28.
6. *Audrey Flack on Painting* (New York: Harry N. Abrams, 1981), p. 77.
7. Ibid., p. 28.
8. John Ahearn, in *Time*, Feb. 20, 1978, p. 2.

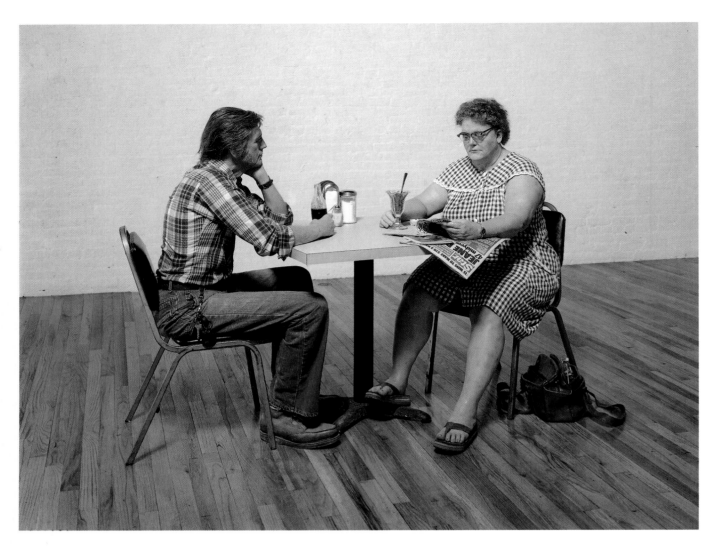

PLATE 69
Duane Hanson
Self-Portrait with Model, 1979.
Polyvinyl, polychromed in oil, with accessories, life size.
Collection Maja and Duane Hanson, Davie, Florida.

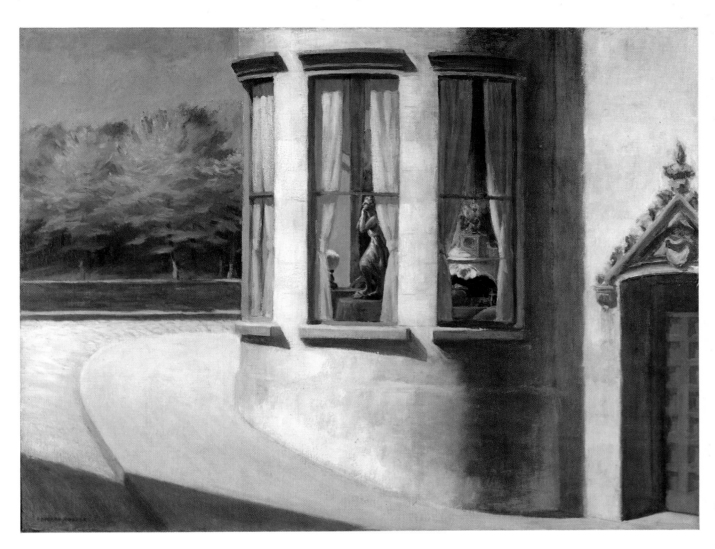

PLATE 70
Edward Hopper
August in the City, 1945.
Oil on canvas, 23 x 30".
Norton Gallery of Art, West Palm Beach, Florida.

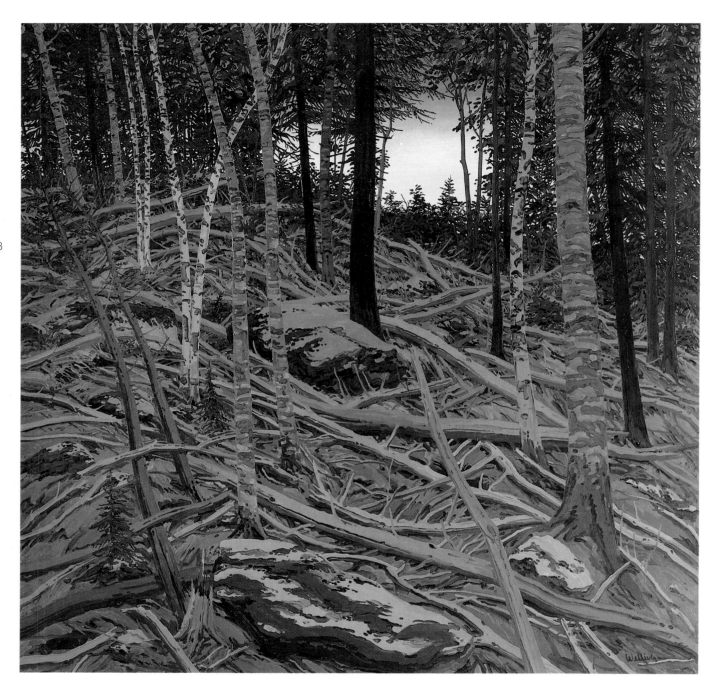

PLATE 71
Neil Welliver
Final Venus, 1984.
Oil on canvas, 96 x 96".
Marlborough Gallery, New York.

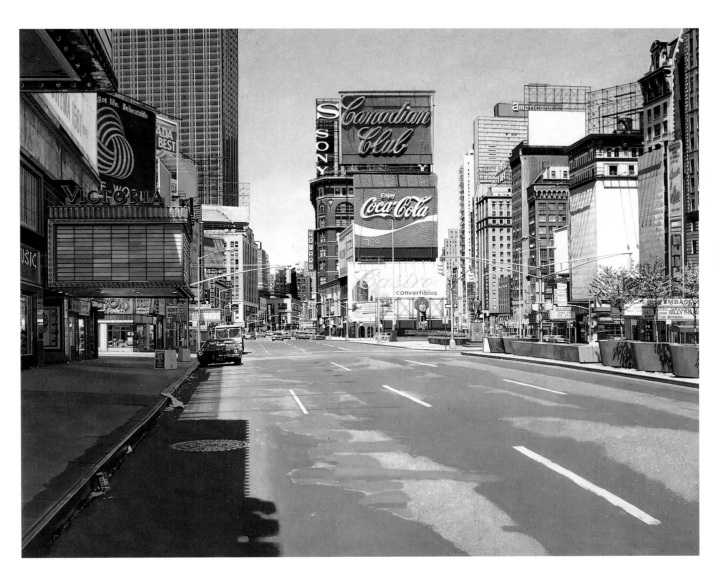

139

PLATE 72
Richard Estes
Canadian Club, 1974.
Oil on Masonite, 48 x 60".
The Neumann Family Collection, New York.

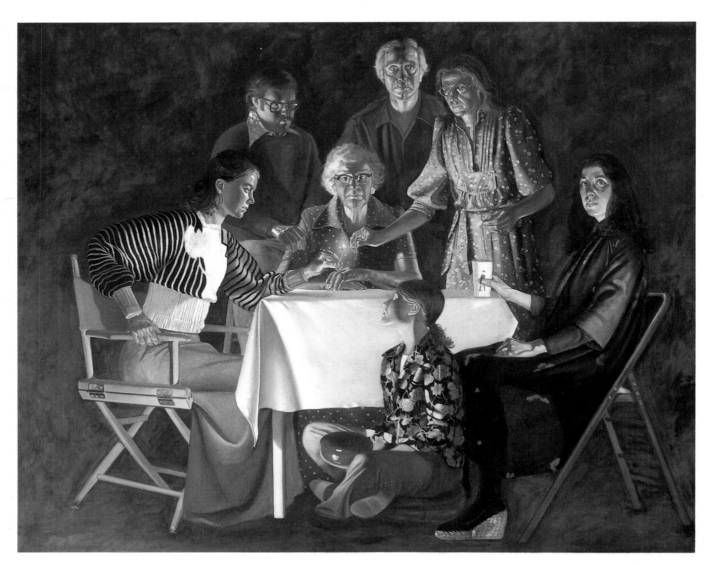

PLATE 73
Alfred Leslie
Birthday for Ethel Moore, 1976.
Oil on canvas, 108 x 132".
Collection the artist; courtesy Oil and Steel Gallery, New York.

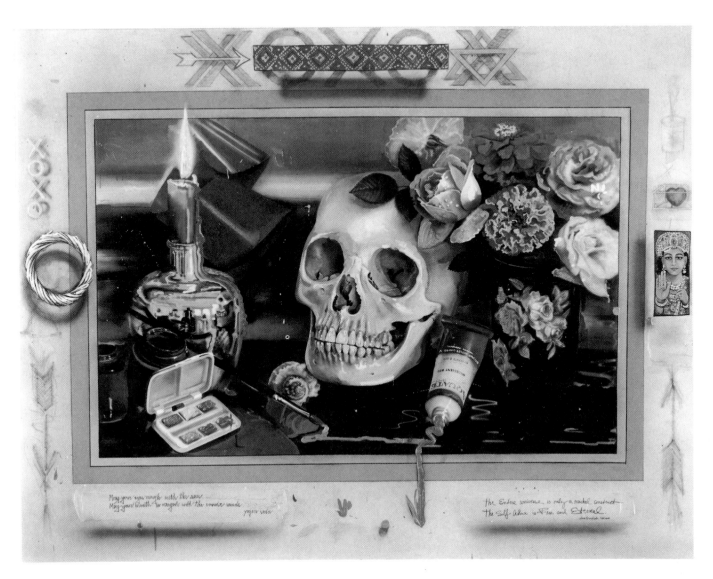

Plate 74
Audrey Flack
Invocation, 1982.
Oil on canvas, 64 x 80".
Louis K. Meisel Gallery, New York.

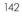142

left

Plate 75
Chuck Close.
Phil, 1983.
Pulp paper on canvas, 92 x 72".
The Pace Gallery, New York.

Plate 76
John Ahearn
Pedro, 1984.
Polyester castings modified and painted by the artist, 80 x 42 x 18".
Collection Edward R. Downe, Jr., New York.

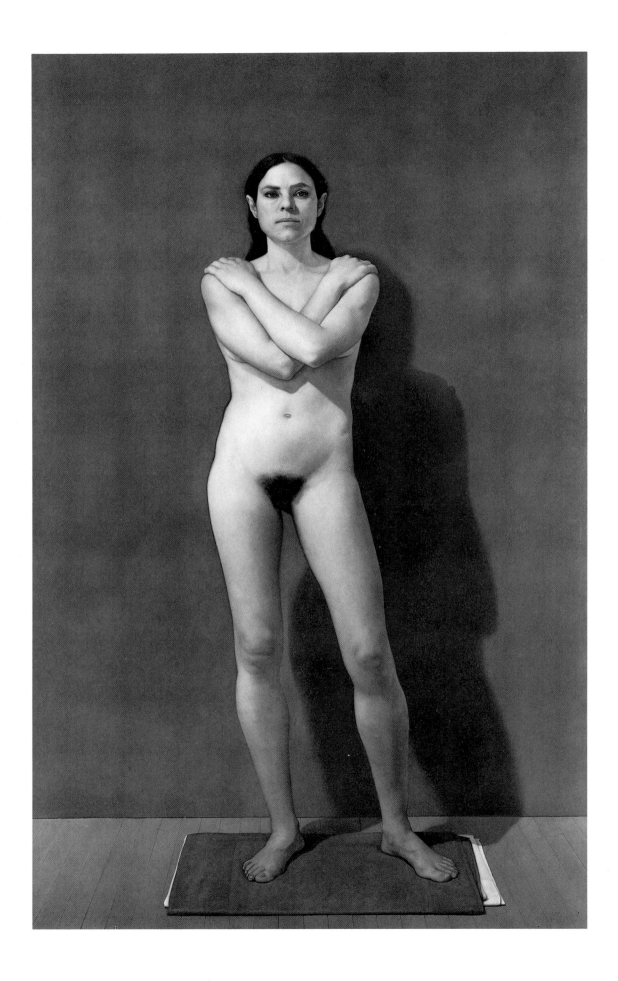

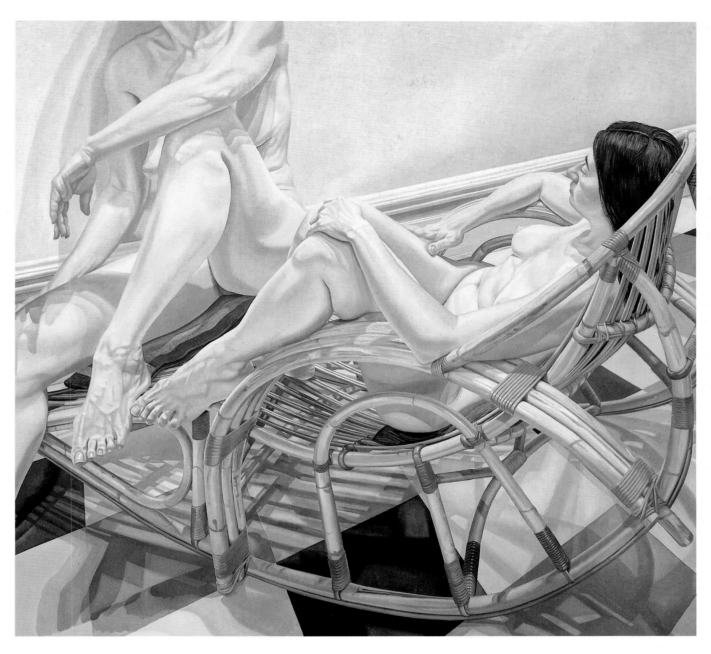

145

left

PLATE 77
William Beckman
Diana IV, 1981.
Oil on wood panel, 84½ x 50⅞".
Hirshhorn Museum and Sculpture Garden, Smithsonian Institution,
Washington, D.C.

PLATE 78
Philip Pearlstein
Two Nudes, Bamboo, and Linoleum, 1984.
Oil on canvas, 96 x 96".
Hirschl & Adler Modern, New York.

VI
BEYOND FORMALISM: LANGUAGE MODELS, CONCEPTUAL ART, AND ENVIRONMENTAL ART

Robert C. Morgan

Painting

John Baldessari
Robert Barry
Jennifer Bartlett
Mel Bochner
Hans Haacke
Douglas Huebler
Joseph Kosuth
Dorothea Rockburne

Sculpture

Siah Armajani
Alice Aycock
Scott Burton
Eva Hesse
Sol LeWitt
Mary Miss
Bruce Nauman
Richard Serra
Charles Simonds
Robert Smithson

At one time Conceptual Art was considered imageless, non-visual, beyond appearance, the last stand of modernism, the final reduction of art. Only the idea mattered. The material object was superfluous. All metaphors vanished, and were transformed into literal facts and objective data. Art was in the process of becoming demystified. Images were relevant insofar as they served to document the phenomenon surrounding the idea. This type of art—an art which held all the mechanics of linguistic structure as its counterpart—signaled a new approach in the history of modernism: a move away from strictly visual criteria. According to one interpretation, offered by the artist Joseph Kosuth, Conceptual Art retained the notion of rational self-criticism but rejected the pretensions and biases of taste as culturally conditioned criteria which isolated aesthetics from other social realities.[1] Although conscious of their explicitly defined intentions, many of these artists emerged inadvertently with ultra-formalist statements regarding the nature of art. Others, like Sol LeWitt and Walter de Maria, employed systems of language and mathematics to conjure concrete realities about form in the wake of Expressionist painting and sculpture. Borrowing heavily from the celebrated negations espoused by Ad Reinhardt, both in his writings and in his final all-black paintings, Conceptual Art in its initial stages was an attempt to suspend the meaning of art in reference to any of its material properties. By the late 1960s, Conceptual Art had succeeded Minimal Art and Pop Art in the attention of the New York avant-garde.

According to Kosuth, making art is an activity subject to the same rules of language that one would find in any field of investigation. In his essay ''Art After Philosophy,'' he argues strongly against what he terms ''Formalist'' art, claiming that it represents ''the vanguard of decoration.'' He goes on to claim that ''its art condition is so minimal that for all functional purposes it is not art at all but pure exercises in aesthetics.''[2] For Kosuth, ''Formalist'' art did not measure up to the challenge of making *meaning*. The solution was to find meaning through ''an inquiry into the nature of art.''[3]

So as not to confuse this inquiry with philosophical inquiry, such as aesthetics, Kosuth argues that art ''will remain viable by not assuming a philosophical stance; for in art's unique character is the capacity to remain aloof from philosophical judgment.''[4] Yet Kosuth's own brand of art-making has relied consistently over the years on the explicit presentation of language as a means of signifying his ideological tenets. He appropriates terms from academic disciplines, such as linguistics, semiotics, and cultural anthropology, and attempts to avoid contradiction by giving his language an''art frame,'' so to speak. Indebted to Duchamp's readymades, Kosuth has allowed the art establishment to give his work the necessary context of meaning. With Duchamp, however, the notion of perceiving the readymades as meaningless signs appears, in retrospect, far less encumbered and contrived than the forced implications in some recent Conceptualism.

In a recent exhibition at the Castelli Gallery in New York, Kosuth mounted a large Duratrans photograph in a large frame.[5] Entitled *Fort! Da! No. 2* (plate 95), the photograph represented the opposite wall of the gallery and a section of the hardwood floor leading to an adjacent room. Both within and on the photograph were four small Xs in different primary colors. A statement in large letters on the wall and in the photograph read: ''There is a surface, and a depth to that, there is language and missing words, there is a spectator.''

As with his earlier *Photo-Investigations* (1965), Kosuth is interested in defining a work through the explicit use of language by giving the object some form of internal reference, and thereby locating its function and definition as art.[6] In *Fort! Da! No. 2* attention is given to the literal aspects of the gallery. The large photograph operates both as a component and as a document, in present and in past time simultaneously. In its original installation at Leo Castelli's, the photograph functioned as a component in referring to other perceivable elements. When separated from this context of viewing, the photograph operates as a fragment of information, a dissociated word. *Fort! Da! No. 2* now functions as a document, isolated from its original context. It is no longer a component within the work. Thus art equals language in that it is dependent upon its usage to be understood; it is language that gives art significance. When taken from its intended usage, its original content is usurped. The frame takes on another kind of meaning, a more traditional meaning, emphasizing the portability of the object. The meaning shifts to another place, another group of spectators, another reference, in an art museum instead of a New York gallery. For Kosuth, the meaning of an art work is paradoxical.

Much of Douglas Huebler's conceptual art over the past decade and a half has centered upon a work from 1971, entitled *Variable Piece*

#70 (in Process) Global, in which he proposed "to photographically document the existence of everyone alive."[7] *Crocodile Tears II: Howard,* 1981 (plate 93), is a continuing narrative piece derived from the earlier proposal.[8] It is largely a fictitious account of a painter named Howard whose aspirations to become a famous artist collide with the realities of the art world. Huebler's work presents a tripartite arrangement of color photographs with an accompanying text framed separately beneath each image. The narrative text conveys a content equal in importance to the three photographs. The photographs in themselves do not carry the content; one has to read the narrative in order for the photographs to make sense.

Huebler was one of the first Conceptualists to evolve a non-objective orientation toward his work, whereby the documentation assumed a major and critical role. As early as 1968, after being an abstract sculptor for several years, he chose to produce documents which gave testimony to his narrative concepts. *Crocodile Tears II: Howard* is one of six narrative accounts of different personalities who represent different aspects of the art world. These narrations attempt to demystify art-making by choosing archetypal people and situations which accurately characterize the circumstances one might find as an artist in today's society. Huebler's perceptions are always insightful, humorous, and convincing; in some cases, they are painfully self-critical. His sophistication about the art world gives Huebler the role of raconteur, of a storyteller who unveils the inner workings and mythological structure of things as they really function; *Howard* is one example.

Lawrence Weiner joins Robert Barry as another among numerous Conceptual artists who have explored the resources of words and verbal language. Together with Huebler and Kosuth, these artists exhibited works in the famous "catalogue exhibition," which was entitled "January 5-31, 1969" and was organized by the adventuresome New York art dealer Seth Siegelaub.[9] Weiner's books and installations play upon the syntactical use of language. Often a work by Weiner will reveal nothing more than a word or a phrase, such as *Flanked Beside* (1971), printed directly on the gallery wall as a sign.[10] In recent years, Weiner has become involved with the language permutations found in architecture. This gives his work a definite physicality that brings language back into the realm of structural support systems with clear visual and allegorical references.

Robert Barry's work as a Conceptualist evolved from earlier concerns as a systemic painter.[11] His canvases from the early 1960s consist of rows of dots in a grid formation, often loosely applied to give the feeling of a subjective, human presence at work. From painting, Barry's concerns became gradually more and more reductive. He moved from painting grids to installing wires and monofilaments between buildings. By 1968, he was doing "invisible" pieces in which radio receivers picked up almost inaudible signals. One such piece was documented in the Siegelaub "catalogue exhibition." Of course, by looking at a photograph of a house or the interior of an empty room it would be impossible to detect a visible work of art; yet Barry would insist that an active system was at work and present in the space.

Language has been the content of Robert Barry's work for nearly two decades.[12] His works from the early 1970s are long lists of words that describe the existence of an invisible form, a presence that exists beyond verbal or visual means. Barry's faith in language as a signifier of human feeling on the most profound levels of human experience is a quality that brings his art into the realm of existential phenomenology. His recent paintings on paper mounted on aluminum, used as studies for larger wall pieces, consist of words pulled indeterminately from other texts. The words are then positioned along the edges of the wall or, more recently, placed in circular formations on a color ground. *Word Circle* has such a circular configuration and suggests a cyclical concept of the passage of time, in contrast to linear progression. Barry's language signifies a search for individual experience and essences within the context of what is read and felt in relation to the identifying color ground on which the word-signs are painted. As in Minimal Art, Barry's conceptualism depends a good deal on the viewer's perception. Perception, in turn, is only a means to "touch ground" with one's emotional reality. This represents a considerably different approach to language than the more detached and analytical procedures of the works of Kosuth and Weiner.

In contrast to the serious, epistemological inquiries made by the New York Conceptualists, another kind of "idea art" has been developing in southern California since the early 1960s, which directs itself toward humor, wit, and droll commentary. The environs of the greater Los Angeles area provided a ready-made background for the activities of avant-garde artists interested in exploring ideas about their cultural milieu in

relation to language. Southern California, and Hollywood in particular, is a haven for publicity seekers. Commercial imagery is rampant in movie and television studios, on freeway billboards, fast-food franchises, car-wash places, and shopping malls. It is an American subculture that relishes pictorial advertising of all kinds. As the entertainment capital of the world, Hollywood is spoon-fed continuously by its own image glut, its own timeless narcissism; it is a culture of mirrors giving its inhabitants a constant dosage of instant replay. Los Angeles is an endless mega-metropolis spilling over into the beaches and surf, sprawling upward toward the mountains, and stretching into the desert sands. Is it any wonder, then, that Conceptual Art of a certain kind would result from such an environment?

The California artist Ed Ruscha in 1962 began working on a series of small publications that were reflective of Pop Art, but also prophetic of early Conceptualism. The first of these small books, called *Twenty-Six Gasoline Stations*, is a sequence of black-and-white photographs of gasoline stations between Los Angeles and Oklahoma City.[13] There is no accompanying narrative. The book gives objective information, and its effect rings of the absurd. Ruscha has also done numerous paintings, which present words on a color field—often sentimental phrases, the kind of statements one might hear on the AM frequency in Los Angeles.

Bruce Nauman, also a Californian, for nearly two decades has had an interest in perception, which he brings to his unique brand of Conceptualism. In the late 1960s, he built a series of corridors, often extremely narrow, which invited the viewer to become a participant by entering into the work. Nauman's early corridors have much in common with Minimal Art. The shapes of these corridors are decisively geometric, sometimes curved, suggesting a phenomenological orientation toward space. For Nauman, the act of perceptual concentration can never be entirely divorced from the viewer's internalized concept of reality.[14] In *Perfect Door, Perfect Odor, Perfect Rodo*, 1972 (plate 94), Nauman is playing upon the permutations of word-phrases as signs, descriptive phrases which gradually dissipate in their meaning. The three signs are positioned horizontally at eye level and emit three shades of white neon. There is a slight spacing between them. The electrical circuitry hangs from each sign so as to emphasize the literalness of the structure. Taking the word "door," he changes it into "odor," and then into "rodo." Through this

deliberate disordering process, an ambiguous sign-value inundates the whole. Either the three parts all make sense, or none of them makes sense. The variations of the neon hue indicate a metaphor in relation to the linguistic variations. Finally, the message is a blunt fact: there is no meaning beyond the level of adjustment and permutation given to each signifier. Meaning is taken from language according to how the components are adjusted for our gaze. Within the context of advertising and Hollywood culture, Nauman's message assumes a certain appropriateness.

Another Californian, John Baldessari, is interested in the process of selection. In his earlier works, such as *Choosing Green Beans* (1972), there is a certain tension between making linguistic and aesthetic choices.[15] Are choices made on the basis of what objects *mean* to the spectator, or are they made on the basis of appearance alone?[16] In *Black and White Decision* of 1984 (plate 92), Baldessari has selected three black-and-white photographs. They are placed in two distinct formats: one higher, and one lower. The upper format is an inverted triangle. The lower format is an elongated rectangle resembling a Cinemascope movie screen from the 1950s. The triangular image is a single cropped photograph of two people playing chess at the beach. Only a minimal amount of information is given. In the lower, rectilinear format, upon which the triangular photograph is perched at mid-point, there are two photographs. One image, presumably taken from a cowboy movie (*Hopalong Cassidy?*), is shown twice, on both the left and right sides. The right version of the photograph is the obverse of the left, so that a rigid symmetry exists. In the middle of these two versions of the same photograph—which shows two horsemen emerging from behind large boulders—is a smaller photograph, another movie still, showing a man and a woman in shadows peering out from behind a pillar. Baldessari's *Black and White Decision* has psychological, linguistic, and metaphysical tension. There is an aura of anticipation, of apprehension, of what the next move is going to be. The Hollywood cult of commercial entertainment depends upon this constant recycling of anticipation and apprehension. There is a sense of abeyance in these photographs. They communicate fragments of speech on an absurd verbal level.

Another aspect of Conceptual Art, which emerged as a significant development during the late 1960s and in the 1970s, was Performance Art, or Body Art. Vito Acconci and Scott Burton were

Figure 47. Robert Smithson, left, with an unidentified friend, 1970. Photo: Ugo Mulas.

Figure 48. Robert Smithson. *The Angel and the Ant-Lion*, 1961. Tempera and ink on paper, 24 x 18". (Not in the exhibition.) Courtesy Diane Brown Gallery, New York. Photo: Jon Abbott.

initially involved with different aspects of performance. Acconci's Body Art was always intensely personal, autobiographical, and self-indulgent. Burton's pieces, or his tableaux, as he preferred to call them, were cool, removed abstractions of body language and movement. In 1973, Acconci decided to relinquish his direct involvement with performance and became interested in setting up situations with props in which others might perform arbitrarily. Over the past decade, Acconci's works have involved complex constructions which function as theatrical devices in which spectators become physically involved in the work.[17]

In Acconci's *People's Wall* of 1985 (plate 98), a freestanding wall made of painted wood, quilted fabric, rubber flooring, and mirrored Plexiglas allows participants to climb inside and assume the contorted positions of the silhouetted figures which have been cut out of the wall. There is a certain paradox involved in that the silhouettes on the two sides of the wall do not match, which is typical of Acconci's work. There is a political or ideological metaphor, psychologically inherent in his work, that suggests a confrontation with conflict and potential disorder, a metaphor that unmasks the social realities that constitute the basis of ideological discourse.

Scott Burton's *Pedestal Tables* of 1979–81 (plate 88) also attempt to substitute the directorial motives in his earlier performance works with a more suggestive presence dependent upon traditional object-making. These copper-plated bronze pedestals have a somewhat forbidding, otherworldly appearance, like nonobjective signs pulled from de Chirico's *pittura metafisica*. These fundamental tripartite, vertical castings are ostensibly decorative furniture, not unrelated to Austrian Art Deco of the 1920s. The basic elements consist of a cylinder, a sphere, and an inverted cone. The suggestion of performance activity is the apparent goal of these configurations. There is an absoluteness—an ineluctable idealism—that occupies the space around them, a certain immobility and intransigence that suggest disorder within the mind of the beholder.

The dialectics between order and entropy were a major concern of the late sculptor Robert Smithson. His early paintings, such as *The Angel and the Ant-Lion* of 1961 (figure 48), suggest an interest in the otherworldly and apocalyptic vision of reality with a strong desire for metaphysical truths.[18] By 1964, Smithson was engaged in producing a very different kind of work. By maintaining a curious science-fiction orientation, he made a series of mirrored wall pieces, devices that would

151

ingeniously reflect the presence of the viewer in relation to the total interior of the room. These works had a prismatic quality. Often the glass was colored so as to give the reflection of the interior an otherworldly aura; Smithson eventually characterized this as his "crystalline metaphor."[19]

After the early mirrored constructions, Smithson revived his interest in glacial structures and the geological strata of the earth's formation. In the film *The Spiral Jetty* (1970), the artist discusses the evolution of land masses, the preglacial shifting of continents, and the structure of the earth's strata.[20] This concern is reflected in an untitled piece from 1968-69 (plate 82) constructed of sheets of glass, stacked vertically, with chips of mica holding the corners in place between each sheet. The dimensions of the piece are 20 inches square, thus forming a cubic translucent object which reiterates the process of its stratified method of construction. Smithson used the tern "non-site" to describe constructions placed in a gallery or museum context, as opposed to pieces constructed in their natural surroundings. This untitled work clearly reveals the artist's interest in process and time, the temporality of form as a condition of entropy, the persistent shifting of molecular masses from one state to another.

Transmutation is a predominant theme in Charles Simonds's recent ceramic sculpture. Whereas Smithson's mature work emphasized the nonrepresentational, minimal essence of the earth's strata, Simonds's statement as a sculptor is essentially narrative and organic. In *Pod II* (plate 81), a squid-like structure lies on a flat base. Growing out from the pod is a series of brick buildings which are gnarled, entangled, and twisted. The statement is a metaphor in relation to architecture, one that Lewis Mumford might appreciate. In spite of its weird, alien-creature appearance, *Pod II* suggests that dwellings and habitats are direct extensions of people's lives.[21] Simonds has been interested in cities of imaginary small people since the early 1970s.[22] Initially he built his clay structures in normally unobserved places in the urban environment, places like window ledges which passers-by could easily overlook. There is also a sexual reference in Simonds's *Pod* series, which is relevant only in the larger sense of organic mysteries and innate forces of nature at work, persistently unfolding on both a macrocosmic and a microcosmic level.

The Minimal Art of the mid-1960s was characterized by its highly reduced, hard-edge, and architectonic qualities. The sculptors—

Figure 49. Sol LeWitt in New York, 1972. Photo: Gianfranco Gorgoni.

including Tony Smith, Donald Judd, Dan Flavin, Sol LeWitt, Richard Serra, and Carl Andre—were generally concerned with the look of industrially produced, prefabricated materials in a provocatively ordered manner. Eva Hesse, a young sculptor who died in 1970, was also interested in the Minimal aesthetic, but in a more organically configured way. Her use of the modular unit is without severity, as in the cast polyester and fiberglass pieces, which have a unique biomorphic presence. In *Ice Piece*, 1969 (plate 83), Hesse created an object that was as mute as Minimal Art, but without the hard-edge tendency. *Ice Piece* is a hybrid form. Neither painting nor sculpture, it exists somewhere in between. It is form without mass, without utility, and without a ready-made category to identify it.

Sol LeWitt, who designed a monograph on Eve Hesse written by the critic Lucy Lippard, had a seminal role in the development of Conceptual Art.[23] In June 1967, LeWitt published his "Paragraphs on Conceptual Art." In the second paragraph, he states:

I will refer to the kind of art in which I am involved as conceptual art. In conceptual art the idea or concept is the most important aspect of the work. When an artist uses a conceptual form of art, it means that all of the planning and decisions are made beforehand and the execution is a perfunctory affair. The idea becomes a machine that makes the art.[24]

LeWitt's premise that "ideas alone can be works of art" opened up a whole new possibility for determining what, in fact, a work of art could be if not contained by a material object.[25] Two months before LeWitt's "Paragraphs" appeared in *Artforum*, Lucy Lippard published an article entitled "Sol LeWitt: Nonvisual Structures," in which she used the term "conceptual" in discussing the artist's new serialized projects:

The two ideas that have increasingly occupied Sol LeWitt over the last four years are enclosure, or containment, and the paradoxical relationship between the visual (or perceptual) and the conceptual emphases in making art.[26]

LeWitt differed from Joseph Kosuth in his interpretation of Conceptual Art by arguing that ideas, given the context of a language statement, could be constructed or manifested in systemic concrete ways.[27] In *Eight-Unit Cube* of 1976 (plate 79) LeWitt has used a standard modular element, an open-sided cube, which has expanded by equal increments into a larger open-sided cube. In this classical work, LeWitt has taken a language concept and translated it into a concrete structure. There is a clear dialectical tension between the concept of *Eight-Unit Cube* and its object counterpart. The issue of scale and environmental placement bears upon the perceiver's knowledge about the form. This perceptual knowledge of the object may function quite distinctly from the purity of the concept.

Richard Serra's *Carnegie* of 1984 (plate 80) has definite roots in Minimal Art except for its tilted totemic appearance, which gives this small monolith a peculiar romanticism. Serra has been interested in placing his massive steel forms in situations where the space is fractured. There is a kind of sublime authority to his earlier "prop pieces," in which large steel plates were tilted against one

153

Figure 50. Richard Serra in his New York studio, 1972. Photo: Gianfranco Gorgoni.

another, structurally holding one another in place, such as *House of Cards* (1969).[28] Implicitly, Serra's works function as a blockage, as a means of preventing our seeing beyond them. In this sense, his statement may be construed as a fascinating commentary on contemporary culture and the routine busyness of everyday life. *Carnegie* has a curious existential presence, a mute stillness. Here may be an opportunity for the lost art of reflection on the stress and power plays that are currently directing the course of culture.

Whereas Serra's commentary on culture is implicit, the work of Hans Haacke is more explicit. Haacke's early work with hydrodynamic and aerodynamic structures began in the early 1960s in Düsseldorf, where he was a member of Group Zero.[29] Upon moving to the United States in the mid-1960s, Haacke continued to work with physical systems, and then turned to sociological and economical systems in the art world. Since 1970, when a planned exhibition at The Solomon R. Guggenheim Museum in New York was cancelled for fear of upsetting trustees with slum real-estate holdings, which Haacke had revealed in one of his works, his projects have been concerned with exposing the economic, political, and ideological motives which support art and culture in the contemporary West—what he calls "the consciousness industry."[30] His recent oil painting *Taking Stock (Portrait of Margaret Thatcher)* (plate 91) is ostensibly a portrait of the British prime minister, Margaret Thatcher; however, if one looks closely there are numerous items represented in the painting that refer to the advertising magnates Charles and Maurice Saatchi.[31] The Saatchi and Saatchi Company PLC is one of the most powerful advertising and promotional services in the world. The iconography in Haacke's painting reveals a piece of paper on the table in front of Prime Minister Thatcher showing the extraordinary worth of paintings sold by the Saatchi investment firm (Brogan Developers Ltd.) in the year ending March 31, 1978.[32] A humorous coda exists in the upper right-hand corner of the painting, which shows the portraits of the two brothers on two cracked dinner plates, presumably connected to their ownership of several of Julian Schnabel's broken-plate paintings, which were exhibited at the Tate Gallery in London about two years before. At the time the decision was made to have the Schnabel exhibition, Charles Saatchi was a member of the Tate Gallery's Patrons of New Art Committee, an office from which he has since resigned.[33] *Taking Stock* is witty and incisive. It carries a reverberation of signs not unlike those utilized by religious painters several centuries ago. Haacke has updated a traditional technique to give his pithy commentaries a subtle passage into the media network of contemporary culture.

The operation of systems in Conceptual Art is also a concern in the recent *Large Rod Series* by Walter de Maria and the furniture-like constructions of Siah Armajani. De Maria emphasizes regularity and standardization in the sculpture called *The Square of the Large Rod Series* of 1985 (plate 36), which is composed of five polygonal rods in solid stainless steel. Each of the rods has a different number of sides, the smallest being a pentagon shape and the largest having thirteen equal sides. All of the rods have equal length, area, and weight, but they differ in height and width. This form of standardization is closely dependent upon the technology of industry. The precise mathematical basis of these rods shares something with the systemic orientations of Sol LeWitt and Carl Andre. De Maria's statement is ultimately a formal one, an aesthetic end game, in which timelessness prevails and "meaningless work" becomes its decisive resolution.[34]

Siah Armajani's evolution as a sculptor is not outside the purview of Minimal Art. His concerns have involved modularity and a phenomenological basis of perception. There is a strong intellectual and physical presence in Armajani's work. For this reason, as with Walter de Maria, his work might be classified as a material form of Conceptualism or Structuralism. With *Open Door Buffet with Windows* of 1984 (plate 87), the success of the piece rests on its definitive relationship of parts to the whole. Its design language is complete unto itself. While it borrows from the idea of a cabinet or buffet, its formal juxtapositions run consciously askew so as to make a reading of the structure nearly incomprehensible. There is nothing predictable in Armajani's system; it avoids regularity and standardization, yet its structural meaning as a cohesion of parts is undeniable.

Site-specific sculpture is a term which came into extensive use during the early seventies. The concept borrows from the practice of earth artists several years earlier, in establishing an exact place of topological reference where a temporal though monumental-scale work would be executed. Large-scale site works by Armajani, Mary Miss, Alice Aycock, Dennis Oppenheim, Newton and Helen Harrison, and Nancy Holt, among others, have all made important contribu-

Figure 51. Alice Aycock, New York, 1985.

Figure 52. Mary Miss, 1985. Photo: Wendy Worth.

tions toward expanding the definition and the function of sculpture.[35] A basic distinction between land art and site-specific works would be in the use of materials and, in most cases, the perspectival reference. Land art emphasized indigenous materials and has often been considered in terms of its aerial perspective. Site-specific sculpture often resorts to common construction materials and is oriented to the ground plane. The artist Diana Shaffer has remarked:

Site sculpture expresses a strong consciousness of time. Its materials and structure are either temporary and tentative looking, geared toward the present, the transient and ephemeral, or they suggest reference to timeless building rituals and materials.[36]

155

Alice Aycock and Mary Miss began working with primitive architectural constructions, built from lumber, in the early 1970s. Aycock thought of her early works in direct relationship to her own body, and she called them "psychophysical spaces."[37] Her 1984 *Fata Morgana (Of Things Seen in the Sky)* (plate 90) has antecedents both conceptually and physically in her early structures, even though its more concise machine-like quality appears to have advanced the resolution of problems set forth years ago. *Fata Morgana* could be a machine parable from Orwell's despotic state. Formally, it relates to Moholy-Nagy's 1930 version of his Light Modulator. Aycock's piece centers on fantasy, a recurrent theme in her work, but is relieved of her usual obsessive references to medieval history and narcissism. The grounded machine operates dialectically in relation to the suspended, reflecting element, introducing new kinetic and spatial possibilities.

Screen, 1984 (plate 89), a black painted aluminum piece by the sculptor Mary Miss, has a deceptive decorative appearance. In relation to her earlier site-specific works, *Screen* redefines some of her initial intentions by presenting a structurally complex metal surface which invites playful perception. Miss has always demonstrated a concern for contrasting spaces, both outdoors and indoors. This piece functions as a ploy, a see-through, portable element that dislocates a given interior in a way not dissimilar to lattices found in architectural structures in Spain or North Africa, where the passage of light from exterior to interior is mediated by intervening fenestration and grille work.

Since the late seventies a great variety of painterly styles have emerged simultaneously in the new York art world. Expressionist forms of painting have received the most press and,

undoubtedly, the most critical attention. However, other forms of painting also began to emerge, which borrowed from earlier conceptual or systemic tendencies. Mel Bocher, at one time considered the most reductive and stringent of artists, has been involved with serialization and systems for at least two decades.[38] His painting *Siege* of 1984 (plate 84) is an eight-sided polygon of sized canvas. The interior network of straight lines painted with different-colored oils has a direct reference to the exterior support. The concept is not too distant from Barnett Newman's "zips," which were intended to reaffirm the support of the color field. In Bochner's *Siege*, the color field is absent. There are only the color lines, which continually reiterate their association with the octagonal edges.

In a peculiar way, Bochner's systemic approach to the canvas is visually comparable to a painting by Sam Gilliam called *Like Today,* 1985 (plate 28). Gilliam's network of color shapes, tightly compressed into a polygonal form, does not appear to have a systemic motive. The method is more related to collage or three-dimensional assemblage, like a hybrid somewhere between Kurt Schwitters and Frank Stella's paintings from the mid-seventies. Gilliam's painting has evolved from an environmental concept of hanging raw canvas from the ceiling with drips and splatters of paint staining the surface in various gestural configurations. The quick energy that communicates in *Like Today* implies a sensitivity that relies on intuitive, as opposed to systemic, ordering.

Dorothea Rockburne's painting on linen, *Capernaum Gate* of 1982–85 (plate 86), evolves from a system related to the golden section, a structural concept evolved by the pre-Socratic musician, mathematician, and architect Pythagoras.[39] Rockburne's painting of folded elements has several acute angles which are ostensibly contrasted to the contained natural flow of the pigment: deep purple, yellow, violet, thalo-greens and blues, with gold leaf. Another purely coincidental, yet completely morphological association is how Rockburne's systemically derived *Capernaum Gate* connects with a formal expressionist painter, such as Joan Mitchell.[40] The implication here, as with the Bochner/Gilliam comparison, is that logical (determinate) and intuitive (indeterminate) methods of painting may produce results which are, in fact, very close.

Conceptual Art tended to emphasize the rigor of intentionality—the language basis of art—to an extreme. Historically, of course, this represented a significant shift in the direction of the New York avant-garde, although preparations for this shift had come through Ad Reinhardt's paintings, Minimal Art, Fluxus, a revival of interest in Duchamp, and various other European influences. By the mid-seventies, however, it had become apparent that a certain dissatisfaction with Conceptual Art was setting in. Some former Conceptualists began seeking new avenues through which to explore sensual vitality in their art without sacrificing their well-earned intentions.

Evidence of this sensuous revival, applied systematically in painting, can be seen in Jennifer Bartlett's *Horizon,* 1979 (plate 85). The work has two basic parts. On the right is a 90° planar arc, a shaped canvas, divided into four quadrilateral sections. On the left is another arc formation, composed of twenty separate tiles (actually baked enamel on steel plates). Running horizontally across and midway through both the right and left parts of this pictorial composition is the suggestion of a distant horizon, perhaps signifying the sensation of standing on the beach and looking out over the Pacific Ocean, an experience well known to Bartlett, who grew up in southern California.[41] There is a four-color pattern in *Horizon* constructed of various tonal values ranging from deep blues to intense violet. The ultimate effect of this painting might be described as systemic sublime.

Formalist criticism has more than a single aspect. Visual formalism suggests that a work of art is interpreted primarily on the basis of its superficial constituent parts—that is, color, shape, line, balance, texture, lyricism, and so on. Linguistic formalism has another connotation, more in keeping with the Russian Constructivists, who saw their shapes and colors as signifiers of a new language system which, for some, held a revolutionary impact. While this distinction is oversimplified, Conceptual Art may be seen in retrospect as an attempt to usurp the visual elements of form in favor of a linguistic counterpart. If such an interpretation holds true, it would imply that "pure" Conceptualism maintained its posture strictly within the boundaries of a formal manipulation of existing codes, in fact, an ultraformalist posture. In recent years, some Conceptualists have retained a sensibility and a method which relishes freedom from the restrictions of aligning themselves to a specific material medium. In other words, their ideational intentions supersede mediumistic considerations.[42]

When one scrutinizes the progressive moves and countermoves that have developed in American art since 1945, it becomes apparent that Conceptual Art not only offered an alternative

to American modernist criteria, but also represented a logical reduction in the chain of formalist endeavors which had previously taken place. Yet to dismiss Conceptualism as merely historical would not adequately reveal the wellspring of ideas which have returned to visual objects within the context of the avant-garde in recent years.

The best of Conceptual Art is more than an antidote or a footnote to formalism. It is a vibrant and important alternative in art-making and an alternative to the entrenchment of both visual and linguistic orientations in criticism. Provocative art, as the art historian Leo Steinberg once proclaimed, has the potential to incite new criteria.[43] If Conceptual Art has made an enduring contribution, it has been in challenging conventional modes of thought in art in relation to perception and vision.

NOTES

1. Joseph Kosuth, *Within the Context: Modernism and Critical Practice* (Ghent, Belgium: Coupure, 1977).

2. Joseph Kosuth, "Art After Philosophy, Part I," *Studio International* (Oct.–Nov. 1969). Reprinted in Gregory Battcock, *Idea Art* (New York: Dutton, 1973), p. 77.

3. Joseph Kosuth, "Introductory Note by the American Editor," *Art-Language*, no. 2 (Feb. 1970), p. 2.

4. Joseph Kosuth, "Art After Philosophy, Part I," p. 91.

5. Joseph Kosuth, Leo Castelli Gallery, 420 West Broadway, New York (May 1985).

6. Joseph Kosuth, *Art Investigations & "Problematics" Since 1965*, five volumes (no date or place of publication). Distributed by Leo Castelli, New York.

7. *Douglas Huebler*, exhibition catalogue (Boston: Museum of Fine Arts and the Institute of Contemporary Art, 1972).

8. Douglas Huebler: "Crocodile Tears II," Leo Castelli Gallery, 142 Greene Street, New York, March 1983.

9. *January 5–13, 1969*, exhibition catalogue, copyright 1969, Seth Siegelaub, New York.

10. *Guggenheim International Exhibition*, exhibition catalogue (New York: The Solomon R. Guggenheim Museum, 1971) (folded sheet in folio).

11. *8 Young Artists*, exhibition catalogue (Yonkers, N.Y.: The Hudson River Museum, 1984). Essay by E.C. Goossen.

12. Robert C. Morgan, "The Invisible and the Visible: Robert Barry and American Conceptualism," in Erich Franz, ed., *Robert Barry* (Bielefeld, Germany: Kunsthalle Bielefeld, 1986).

13. Edward Ruscha, *Twenty-Six Gasoline Stations* (Alhambra, Calif.: The Cunningham Press, 1967). Original edition, 1962.

14. Marcia Tucker, "Phenomenology," *Artforum*, Dec. 1970).

15. John Baldessari, *Choosing Green Beans* (Bari, Italy: John Baldessarri, 1972).

16. See my comments in "Conceptual Art and Photographic Installations: The Recent Outlook," *Afterimage*, Dec. 1981.

17. For a good example, an audiotape cassette of an installation was made for exhibition at San Diego State University, called *Vito Acconci: Portable City* (San Diego: University Gallery, Apr.–May 1982).

18. *Robert Smithson: The Early Work, 1959–62*, exhibition catalogue (New York: Diane Brown Gallery, Jan.–Feb. 1985).

19. Robert Smithson, "Entropy and the New Monuments," *Artforum* (June 1966), reprinted in Nancy Holt, ed., *The Writings of Robert Smithson* (New York: New York University Press, 1979).

20. Robert Smithson, *The Spiral Jetty*, color, 35 minutes, 1970. Distributed by Castelli-Sonnabend, New York.

21. *Charles Simonds* (New York: Leo Castelli Gallery, exhibition catalogue, Oct.–Nov. 1984).

22. Charles Simonds, "Selected Work," in Alan Sondheim, ed., *Individuals: Post-Movement Art in America* (New York: Dutton, 1977), pp. 290–312.

23. Lucy R. Lippard, *Eva Hesse* (New York: New York University Press, 1976).

24. Sol LeWitt, "Paragraphs on Conceptual Art," *Artforum* (June 1967), reprinted in Alicia Legg, ed., *Sol LeWitt*, exhibition catalogue (New York: The Museum of Modern Art, 1973), pp. 166–167.

25. Sol LeWitt, "Sentences on Conceptual Art," *Art-Language: The Journal of Conceptual Art* (May 1969), reprinted in Ursula Meyer, *Conceptual Art* (New York: Dutton, 1972), pp. 174–175.

26. Lucy R. Lippard, "Sol LeWitt: Nonvisual Structures," in *Changing* (New York: Dutton, 1971), pp. 154–166.

27. This issue is made clear in both his "Paragraphs" and "Sentences." Kosuth's position is clarified in *Art-Language*, no. 2 (Feb. 1970), pp. 1–3; modifications in this position are discussed in "Necrophilia Mon Amour," *Artforum* (May 1982).

28. Jack Burnham, *The Structure of Art* (New York: Braziller, 1972), pp. 140–141.

29. Bitite Vinklers, "Hans Haacke," *Art International* (Sept. 1969), pp. 44–49,56.

30. The circumstances surrounding the cancellation of the Guggenheim Museum exhibition are outlined in Jack Burnham, "Steps in the Formulation of Real-Time Political Art," in Hans Haacke, *Framing and Being Framed* (New York: New York University Press, and the Press of the Nova Scotia College of Art and Design, 1975), pp. 127–140. Hans Haacke attributes the term "consciousness industry" to Hans Magnus Enzensberger in "The Constituency," *Tracks*, Fall 1977.

31. Information and iconography related to *Taking Stock* appear in my interview with Hans Haacke, in *Real Life Magazine*, #13 (Autumn 1984), pp. 5–11; and in a special number of *October #30* (Fall 1984) devoted to Haacke.

32. Ibid.

33. See "A Conversation with Hans Haacke," *October #30* (Fall 1984), p. 27.

34. This phrase refers to a short essay called "Meaningless Work," written by de Maria in 1960. It was originally published in *An Anthology*, edited by La Monte Young and Jackson Mac Low (New York, 1963); reprinted in Richard Kostelanetz, ed., *Esthetics Contemporary* (Buffalo: Prometheus, 1978), pp. 242–244.

35. Some of these artists' projects are documented and discussed in *Land Marks*, exhibition catalogue (Annandale-on-Hudson, N.Y.: Edith C. Blum Art Institute, Bard College, 1984). Curator of the exhibition was Linda Weintraub.

36. Diana Shaffer, "Drawings for Site Sculpture," in Sam Hunter, ed., *New Directions: Contemporary American Art* (Princeton, N.J.: Commodities Corporation, 1981), p. 72.

37. Alice Aycock, "Work: 1972–74," in Sondheim, *Individuals* (New York: Dutton, 1977), pp. 104–121.

38. Mel Bochner, "Serial Art, Systems, Solipsism," in Gregory Battcock, ed., *Minimal Art* (New York: Dutton, 1968), pp. 92–102.

39. Rockburne comments on her work in *14 Americans: Directions of the 70s*, produced by Michael Blackwood. Color, 16mm, 90 minutes. Distributed by Blackwood Films, New York, 1979.

40. This morphological analogy, a criterion once considered anathema to "pure" Conceptualism, refers only to Mitchell's recent paintings—in particular, one called *Exstasie*, completed in 1984, which manifests shapes and acute angles similar to those found in *Capernaum Gate*.

41. Nan Robertson, "In the Garden with Jennifer Bartlett," *Art News* (Nov. 1983), pp. 72–77.

42. See my comments in "The Delta of Modernism," in Peter Frank, ed., *Re-Dact* (New York: Willis, Locker, and Owens, 1984), pp. 122–131.

43. Leo Steinberg, "Contemporary Art and the Plight of Its Public," in Gregory Battcock, ed., *The New Art* (New York: Dutton, 1966; revised 1973), pp. 205–226.

PLATE 79
Sol LeWitt
Eight-Unit Cube, 1976.
Painted aluminum, 120 x 120 x 120".
Collection Martin Z. Margulies, Miami.

right
PLATE 80
Richard Serra
Carnegie, 1984.
Cor-ten steel, 53 x 24 x 24".
Larry Gagosian Gallery, New York.

160

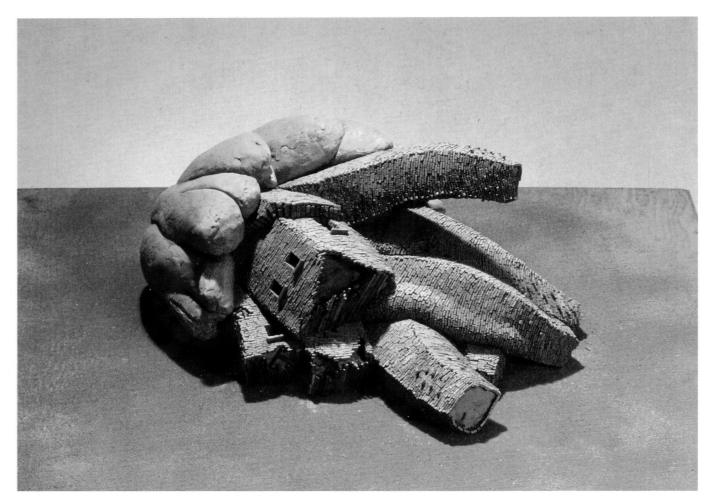

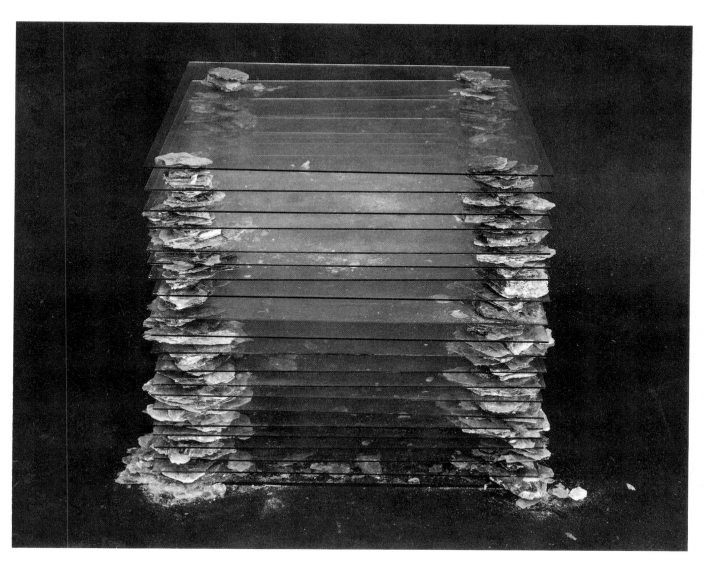

PLATE 82
Robert Smithson
Untitled, 1968–69.
Glass and mica, 26 x 20 x 20".
John Weber Gallery, New York.

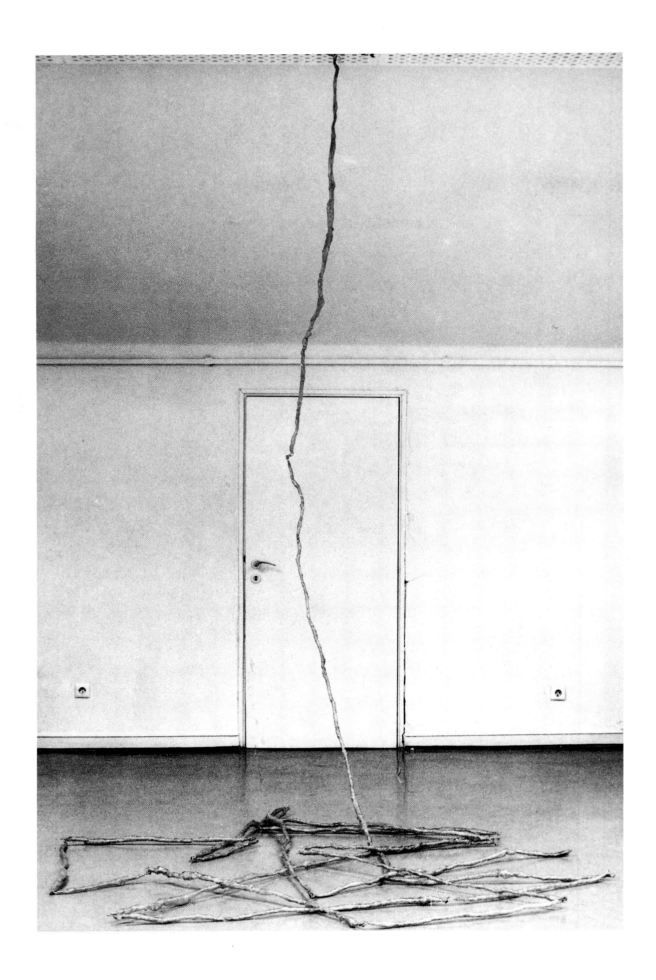

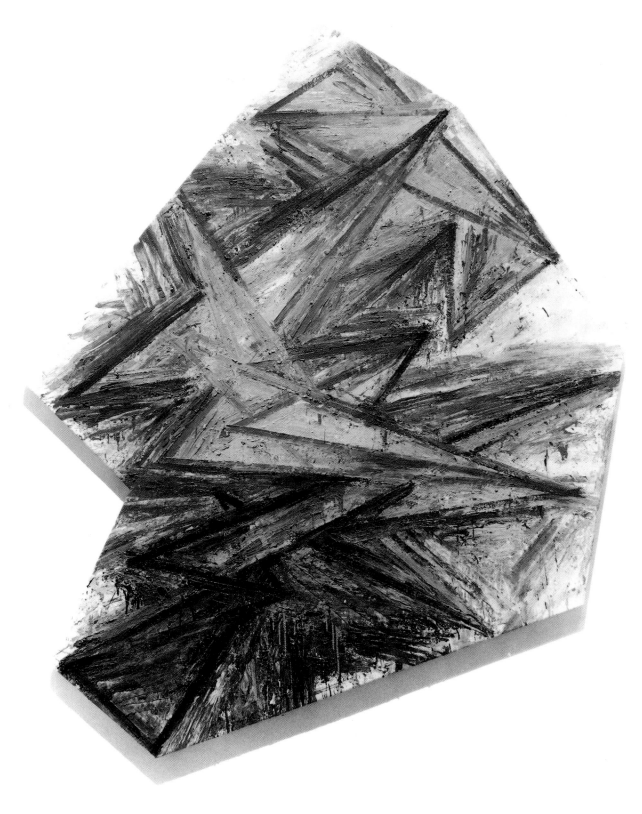

left

PLATE 83
Eva Hesse
Ice Piece, 1969.
Fiberglass and wire, 62′ x 1″.
Xavier Fourcade Gallery, New York.

PLATE 84
Mel Bochner
Siege, 1984.
Oil on canvas, 100 x 79″.
Sonnabend Gallery, New York.

164

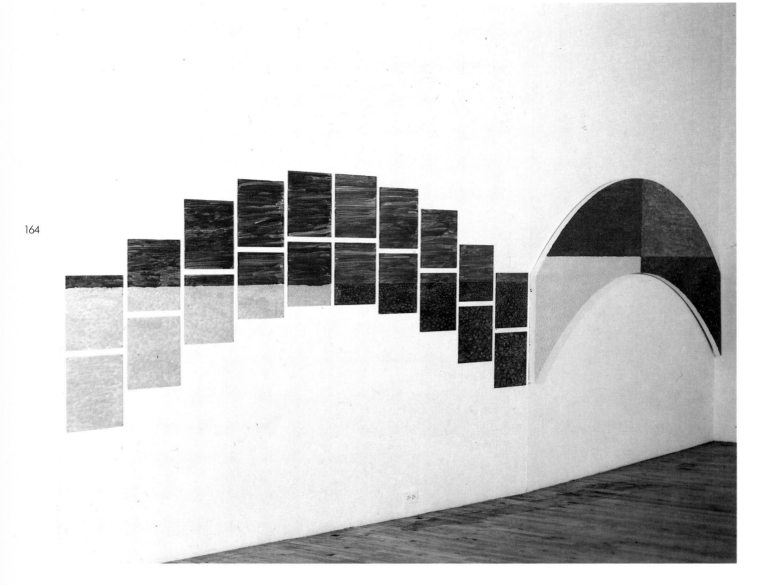

PLATE 85
Jennifer Bartlett
Horizon, 1979.
Enamel, silkscreen grid and baked enamel on steel plates, oil on canvas
(20 plates, 1 canvas), 48 x 250".
Collection Martin Sklar, New York.

right
PLATE 86
Dorothea Rockburne
Capernaum Gate, 1982–85.
Oil paint and gold leaf on gessoed linen, 92 x 85 x 4".
Xavier Fourcade Gallery, New York.

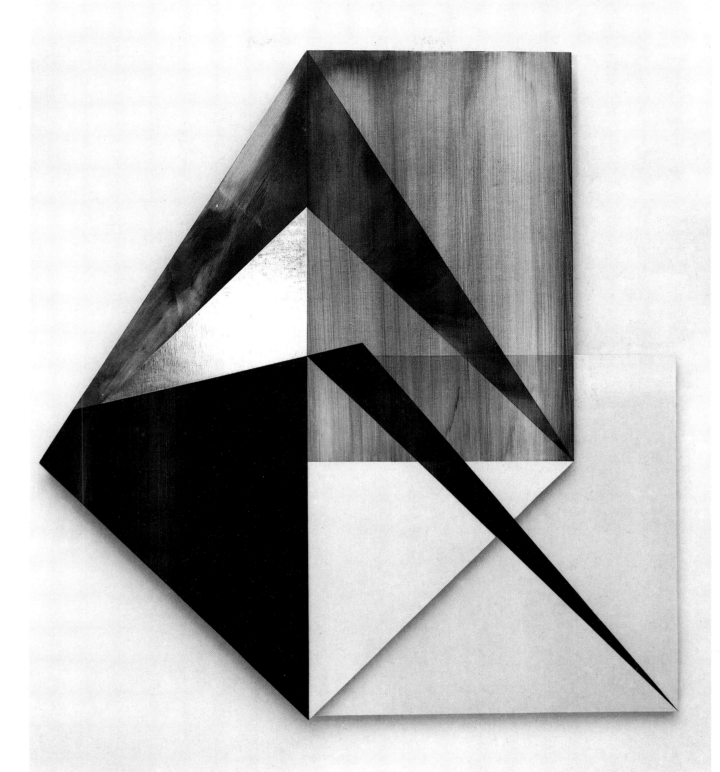

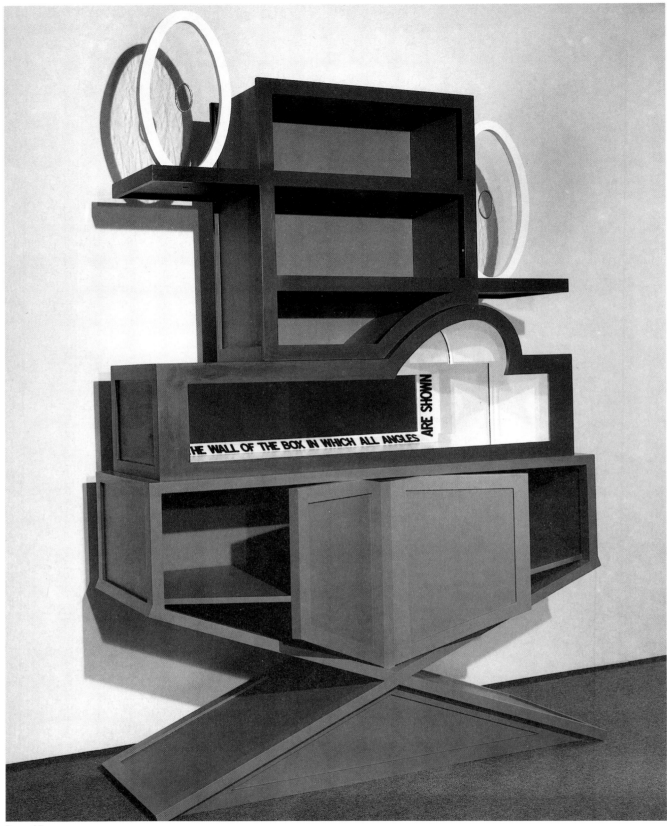

PLATE 87
Siah Armajani
Open Door Buffet with Windows, 1984.
Painted wood with mirror and stained glass, 103½ x 65 x 31".
Max Protetch Gallery, New York.

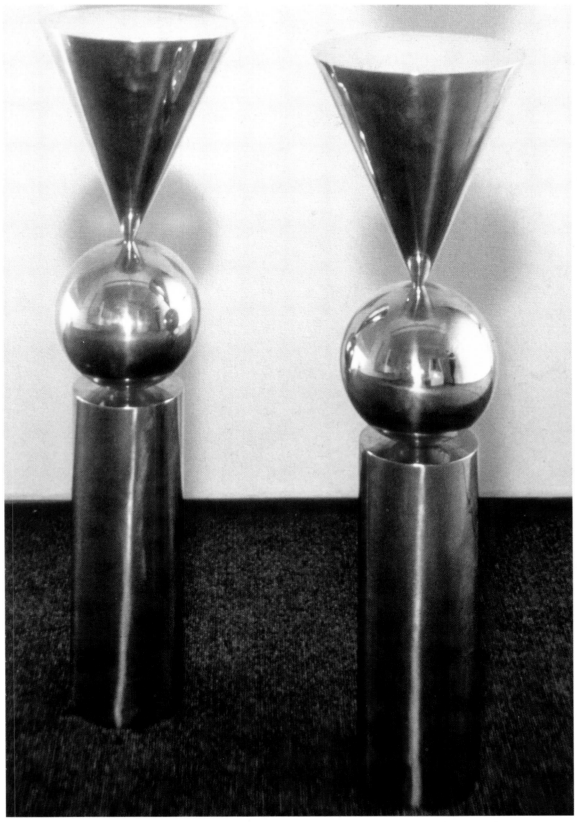

PLATE 88
Scott Burton
Pedestal Tables, 1979–81.
Copper-plated bronze, 37 x 11 x 11".
Max Protetch Gallery, New York.

168

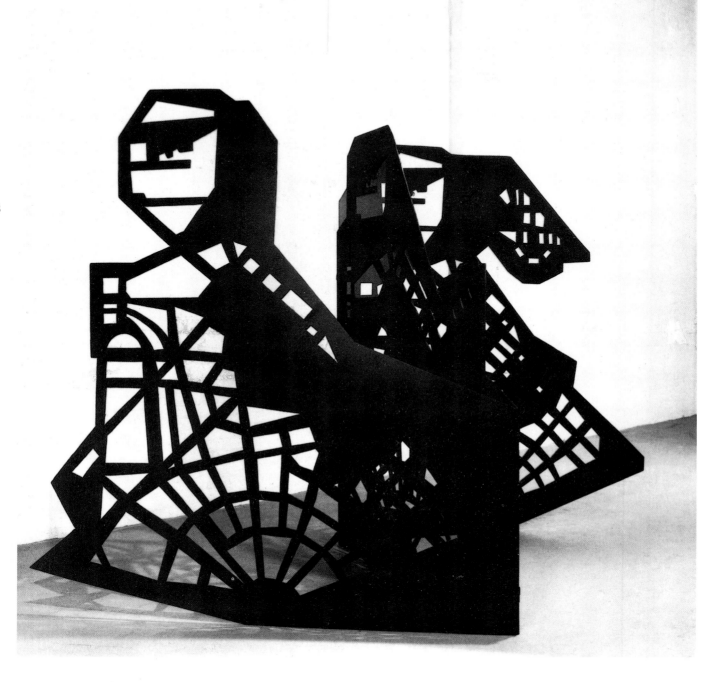

Plate 89
Mary Miss
Screen, 1984.
Painted aluminum, 76 x 96 x 72".
Max Protetch Gallery, New York.

right
Plate 90
Alice Aycock
Fata Morgana (Of Things Seen in the Sky), 1984.
Steel, engine, mirror, neon, 130 x 50 x 70".
John Weber Gallery, New York.

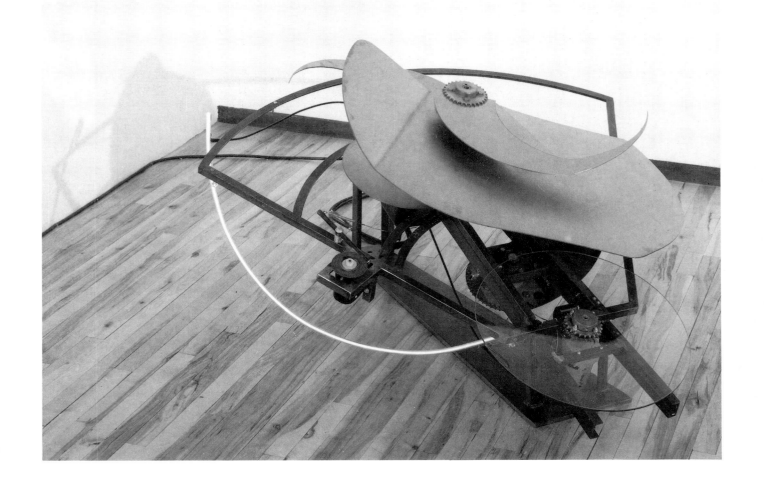

170

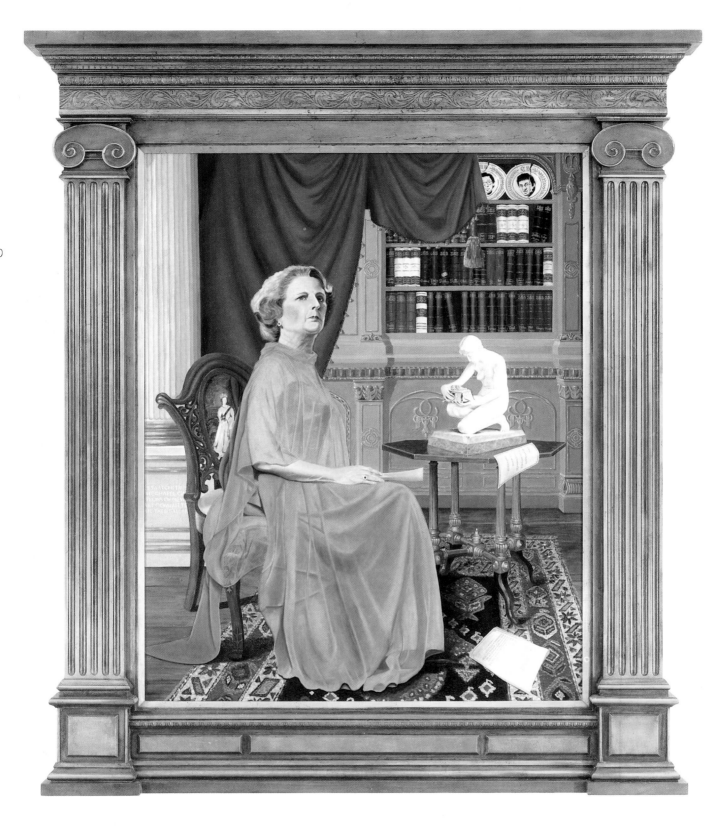

PLATE 91
Hans Haacke
Taking Stock (Portrait of Margaret Thatcher), 1985.
Oil on canvas, wood, gold leaf, with photographs, 95 x 81 x 7".
Collection Gilbert and Lila Silverman, Southfield, Michigan.

Inscriptions:

On the foot of the column, left: ES SAATCHI TRUS/ITECHAPEL GAL/TRONS OF NEW/ ART COMMITTEE/HE TATE/GALLER

On top shelf of the bookcase:
MS, CS.

On the spines of the books in the bookcase: Allied Lyons, Avis, BL, Black & Decker, Blue Nun, British Airways, British Arts Council, British Crafts Council, British Museum, British Rail, Campbell Soup, Central Office of Information, Conservatives British Elections, Conservatives European Elections, Cunard, Daily Mail, Dunlop (acc. lost), Dupont, Gilette, Great Universal Stores, Johnson and Johnson, IBM, Massey-Ferguson, Max Factor, National Gallery, National Portrait Gallery, Nestle, Playtex, Proctor & Gamble, Rank Organization, Rowntree Mackintosh, Royal Academy, South Africa Nationalist Party, Serpentine Gallery, Tottenham Hotspurs, TV-am, United Biscuits, Victoria & Albert Museum, Wales Gas, Walt Disney, Wimpey, Wrangler.

On the paper hanging over the edge of the table:
In the year ended March 31st 1978 Brogan Developers Ltd. (Saatchi Investment Ltd.) sold art works valued at £380,319.

On the paper lying at Thatcher's foot:
Saatchi & Saatchi Company PLC/The year ended September 1982/Furniture, equipment, works of art and motor vehicles/Gross current replacement cost £5,095,000. Tangible net assets are stated at historical cost or valuation less accumulated depreciation. The cost and valuation of tangible fixed assets is written off by equal annual installments over the expected useful lives of the assets: for furniture and equipment between 6 and 10 years. No depreciation provided for works of art.

The initials MS and CS on the rims of the broken plates on the top shelf of the bookcase refer to the brothers Maurice and Charles Saatchi, whose portraits appear in the center of the plates. In 1982 Julian Schnabel, known for his paintings of broken plates, had an exhibition in the same space at the Tate Gallery where the Haacke show was later installed. Nine of the eleven paintings by Schnabel were owned by Doris and Charles Saatchi. At the time, Charles Saatchi was a member of the Patrons of New Art Committee

of the Tate. The Museum is a public institution operated by the British government. While the Patrons are a private association with the goal of acquiring and donating contemporary works to the Tate, they also appear to have influence on the museum's exhibition policies. Among its members are collectors and nearly all London art dealers, as well as the New York dealer Leo Castelli. There have been complaints that the Saatchis have never donated a work to the Tate Gallery.

Charles Saatchi was also a member of the Board of Trustees of the Whitechapel Gallery, another public institution in London. It is suspected that he profited from inside information about exhibition plans of the Gallery, which allowed him to buy works, notably by Francesco Clemente and Malcolm Morley, at a favorable moment. Doris Saatchi, a Smith College graduate and ex-copywriter for Ogilvy & Mather, and her husband Charles began collecting art in the early '70's. Initially interested in photorealism, they shifted their attention to minimalism and neoexpressionism. When the Museum of Contemporary Art in Los Angeles opened in 1983, it invited eight collectors to present selections from their holdings. The Saatchis chose works by Baselitz, Chia, Clemente, Guston, Kiefer, Morley, Schnabel, and Stella. Saatchi & Saatchi made a bid to buy *Art in America* when Whitney Communications offered it for sale.

The financial base for such ventures is the income from the advertising agency Saatchi & Saatchi Company PLC, which has been built by the Saatchi brothers through mergers into the largest British advertising agency and the eighth largest worldwide. In 1982 they acquired Compton Communications, an important New York agency with a worldwide network, and in 1983, McCaffrey & McCall, also of New York. Since then they have bought the New York-based market research firm Yankelowitch, Skelly, & White, the Hay Group, a management consultancy firm of Philadelphia as well as the California agency Cochrane, Chase, Livingston & Co. About half of the revenues appear now to originate in the U.S. Shares of Saatchi & Saatchi are traded on the stock exchanges in New York and London. The Saatchi brothers personally control about 10 percent of the equity. *Fortune* quoted an unnamed advertising associate describing Charles Saatchi as a man with an "insatiable desire to own every-

thing and dominate everything all the time."

Saatchi & Saatchi ran Margaret Thatcher's election campaigns in 1979 and 1983. *The New York Times* wrote that the themes of its political advertisements "tend to be simple to the point of brutality." One of the ads suggested that the Labor Party platform was identical with that of the British Communist Party. Another ad, directed to the Asian and West Indian population, showed a black man with the caption "Labor Say He's Black; Tories Say He's British." Because of the poor record of the Conservative Party in race relations, several West Indian publications in London rejected the ad as insulting. Saatchi & Saatchi was also in charge of the election campaign of the Conservative Party for the European Parliament. After the Tory victory of 1979 Mrs. Thatcher handed the $25 million British Airways account over to the Saatchis, thereby breaking a 36-year relationship with the U. S. agency Foote, Cone & Belding.

The South African subsidiary of Saatchi & Saatchi was hired by the governing Nationalist Party to promote the adoption of a change of the South African constitution. Foes of apartheid say that this change serves as a political smoke screen to confuse foreign critics of apartheid and that, in effect, it cements the racist system, which reserves political power exclusively for the white minority (16 percent of the population).

Doris and Charles Saatchi have opened a private museum in the north of London, designed by Max Gordon, a friend and former colleague at the Tate. A catalogue of the Saatchi collections with contributions from well-known art critics and historians has been prepared by Doris Saatchi, who also writes for the *World of Interiors, Artscribe, Architectural Review,* and is the London editor of the American edition of *House and Garden.* Questions have been raised about art works owned by the company exhibited with labels attributing them to the collection of Doris and Charles Saatchi.

In February of 1984, one month after the opening of the Haacke exhibition at the Tate Gallery, Charles Saatchi resigned his position on the Patrons of New Art Committee of the museum. He also resigned his trusteeship of the Whitechapel Gallery.

(Copyright © by Hans Haacke, 1985.)

172

PLATE 92
John Baldessari
Black and White Decision, 1984.
Black-and-white photographs, gelatin silver prints, 64 x 70¾".
The Eli Broad Family Foundation, Los Angeles.

PLATE 93
Douglas Huebler
Variable Piece No. 70 (in Process) Global Crocodile Tears II: Howard, 1981.
Three photographs, 3 texts; overall 55 x 118¾".
Leo Castelli Gallery, New York.

PLATE 94
Bruce Nauman
Perfect Door, Perfect Odor, Perfect Rodo, 1972.
Neon and glass tubing, three sections each: 21½ x 28¾," edition of three.
Leo Castelli Gallery, New York.

PLATE 95
Joseph Kosuth
Fort! Da! No. 2, 1985.
Duratrans photo process, 72 x 120".
Leo Castelli Gallery, New York.

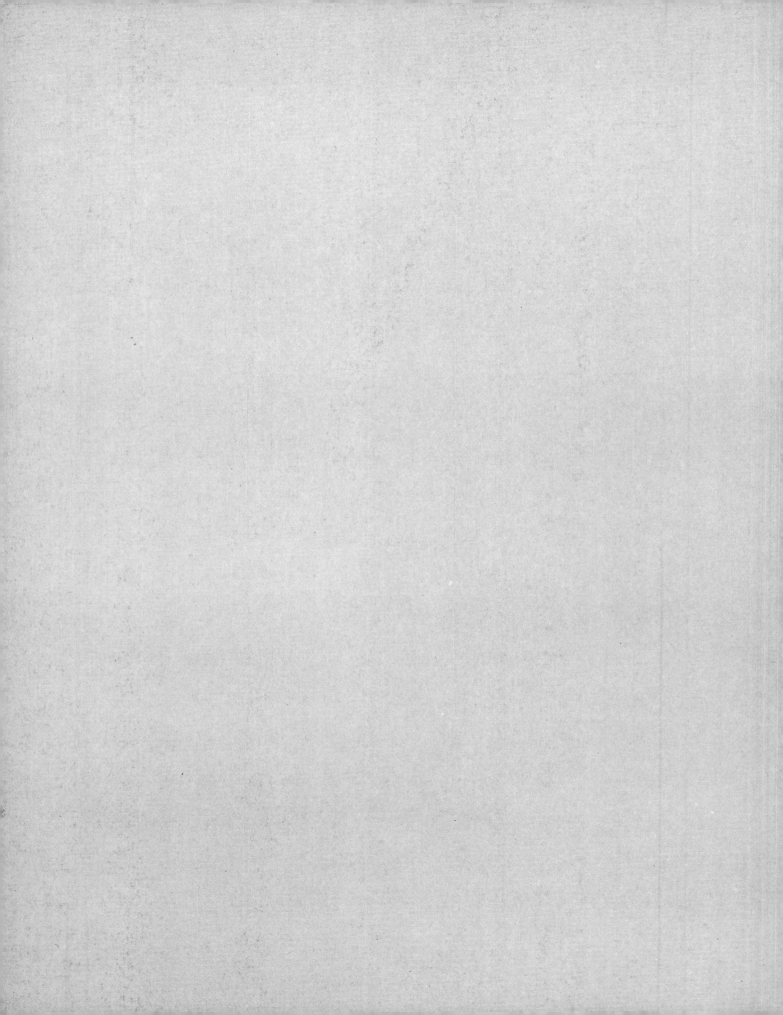

VII
THE ART OF CULTURAL VIOLENCE

Karen Koehler

Painting

Vito Acconci
Nicolas Africano
Ida Applebroog
Jonathan Borofsky
Richard Bosman
Charles Garabedian
Leon Golub
Neil Jenney
Barbara Kruger
Robert Longo
Peter Saul

Sculpture

Robert Arneson
Chris Burden
H. C. Westermann

...artists are like the guardians of culture. I'm totally obsessed with the idea of human value. I feel like I'm contributing to my culture, posing certain questions about living and the pressures of living today.[1]

Robert Longo, 1983

The turbulence of our epoch has caused many artists to confront the violence that surrounds them—focusing on themes of the tempestuousness of our culture, working in styles that are aggressive and impassioned, creating paintings, objects, and environments that are full of the anxiety that permeates our times. Cultural violence is a common theme for many of the artists who are part of the current surge toward recognizable imagery. Sometimes called the New Imagism, this pronounced trend toward representation and figuration has become the avant-garde of the last decade. Many of the artists have, in fact, been producing figurative work since the sixties or seventies—Leon Golub, Peter Saul, and others—yet their intentions can be aligned in many ways with artists whose figurative work has more recently come to the forefront. They share, among other things, an emphasis on narrative content, a reaction against formalism, and a desire to strengthen the relationship of art to society. The new movement as a whole was anticipated by the so-called Chicago style of the Hairy Who group and such Chicago artists as H.C. Westermann and Ed Paschke. In 1959, Peter Selz was curator of an exhibition at The Museum of Modern Art in New York called the ''New Image of Man,'' which included figurative work done in an Abstract Expressionist mode. The new figuration, however, is clearly tied to our specific historical moment, as part of art's internal forces and a product of our social climate.[2]

The revival and reinterpretation of subject matter is part of a need to communicate more directly and less esoterically than did the abstract art that preceded it. New Imagists rely on manipulations of narrative language—on symbol, allegory, and metaphor, as well as specifically visual tropes. Using these tools, they have created an art that is emotionally and visually charged.

The Art of Cultural Violence, while part of the broader movement of New Imagism, nonetheless has its own direction. Artists such as Golub, Bosman, Applebroog, and Borofsky feel the need to create art that is more than emotionally charged—they need that charge to be directed toward specific aspects of social, cultural, or personal relationships. The Art of Cultural Violence stands beside yet within the less activist but equally expressive contemporary movement of

figuration. Like any circle within a circle, the energy is more concentrated and frenetic.[3]

All art is in some ways a product of its social climate, and this is particularly true in times of social transformation and crisis. The plurality of styles that existed in the last two decades is illustrative of the variety of equations that can exist between art and society. But it is also illustrative of the consciousness that modern art and the modern world are in a state of flux and confusion. We have entered the autumn of the twentieth century and self-consciously see ourselves as moving about in the end of an era. The sense of also embarking on a new age—a utopian spirit—that could accompany such an awareness has not yet taken hold. There is an overwhelming sense of doom and desperation that we cannot shake loose. Its grip is all-pervasive, and threatens our basic rights and our very existence. The malevolence is endless: urban violence and crime, threats to privacy and individual integrity, threats to the rights to our bodies, the constant cacophony and numbing effect of media bombardment, corporations devouring each other, international religious fanaticism, small children playing with Rambo dolls, virulent man-made poisons spewing into our air and water, new diseases, guns and no butter, terrorist aggression, and, ultimately clouding over all these issues, utter and complete nuclear annihilation—all these things make it impossible to see beyond our current fears and anxiety.

The emergence, then, in the 1980s of a dominant style of narrative, imagist art might be seen as a need to communicate these fears more directly and less conceptually. It is also tangentially indicative of the need to strengthen the contract between art and potential social and cultural change. That much of the art is aggressive and violent in both subject and style reflects the unfortunate current state of affairs—the real-life violence not only against the individual, but the apocalyptic threat to the very existence of culture.

Different types of cultural violence are expressed. Some artists fairly objectively portray aspects of global and state tensions: the conflict of nations, specific classes, and the constant nuclear threat. Others deal with violence on a more local scale: the violence of the city, people against people, men against women, people against themselves—the violence that is incubated and explodes in the urban heat. In still other cases, the violence is less physical and more psychological: the isolation, depression, and personal torment that is the product of our inability to find self-

actualization, autonomy, self-awareness. These categories obviously interpenetrate and overlap; certain vocabularies, such as the direct use of media images and suggestions of media manipulation, are found in all categories. Indeed, it is the artists' metaphoric connection of these levels of violence that gives the images their resonance and their effectiveness. What does emerge, overall, is the interaction of these various types of cultural violence—whether it be to the individual psyche or the violence that threatens culture in its broadest sense—all are interconnected. And it is here, in art's ability to function multidimensionally, that the potential of art to effect cultural change can be found.

In the past few years, many artists have, in fact, been actively engaged in protest actions and numerous exhibitions with specific political messages, beginning in 1982 with "The Atomic Salon" at Ronald Feldman Galleries in New York, and followed by antinuclear shows at such prestigious places as The New Museum of Contemporary Art in New York. The year 1984 witnessed numerous exhibitions that presented an Orwellian vision of our nuclear future, as well as an unprecedented art-world action in which artists, galleries, museums, and writers organized and presented exhibitions and performances against United States intervention in Central America, led by the group Artists' Call.[4]

The up-front awareness of sociopolitical crises and the artistic expressions that accompanied these events helped to bring attention to and direct the Art of Cultural Violence. Although the artists who work in this mode are now seen as *the* avant-garde (and, significantly, are part of a comparable European movement), art expressing social concern has been a significant aspect of American art throughout the twentieth century.

In the first decade of the twentieth century, the artists who grew up around Robert Henri, known as the Ash Can School, concerned themselves with heroicizing the working classes in the city by choosing them as worthy subjects for painting. In the thirties, such artists as William Gropper, Reginald Marsh, and Raphael and Moses Soyer responded to the social horrors caused by the Depression. In the forties, Edward Hopper captured the essence of urban isolation in his *Nighthawks* (figure 53) and Ben Shahn movingly portrayed the daytime existence of children on the same city streets (figure 54). Even Pop artists in the sixties, such as Andy Warhol, chose to portray aspects of violence in our culture—serializing and thereby devaluing the associations of the electric

chair in his *Orange Disaster* (figure 55).

What separates the Art of Cultural Violence in the seventies and eighties from its antecedents in American art is its critical stance toward the violent relationships in our culture. Today's images are not simply representative, as in the sympathetic style of social realism or in the ambiguous fashion of Warhol's electric chairs. Rather, artists today critically confront the complex, interactive role of art in a culture that is dominated by fragmentation and dislocation, and is fraught throughout with violence. There is a constant equivocation of communication levels in the Art of Cultural Violence, a perpetual transition from the public statement to the private statement, and from the private back to the public. A message can be simultaneously a pronouncement and a confession, an objective and a subjective expression of social content. This quality of the artistic experience requires an examination of both the form and the content with an awareness that the equivocation of the artistic message is a constituent of the fragmentation of the culture.

Leon Golub has always painted in a violent, figurative style. His *Gigantomachies* of the sixties and seventies are expressionistic images of warring classical nudes. His *Vietnam* paintings of 1972–73 deal with more particular events. The more recent *Mercenaries* series is a blending of the specific and the general. These paintings are, according to the artist, "from the contemporary world as given to us by the media"[5]—they evoke the quality of a media experience. Although they are massive in scale, the figures themselves are drawn from fragments of photographs, taken from numerous sources. Some are directly related to the theme, such as those derived from photographs of death squads in El Salvador, or from sado-masochistic magazines. Other photographic sources are less referential—taken, for example, from sports articles. The purpose of the photographs, regardless of their origin, is to create an objectivity, a detached observation that Golub believes is crucial to his paintings. Despite the immediate revulsion we experience when viewing works such as *Interrogation I,* 1981 (plate 107), the abstract fields of colors that make up the background allow the viewer to momentarily escape the brutality of the subject. However, the tensions between the colors and shapes move the viewer back into a dialogue with the subject. The color interactions are echoed in the tensions set up between the figures and the background, pushing them forward, challenging us, and forcing us to recognize the brutal confrontation between the

actual characters depicted: the victim, naked, hung upside down, and his "interrogators" standing fully clothed on either side. Golub's *Interrogators* intentionally attacks our own violent tendencies, our potential to identify with the violence of their actions. The work also expresses Golub's violence in the very way he makes his paintings: after applying layers of paint, Golub dissolves certain areas with solvent, and scrapes down through the paint, in some cases to the raw canvas, using, among other tools, a meat cleaver.

While we might uncomfortably identify with the aggressors, we also identify with the victim. We are all victims of the power structure— political, corporate, interpersonal. The idea of the interrogation is meant to go beyond the characters represented. According to the artist, "One can think about them realistically as figures in the street, images of potential urban terror, or on a conceptual level—how governments deal with their citizens.... They represent power in the abstract, even if they represent power in the specific."[6] The attributes of the *Interrogators* work in a similar way. They point and gesture in an awkward, uncomfortable fashion; they hold their weapons clumsily. Their uniforms and their origins, while recognizable, are unspecific. One has a tendency to associate them with the violence in Central America, yet they are not specifically American, Cuban, South African, or Soviet. For Golub, it's not important what states they repre-

sent. "It's a matter of how power is used. Who really has the power?"[7]

Neil Jenney's painting *Them and Us* of 1969 (plate 106) deals with a similar theme, of powers in opposition. His large canvas shows nothing but two fighter planes, one American and one presumably Soviet, against a blue sky. The candid, simple representation of the subject, spelled out for us in the title carved into the frame, reveals the "literalness" that Jenney strives for. This literalness, however, is significantly different from Golub's complex notion of objectivity. Whereas Golub's levels of meaning reveal themselves slowly, the tensions within *Them and Us* are immediately recognizable. Jenney's painterly style of strokes and drips has been referred to as "finger painting," and the surface becomes a mosaic of brushwork, juxtaposed with and diffusing the theme of warfare. In fact, the airplanes don't appear to be warring at all—they are flying in tandem, in the same direction. The confrontation therefore lies more between the style and the subject than between the nations symbolized. The allover quality of the brushwork energizes the composition formally, and oppositional forces become equalized within the canvas—questioning the narrative and the notions of "them" and "us."

Chris Burden's recent work also deals with war and weapons. His "Cost-Effective Micro-Weaponry" connects war machines—boats, planes, submarines—all created on the miniature

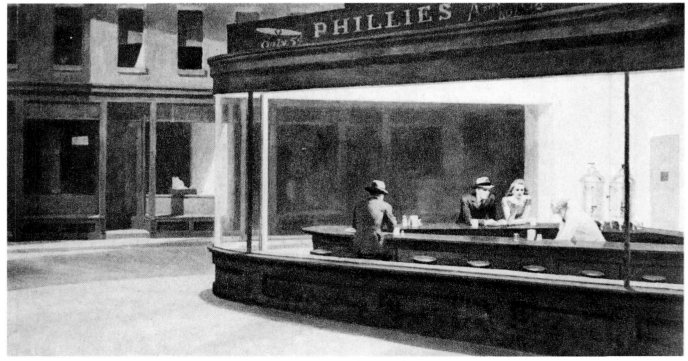

Figure 53. Edward Hopper. *Nighthawks*, 1942. Oil on canvas, 30 x 60". (Not in the exhibition.) The Art Institute of Chicago.

180

scale of children's toy models. Assembled from tinker toys, erector sets, obsolete electric motor components, and various other found objects gathered from the toy room and the work room, they are a strange conglomeration of objects that are the toys of both boys and men. His group of ships entitled *The Nina, The Pinta* (plate 103), and *The Santa Maria* evokes associations with children's toys, and the Columbus idea, of course, smacks of Western imperialism in its infant stages. These toys are in many ways obvious equivalents of governments building weapons, including an especially humorous parody regarding their "cost-effectiveness."

Jamey Gambrell has referred to these ships as "psychological caricatures of military machines seen through the reverse perspective of child-hood."[8] And, as Gambrell points out, while they certainly refer to the notion that those in the Pentagon are overgrown children playing with destructive toys, they avoid being confined to this cliché interpretation. They speak of the institutionalization of military aggression in the would-be harmless toys of our children, yet they are curiously self-reflexive and benign. The beautiful intricacies of their design, the careful color placement, textural contrasts, and repeated forms, the curious meaning-charged relationships that exist between the assembled parts—all these aspects unite to always bring them back to the level of the miniature, the art object. The experience remains narrational and paradoxical.

The active violence of Burden's earlier performance pieces is curiously missing. Since he is known for works in which he fired shots at a Boeing 747, had himself shot, and literally crucified himself to a Volkswagen, it seems strange indeed that he would leave out this level of direct confrontation in his military toys. Yet, because they force us to question our attraction, they are effective statements. The violence is suggestive rather than immediate, and allows us to move beyond questions of what defines the boundaries of art and into the story that lies behind the toys. Or, perhaps, ahead of them.

The performance pieces of Vito Acconci have also been vulgar affronts to our sensibilities. A video piece shows Acconci biting himself and displaying the teeth marks. In a performance installation Acconci masturbated inside a plat-form, speaking of sexual fantasies through a microphone to gallery-goers as they walked across a ramp above the artist. In his "vehicle self-erecting structures" the artist moved closer to the realm of social criticism. His *Instant House* is made up of United States flags on the inside and Soviet flags on the outside. The walls of the house alternately collapse and are rebuilt, activated by a participating viewer who sits inside the house on a swing. What unifies all his work is a challenge to the viewer—we are not allowed to be passive spectators (plate 98). According to Acconci, "I

Figure 54. Ben Shahn. *Liberation*, 1945. Tempera on cardboard, mounted on composition board, 29¾ x 40". (Not in the exhibition.) The Museum of Modern Art, New York.

Figure 55. Andy Warhol. *Orange Disaster*, 1963. Acrylic and silkscreen enamel on canvas, 9'2" x 6'10". (Not in the exhibition.) Courtesy Leo Castelli Gallery, New York.

want to put the viewer on shaky ground so he has to reconsider himself and his circumstance . . . the viewer has to decide if he will accept this kind of aggression or find some way out of it."[9]

Acconci's stance remains relatively ambiguous. In an unsettling way, Burden's "Cost-Effective Micro-Weaponry" finds a black humor in the notions of war and the apocalypse. Robert Morris finds nothing humorous in the idea of nuclear annihilation, and an imposing seriousness is indeed the first impression of his recent sculptures. In his *Firestorm* series (plate 145), Morris combines pastel drawings of swirling, fiery, Turneresque atmospheric explosions with reliefs of human residue left by an atomic storm: skulls, genitalia, breasts, fetuses, and other assorted body parts are encased in a twisted and compressed postnuclear fossil.[10] A master of the dramatic effect, Morris also often includes "the tortured marks of desperately grasping fingers—the fingers of the victims and the artist."[11] The pastels refer to Leonardo's Deluge drawings, copies of which, in fact, Morris included as part of his complex installation *The Natural History of Los Alamos*—along with photographs of the scientists who developed the bomb, and huge sculptural versions of the Four Horsemen of the Apocalypse, astride phallic missile forms. The references in his apocalyptic work to specific images and motifs from the history of art are part of the complex conceptual equation that Morris weaves between art and social and political history. However romantically and symbolically dramatic his works are, they are nonetheless firmly planted in the present. Potential nuclear annihilation remains a constant, ever-present concern: "It's out there, the possibility," the artist states. "Everyday you can find something in the news that reminds you it's there. How can you not think of it?"[12]

Robert Arneson is another sculptor who includes apocalyptic imagery in some of his works. *Holy War Head* (1982) includes a cast of his own portrait as the cloud on an atomic mushroom, his forehead clearly marked as a target. *Holy War Head* is also suggestive of a cinerary urn. Arneson's humorous yet cryptic creatures, half dog, half Arneson, such as *Doggie Bob* of 1982 (plate 100), might be the humble monsters of a radiation-filled planet, or just personal reactions to a world gone haywire.

Richard Bosman's *Panic,* 1982 (plate 99), is also apocalyptic. In a street scene of fire and chaos, with buildings falling into crevices of heaving pavement, panic-stricken people run from the scene, their screaming faces confronting us directly. Bosman, along with Peter Saul, is an artist whose violent themes are about our urban environments, in each case tempered with media-derived vocabularies.

Rendered in a crude style, somewhat evocative of comic strips, Bosman's paintings are about nonspecific violence. *Panic* (plate 99) might be a depiction of a scene taken from a news broadcast, a disaster movie, or a cheap novel, and the street might be in Beiruit, Hiroshima, or West Philadelphia. It is the media world, in which current events and fiction become blurred, the broadcast reality that has, in fact, become our reality—the norm against which we measure all things, and from which we develop our responses to visual stimulation. Bosman draws our attention to the violence of the streets. He creates a strong physical response to the work through the application of harsh and disturbing colors in aggressive, thick passages of paint. The color and luscious handling bring about a private response. But our reactions become desensitized—the painting equivocates unnervingly between the actual violence of our times and the violence of the "entertainment" industry. The creation of a violent art has become so everyday that we no longer respond directly. Nonetheless, Bosman does not allow us to remain comfortable; we cannot escape the reality of the painting, despite our intentional distancing.

There is no way to avoid the grotesque violence of Peter Saul, who assaults us on all levels. His *Subway II* of 1982 (plate 101) is an illustration of the cartoon pornography that characterizes his work. A subway train wreck is ostensibly the subject, although the real theme is that of violence, pure and gruesome. His style is a mixture of Walt Disney and Surrealism: a chainsaw penis cuts one figure in half, while a double barrel shotgun, which is blowing his head off, is held by a policeman being knifed in half by a two-headed man who wears two hats that read "rong" and "rite," who is being blow-torched by another policeman. Day-Glo figures ooze from one into the other, in a distorted, perverted explosion of pornography and violence. There clearly is no wrong and right in this picture; the victim becomes the aggressor becomes the victim. As with Chris Burden's and Vito Acconci's performance pieces, *Subway II* is an affront to our tolerance for morbidity and gore, and a direct challenge to our complacent and uncommitted culture. Bosman and Saul force us to confront our murderous age, where we fear the streets we walk on, yet have learned to regard violence as cliché.

Figure 56. Leon Golub, 1984. Photo: Abe Frajndlich.

Figure 57. Vito Acconci with his *People's Wall,* New York, 1985.
Photo: Abe Frajndlich.

Ida Applebroog's paintings and drawings also rely on a complex synthesis of media forms. There is a correspondence in her work to the sequences of cinematography, and the style often suggests cartoons or film stills. Applebroog explores the psychological violence that permeates the modern psyche; she discloses the anxiety, anguish, and confusion caused by many different sources—the brutality of institutions, our values and our morals, our stereotypes and ourselves.

Applebroog's special criticism has ranged from the politically confrontational to the subtly disarming. In the fashion of Hans Haacke, Applebroog installed a series of portraits at the New York City Chamber of Commerce in 1982. Her unflattering additions to the pictures of such local leaders as Andrew Mellon and John D. Rockefeller were disturbing enough to have the show removed within an hour. On New Year's Eve, 1984, the Times Square Spectacolor Billboard carried Applebroog's holiday message to the crowd below. In an exchange between an elderly man and wife, the man asks, "Life is good, isn't it, Mother?" A poignant silence is followed by an atomic blast.[13]

Her more recent work has included a series of "window-shade" pictures in which the viewer, as voyeur, peers through a window frame with a raised shade or pulled curtains, into the private agonies of Applebroog's characters. Her subsequent series of drawings and paintings, entitled *Inmates and Others,* explores the concept that we are all inmates—captives of our social structures and interactions. These everyday situations are revealed as parallel imprisonments to those endured by people in hospitals and homes for the aged.

One of the most striking paintings in the *Inmates* series is *Wentworth Gardens* of 1984 (plate 96). The central figure is a middle-aged woman in a housedress, gingerly holding a gun in both hands. Her entire figure is rendered in the same brilliant red, juxtaposed against an absolutely bare white background. Applebroog combines an oil wash with a thick impasto, the outlines acting almost as relief. The canvas is divided, and the smaller section contains a man holding a shotgun, and wearing a suit, a tie, and one large glove. The red of the female figure becomes a blood red, a temporal suggestion within the narrative. The symbolic impact of the red develops contextually in relation to the story: the threat of bloody murder or suicide, and the living murder of imprisonment that exists within ourselves. The gun the woman holds is actually a

negative silhouette, suggesting that the woman is, in fact, a prisoner of her own fantasy, as much as she is a prisoner of Wentworth Gardens. Both faces are hauntingly emotionless; the impact comes instead from the tentative way the woman holds her non-weapon and the awkward yet assertive way the man clutches his.

Applebroog refers to her "window-shade" pictures as "do-it yourself projection tests, in which the viewer interprets the action according to his or her psychological perceptions."[14] The same might be said of her *Inmates and Others* series, in which the implied diptych functions pluralistically. The male figure in *Wentworth Gardens* acts as a subplot, underscoring and interacting with the potential violence of the female character. The secondary figure, then, comments on the central one, and creates an internal dialogue. Simultaneously, of course, we are also engaged in a multidimensional visual parlance with the picture. Overall, the effect is one of intentional ambiguity. Every element of the painting—the glove, the guns, the colors, the scale, the application of the paint—functions enigmatically, yet always with an inescapable undercurrent of threat.

The technique of isolating the figures against blank backgrounds and working with narrative series also characterizes the work of Nicolas Africano. His painting *Whiskey per Tutti* (plate 104) is part of his 1980 *Girl of the Golden West* series. Based on the 1910 opera by Giacomo Puccini, the tragedy of these fictional paintings is much less directly expressed than in his *Battered Woman* series of 1976. Nonetheless, they speak of the implied suffering in human relationships, albeit melodramatically. "One must have equal parts of joy for equal parts of sorrow," according to Africano. He also feels that his art should be "purposeful, even useful."[15] *Whiskey per Tutti*, then, must be seen, in the context of his oeuvre, to reveal the emotional paralysis of human interaction which the artist intended.

Visual fictions, in which the associations between images are complex and dislocated, characterize the work of Applebroog and Africano. Charles Garabedian's paintings and prints work in a similar way—questioning the notions of fiction and reality, mirroring our confused and troubled times. We move about as if in a dream or, more accurately, a movie—where we have no control over events that affect the fabric of our lives. We see ourselves as incapable of correcting the atrocities we see taking place in our neighborhoods and on the nightly news.

No artist has expressed the complicated angst of our age more accurately than Charles Garabedian. Works such as *Night Parthenon* and *Ulysses* of 1984 (plate 105) reveal the frantic terror, disillusion, and distorted anxieties of our civilization. Garabedian's figures refer to classical and primitive times, yet they embody the abandonment and traumatic emotional content of the late twentieth century. In *Ulysses*, Garabedian's figure floating alone out to sea is not the triumphant hero of Ithaca, but a naked man turning hesitantly toward us. His pitiful raft is entrapped by nets, his expression one of fear and resignation. In his metaphorical vulnerability, Ulysses is a modern man as much as he is a mythic man—as well as a man trying to hide behind his mythology. Garabedian's Cézannesque treatment of the figure and his sensuous colors serve to magnify Ulysses' predicament, as does the distorted, tilted spatial treatment. Ulysses is not the god-like human being of the golden past; he is the all-too-human man of the present. His past is a series of entwined nets and waters, his destination is unseen. Whereas Abstract Expressionist mythmakers like Adolph Gottlieb and William Baziotes created alternative spiritualities, Garabedian's use of myth shows only the falsehood of mythological systems. Ulysses remains the existential hero, tentatively looking back at his past, floating alone toward an unknown future.

Jonathan Borofsky and Robert Longo also deal with the anxieties of our age—yet in a strikingly more complex and synthetic way. The work of these two artists is certainly very different: Borofsky's work is noisy and expressionistic; Longo's pieces are monumental and distilled. Nonetheless, their approaches to cultural violence are similar in a very important way. Many artists isolate the symptoms of our troubled society, and present a multileveled critique, connecting the various conditions of violence, from the specific to the general. Longo and Borofsky also approach the interconnected relationships that exist between the violent manifestations of our culture. The difference is that their art is as much about the dynamic relationships themselves as about the specific situations they address. The result is a more holistic and gestalt-like experience. The effect upon one's consciousness is therefore both immediate and long-lasting—there is a heightening of one's awareness of the complexities involved in the cultural issues that we face.

Of his work, Borofsky has said, "the side of me which is the core of feeling—the heart, the spirit—is connected with the conceptual side of

me.... I've put the two together, physically and symbolically."[16] Borofsky creates environments that transform these tendencies into alternative realities (plate 97). Upon entering one of his installations, a person is immediately confronted by the complexities of his world view. One finds a room full of larger-than-life moving robotic men; large-scale expressionistic drawings and paintings on the walls, on the ceilings, and leaning at strange angles as objects on the floor; a Ping-Pong table ready to be used; neon forms flashing through the air; sound tracks of melancholic popular music accompanying a massive figure who has the head of a sad clown and the pink body of a ballerina whose pointed toe turns in a continuous pirouette; fliers with political messages scattered throughout, covering the floor. It is impossible to experience a single element of the environment without other aspects interfering. One's attention is constantly dislocated, and the relationships between the objects strain and pull, creating ever new associations as one walks around the installation. Borofsky's moving and talking objects turn into vibrating metaphors of our frenetic contemporary existence—the chaos of our streets, the perpetual bombardment of the media. All the while his environments are tamed through the action of meditative counting: each

piece is numbered in an attempt to create an order, a system within the chaos—as well as a reference to infinity within absurdity. His objects are repetitive: certain themes, certain figures (Man with a Briefcase, Molecule Man, Running Man) are made and remade with slight yet poignant variations. The thought that becomes an image is semantically shifted, each time taking on new connotations. Within a single object or figure, multiple meanings abound—the Running Man is escaping and being chased; the Ping-Pong game is a lighthearted pastime and full of potential aggression. Borofsky's ability to capture the pace of the modern experience is brought about by the constantly shifting juxtapositions of artistic styles, mediums, and scale. The amount of ambiguity and conflict that results from the chaotic atmosphere is simultaneously critical of and the same as the modern frenzy that he confronts. Although scattered and fragmented, the elements of his environments ultimately come together in an allover synthesis, because of the clustering and connecting associations.

Many of Borofsky's reccurring themes are concerned with political issues. Political associations also form between the objects: in one installation he placed a barbecue grill near a painting of a Cambodian woman. In an image

185

Figure 58. Jonathan Borofsky exhibition installation, Paula Cooper Gallery, New York, 1983.

approximating a self-portrait, he placed within his own head a picture of the Polish radical Lech Walesa. His painting entitled *2,841,778 Male Aggression Now Playing Everywhere* of 1981–83 (plate 97) displays a striding man who is both Borofsky himself and an archetypal male, with a series of weapons replacing and representing his phallus. This man becomes, then, a symbol of violence, oppression, and anxiety—things of which the man himself and the viewer are both victims, raising issues of the psychological dilemmas that are the cause and the result of political awareness.

Robert Longo's work is equally complex. Architectonic sculptures such as *Friends* of 1985 (plate 108) contain a juxtaposition of styles and media that forms a dialectical synthesis of rationality and expressiveness, as do Borofsky's all-over environments. The different elements of Longo's *Friends* of 1985 (plate 108) at first, in fact, seem rather disparate. Two large nudes form the side panels, realistically rendered in a photographic style. While one figure is male and the other female, they both appear to be androgynous, indicating, according to Longo, the equality of the sexes.[17] One figure is upside down, and the sense of placement in space is unclear; as the figures twist and turn in their poses, their relationship to each other is also circular. The top center panel is a Duratrans photograph of a flame, which rises out of green leaves cast in plaster, tightly arranged in another square panel. The back of Longo's tableau is a series of minimalist steel cubes that contradict yet heighten the imagistic front of the piece. On a specific level, this work is intended to be a monument to his friends and an altar vaguely referring to his father's death. On a more universal scale, his juxtaposition of the flames and leaves suggests such simple interpretations as the forces of earth and fire. The figures themselves are simultaneously orgiastic and tortured. In his transposition of these concepts into graphite drawings and plaster casts of plastic leaves (one more step removed), Longo both neutralizes and intensifies potential meanings. The steel back of the piece functions as an abstract monument, yet is oddly robotic and machine-like, transforming itself in relationship to the front of the piece. Longo intentionally sets up this conflict and metamorphosis: the front of the work is meant to bleed meaning, to express a fullness of emotion, while the back is curiously dispassionate and numbing. All the while, then, the spaces affect each other—the back gives resonance to the front, the front in turn gives meaning to the back— just as the various imagistic components impart

multidimensional meaning to each other.

Longo's work is highly theatrical and operatic. Yet his techniques create a curious distancing, a purified kind of expressiveness. His figures are taken from photographs that are transferred into the piece with the intermediary assistance of an illustrator, thereby incorporating the uncommitted hand of a commercial artist. The sculptural elements are made with the help of a foundry and studio assistants. The result of this method is to further enhance the distancing, chilling his themes, neutralizing the objects, and turning them into archetypes. One would expect that this distancing would make his images emblematic. On the contrary, it helps to set up the metaphysical interaction that takes place between the objects, a poetic yoking together of disparates that then infects the entire piece with an invisible electric charge, an urgency that is mysteriously frozen.

The word "VALUE" is prominently embossed on the front of *Friends,* enigmatically both giving and taking meaning: our society is becoming increasingly valueless, yet the distilled intensity of Longo's figures and their elemental altar is very much about those basic things that *have* value, and should *define* our values, although exactly what those things are remain below the surface

Figure 59. Robert Longo, New York, 1985. Photo: Richard Leslie Schulman.

and unrealized. In fact, their struggle to come to the surface is yet another complex aspect of this sculpture—the struggle of our existence, the confusing signals of coldness and passion that we encounter every day. Longo believes that we cannot avoid the violence that surrounds us in the city and bombards us across the air waves; furthermore, the artist has a duty to confront cultural violence as a guardian of that culture.

Longo captures the quality of the media experience in his tableaux, accepting yet questioning its artistic role. By using media sequencing, Longo and Borofsky reveal their sensitivity to the schizophrenia of our culture. And, though they are critical of the media experience, they are nonetheless perceptually and conceptually adapted to it. They directly interfere with the message and the role of the media by drastically altering the content of publicly consumed culture. In the work of these two artists, one finds a commitment to popular culture, coupled with a conscious awareness of its destructiveness.

In a similar way, Barbara Kruger blatantly adopts a media format. In works such as *Untitled ("Your Fictions Become History")* of 1983 (plate 109) her message is broadcast in the style of an advertisement, and the word becomes the primary rather than the secondary element. Her pictures are a complicated equation of literalness and ambiguity. She takes a critical view of our sexist culture, and directly addresses the audience with a statement intended to make us rethink the tenets of society.

In a recent study of contemporary imagery, Marcia Tucker states: "Violence, in all possible forms, is perhaps the most prevalent theme in recent painting."[18] In response to the new trend toward expressive figuration, Hilton Kramer wrote, "Every genuine change of style may therefore be seen as a barometer of changes greater than itself. It signals a shift in the life of a culture—in the whole complex of ideas, emotions, and dispositions that at any given moment governs our outlook on art and experience."[19] The violence in art today is clearly a response to the violence in our culture. Are we to conclude, then, that all is not well with the world and continue on our depressed, isolated, fearful and media-mesmerized way, all the while followed by our nuclear shadows?

This exhibition offers within itself perhaps a better vision. It begins with the dynamic growth of Abstract Expressionism and culminates with the new work of artists who portray the violence of our society. In art one finds the need to affirm the value of ongoing culture. Perhaps within that continuous renewal of artistic energies we can glimpse the forces that will move us forward to a less violent future.

NOTES

I wish to express my thanks to Gary Orlinsky for his helpful and sensitive insights into the art, and to the staff of the University Gallery, University of Massachusetts, for their gracious assistance.
1. Robert Longo in Michael Brenson, "Artists Grapple with New Realities," *The New York Times*, May 15, 1985, sec. 2, p. 30.
2. Numerous and significant exhibitions have helped to substantiate the trend and advance its causes, including "New Image Painting" in 1978 at the Whitney Museum of American Art, and "The Figurative Tradition," also at the Whitney, in 1980. In 1982, "Eight Artists: The Anxious Edge" at the Walker Art Center in Minneapolis; "Focus on the Figure" at the Whitney; "New Figuration in America" at the Milwaukee Art Museum; "The Figure Beside Itself" at the University Gallery, University of Massachusetts/Amherst; and "Figuration" at the University Art Museum, University of California, Santa Barbara, were among the important imagist shows. In 1984, the Hirshhorn Museum and Sculpture Garden at the Smithsonian Institution presented the ambitious exhibition "Content: A Contemporary Focus, 1974–1984." The American Pavillon at the Venice Biennale, "Paradise Lost/Paradise Regained: American Visions of the New Decade," concerned itself with New Imagism's interpretation of the "American Dream." In addition to this brief selection, there were also numerous important shows in private galleries that helped to institutionalize the new interest in figuration and imagery.
3. An appropriate comparison is the case of German Expressionism, which was much more activist after World War I than before the war. The need to bring about an awareness of sociopolitical issues was seen as an essential component of all art-making.
4. Other recent political art shows include the 1983 "Art for a Nuclear Weapons Freeze," an exhibition and auction at Brooke Alexander, Inc. in New York; "Disarming Images: Art for Nuclear Disarmament," an exhibition organized by Bread and Roses and circulated throughout the U.S. by the Art Museum Association of America, 1984; "The Shadow of the Bomb," a joint exhibition at the University Gallery, University of Massachusetts/Amherst, and the Mount Holyoke Art Museum, South Hadley, Massachusetts, also in 1984. In January 1985, Political Art Documentation/Distribution organized a series of events to coincide with the inauguration— "State of Mind/State of the Union."
5. Leon Golub, in Mathew Baigell, "'The Mercenaries': an interview with Leon Golub," *Arts Magazine* (May 1981), p. 167. See also

Corinne Robins, "Leon Golub: The Realm of Power," *Arts Magazine* (May 1981), pp. 170–73; Carter Ratcliff, "Theatre of Power," *Art in America* (Jan. 1984), pp. 75–82, and Jeanne Siegel, "Leon Golub/Hans Haacke: What Makes Art Political?" *Arts Magazine* (Apr. 1984), pp. 107–113.
6. Baigell, pp. 167, 168.
7. Ratcliff, p. 8.
8. Jamey Gabrell, "Disarming Metaphors," *Art in America*, Jan. 1984, p. 84. See also Sally Yard, "The Shadow of the Bomb," *Arts Magazine*, Apr. 1984, p. 81.
9. Vito Acconci, in Ellen Schwartz, "Vito Acconci," *Art News*, Summer 1981, p. 94.
10. For a description of how Morris's new and apocalyptic work reflects concerns of his long and stylistically varied career, see Philip Patton, "Robert Morris and the Fire the Next Time," *Art News*, Dec. 1983, pp. 84–91.
11. Robert Morris, in Patton, p. 86.
12. Ibid., p. 90.
13. For a discussion of these events see Linda McGreevy, "Under Current Events: Ida Applebroog's Inmates and Others," *Arts Magazine*, Oct. 1984, pp. 128–131.
14. Ida Applebroog, in Helaine Posner, *Domestic Tales*, exhibition catalogue, University of Massachusetts/Amherst, Amherst, 1984, p.8.
15. Nicolas Africano, in Mitchell D. Kahan, *Nicolas Africano: Paintings, 1976–1983*, exhibition catalogue, North Carolina Museum of Art, 1983 pp. 10, 13.
16. Jonathan Borofsky, in *Content: A Contemporary Focus, 1974–1984*, exhibition catalogue, Hirshhorn Museum and Sculpture Garden, Smithsonian Institution, Washington, D.C., 1984. Contributions by Howard N. Fox, Miranda McClintic, Phyllis Rosenzweig.
17. Conversation with the artist, Metro Pictures, New York, July 10, 1985.
18. Marcia Tucker, "An Iconography of Recent Figurative Painting: Sex, Death, Violence, and the Apocalypse," *Artforum*, Summer 1982, p. 75.
19. Hilton Kramer, "Expressionism Returns to Painting," *The New York Times*, July 12, 1981, sec. 2, p. 1. It is important to distinguish, as well, that art can be more than a passive "barometer"—it can be an agent of change.

right

Plate 96
Ida Applebroog
Wentworth Gardens, 1984.
Oil on canvas, 100 x 100". Two panels: 100 x 33½" and 100 x 66½".
Ronald Feldman Fine Arts, New York.

Plate 97
Jonathan Borofsky
2,841,778 Male Aggression Now Playing Everywhere, 1981–83.
Acrylic on canvas, 109½ x 83¾".
Collection Suzanne and Howard Feldman, New York.

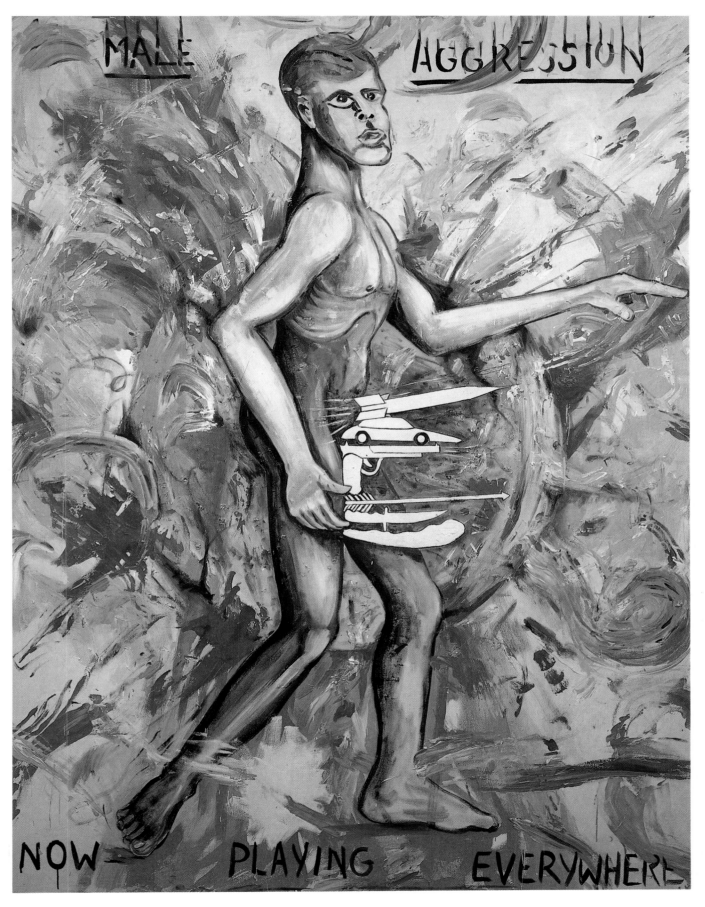

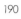

190

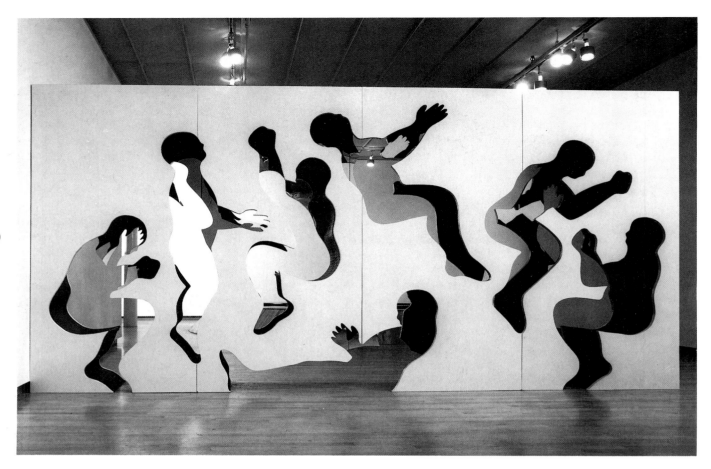

Plate 98
Vito Acconci
People's Wall, 1985.
Painted wood, quilted fabric, rubber flooring, mirrored Plexiglas,
96 x 192 x 27".
Carpenter + Hochman Gallery, New York.

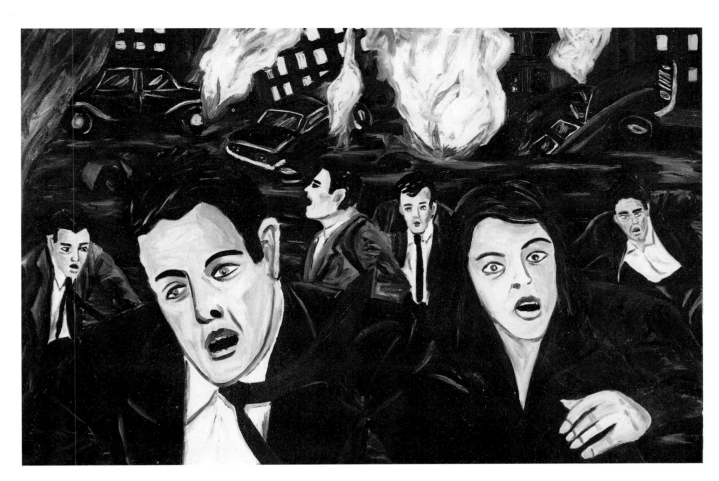

Plate 100
Robert Arneson
Doggie Bob, 1982.
Glazed ceramic, 36 x 33 x 21".
Allan Frumkin Gallery, New York.

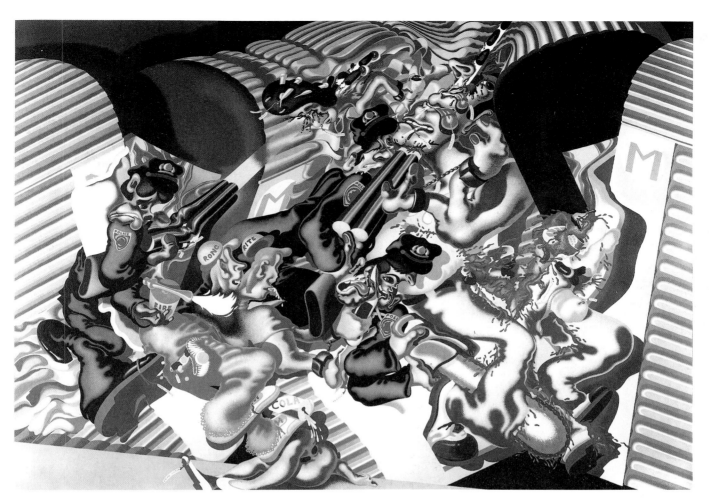

PLATE 101
Peter Saul
Subway II, 1982.
Acrylic on canvas, 78 x 106".
Allan Frumkin Gallery, New York.

PLATE 102
H. C. Westermann
Battle to Death in the Ice House, 1971.
Wood, rope, glass, mixed mediums, 32 x 26 x 20½".
Allan Frumkin Gallery, New York.

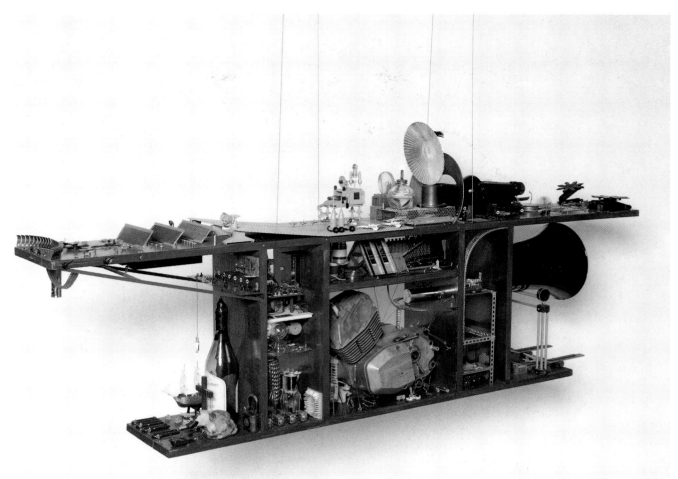

PLATE 103
Chris Burden
The Pinta, 1982.
Wood, toys, motorcycle engine, paint, and electronic parts,
30 x 70 x 10½". Ronald Feldman Fine Arts, New York.

PLATE 104
Nicolas Africano
Whiskey per Tutti, 1980.
Acrylic, oil, enamel, and magna on Masonite, 48 x 84".
Collection Holly and Horace Solomon, New York.

right
PLATE 105
Charles Garabedian
Ulysses, 1984.
Acrylic on canvas, 90 x 66".
Hirschl & Adler Modern, New York.

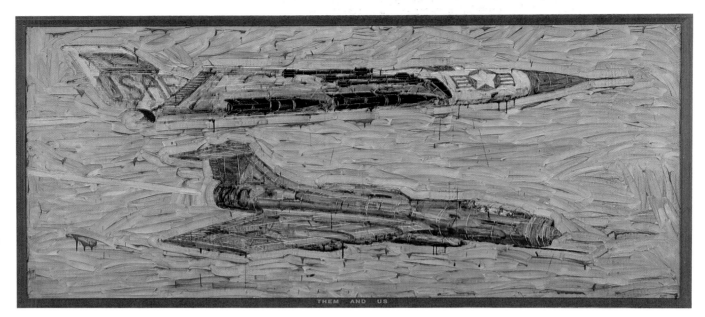

PLATE 106
Neil Jenney
Them and Us, 1969.
Acrylic on canvas, 58½" x 11'3".
The Museum of Modern Art, New York,
Gift of Louis G. and Susan B. Reese, 1985.

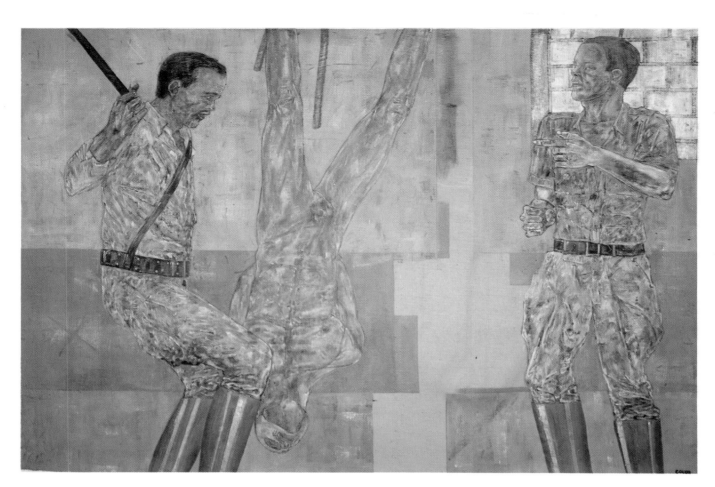

PLATE 107
Leon Golub
Interrogation I, 1981.
Acrylic on canvas, 120 x 176".
The Eli Broad Family Foundation, Los Angeles.

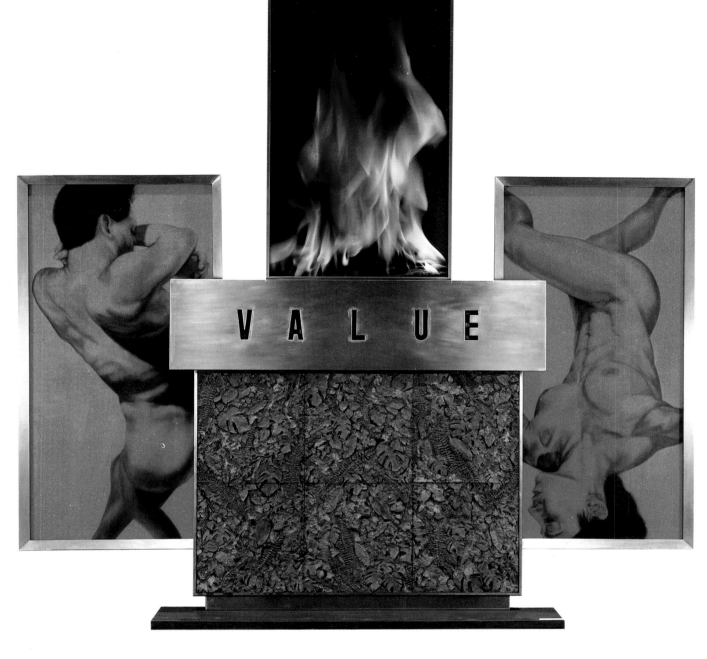

PLATE 108
Robert Longo
Friends, 1985.
Charcoal, graphite, and dye on paper, plastic, steel, 191¾ x 189 x 7".
Metro Pictures, New York.

right
PLATE 109
Barbara Kruger
Untitled ("Your Fictions Become History"), 1983.
Photomontage, 120 x 96".
Annina Nosei Gallery, New York.

VIII
PATTERN AND
DECORATION

Sam Hunter

Painting

Robert Kushner
Kim MacConnel
Rodney Ripps
Robert Zakanitch
Joe Zucker

Sculpture

Judy Pfaff
Ned Smyth

As we have seen in Richard Sarnoff's essay on realism, there were clearly irrational visual and intellectual crosscurrents at work in the New Realism, operating in a complex tension with the ironist qualities of both contemporary abstraction and Pop Art rather than in association with traditional realism.[1] By 1974 the conservative and ambivalent mode represented by illusionistic Photo-Realism had developed into a reaction against Minimalist aesthetics fully as dramatic as Conceptual, Technology, and Environmental art. The shift in artistic sensibility had become a dominant factor, and seemed to reflect a spirit of skepticism, a mood that challenged many of the deepest assumptions fundamental to the general hopefulness and progressive approach characteristic of modern art up to that time. It was as if optimism about humanity's future, faith in technology, and quasi-scientific belief in purity, logic, and formal procedures had all lost credibility as intrinsic values in the realm of artistic expression. A true catalyst, the change generated two distinctive new impulses. The first came with the emergence of the decorative/ornamental tendency in painting, variously referred to as Pattern Painting, Pattern and Decoration, or, more familiarly, P&D. The second tendency, which is analyzed by Kim Levin in the next essay, brought a return to imagery of an explicit kind, usually expressionist or surreal in form and content, and it burst upon a generally delighted public in the "New Image Painting" exhibition held at the Whitney Museum of American Art in 1978. Despite the parochial and nationalistic nature of that setting, New Image art developed in a close parallel with artistic events already under way in the European "trans-avant-garde," as the Italian art critic Achille Bonito Oliva had designated the new international movement.

These fresh departures have proved far less tidy and controlled than the self-reflexive aesthetics of Minimalism and Post-Painterly Abstraction, or the criticism that had upheld and expounded the virtues of such work. Art abruptly turned away from intellect, theory, and what the younger generation felt to be a constricting concept of painting and sculpture as objects in a world of objects. Like their colleagues of Conceptual Art and Environmental Art, younger artists interested in ornament and image sought inspiration in the natural world, but they also embraced human nature, as well as ideas, poetry, and personal vision. Instead of the hard, clean edges of geometry and the pristine surfaces of Primary Structures, the new P&D reveled in kitsch, in

representational strategies of a rudimentary and primitive character, in cheesy textures, loud colors, and cheap materials scavenged from Canal Street shops in New York. These eclectic, primitivist surfaces interacted with more private signs and meanings, wit and humor, and even with a deliberate pose of defiant eccentricity. The new bohemia would be politically subversive, populist, reactionary, and deceptively simplistic in its values, occasionally given to irony but more often cultivating an unsophisticated pose. Above all, these artists were determined to claim their liberation from the stifling orthodoxies of impersonality and purism of the 1960s.

At the core of this post-modern sensibility was a certain ambivalence not only about politics, technology, and twentieth-century aesthetics in general, but also about the notion of moving backward (reflected in deliberately archaic styles and the affectation of "bad" painting, as well as in illusionism and patterns) while simultaneously going forward into an uncertain future. In this time of extreme artistic diversity and almost rampant eclecticism, work of high quality still goes on in formalist abstraction, as we shall see, but ideological purism no longer rules the day.

By 1975 decoration had become a common feature in the work of a whole group of artists, among them Joyce Kozloff, Tony Robbin, Miriam Schapiro, and Robert Zakanitch (plate 113), who regularly met, along with the art critic Amy Goldin, to share their interests. According to the critic Carrie Rickey, writing on the origins of the decorative movement in an article for the June–July 1980 issue of *Flash Art*, the term "Pattern Painting" was coined by Mario Yrissary. Yrissary, a painter of repeating geometric motifs in optically active colors, also organized the first systematic group discussion on the topic in New York. It came as part of the accelerating reaction among younger artists against the perceived tyranny of Minimalist values, and while this development filled the art scene with conflicting tendencies, it nonetheless brought a sense of resurgent energy, with a felt need for the exchange of ideas.

Pattern Painting utilized a wide variety of surfaces and crude cartoon-like images that were equally reminiscent, it then seemed, of Matisse's high-art cutouts and of debased urban graffiti, perhaps most evident in Kim MacConnel's bright and irreverent *U-Totem* (plate 111). Then the new Decoration revealed one of its most interesting aspects, in the variety of materials the artists managed to incorporate in their works—paper, cotton, cheap printed fabric, and second-hand

Figure 60. Robert Kushner dressed in the costume he designed for the performance "Every Day Is Sunday," 1972. Photo: Harry Shunk.

Figure 61. Judy Pfaff in her New York studio, 1982. Photo: Waring Abbott.

furniture. The humble materials spoke on one level of the studio world's condition of impoverishment among emerging young artists of the seventies, while at the same time they also celebrated a new and somewhat "funky" eclecticism, evoking Chinese, Indian, and Islamic folk sources. All of these elements were then translated into an improvised and cheerfully makeshift vernacular style. The loose tapestries and emblematic signs and images, particularly in the work of Kim MacConnel and Robert Kushner, also achieved an impressive opulence and complexity, despite the plebeian fabrics, and thus directly challenged the formalist austerities of Minimalism.

Pattern and Decoration, like some of the more expressionist and symbolist forms of the 1970s, grew out of the subculture of New York City's alternative exhibition spaces and the privately operated lofts in which the first important public manifestations were hatched. One of the most important of the downtown havens was 98 Greene Street, known by its address, in the manner of Stieglitz's legendary 291, which also had been dedicated to the encouragement of avant-garde experiment. Horace and Holly Solomon, now known for their commercial art gallery, opened this noncommercial loft space in the fall of 1969. Over the next four years they devoted themselves to presenting a variety of artistic expression and experience, including performance pieces by Billy Apple and Anna Lockwood, Bill Beckley, Jackie Curtis, Dan Graham, Robert Kushner, Gordon Matta-Clark, and Dennis Oppenheim, as well as Holly's own *Footnotes to Macbeth* and *Boxing Match*. Charles Simonds and Thomas Lanigan-Schmidt, as well as Matta-Clark, created installations and showed sculptural objects. Brad Davis, Susan Hall, Denise Green, Roger Welch, and Stephen Shore, among others, showed paintings, drawings, photography, and texts, and also a number of poetry readings were organized.

Some critics have ascribed responsibility for the influx of Pattern and Decoration to Frank Stella and Lucas Samaras, whose mid-seventies paintings blurred the distinctions between the decorative and the expressive, high and low art, avant-garde and graffiti and kitsch. Today, the explosive rehabilitation of old, consecrated values in art continues, and many link it to a wider cultural consciousness of past artistic styles, a vision particularly rooted in the cultures of the East, as well as in the rich heritage of crafts arts.

Carrie Rickey, in her seminal essay in the

205

catalogue of the 1980 exhibition "Dekor," characterized the new decorative trend as "Maximalism," to suggest that P&D artists were responding negatively but exuberantly to the prevailing aesthetic order, with a novel art far more complex in surface, and with vibrant color, ornament, and a greater variety of design, than anything allowed by the reductive Minimalism. But there were, of course, considerable differences among the artists. Ned Smyth, for instance, continues to espouse a spiritual rather than a stylistic idea.

> *Decoration has been a move away from rational and elitist expression towards an emotional and humanist interpretation. Decoration is particularly valid not because it takes a "low art" and makes it high but because decoration is a rich tradition invented to communicate. Decoration is a vehicle that acknowledges our past and glorifies the environment that has supported us.[2]*

Humanist sentiment is strongly emphasized in Smyth's recent large-scale drawings and such dramatic and poignant wall mosaics on traditional themes as his *Expulsion* (plate 110). In other recent monumental reliefs, as well as drawings, Smyth has shown nude men and women in various attitudes silhouetted against a checkerboard background reminiscent of Assyrian art. His current human imagery and earlier animal grotesques reflect various moods that derive from individual emotion—alertness, calm, fear, aggression—yet attain the status of archetypes. Man the predator and man the victim of natural forces or animal assault play off, in Smyth's mythologies, against man as an embodiment of civilized values.

As early as 1972 Robert Kushner and Kim MacConnel were experimenting with found and painted fabric. For his performance pieces Kushner designed strikingly original and fantastic costumes that combined high-fashion artifice and a kind of *grand guignol* melodrama. In one particularly flamboyant performance, Kushner added fresh produce to his set piece and called it *Robert Kushner and His Friends Eat Their Clothes*. Of course, such personal and extravagant theater contained a strong and conscious element of parody directed at Minimalist severity and the visual impoverishment of Conceptualist performances. By focusing on the human body and on materials related to it, Kushner blazed a new trail into realms of feeling, drawing on associations with heretofore ignored or downgraded areas of art history. Symbolically, he also indicated new ways of mastering the shabby downtown environment. Recent work, such as *Ride* (plate 114), shows a more seductive approach to the human figure,

set adrift on a ground of layered and luxurious ornamental motifs.

Joe Zucker's half-humorous and childlike but also highly formalized painting *Successful Pirates* (plate 115) mixes metaphors of play and commercial techniques in a successful assault on the School of Paris taste fetish. Cotton wadding, combined with gelatinous Rhoplex glazes, creates a decorative glut; within an intricate web of linear exposition, of the kind of imagery customarily found in boys' action comic books, we are nonetheless reminded of serious artistic issues. By a subtle adjustment of style and content, the work manages to convert a simplistic exercise of a new decorative primitivism into both an homage to and a criticism of Pollock's more grandiose and frenzied Action Painting style.

Judy Pfaff (plate 112) is an unusual, highly individual artist of the Pattern and Decoration tendency. Indeed, she should be viewed more an heir of Pollock's unstructured allover fields than the follower of traditions established by Stella or by Matisse in his late cutouts. Pfaff deliberately creates a riotous experience of form and color in deep space or in high wall relief—brilliantly varied, knowingly tacky in its materials (plastic, reflective Mylar, contact paper in spiraling loops, wire mesh, and even personal memorabilia), all suspended in a kind of transparent, theatrical, and tinseled grotto, palpitant with controlled

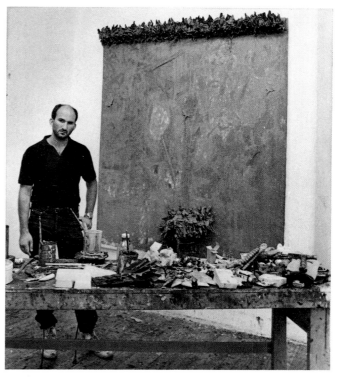

Figure 62. Rodney Ripps in his New York studio, 1985. Photo: Wendy Worth.

baroque energies. Yet, from this unpromising chaos of cheap materials, flung every which way, she commands a visible formal coherence, and is capable of articulating a nuanced visual vocabulary of impressive richness and diversity. Her art combines the spatial control and formal bravado of the fifties, recalling the Abstract Expressionists, with the fuller color, expressive range, flash, and informational overload of the eighties.

Rodney Ripps has also adopted the new vernacular taste, successfully transcending the barriers between high and low art. His distinctive expression today consists of constructions that partake of attributes characteristic of both painting and sculpture. To achieve this, he customarily mixes pigment liberally into a wax medium and then coats his fabric and wire forms so heavily that they present themselves as crudely modeled sculpture. On another level, the gaudy use that Ripps made in the past of mundane, non-art materials put his work in proximity to deliberate kitsch. In the late seventies, however, Ripps's gestural and gaudy inventions began to evolve into rather surprising, grand, and ambitious high-relief structures of a distinctly expressionist and clearly figurative nature.

In a recent exhibition in New York, Ripps explored an even more promising and original terrain of monumental abstraction, which carried distinct landscape associations. *Mountain (The Guardian)* (plate 116) is a work from a new phase of his development. Here he has created broad expanses of subtly inflected surface in nearly monochrome yellows, with touches of gray and green, enlivened with faint brush and knife marks that recall the variegated surfaces and jagged forms of Clyfford Still, as well as the genre of the American "Abstract Sublime," first defined in print by the art historian Robert Rosenblum in a celebrated article.

Ripps's textured surfaces negate illusionistic space and concentrate attention on themselves, yet they also manage to convey a vision of a broad, romantic, Western landscape. The vivid impression of the presence of nature is wrung from a visible "history" of the alternately onerous and exalting paint process. Elements of bravura and drama are introduced by the imposition of a mixed nature/architectural element of painted relief construction set out in clumps of obtrusive leaves thickly impasted in encaustic. These curious forms can be viewed alternately as metaphors for wreaths, cornices, or a surmounting crown in works of increasingly subtle and expressive brushstroke and metaphoric power. This new body of work has identified Ripps as one of the more serious and probing artists in a rapidly maturing younger generation of painters of impressive distinction, who feel deeply bound to the great traditions of modern Western painting, despite their earlier vernacular orientation.

207

NOTES

1. This essay on Pattern and Decoration has been adapted in part from Sam Hunter and John Jacobus, *Modern Art, Painting, Sculpture, Architecture* (New York, 1985), Chapter 22, "Post-Minimalism in Painting and Sculpture: From Environments to Neo-Expressionism," pp. 374–377.

2. Unpublished interview by the author with the artist, June 1981.

PLATE 110
Ned Smyth
Expulsion, 1985.
Mosaic, stone, and glass on plywood, 84½ x 97 x 5½" overall.
Holly Solomon Gallery, New York.

PLATE 111
Kim MacConnel
U-Totem, 1984.
Acrylic on cotton, 96 x 108".
Holly Solomon Gallery, New York.

210

PLATE 112
Judy Pfaff
Untitled, 1984.
Mixed mediums, 68 x 99 x 35".
Collection Leonard and Gloria Luria, Miami.

right
PLATE 113
Robert S. Zakanitch
Hoedown, 1983.
Acrylic on canvas, 109¾ x 85¾".
Robert Miller Gallery, New York.

212

top
PLATE 114
Robert Kushner
Ride, 1985.
Cast paper, 3 panels in one frame: 43¾ x 85".
Holly Solomon Gallery, New York.

bottom
PLATE 115
Joe Zucker
Successful Pirates, 1979.
Cotton, acrylic, Rhoplex on canvas, 60 x 96".
Collection John Solomon, Los Angeles.

right
PLATE 116
Rodney Ripps
Mountain (The Guardian), 1985.
Encaustic and oil on linen, 104 x 74".
Marisa del Re Gallery, New York.

IX
APPROPRIATING THE PAST: NEO-EXPRESSIONISM, NEO-PRIMITIVISM, AND THE REVIVAL OF ABSTRACTION

Kim Levin

Painting

Gregory Amenoff
Donald Baechler
Jean-Michel Basquiat
Troy Brauntuch
Eric Fischl
Jedd Garet
Jack Goldstein
Philip Guston
Keith Haring
Malcolm Morley
Robert Morris
Robert Moskowitz
Elizabeth Murray
Katherine Porter
Judy Rifka
Susan Rothenberg
David Salle
Kenny Scharf
Julian Schnabel
Sean Scully
Frank Stella
Gary Stephan
Donald Sultan
Terry Winters

Sculpture

John Duff
Nancy Graves
Bryan Hunt
Tom Otterness
Lucas Samaras

In 1817 Goethe wrote that all cultures go through four stages. The first is one of community and powerfully shared symbols and visions. The second and third become progressively analytical and abstract. And the fourth—and final—stage is, according to him, characterized as follows: "Human need, aggravated by the course of history, leaps backwards, confuses priestly, folk, and religious beliefs, grabs now here, now there, at traditions, submerges itself in mysteries, sets fairy tales in the place of poetry, and elevates these to articles of belief."[1]

The start of a new decade doesn't necessarily match up with a sudden shift in sensibility, but 1980 did. The analytical and the formal were rejected, and strange new kinds of historicism, primitivism, and expressionism were irrationally embraced.

In the real world, the decade started out in the shadow of a number of events that could be read as warnings against modern hubris. Three Mile Island nearly melted down; Skylab fell out of the sky. But technological accidents weren't the only signs and portents. There was the hostage crisis in Iran, a country that had recently undergone a violent revolt against modernity. Cultism, extremism, and terrorism were on the rise; supernatural horror movies were the rage. Religious fundamentalists right here at home were militating against Darwin in favor of Adam, and an old-fashioned movie hero was elected president—as if appropriating Biblical stories and Hollywood fictions might save us from unnerving realities. Even the sudden fad for roller-skating gave evidence of a new nostalgia for a past that never was. The utopian future had evaporated. Rationality was on the wane. The ideals of modernity were on the defensive.

In the art world, the eighties began in the wake of a proliferating array of simultaneous art movements. Including Narrative Art, "Bad Painting," Pattern and Decoration, New Imagism, New Wave, Naïve Nouveau, and any number of personal "retro" revivals, these new movements made it look as if the future would be built on the taboos of the modernist past. The decade began with the "rebirth of painting," the discovery of Europe's new German and Italian painters bravely attempting to come to terms with their national pasts, and the emergence of an informal expressionistic aesthetic in New York's East Village that embraced rowdy street art and rough graffiti. The decade also began amid heated debates about post-modernism and whether we might stand poised at the start of a new post-modern age.

Suddenly out of the welter of overlapping styles that competed during the so-called pluralistic days of the late seventies, Neo-Expressionism emerged dominant both here and abroad. The antiquated concept of a *Zeitgeist* found favor again. But the spirit of the times was not confined to Neo-Expressionist art. It involved a widespread rejection—or at least an apparent rejection—of the experimental, the original, the inventive, the analytical, and anything that was obviously "avant-garde." By 1980 the characteristics Goethe described so long ago were becoming apparent in the most recent art. The heady idea of a post-modern culture making a new start was supplanted by a deliberately regressive art that seemed to look back.

The new sensibility has its celebrated *enfants terribles*: Keith Haring, Jean-Michel Basquiat, Kenny Scharf—all of whose work retains close ties to graffiti and street art. And it has its luminaries: Julian Schnabel, David Salle. But it also has elder statesmen such as Andy Warhol, Frank Stella, Robert Morris, Lucas Samaras, Malcolm Morley, Neil Jenney, and Leon Golub—survivors from Pop, Minimalist, and Photo-Realist days (and in the case of Golub, from Chicago Funk)—whose work anticipated and seeded the new sensibility. Jon Borofsky started out as a Conceptualist, counting compulsively. Nancy Graves made post-Minimalist scatter pieces with camel bones. Susan Rothenberg and Donald Sultan, as well as Robert Moskowitz (earlier a Pop artist), were associated in the seventies with New Image painting. And then there's Philip Guston, former Abstract Expressionist and honorary ancestor of the new sensibility, who turned his laden brush to expressive tragicomic figuration in the sixties. His 1978 canvas in this exhibition—depicting a stack of knobbly-kneed legs in an empty white room—could almost be a metaphor of the way young artists at about the same time were beginning to people the bare white space left by formalism with the unnerving refuse of humanity.

"Art in our time is malice," remarked the critic Clement Greenberg in 1980.[2] "Pictures," "statues," "figurines," and other conventional art objects had begun to reappear, along with such classical materials as bronze, marble, and oil, and a new interest in bases, frames, statuettes, and monuments—all of which had fallen into disrepute. The human figure reemerged as anachronistic protagonist, either desultorily bare of skills or clothed in some obsolete style. Apparently abandoning modernist ideals of originality and progress, artists were starting to recycle the past, returning

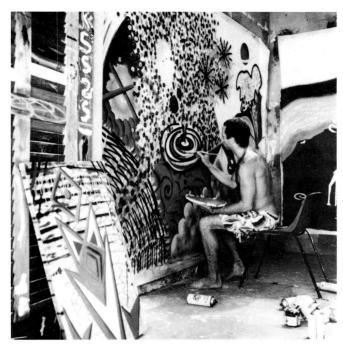

Figure 63. Kenny Scharf, 1984. Photo: Tseng Kwong Chi.

Figure 64. Julian Schnabel in Bridgehampton, Long Island, New York, 1984.

to traditional materials, conventional formats, reactionary figuration, equally reactionary abstraction, and even sometimes academic techniques. With the return to devalued conventions came the use of second-hand forms, borrowed styles, and repossessed images. The emphasis was on familiar human content rather than innovative form.

Anomalous aspects of twentieth-century art that had been ignored during formalist days began to be noticed and reappraised: not just Expressionism and Surrealism but the unwillingly modern styles of the 1930s, including social realism, socialist realism, and fascist neoclassical art. The perversely philistine late work of Picabia and the grandiosely cynical late work of de Chirico were being admired by artists and searched for clues, as were the blithe superficialities of those easiest of modern masters, Chagall and Dufy, all of whom have had major museum and gallery exhibitions in the past few years. Picabia has been a source for Schnabel and Salle, as well as for the German artist Sigmar Polke. Kim MacConnel, among others, has expressed admiration for Dufy. De Chirico has been referred to in the work of artists as different as Jedd Garet and Andy Warhol, and Italian painters have been borrowing from Chagall.

Besides delving into previously not quite respectable styles of the past, artists began to explore cultural archetypes, and a personal past of infancy, ancestry, roots. Craving perhaps to return to states of effortless innocence, ignorance, and unconsciousness, they didn't just retrieve devalued conventions. They embraced the primal and primitive in numerous ways. Rudimentary images, infantile impulses, childish icons, adolescent idolatries, totemic objects, and metaphors of crude physicality abound in recent work.

Tom Otterness's chunky robots and brutes, Keith Haring's rapid-transit baby clones, Kenny Scharf's plasmatically surreal cartoon monsters are among the images that "regress" to childhood. So do Lucas Samaras's bronze fairytale hags on an adult's chair. Eric Fischl's anxious suburban bathroom scene and Jon Borofsky's hyperkinetic fantasy of phallic weaponry revert to awkward adolescence, not only in terms of subject matter but also in their uneasy techniques. The works of Jean-Michel Basquiat and Donald Baechler cultivate "unskilled" images and techniques. Raw physicality can be expressed as nervous energy, as in Judy Rifka's quivering work, or as muscularity and physical fitness. In Robert Longo's *Value*, for

217

instance, the ironic "value" of the male and female figures is in their sleek physique.

Sometimes physicality is expressed simply as technical or stylistic prowess, other times it is ritualized action, psychosexual event. Troy Brauntuch's *Floorboards,* an indistinct glimpse of sphinx-like human creatures crouched in animalistic positions submitting to water therapy, depicts a purely physical cleansing ritual. Fischl's *Haircut,* in which a naked girl squats on the bathroom floor bathed in stripes of Levolor light, is—with the central scissors and mirror focused on hidden genitals—an illustration of a boy's castration anxiety. A corollary to the expression of human nature as savage or immature can also be seen in works such as these: it's that civilization and civilized skills exist as a thin, artificial veneer.

Retrogressive, regressive, and unrepressed, the new sensibility makes inspired use of not quite respectable images, often recycling what devout formalists would have considered visual trash. Schlock, kitsch, animated-cartoon stylizations, television trivialities, mass-media stereotypes, and commercial clichés are often the new artists' most fertile source materials. The trite, the degraded, the simplistic, and the debased now have a perverse allure. Some artists subject formalist art to the same heretical recycling process. Sherrie Levine and Mike Bidlo, among others, critique the concept of originality with hand-painted replicas. Levine's work replicates art-book reproductions of work by early modernists such as Malevich and Schiele; Bidlo re-creates Pollock's drip paintings and other celebrated modern works, and enacts apocryphal events from the lives of the artists.

If the politicized experimental artists of the seventies tried to do things that had never been done in order to break down boundaries between art and real-life concerns, artists are now involved with reclaiming that which has been rejected or popularized, and redefining the separateness of art. It's as if they're taking stock of our collective visual vocabulary, seeking twentieth-century myths, retrenching to heroics in the face of adversity. They realize that most of our truly modern shared mythologies come from movies, cartoons, and television. When the generation that cut its teeth on Warhol, The Flintstones, and Dr. Seuss—and their older cousins, who grew up on Disney, Dali, de Kooning, and Dr. Spock—discovered Walter Benjamin's insights in his famous essay "Art in the Age of Mechanical Reproduction," it was love at first sight.

Benjamin, in a footnote in that essay, quotes Bertolt Brecht, who uncannily anticipated

recent art: "If the concept of 'work of art' can no longer be applied to the thing that emerges once the work is transformed into a commodity, we have to eliminate this concept with cautious care but without fear, lest we liquidate the function of the very thing as well. For it has to go through this phase without mental reservation, and not as a noncommittal deviation from the straight path; rather, what happens here with the work of art will change it fundamentally and erase its past to such an extent that should the old concept be taken up again—and it will, why not?—it will no longer stir any memory of the thing it once designated."

This wasn't simply a generational shift, due to the emergence of a new crop of younger artists who share a prefabricated unconscious implanted by childhood TV. Artists who in the seventies had done ephemeral, unconventional, and often unsaleable work—using the land, their own bodies, or other nontraditional mediums—began working in valuable permanent materials. Conceptualists and post-Minimalists started to paint. Painters— and only a few years earlier painting was widely rumored to be dead—switched from acrylics to time-honored oils. Even Conceptualist performance artists who had once quietly documented their own improvised, often private, acts began staging elaborate spectacles, reviving the idea of art as entertainment.

To name just a few: the Earthwork artist Michael Heizer has been making blocky granite and bronze sculptures with elaborate bases, the Conceptualist Mel Bochner now makes "abstract"

Figure 65. Tod Wizon, Julian Schnabel, Markus Lupertz, and Jorge Immendorf, with a painting by Eric Fischl in the background, 1984. Photo: Roland Hagenberg.

218

paintings, Hans Haacke's acerbic exposés can now take the form of an academic portrait, Lucas Samaras has cast a series of figurines in silver-plated bronze and is now painting mock-expressionist skulls, Chuck Close has switched from acrylic to oil paint, and Laurie Anderson's work has evolved into theatrical extravaganza, as has Dennis Oppenheim's with its fireworks displays.

Sensation and sensationalism, not intellect or technical prowess, are the hallmarks of the new art. Ideas aren't what many artists are looking for right now. They're after more visually substantial if shallower thrills. Overblown metaphor, sensuous color, material pleasure, and the romance of the making of art have replaced formal and narrative logic. Grandiose technique often accompanies crude or banal imagery; grandiose subjects and crude execution go together too. After more than a decade of post-Conceptualist thought in art, there are still all kinds of ambivalences about the relationship between the art object and the image. Between the mind and the hand, the new painting and sculpture tends to become a conceptually deconstructive act.

After nearly a century of modernism, art (in Europe as well as America) seems to have reached a point where the only means left for radical innovation are to be reactionary. A complex desire for "the illusion of normalcy"—as well as more than a touch of malice toward the formalist reductions that Clement Greenberg championed—is at the core of the appropriations from the trivialized present and the discredited past. Recent art can be seen as showing neoconservative, ultratraditional, antimodern attitudes. It also implies a kind of primitivism, which the *American Heritage Dictionary* defines as "a belief that the acquisitions of civilization are evil or that the earliest period of human history was the best." In this respect a primitivizing stance is thoroughly in the modern tradition, the latest in a series of episodes in which primitivist elements have been incorporated into modern art. We're now being reminded that the twentieth-century process of formalist reduction has been accompanied all along by a parallel reduction to the rawest content, the most elementary expression, in a quest for primal authenticity. While one branch of modernism went ever purer, the other went ever messier, cruder, and more impure. The first ended up flattened against the canvas. The second may still be willing itself to savagery, following the precedent of such artists as Nolde, Picasso, and Dubuffet. In this context subway graffiti are the most recent variant on *Art Brut*.

The noble savage is a concept dreamed up by sophisticates. The desire for innocence is a by-product of its loss. Similarly, the thirst for pictorial content is felt by the progeny of those who drained it from their work. But subject matter does not automatically confer meaning. It can lead instead to the deliberate exploration of meaninglessness, the exploitation of cliché. It can result in forms that are purposely intrusive, inadequate, or inappropriate, and in images that are undeveloped, incomplete, or unnatural. Any attempt to recapture lost values of the past suffers from omissions, inconsistencies, lapses of historical memory—but also creatively benefits from these misunderstandings. The result: works that are conservative and progressive at the same time.

As for the natural world in recent art, it tends to be unnatural and artificial, too, an alien place teeming with malevolent force. Gregory Amenoff's abstractions of suffocating roots and vines, Jack Goldstein's ominously cosmeticized and slickly photographic celestial phenomena, Terry Winters's proliferating spores, Nancy Graves's hybrid bronze flora grafted from incongruous parts, and Donald Sultan's turgid forest fire (painted with tar and dried leaves on tile) all suggest inhuman energies out of control. In Jedd Garet's diptych *Two*, humanity deteriorates to a dispirited contrast: between the surreal human figurine fashioned from twigs and the cubistic one of rock, everything is inhuman and unnatural, including the color. Robert Morris's swirling voids, framed by sculpted, clawed, and cast viscera, genitalia, and other body parts, suggest a post-holocaust world in which humanity remains only as mulch for a kingdom of insects and grasses.

In one sense the radical reactionism of recent art is a provocation thoroughly in the modern tradition. As Marshall Berman sees it in *All That Is Solid Melts into Air:* "To appropriate the modernities of yesterday can be at once a critique of the modernities of today and an act of faith in the modernities. . .of tomorrow."[3] But the situation in art isn't as simple as that. The art of the eighties so far may be aggressive, cannibalistic, and crude, but it's hardly dumb. With its variable mixtures of Neo-Expressionist, Neo-Abstract, and Neo-Surreal elements; its post-graffiti, pseudo-primitive, or mock-commercial leanings; its less than flattering imitations of popular culture and the media, as well as of previous periods of art, it exudes an unwillingness to make something new. It's as if painters and sculptors are now paraphrasing the statement the Conceptualist Douglas Huebler made as a work of art in 1969: "The world

is full of objects, more or less interesting; I do not wish to add any more. I prefer simply to state the existence of things. . . ." Artists now are expressing a similar feeling—not toward objects but toward images. As another Conceptualist, Joseph Kosuth, observed in 1982, the rebirth of painting, is "not simply painting but a reference to painting; as if the artists are using the found fragments of a broken discourse."[4]

Earlier in our century, when Expressionists and Surrealists explored the subjective and the "subconscious," it was in a spirit akin to the then new science of psychoanalysis, and in an age of rational ideals. Artists working now in Neo-Expressionist and Neo-Surrealist modes have different motives. Acting out the compulsions of the psyche physically instead of dissecting them analytically, they're attempting to retrieve or at least to represent atrophied instincts, as well as critiquing the images bequeathed to us from styles of the modern past. The same can be said for the Neo-Abstractionists. Their work seems less involved with abstract form than with representing the externalized images of abstract forms.

In fact, the modernist distinction between representational art and abstraction is no longer valid. Both by now have become artificial devices for propagating images. Artists such as Frank Stella, Elizabeth Murray, and Gary Stephan are dealing with images of abstract forms and collisions between different species of abstraction. Their work implies a schema of generic nonrepresentational shapes, and grapples with the uncomfortable relationship between abstraction and decoration. Sean Scully's thick stripes (hugging memories of Stella's early stripes and Jasper Johns's flags) and John Duff's spare parts (holding Minimalist memories) aren't formal but physical and imagistic, as are Katherine Porter's explosive (and decorative) maelstroms and Bryan Hunt's sculpture, alluding to both modern and classical modes. Abstract modern form has become just another kind of used-up devalued image—to be depicted, critiqued, liquidated. In that sense, "What we are witnessing," as Craig Owens wrote in 1982, "is the wholesale liquidation of the entire modernist legacy."[5]

Along with the feeling of bankruptcy that permeates our art and culture lately goes a sense of detachment and loss. A casual intransigence— a refusal to claim significance—accompanies the insatiable appetite for grandeur in much of this new work. Forms and images often appear meaningless, disoriented, or mute—reduced to

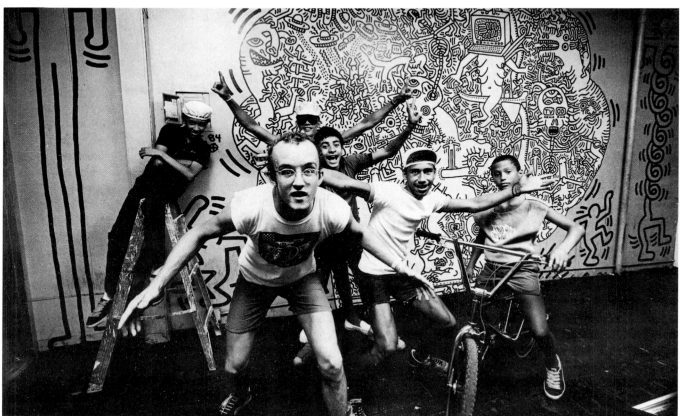

Figure 66. Keith Haring and friends, 1984. Photo: Tseng Kwong Chi.

insincere gestures, pulp heroics, crass impieties, or slick mockery. Yet more is going on in many of these offhand works than immediately meets the eye. Besides hidden skills, such as the painterly and coloristic subtleties that lurk within crude or apparently careless surfaces, there are messages that hide behind seemingly callous or inconsequential imagery.

Robert Moskowitz's *Stack* turns a symbol of the industrialized modern world into an abstract emblem that's also a tombstone. Salle's plundered images tell us that abstraction is trite, representation is futile, and figuration is obscene. In his *Wild Locusts Ride*, dominated by a sunbather, a Santa Claus, and a poster image of militant marchers, he pairs a placid leisure image (the contented consumer, whose emblem is Santa Claus, god of the annual buying binge) with the angry image of striking workers (the dissatisfied producers), cynically summing up the economic system. Schnabel's velvet mélange of desultory brushwork and imagery, *A Private School in California*, invites thoughts of the good life enjoyed by the privileged child. But its tabloid subject, hidden in the splashiness, is sexual exploitation—the horror of child molestation by headmistresses. Even the almost autistically incommunicative image in Donald Baechler's *Die Fahne Hoch* contains a comment on the modern world: the rudimentary flag-waving head is a slur on simplistic nationalistic stereotypes. And in Susan Rothenberg's *A Golden Moment*, the flurry of impressionistic brushwork coalesces into the image of a bespectacled man with a fatuous smile on his face, contemplating a small red square and a smaller blue one: the figure looks suspiciously like the old formalist Mondrian.

At a moment of higher stakes and lower expectations, the new picture and statue makers are confronting the powerlessness of forms; in an atmosphere overloaded with mechanically and electronically replicated images, they're striving to simulate and stimulate the power of emotions—and to express that endeavor's futility. Recent art partakes of our late-twentieth-century malaise: "psychic numbing," as it has been called. Exuberance may mask despair in some of this work but it also expresses anomie.

Manipulative, sometimes bombastic, the new art plays on the emotions—on our cultural conditioning—rather than venting personal agonies. It makes the most of hyperbole and innuendo as signifiers of emotion. In fact, "pseudo-Expressionist" would be a more accurate term for

Figure 67. Mike Bidlo: "…a chicken in every pot, a Pollock over every couch." Action installation of *Blue Poles* being repainted by Bidlo at the steps of The Metropolitan Museum of Art, New York. Photo: Hope Sandrow.

Figure 68. Jack Goldstein, 1985.

much of the manically heroic work, if "pseudo" weren't for some still a derogatory term. One of the chief new virtues in the complicated, contradictory eighties is shallowness; "simplistic" is becoming a term of praise. Phony emotions, images, and styles are highly valued qualities right now. Artificiality and inauthenticity are the twin poles toward which the most genuine recent art is oriented. Even work that gives the appearance of genuine spontaneity can be the result of a premeditated (and academic) process. Malcolm Morley, Jon Borofsky, and Donald Baechler enlarge their images from doodles or watercolor sketches—Morley by means of a grid, the others by mechanical projection. The brushwork in their art is deceptively innocuous. Their imagery is distanced and retrieved: the copy exists within the original.

Along with the recent unwillingness to experiment with new forms goes an emphasis on preservation. The renewed interest in frames and monumentality is one sign of this; the insistent physicality of the iconography and the muscularity of abstract shapes are others. Out of a sense of helplessness, human beings are asserting themselves physically: the body-building craze, the wrestling mania, the emphasis on physical fitness and muscular development—on preserving the flesh—are counterparts to the new art, which takes an absurdly heroic stance in the face of vulnerability.

Right now wrestling and body-building seem the sports of metaphor, the first with its rituals of contrived aggression and spontaneity, the second with its emphasis on pumped-up spectacle. The phoniness of actions or positions doesn't detract from the fascination with these displays of bulky physicality. In fact, the fakery is part of the attraction: the craving for authenticity extends far beyond the world of art. In the middle of the energetic, creepy, boisterous, manipulative, surreal eighties, we don't have the benefit of hindsight. So we take our cues where we find them, pick up clues as we go—in the wrestler Hulk Hogan's mock agonies and in the rock star Madonna's junk-jewelry message of being a material girl in a material world.

We can think about recent painting and sculpture in terms of a new *Zeitgeist*, a sudden break with the past, an unexpected reversal of taste, or we can call it a last waltz with modernism. We can say that the grand Picasso retrospective at The Museum of Modern Art in 1980 (and the revelation of his late work) gave artists permission to be painterly,

instinctual, and expressive again. Or we can cite in retrospect "The New Image" exhibition at the Whitney Museum of American Art in 1979, which now seems to have heralded the return to recognizable painted imagery, or The New Museum's "Bad Painting" show in 1978, which proposed an aesthetic of apparent ineptness and dubious taste. At the start of the eighties there was also the retrospective of Joseph Beuys's work at The Solomon R. Guggenheim Museum, dredging up historical agonies; The Times Square Show in a vacant building, offering an irreverent and messy new derelict art; and a number of big international exhibitions in Europe that gave credence to the new agitated, histrionic, painterly art.

It should also be pointed out that, for the first time since the end of World War II, it is no longer possible to present a balanced view of current art in an exhibition limited to American works. All through the fifties and sixties, and into the seventies, American artists were at the forefront of the avant-garde. But it's difficult to speak of the art of the eighties without giving credit to the new European painters, some of whom have been at work for two decades and more. They have recently made their mark on American art, just as American Pop and Minimalist art left deep imprints on European art a decade or two ago. In

Figure 69. Pablo Picasso. *The Artist and His Model*, 1963. Oil on canvas, 31¾ x 39¼". (Not in the exhibition.) Collection Marina Picasso, Paris.

the 1950s, New York's Abstract Expressionism was exported around the world and was called an international style. And now, in the midst of nomadic lifestyles and a fertile symbiotic interchange, much is being made of the "nationalistic" tendencies of this more truly international new art. Perhaps we should think of it instead as global regionalism, for artists everywhere are seeking personal and historical roots.

A number of critics and curators have claimed lately that recent art, with all its excesses, is a reaction against Minimalist reductions. But between the Minimalist structures and surfaces of the sixties—now perceived as repressive—and the regressive painting and sculpture of the present, there lies the elusive art of the seventies. And it may be more useful and more accurate to ask what was germinating then that sprang to life in the eighties. How did the so-called pluralism of the seventies evolve into what the critic Craig Owens has dubbed the "puerilism" of the present? How did high-minded social-protest art and highly intellectualized investigations into the nature of semiotic structures give way to what another critic, Thomas Lawson, has called "cultural cannibalism"?

In a convoluted way the adventurous art of the seventies can explain the new and newly conservative—and sometimes ultra-reactionary—art of today. The seventies began with an escape from the traditional art object (and the gallery system) but ended up with big, handsome, decorative art objects hanging on gallery walls. At the start of that decade, Conceptualism, post-Minimalism, Earthworks, Body Art, eccentric performance work, and unwieldy site sculpture turned our attention away from man-made abstract forms to the frailties of the natural world. Photo-Realism, though no one likes to admit it, raised the possibility that art could be imitation of images rather than invention of forms. And in the desire to make work that was something other than a formal art object—anything other than art for art's sake—many artists during the seventies turned to projects having to do with human behavior, moral responsibility, social consciousness, populist accessibility, and survival. Their activist and feminist concerns with human content and context coaxed expressive elements and figuration once again into art. Wanting their work to be useful and playful, they embraced a feminized, hands-on aesthetic of the homemade, the hand crafted, the improvised, which admitted human imperfections and awkwardness.

By the end of that decade accessibility came to mean decoration and a return to traditional formats; social responsibility was coopted by various kinds of asocial if not antisocial expressionism, including graffiti; and survival became a matter of worldly success. Nevertheless, the concerns of the seventies have had their effect.

223

Figure 70.

Steve Martin "appropriating" Franz Kline.
Courtesy Sidney Janis Gallery.
Photo: Annie Liebowitz.

The Neo-Expressionism, primitivism, and historicism of recent art have less to do with reacting belatedly against Minimalism than with responding to what happened in art during the scattered seventies. Artists are now subjecting those concerns to almost unrecognizable embellishments and revisions which imply that the immaterial art of the seventies may have gone too far afield too fast.

The new sensibility, addressing itself to the contemporary clutter of sensory stimuli, is an odd reformation that reinterprets the need for content in terms that are visual instead of intellectual, sensuous rather than severe. Satiated with ideas, artists no longer want a thinking art that needs to be read; they want something pleasurable to look at again. If linguistic structure was a logical model for many artists in the previous decade, those of the eighties are finding their models in the inchoate workings of the memory and psyche: in irrational splices and displacements, subliminal associations, discontinuous fragments whose connective logic has long since dissolved, and forms whose structural integrity is a matter of faith. Even the photograph is no longer a dependable documentary tool, thanks partly to the computer's simulation techniques; photography is being used manipulatively by such artists as Barbara Kruger and Cindy Sherman to explore simulation and fakery. Playing fast and loose, drawing on detached physicality and sheer nervous energy, artists are dealing in deceptively easy imagery—hastily drawn, sketchily brushed, or just as rapidly taken from commercial photographic techniques. The aim is apparent effortless ease as well as instant gratification.

A decade or so ago, artists chose content and context over form, specific meanings over abstract truths, worldly problems over self-referential art. They aligned themselves with the amateur rather than the specialist. Now they're opting for manipulative imagery in a world of degenerated forms; they're scavenging among styles, seeking reconciliations, merging their skills with gaucheries. They're trying to integrate the abstract and the representational, the artificial and the natural, the replica and the original, wanting everything at once—and they're creating a truly synthetic art, in every sense of the word.

Identity may have been a central concern of the seventies; nonentity is more pertinent now. When a work of art is inhabited by preexisting images and forms, or simulates emotional gestures to express an angst of emptiness, it's lack of identity that comes to the fore. That's one of the consequences of the loss of faith in the modernist ethos of originality. But when the reactionary is seen as the radical, the past as the future, the old as the new, and the spurious as the genuine, broader issues of individuality and authenticity crop up. The present retreat, with its desire for falsity, for manipulated images, repossessed styles, prepackaged forms, is an ambivalent attempt to return to old values. As modernist belief systems are becoming increasingly inadequate, artists are exposing awful truths and giving profound warnings. In the late stage of a culture—cast adrift in contradictions, haunted by myths of history and style and by omens of vulnerability—artists are uneasily grabbing hold of traditions, however spurious they may be, and elevating them to stave off disbelief.

NOTES

1. Quoted from Kathleen Agena, "The Return of Enchantment," *The New York Times Magazine,* Nov. 27, 1983, pp. 79-80.
2. In an interview in *Flash Art,* March–Apr. 1980.
3. Marshall Berman, *All That Is Solid Melts into Air: The Experience of Modernity* (New York: Simon & Schuster, 1982), p. 36.
4. Joseph Kosuth, "Necrophilia Mon Amour," *Artforum,* May 1982.
5. Craig Owens, "Honor, Power, and the Love of Women," *Art in America,* Jan. 1983.

right
PLATE 117
Frank Stella
Brazilian Merganser, 1977–80.
Aluminum and mixed mediums, 120 x 84".
Collection Martin Z. Margulies, Miami.

226

PLATE 118
Philip Guston
The Floor, 1976.
Oil on canvas, 69 x 98".
Estate of Philip Guston; David McKee Gallery, New York.

right

PLATE 119
Terry Winters
Lumen, 1984.
Oil on linen, 101 x 68".
Sonnabend Gallery, New York.

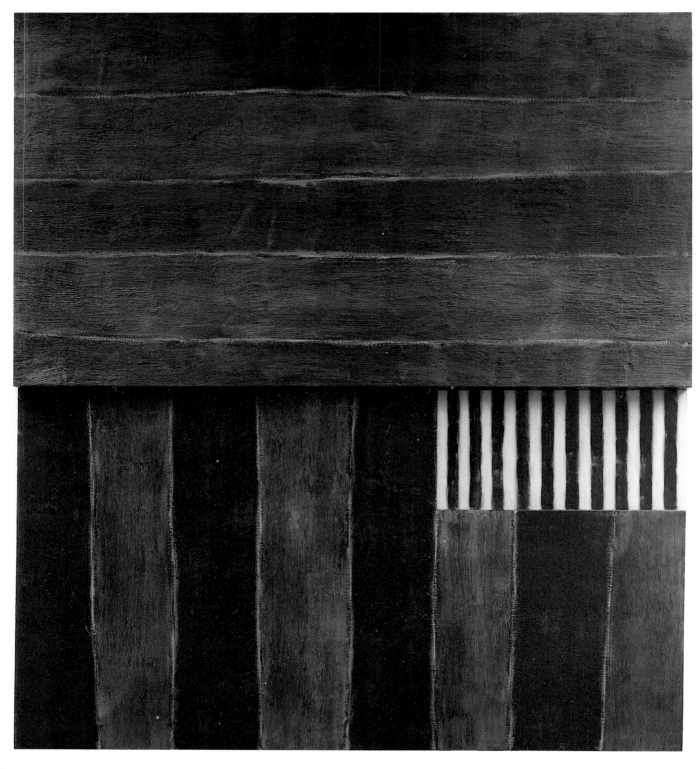

PLATE 120
Sean Scully
Narcissus, 1984.
Oil on canvas, 109 x 96".
The Edward R. Broida Trust, Los Angeles.

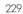

PLATE 121
Susan Rothenberg
A Golden Moment, 1985.
Oil on canvas, 54 x 48".
Collection Eli and Edythe L. Broad, Los Angeles.

230

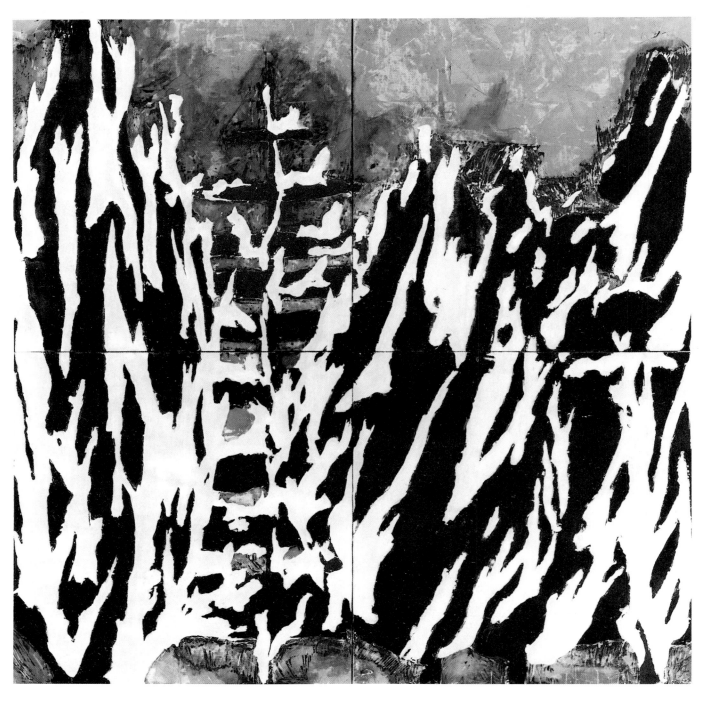

right

PLATE 122
Donald Sultan
Forest Fire, October 28, 1983.
Mixed mediums, 96 x 96".
Blum-Helman Gallery, New York.

PLATE 123
Elizabeth Murray
Simple Meaning, 1982.
Oil on two canvases, 107 x 96".
Collection Jerry and Emily Spiegel, Kings Point, New York.

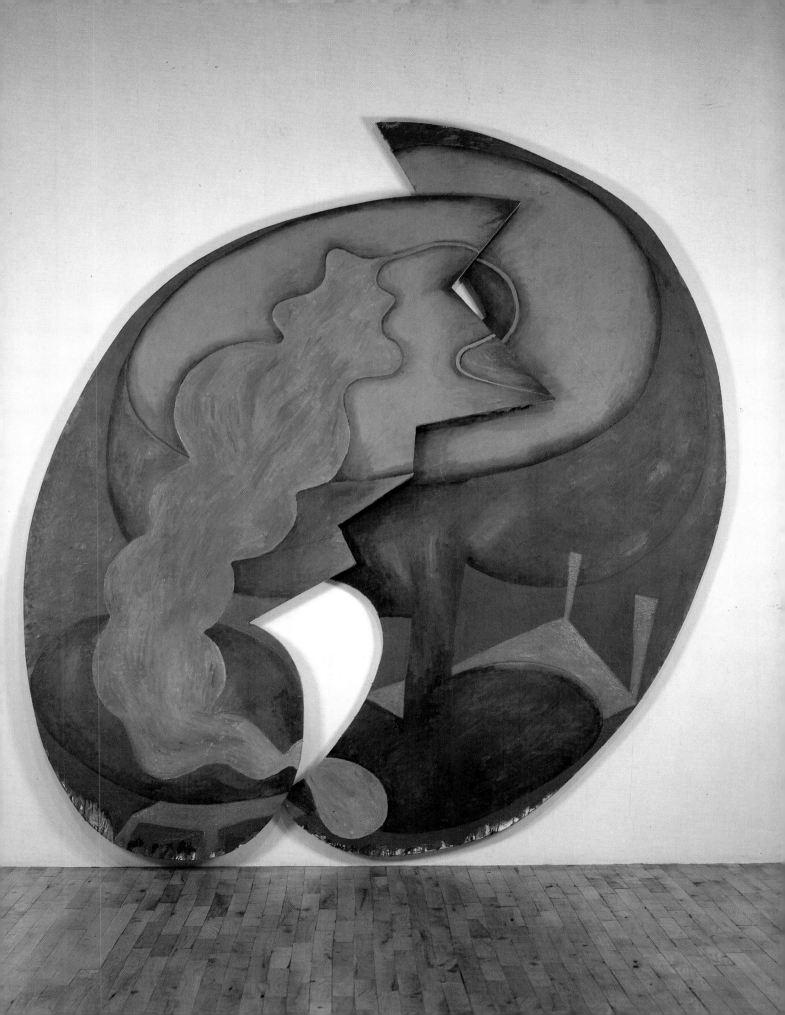

232

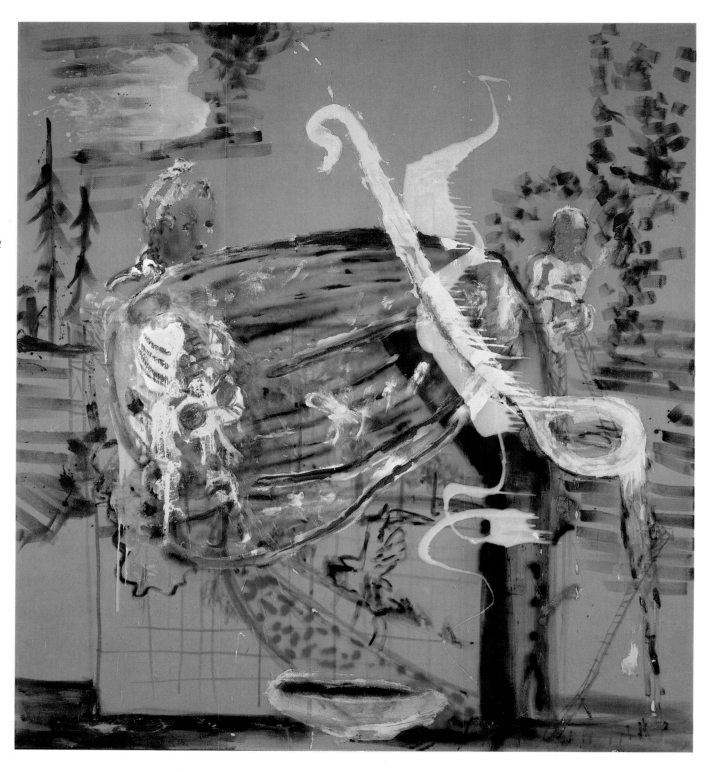

PLATE 124
Julian Schnabel
A Private School in California, 1984.
Oil and modeling paste on velvet, 120 x 108".
Collection Edwin L. Stringer, Q.C., Toronto.

right

PLATE 125
Bryan Hunt
Mysterian (Barcelona Series), 1985.
Bronze and limestone, 58½ x 25 x 19½".
Blum-Helman Gallery, New York.

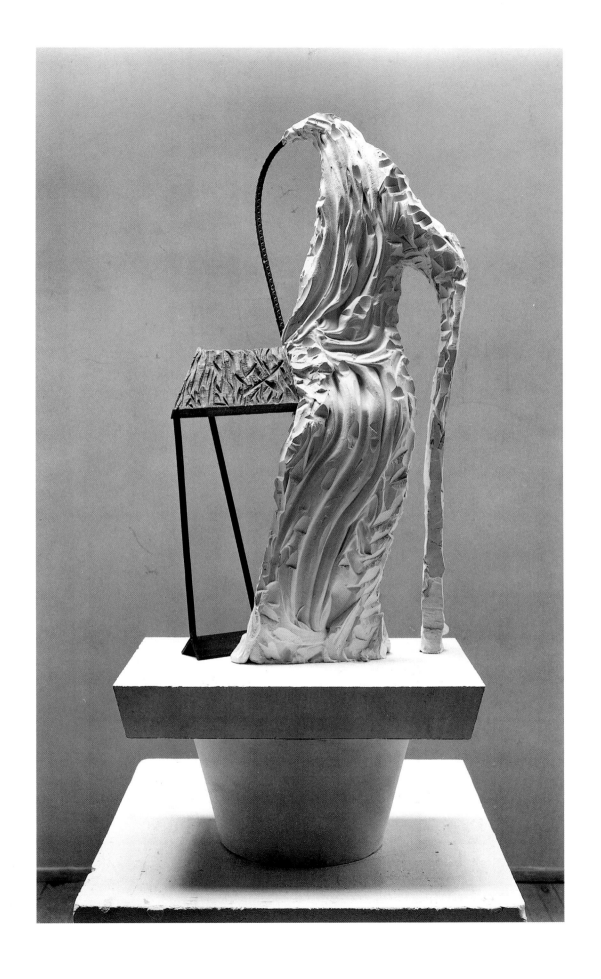

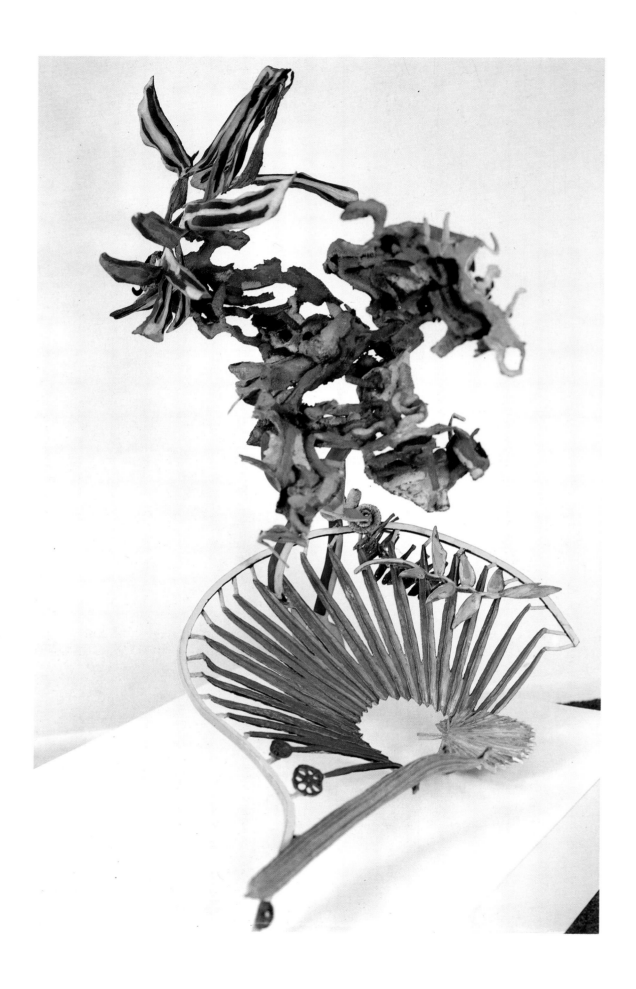

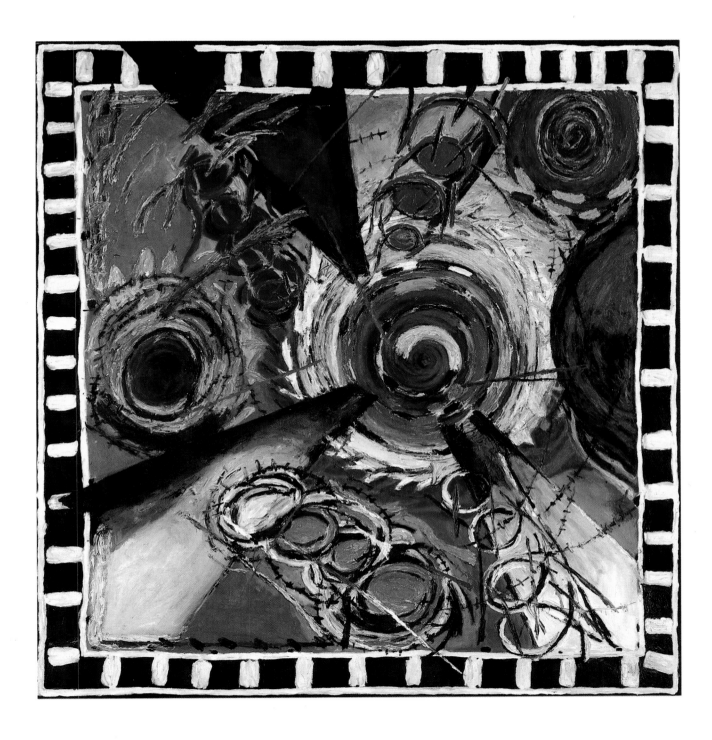

left

PLATE 126
Nancy Graves
Circumfoliate, 1983.
Patinated bronze, 46½ x 44½ x 32½".
Collection Leonard and Gloria Luria, Miami.

PLATE 127
Katherine Porter
La Libertad, 1980.
Oil on canvas, 84½ x 88⅝".
Private collection; courtesy of David McKee Gallery, New York.

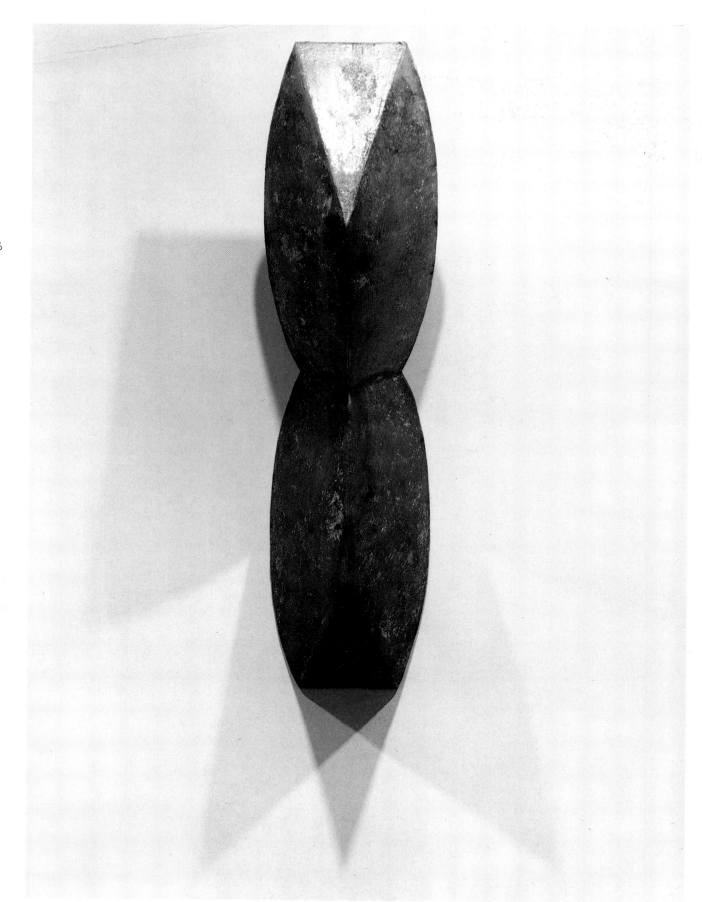

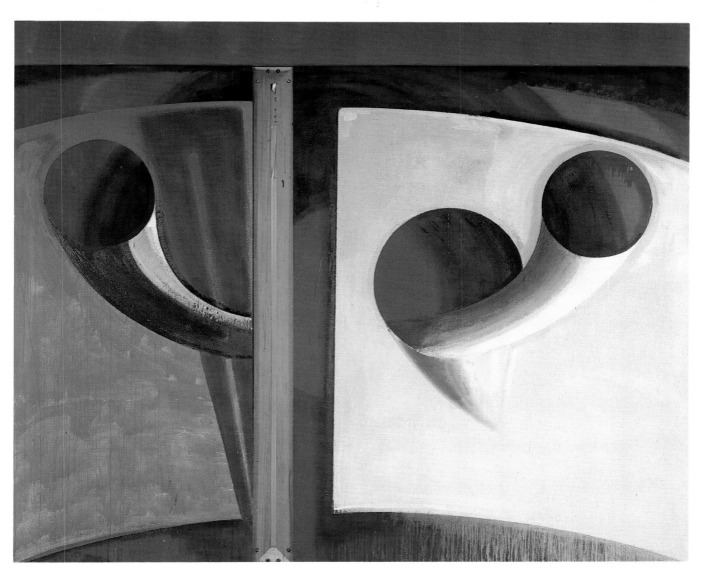

left

PLATE 128
John Duff
Macaha, 1985.
Fiberglass and enamel paint, 61½ x 15⅝ x 21¾".
Margo Leavin Gallery, Los Angeles.

PLATE 129
Gary Stephan
Out, 1984.
Acrylic on linen, wood, 113 x 136".
Collection Irma and Norman Braman, Miami.

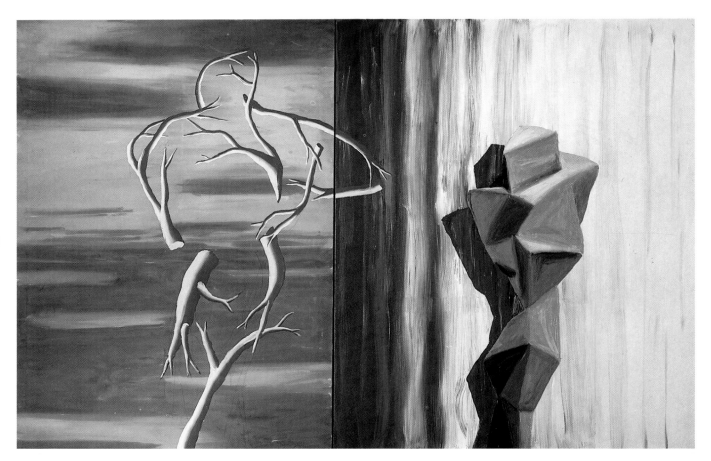

PLATE 130
Jedd Garet
Two, 1984.
Acrylic on canvas, 104 x 158".
The Museum of Modern Art, New York,
Gift of Anna Marie and Robert Shapiro, 1984.

right
PLATE 131
Gregory Amenoff
Deceit, 1983.
Oil on canvas, 94¼ x 76".
Collection Martin Sklar, New York.

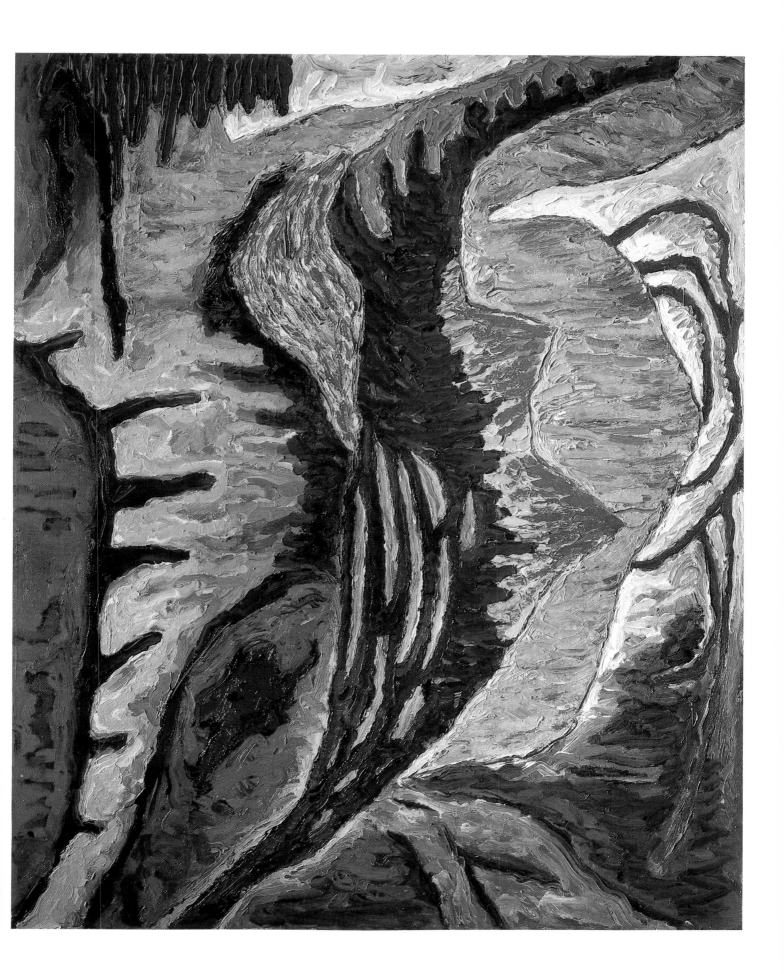

240

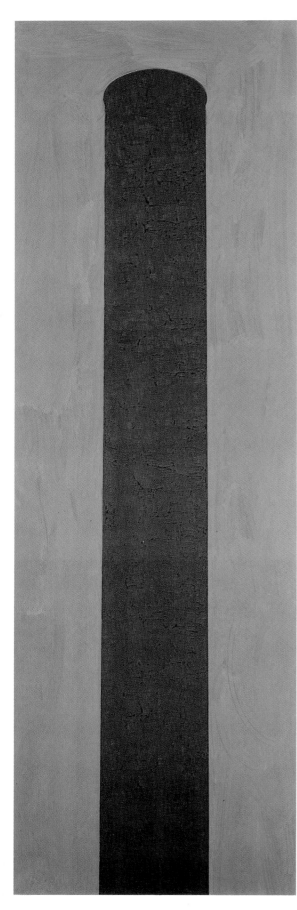

PLATE 132
Robert Moskowitz
Stack, 1979.
Oil on canvas, 108 x 34".
Collection Mr. and Mrs. Raymond Nasher, Dallas.

right
PLATE 133
Jack Goldstein
Untitled, 1985.
Acrylic on canvas, 96 x 62".
Metro Pictures, New York.

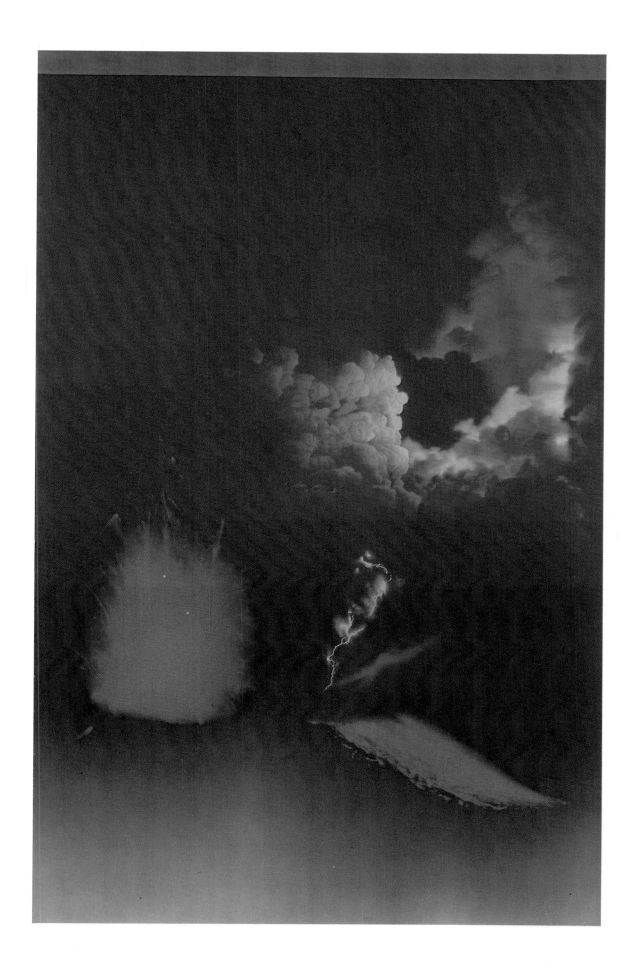

242

Plate 134
Malcolm Morley
La Plage, 1980.
Oil on canvas, 72½ x 98¾".
Collection Martin Z. Margulies, Miami.

PLATE 135
Judy Rifka
Five Nudes with Still Life, 1984.
Oil on two linen panels, 96 x 108 x 9″.
Archer M. Huntington Art Gallery, The University of Texas at Austin,
Archer M. Huntington Museum Fund, 1985.

PLATE 136
David Salle
Wild Locusts Ride, 1985.
Oil and acrylic on canvas with fabric, 75 x 104½".
Collection the artist; courtesy Mary Boone Gallery, New York.

PLATE 137
Eric Fischl
Haircut, 1985.
Oil on linen, 104 x 84".
The Eli Broad Family Foundation, Los Angeles.

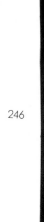

246

Plate 138
Troy Brauntuch
Floorboards, 1984.
Pastel on cotton, 108 x 144".
The Eli Broad Family Foundation, Los Angeles.

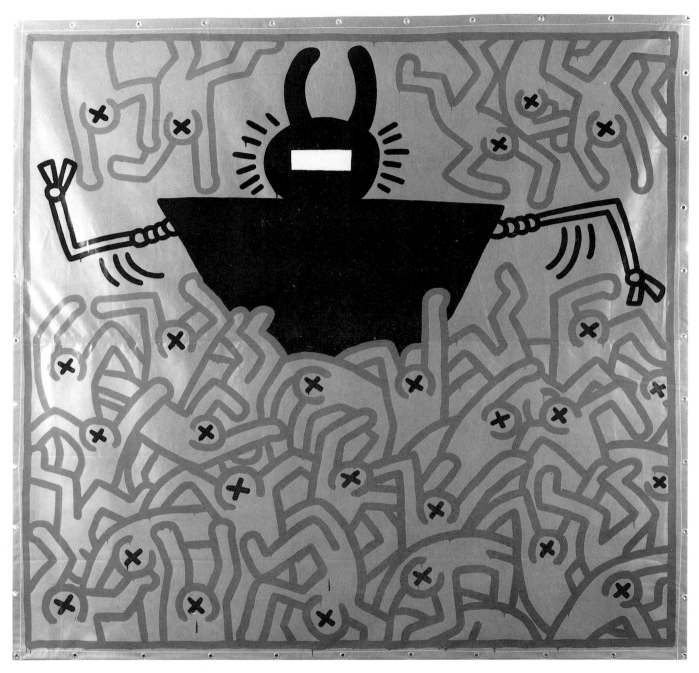

PLATE 139
Keith Haring
Untitled, 1983.
Vinyl ink on vinyl tarpaulin, 120 x 120".
Tony Shafrazi Gallery, New York.

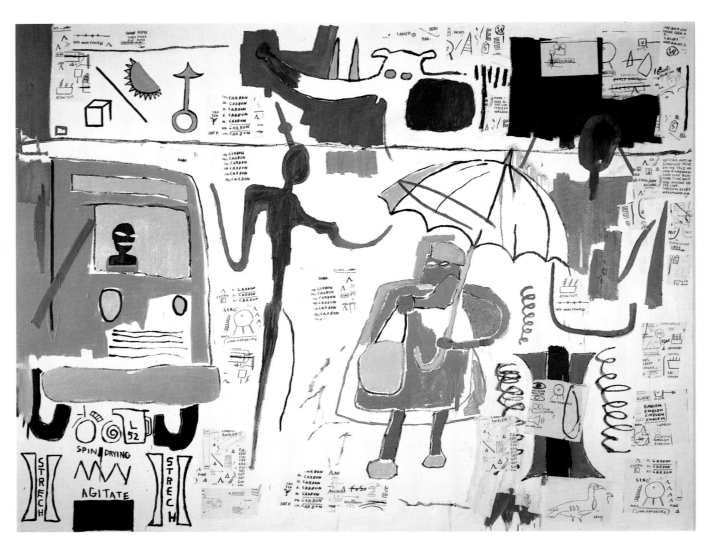

PLATE 140
Jean-Michel Basquiat
Gua-Gua, 1984.
Oil on canvas, 80 x 102".
Collection Robert and Doris Hillman, New York.

right
PLATE 141
Donald Baechler
Die Fahne Hoch, 1984.
Acrylic, acrylic medium, and paper on canvas, 97 x 64".
Collection Tony Shafrazi, New York.

250

PLATE 142
Kenny Scharf
Sajippe Kaaka Joujesh, 1984.
Oil on canvas, 127½ x 151½".
Tony Shafrazi Gallery, New York.

right

PLATE 143
Tom Otterness
Frog and Robot, 1985.
Cast bronze, 34½ x 41 x 41".
Collection Mrs. Emily Fisher Landau, New York.
Courtesy of Brooke Alexander Gallery, New York.

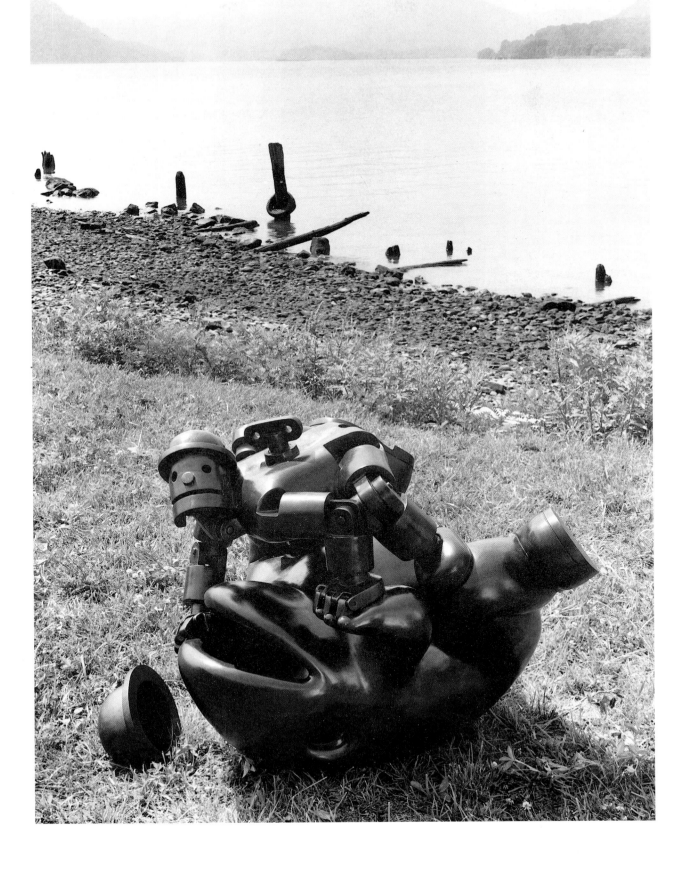

left

PLATE 144
Lucas Samaras
Chair with Four Figures, 1983.
Bronze, 33⅛ x 17½ x 19½".
The Pace Gallery, New York.

PLATE 145
Robert Morris
Untitled, 1983–84.
Painted Hydrocal, pastel on paper, 88 x 72 x 3½".
The Eli Broad Family Foundation, Los Angeles.

Reappraising the New York School

General Sources

Ashton, Dore. *The New York School, A Cultural Reckoning,* Penguin, 1979.

Greenberg, Clement. *Art and Culture,* Boston: Beacon Press, 1961.

Guilbaut, Serge. *How New York Stole the Idea of Modern Art: Abstract Expressionism, Freedom, and the Cold War,* translated by Arthur Goldhammer. Chicago: University of Chicago Press, 1983.

Hobbs, Robert C., and Gail Levin. *Abstract-Expressionism, the Formative Years,* New York: Cornell University Art Museum and the Whitney Museum of American Art, 1978.

Kramer, Hilton. "American Art Since 1945: Who Will Write Its History?" *The New Criterion,* special issue, summer 1985, pp. 1–9.

Lane, John R., and Susan C. Larsen, eds. *Abstract Painting and Sculpture in America, 1927–1944.* Pittsburgh: Museum of Art, Carnegie Institute; and New York: Harry N. Abrams, 1983.

McShine, Kynaston, ed. *The Natural Paradise: Painting in America, 1800–1950.* New York: The Museum of Modern Art, 1976.

Rand, Harry. "The 1930s and Abstract Expressionism," *The Genius of American Painting,* ed. John Wilmerding. New York: Morrow, 1973, pp. 249–301.

Sandler, Irving H. *The New York School: The Painters and Sculptors of the Fifties,* New York: Harper & Row, 1978.

———. *The Triumph of American Painting: A History of Abstract Expressionism,* New York and Washington, D.C.: Frederick A.

Praeger, 1970.

Schimmel, Paul, et al. *Action/Precision: The New Direction in New York, 1955–60.* (On Bluhm, Goldberg, Hartigan, Held, Leslie, Mitchell.) Newport Harbor Art Museum, 1984.

Seitz, William C. *Abstract Expressionist Painting in America,* Cambridge, Mass: Harvard University Press for the National Gallery of Art, 1983.

Sources on Specific Artists

Baziotes

Alloway, Lawrence. *William Baziotes, A Memorial Exhibition,* New York: The Solomon R. Guggenheim Museum, 1965.

Preble, Michael, Barbara Cavaliere, and Mona Hadler. *William Baziotes: A Retrospective Exhibition,* Newport Harbor Art Museum, 1978.

Bolotowsky

Breeskin, Adelyn, et al. *Ilya Bolotowsky,* New York: The Solomon R. Guggenheim Museum, 1974.

Elderfield, John. "American Geometric Abstraction in the Late Thirties," *Artforum,* vol. 11, December 1972, pp. 35–42.

Larsen, Susan C. "Going Abstract in the Thirties: An Interview with Ilya Bolotowsky," *Art in America,* vol. 64, September–October 1976, pp. 70–79.

Bourgeois

Lippard, Lucy R. "Louise Bourgeois: From the Inside Out," *Artforum,* vol. 13, March 1975, pp. 26–33.

Pincus-Witten, Robert. "Bourgeois Truth," in *Louise Bourgeois: Recent Work,* New York: Robert Miller Gallery, 1982.

Wye, Deborah. *Louise Bourgeois,* New York: The Museum of Modern Art, 1982.

Calder

Arnason, H.H., and Pedro Guerrero. *Calder,* New York: Van Nostrand, 1966.

———, and Ugo Mulas. *Calder,* New York: The Viking Press, 1971.

Calder, Alexander. *An Autobiography with Pictures,* New York: Pantheon, 1966.

Lipman, Jean. *Calder's Universe,* New York: The Viking Press, 1976.

Cornell

Ashton, Dore, et al. *A Joseph Cornell Album,* New York: The Viking Press, 1974.

McShine, Kynaston, ed. *Joseph Cornell,* New York: The Museum of Modern Art, 1980.

Waldman, Diane. *Joseph Cornell,* New York: George Braziller, 1977.

Davis

Arnason, H.H., et al. *Stuart Davis Memorial Exhibition,* Washington, D.C.: National Collection of Fine Arts, 1965.

Goossen, E.C. *Stuart Davis,* New York: George Braziller, 1959.

Kelder, Diane, ed. *Stuart Davis,* New York: Frederick A. Praeger, 1971.

Lane, John R. *Stuart Davis: Art and Art Theory,* Brooklyn: The Brooklyn Museum, 1978.

de Kooning

Gaugh, Harry F. *Willem de Kooning,* New York: Abbeville Press, 1983.

Hess, Thomas B. *Willem de Kooning,* New York: The Museum of Modern Art, 1968.

———. *Willem de Kooning: Drawings,* Greenwich, Conn.: New York Graphic Society, 1972.

Larson, Philip, and Peter Schjeldahl. *De Kooning: Drawings/Sculptures,* New York: Dutton and the Walker Art Center, 1974.

Rosenberg, Harold. *De Kooning,* New York: Harry N. Abrams,

1974.

Waldman, Diane. *Willem de Kooning in East Hampton*, New York: The Solomon R. Guggenheim Museum, 1978.

Diebenkorn

Ashton, Dore, and George Neubert. *Richard Diebenkorn: Small Paintings from Ocean Park*, Houston Fine Art Press and Hine, Inc., San Francisco, 1985.

Buck, Robert T., Jr., et al. *Richard Diebenkorn: Paintings and Drawings, 1943–1976*. Buffalo: Albright-Knox Art Gallery, 1976.

Francis

Buck, Robert T., Jr., et al. *Sam Francis: Paintings, 1947–1972*, Buffalo: Albright-Knox Art Gallery in cooperation with Corcoran Gallery of Art, Whitney Museum of American Art, and Dallas Museum of Fine Arts, 1972.

Selz, Peter, et al. *Sam Francis*, rev. ed. New York: Harry N. Abrams, 1982.

Gorky

Arts Magazine, vol. 50, March 1976. Special issue: Arshile Gorky.

Lader, Melvin P. *Arshile Gorky*, New York: Abbeville Press, 1985.

Levy, Julien. *Arshile Gorky*, New York: Harry N. Abrams, 1966.

Rand, Harry. *Arshile Gorky: The Implications of Symbols*, Montclair, N.J.: Allanheld & Schram, 1980.

Rosenberg, Harold. *Arshile Gorky: The Man, the Time, the Idea*, New York: Grove Press, 1962.

Schwabacher, Ethel K. *Arshile Gorky*, New York: Macmillan and the Whitney Museum of American Art, 1957.

Waldman, Diane. *Arshile Gorky, 1904–1948: A Retrospective*, New York: Harry N. Abrams and The Solomon R. Guggenheim Museum, 1981.

Gottlieb

Doty, Robert, and Diane Waldman. *Adolph Gottlieb*, New York: Whitney Museum of American Art and The Solomon R. Guggenheim Museum, 1968.

MacNaughton, Mary Davis, et al. *Adolph Gottlieb: A Retrospective*, New York: The Arts Publisher and the Gottlieb Foundation, 1981.

Wilkin, Karen. *Adolph Gottlieb: Pictographs*, Edmonton Art Gallery, 1977.

Guston

Ashton, Dore. *Yes, but . . . : A Critical Study of Philip Guston*, New York: The Viking Press, 1976.

Feld, Ross, et al. *Philip Guston*, New York: George Braziller and the San Francisco Museum of Modern Art, 1980.

Hofmann

Bannard, Walter D. *Hans Hofmann: A Retrospective Exhibition*, Washington, D.C.: Hirshhorn Museum and Sculpture Garden, Smithsonian Institution; and Houston: Museum of Fine Arts, 1976.

Hofmann, Hans. *Search for the Real and Other Essays*, rev. ed., Cambridge, Mass.: MIT Press, 1967.

Hunter, Sam. *Hans Hofmann*, sec. ed., New York: Harry N. Abrams, 1964.

Seitz, William C. *Hans Hofmann*, New York: The Museum of Modern Art, 1963.

Hopper

Goodrich, Lloyd. *Edward Hopper*, New York: Harry N. Abrams, 1971.

Levin, Gail. *Edward Hopper: The Art and the Artist*, New York: Norton and the Whitney Museum of American Art, 1980.

———. *Edward Hopper*, New York: Crown, 1984.

Kline

de Kooning, Elaine. "Franz Kline, Painter of His Own Life," *Art News*, vol. 61, November 1962, pp. 28–31 +. (Also in the catalogue for the Kline memorial exhibition, Washington, D.C., Gallery of Modern Art, 1962.)

———. "Two Americans in Action: Franz Kline, Mark Rothko," *Art News Annual*, vol. 56, November 1957, part II, pp. 88–97 +.

Gaugh, Harry F. *The Vital Gesture: Franz Kline in Retrospect*, New York: Abbeville Press and the Cincinnati Art Museum, 1985.

Goldwater, Robert. "Franz Kline: Darkness Visible," *Art News*, vol. 66, March 1967, pp. 38–43 +. (Also in *Franz Kline, 1910–1962*, Marlborough-Gerson Gallery,

1967.)

Hess, Thomas B. "The Convertible Oyster," *New York Magazine*, vol. 8, April 7, 1975, pp. 68–70.

Krasner

Rose, Barbara. *Krasner/Pollock: A Working Relationship*, New York: Grey Art Gallery; and East Hampton, N.Y., Guild Hall Museum, 1981.

———. *Lee Krasner*, New York: The Museum of Modern Art; and Houston: Museum of Fine Arts, 1983.

Tucker, Marcia. *Lee Krasner: Large Paintings*, New York: Whitney Museum of American Art, 1973.

Mitchell

Harithas, James. *My Five Years in the Country: An Exhibition of Forty-nine Paintings by Joan Mitchell*, Syracuse: Everson Museum of Art; and New York: Martha Jackson Gallery, 1972.

Nochlin, Linda. "Joan Mitchell: Art and Life at Vétheuil," *House and Garden*, vol. 56, November 1984, pp. 192–97 +.

Tucker, Marcia. *Joan Mitchell*, New York: Whitney Museum of American Art, 1974.

Motherwell

Arnason, H.H., et al. *Robert Motherwell*, sec. ed., New York: Harry N. Abrams, 1982.

Ashton, Dore, and Jack D. Flam. *Robert Motherwell*, New York: Abbeville Press and Albright-Knox Art Gallery, 1983.

O'Hara, Frank. *Robert Motherwell*, New York: The Museum of Modern Art, 1965.

Terenzio, Stephanie. *Robert Motherwell and Black*, Storrs: William Benton Museum of Art, 1980.

Nevelson

Albee, Edward. *Louise Nevelson: Atmospheres and Environments*, New York: Potter and the Whitney Museum of American Art, 1980.

Glimcher, Arnold. *Louise Nevelson*, New York: Frederick A. Praeger, 1972.

Gordon, John. *Louise Nevelson*, New York: Frederick A. Praeger and the Whitney Museum of American Art, 1967.

Lipman, Jean, et al. *Nevelson's*

World, New York: Hudson Hills Press and the Whitney Museum of American Art, 1983.
Mackown, Diana. *Dawns + Dusks*, New York: Scribner, 1976.

Newman

Hess, Thomas B. *Barnett Newman*, New York: The Museum of Modern Art, 1971.
Richardson, Brenda. *Barnett Newman: The Complete Drawings, 1944–1969*, Baltimore: Museum of Art, 1979.
Rosenberg, Harold. *Barnett Newman*, New York: Harry N. Abrams, 1978.

Noguchi

Grove, Nancy, and Diane Botnick. *The Sculpture of Noguchi, 1924–79*, New York: Garland, 1982.
Hunter, Sam. *Isamu Noguchi*, New York: Abbeville Press, 1978.
————. *Isamu Noguchi: 75th Birthday Exhibition*, New York: Andre Emmerich Gallery, 1980.
Noguchi, Isamu, and R. Buckminster Fuller. *A Sculptor's World*, New York: Harper & Row, 1968.
————. *Isamu Noguchi: The Sculpture of Spaces*, New York: Whitney Museum of American Art, 1980.

Pollock

Arts Magazine, vol. 53, March 1979. Special issue: Jackson Pollock.
Frank, Elizabeth. *Jackson Pollock*, New York: Abbeville Press, 1983.
Friedman, B. H. *Jackson Pollock: Energy Made Visible*, New York: McGraw-Hill, 1972.
O'Connor, Francis V. *Jackson Pollock*, New York: The Museum of Modern Art, 1967.
————, and E. V. Thaw. *Jackson Pollock: A Catalogue Raisonné*, 4 vols., New Haven: Yale University Press, 1978.
Rose, Bernice. *Jackson Pollock: Drawing into Painting*, New York: The Museum of Modern Art, 1980.
Rubin, William S. "Jackson Pollock and the Modern Tradition: Part One," *Artforum*, vol. 5, February 1967, pp. 14–22. "Part Two," March 1967, pp. 28–37. "Part Three," April 1967, pp. 18–31. "Part Four," May 1967, pp. 28–33.
————. "Pollock as Jungian Illus-

trator: The Limits of Psychological Criticism," *Art in America*, vol. 67, November 1979, pp. 104–23. "Part II," December 1979, pp. 72–91.

Pousette-Dart

Gordon, John, et al. *Richard Pousette-Dart*, New York: Whitney Museum of American Art, 1963.
Levin, Gail. "Richard Pousette-Dart's Emergence as an Abstract Expressionist," *Arts Magazine*, vol. 54, March 1980, pp. 125–29.
Monte, James K. *Richard Pousette-Dart*, New York: Whitney Museum of American Art, 1974.

Reinhardt

Arnason, H. H., and Barbara Rose. *Ad Reinhardt: Black Paintings, 1951–1967*. New York: Marlborough Gallery, 1970.
Lippard, Lucy R. *Ad Reinhardt*. New York: Harry N. Abrams, 1981.
Reinhardt, Ad. *Twenty-five Years of Abstract Painting*, New York: Betty Parsons Gallery, 1960.
Rowell, Margit. *Reinhardt and Color*, New York: The Solomon R. Guggenheim Museum, 1980.

Roszak

Arnason, H. H. *Theodore Roszak*, Minneapolis: Walker Art Center, 1956.
Roszak, Theodore. "In Pursuit of an Image," *Quadrum*, 2, November 1956, pp. 49–60.
————. "Some Problems of Modern Sculpture," *Magazine of Art*, vol. 42, February 1949, pp. 53–56.

Rothko

Ashton, Dore. *About Rothko*, New York: Oxford, 1983.
Clearwater, Bonnie, and Dore Ashton. *Mark Rothko: Works on Paper*, New York: Hudson Hills Press in association with the Rothko Foundation and American Federation of Arts, 1984.
Sandler, Irving H. *Mark Rothko, Paintings, 1948–1969*, New York: Pace Gallery, 1983.
Selz, Peter. *Mark Rothko*, New York: The Museum of Modern Art, 1961.
Waldman, Diane. *Mark Rothko, 1903–1970: A Retrospective*, New York: The Solomon R. Guggenheim Museum, 1978.

David Smith

Carmean, E. A., Jr. *David Smith*, Washington, D.C.: National Gallery of Art, 1982.
Fry, Edward F. *David Smith*, New York: The Solomon R. Guggenheim Museum, 1969.
Gray, Cleve, ed. *David Smith by David Smith*, New York: Holt, Rinehart and Winston, 1968.
Krauss, Rosalind E. *The Sculpture of David Smith: A Catalogue Raisonné*, Garland, 1977.
————. *Terminal Iron Works: The Sculpture of David Smith*, Cambridge, Mass., and London: MIT Press, 1971.
McCoy, Garnett, ed. *David Smith*, New York: Frederick A. Praeger, 1973.
Marcus, Stanley E. *David Smith: The Sculptor and His Work*, Ithaca: Cornell University Press, 1983.
Wilkin, Karen. *David Smith*, New York: Abbeville Press, 1984.

Still

O'Neill, John P., ed. *Clyfford Still*, New York: Harry N. Abrams and The Metropolitan Museum of Art, 1979.
Smith, Gordon M., et al. *Clyfford Still: 23 Paintings in the Albright-Knox Art Gallery*, Buffalo, 1966.
Still, Clyfford, et al. *Clyfford Still*, San Francisco Museum of Modern Art, 1976.

Color Field Painting, Reductivist Painting, and Minimal Art

Battcock, Gregory. *Minimal Art*, New York: Dutton, 1968.
————, ed. *The New Art*, New York: Dutton, 1966; revised, 1973.
Berlind, Robert. "Robert Mangold: Nuanced Deviance," *Art in America*, May 1985.
Bourdon, David. *Carl Andre: Sculpture, 1959–1977*, New York: Jaap Rietman, 1978.
Fried, Michael. "Art and Objecthood," *Artforum*, June 1967.
————. *Morris Louis: 1912–1962*, Boston: Museum of Fine Arts, 1967.
Gablik, Suzi. "Minimalism," in Stangos, Nikos, *Concepts of Modern Art*, New York: Harper & Row, 1974; revised, 1981.
Geldzahler, Henry. *New York Paint-*

ing and Sculpture: 1940–1970, New York: Dutton, in collaboration with The Metropolitan Museum of Art, New York, 1969.

Greenberg, Clement. "Modernist Painting," *Art and Literature*, Spring 1963. Reprinted in Battcock, *The New Art*, 1973.

———. *Post-Painterly Abstraction*, Los Angeles County Museum, 1964. Reprinted in Rose, Barbara, ed. *Readings in American Art Since 1900: A Documentary Survey*, New York: Praeger, 1968.

Hughes, Robert. "The End of Modernity," Public Broadcasting System, New York: *The Shock of the New, Part VIII*, 1980.

Hunter, Sam. *Tony Smith*, New York: Pace Gallery, 1980.

Hunter, Sam, and John Jacobus. *American Art of the Twentieth Century*, New York: Harry N. Abrams; and Englewood Cliffs, N.J.: Prentice-Hall, 1975.

Leider, Philip. "The Thing in Painting Is Color," *The New York Times*, August 1968. Reprinted in Johnson, Ellen H. *American Artists on Art 1940–1980*, New York: Harper & Row, 1982.

Lippard, Lucy R. *Changing*, New York: Dutton, 1971.

Morris, Robert. "Notes on Sculpture," *Artforum*, February 1966. Reprinted in Battcock, *Minimal Art*, 1968.

———. "Notes on Sculpture, Part II," *Artforum*, October 1966. Reprinted in Battcock, *Minimal Art*, 1968.

Rose, Barbara. "ABC Art," *Art in America*, October 1965. Reprinted in Battcock, *Minimal Art*, 1968.

———. *American Art Since 1900: A Critical History*, New York: Praeger, 1967.

Rudikoff, Sonya. "Helen Frankenthaler's Painting," in Friedman, B. H., ed. *School of New York: Some Younger Artists*, New York: Grove Press, 1959.

White, Robin. "Interview with Brice Marden," *View*, Oakland and New York: Crown Point Press, 1980.

———. "Interview with Robert Mangold," *View*, Oakland and New York: Crown Point Press, 1978.

Wollheim, Richard. "Minimal Art," *Arts Magazine*, January 1965. Reprinted in Battcock, *Minimal Art*, 1968.

"The Responsive Eye": Art of Light, Perception, and Movement

General Sources

Hunter, Sam. *American Art of the 20th Century*, New York: Harry N. Abrams, 1973.

Lippard, Lucy R. "'Diversity in Unity': Recent Geometricizing Styles in America," in *Abstract Art Since 1945*, Greenwich, Connecticut: New York Graphic Society, 1971, pp. 231–257.

Rickey George. "Movement, Optical Phenomena, and Light," in *Contemporary Art, 1942–1972: Collection of the Albright-Knox Art Gallery*, New York: Praeger, 1973, pp. 299–341.

Sources on Specific Artists

Ashton, Dore. "Agnes Martin and . . ." in *Agnes Martin: Paintings and Drawings, 1957–1975*. London: Arts Council of Great Britain, 1977.

Flavin, Dan. ". . . In Daylight or Cool White," in *Dan Flavin: Fluorescent Light*, Vancouver Art Gallery, Ottawa, 1969.

Held, Al. Interview with Stephen Westfall, in *Art in America*, vol. 73, June 1985, pp. 113–121.

Irwin, Robert. "Notes Toward a Model," in *Robert Irwin*, Whitney Museum of American Art, New York, 1977.

Martin, Agnes. "Notes from a Lecture at Yale University, 1976," in *Agnes Martin: Paintings and Drawings, 1957–1975*, London: Arts Council of Great Britain, 1977.

Rickey, George. Untitled essay, in *George Rickey: Retrospective Exhibition, 1951–1971*, Los Angeles: University of California at Los Angeles Art Gallery, 1971.

Rosenthal, Nan. *George Rickey*, New York: Harry N. Abrams, 1977.

Seawright, James. "Phenomenal Art: Form, Idea, Technique," in *On the Future of Art*, New York: The Viking Press, 1970, pp. 77–95.

Wechsler, Lawrence. *Seeing Is Forgetting the Name of the Thing One Sees: A Life of a Contemporary Artist—Robert Irwin*, Berkeley: University of California Press, 1982.

The Object of Pop Art and Assemblage

Alloway, Lawrence. *American Pop Art*, New York: Whitney Museum of American Art, 1974.

———. *Robert Rauschenberg*, Washington, D.C.: Smithsonian Institution, National Collection of Fine Arts, 1977.

———. *Roy Lichtenstein*, New York: Abbeville Press, 1983.

Ashbery, John, et al. *R.B. Kitaj*, Washington, D.C.: Hirshhorn Museum and Sculpture Garden, Smithsonian Institution, 1981.

Ashton, Dore. *Richard Lindner*, New York: Harry N. Abrams, 1978.

Beal, Graham, et al. *Jim Dine: Five Themes*, New York and Minneapolis: Abbeville Press in association with the Walker Art Center, 1984.

Coplans, John, ed. *Roy Lichtenstein*, New York and Washington, D.C.: Frederick A. Praeger, 1972.

Cowart, Jack. *Roy Lichtenstein, 1970–1980*, New York: Hudson Hills Press in association with The Saint Louis Art Museum, 1981.

Crichton, Michael. *Jasper Johns*, New York: Harry N. Abrams in association with the Whitney Museum of American Art, 1977.

Francis, Richard. *Jasper Johns*, New York: Abbeville Press, 1984.

Hickey, Dave, and Peter Plagens. *The Works of Ed Ruscha*. New York: Hudson Hills Press in association with The San Francisco Museum of Modern Art, 1982.

Hunter, Sam, and Don Hawthorne. *George Segal*, New York: Rizzoli, 1984.

Martin, Henry. *Arman*, New York: Harry N. Abrams.

Plagens, Peter. *Sunshine Muse: Contemporary Art on the West Coast*, New York and Washington, D.C.: Frederick A. Praeger, 1974.

Ratcliff, Carter. *Andy Warhol*, New York: Abbeville Press, 1983.

———. *Red Grooms*, New York: Abbeville Press, 1984.

Russell, John, and Suzi Gablik, eds. *Pop Art Redefined*, New York and Washington, D.C.: Frederick A. Praeger, 1969.

Seitz, William. *The Art of Assemblage*, New York: The Museum of Modern Art, 1961.

Stealingworth, Slim [pseud., Tom Wesselmann]. *Tom Wesselmann*, New York: Abbeville Press, 1980.

Waldman, Diane. *John Chamberlain: A Retrospective Exhibition*, New York: The Solomon R. Guggenheim Museum, 1971.

Return to Realism

General Sources

Art in America, September 1981, pp. 85–95. Special issue: Realism.

Arthur, John. *Realism-Photorealism,* Tulsa: Southwestern Art Association, 1980.

Battcock, Gregory. *Super Realism: A Critical Anthology,* New York: Dutton, 1975.

Imagist Realism. Palm Beach: Norton Gallery and School of Art, 1974. Essay by Richard Martin.

Meisel, Louis K. *Photorealism,* New York: Harry N. Abrams, 1980.

Real, Really Real, and Superreal, San Antonio, Texas: San Antonio Museum of Art, 1981. Essays by Linda Nochlin, Philip Pearlstein, and Alvin Martin.

Stevens, Mark. "Art Imitates Life: The Revival of Realism," *Newsweek,* vol. 909, June 7, 1982, pp. 64–71.

Sources on Specific Artists

Ahearn

de Ak, Edit. "John Ahearn, 'We Are Family,' 877 Intervale Ave., Bronx," *Artforum,* November 1982.

Beckman

Arthur, John. "William Beckman," in *Realists at Work,* New York: Watson Guptill, 1983, pp. 24–37.

Belz, Carl. *The Art of William Beckman and Gregory Gillespie,* Waltham, Mass.: Rose Art Museum, Brandeis University, 1984.

Close

Close Portraits, Minneapolis: Walker Art Center, 1980.

Wise, Kelly, ed. *Portrait: Theory—Chuck Close,* New York: Lustrum Press, 1981.

Estes

Arthur, John. "Artist's Dialogue: A Conversation with Richard Estes," *Architectural Digest,* October 1982, pp. 204–209.

Richard Estes: The Urban Landscape, Boston: Museum of Fine Arts, 1978.

Flack

Flack, Audrey. *Audrey Flack on Painting,* New York: Harry N. Abrams, 1981.

Kozloff, Max. "Audrey Flack," *Artforum,* June 1974, p. 65.

Hanson

Duane Hanson, Stuttgart: Württembergischer Kunstverein, 1974.

Hanson, Duane. "Presenting Duane Hanson," *Art in America,* September 1970.

Leslie

Alfred Leslie: Retrospective, Boston: Museum of Fine Arts, 1976.

Westfall, Stephen. Interview with Alfred Leslie in *Art in America,* June 1985, pp. 112–113.

Pearlstein

Pearlstein, Philip. Personal statement in Mark Strand, ed., *Art of the Real,* New York: Clarkson N. Potter, 1983, pp. 89–113.

Philip Pearlstein, New York: Hirschl & Adler Modern, 1985. Introduction by Scott Burton.

Welliver

Kuspit, Donald. "Terrestrial Truth: Neil Welliver," *Art in America,* April 1983, pp. 138–144.

Welliver, Neil. Personal statement in Mark Strand, ed., *Art of the Real,* New York: Clarkson N. Potter, 1983, pp. 201–229.

Beyond Formalism: Language Models, Conceptual Art, and Environmental Art

Battcock, Gregory, ed. *Idea Art,* New York: Dutton, 1973.

Burnham, Jack. *The Structure of Art,* New York: George Braziller, 1971.

———. *Great Western Salt Works: Essays on the Meaning of Post-Formalist Art,* New York: George Braziller, 1974.

Haacke, Hans. *Framing and Being Framed,* New York: The New York University Press; and The Press of the Nova Scotia College of Art and Design, 1975.

———. "The Constituency," *Tracks,* vol. 3, no. 3, Fall 1977.

———. "Broadness and Diversity of the Ludwig Brigade," *October,* no. 13, Fall 1984.

Hobbs, Robert. *Robert Smithson: Sculpture,* Ithaca: Cornell University Press, 1981.

Holt, Nancy, ed. *the Writings of Robert Smithson,* New York: The New York University Press, 1979.

Huebler, Douglas. *Crocodile Tears,* Buffalo: CEPA and Albright-Knox Art Gallery, 1985.

Kostelanetz, Richard, ed. *Esthetics Contemporary,* Buffalo: Prometheus, 1978.

Kosuth, Joseph. "Introductory Note by the American Editor," *Art-Language,* vol. 1, no. 2, February 1970.

———. *Within the Context: Modernism and Critical Practice,* Ghent, Belgium: Coupure, 1977.

Legg, Alicia, ed., *Sol LeWitt,* New York: The Museum of Modern Art, 1978.

LeWitt, Sol. "Paragraphs on Conceptual Art," *Artforum,* June 1967.

———. "Sentences on Conceptual Art," *Art-Language: The Journal of Conceptual Art,* vol. 1, no. 1, May 1969.

Lippard, Lucy R. *Changing,* New York: Dutton, 1971.

———, ed. *Six Years: the Dematerialization of the Art Object from 1966 to 1972,* London: Studio Vista, 1973.

Meyer, Ursula, ed. *Conceptual Art,* New York: Dutton, 1972.

Morgan, Robert C. "Conceptual Art and the Continuing Quest for A New Social Context," *Journal: Southern California Art Magazine,* no. 23, June–July 1979.

———. "Conceptual Art and Photographic Installations: The Recent Outlook," *Afterimage,* vol. 9., no. 5, December 1981.

———. "The Invisible and the Visible: Robert Barry and American Conceptualism," in Erich Franz, ed., *Robert Barry.* Bielefeld: Kunsthalle, 1985.

Siegelaub, Seth, ed. *January 5–31, 1969,* exhibition catalogue, New York, 1969.

Tucker, Marcia. "Phenomenology," *Artforum,* December 1970.

Vinklers, Bitite. "Hans Haacke," *Art International,* vol. XIII, no. 7, September 1969, pp. 44–49, 56.

The Art of Cultural Violence

"Art and Politics: Golub, Kruger, Spero, and Burden," *Art in America,* January 1984. Articles by Carter Ratcliff, Jamey Gambrell, Donald Kuspit, and Craig Owens.

Brenson, Michael. "The Human Figure Is Back in Unlikely Guises," *The New York Times,* January 13, 1985.

Content: A Contemporary Focus,

1974–1984, exhibition catalogue, Hirshhorn Museum and Sculpture Garden, Smithsonian Institution, Washington, D.C., 1984. Contributions by Howard N. Fox, Miranda McClintic, Phyllis Rosenzweig.

Critical Perspectives in American Art, exhibition catalogue, University Gallery, University of Massachusetts, Amherst, 1976.

Felshin, Nina, *Disarming Images: Art for Nuclear Disarmament.* An exhibition organized by Bread and Roses, the cultural project of the National Union of Hospital and Health Care Employees, AFL-CIO, and Physicians for Social Responsibility, New York City. Circulated by the Art Museum Association of America. New York, 1984.

The Figurative Tradition and the Whitney Museum of American Art, exhibition catalogue, Whitney Museum of American Art, New York, 1980. Contributions by Patricia Hills and Roberta K. Tarbell.

Focus on the Figure: Twenty Years, exhibition catalogue, Whitney Museum of American Art, New York, 1982.

Foster, Hal. "For a Concept of the Political in Art," *Art in America,* April 1984, pp. 17–19.

Gambrell, Jamey. "Artists Against Intervention," *Art in America,* May 1984, pp. 9–11 + .

Gans, Herbert. "American Popular Culture and High Culture in a Changing Class Structure," in *Art, Ideology and Politics,* ed. by Judith H. Balfe and Margaret Jane Wyszomirski, New York, 1985, pp. 40–57.

Hunter, Sam. *New Image/Pattern and Decoration: From the Morton G. Neumann Family Collection,* exhibition catalogue, Kalamazoo Institute of the Arts, Kalamazoo, Michigan, 1983.

Kramer, Hilton. "Expressionism Returns to Painting," *The New York Times,* July 12, 1981.

Lippard, Lucy. *Get the Message,* New York, 1984.

Lyons, Lisa. *Eight Artists: The Anxious Edge,* exhibition catalogue, Walker Art Center, Minneapolis, 1982.

New Figuration in America, exhibition catalogue, Milwaukee Art Museum, Milwaukee, 1982. Contributions by Gerald Nordland, Russell Brown, Peter Schjeldahl.

Rosenthal, Mark. "From Primary Structures to Primary Imagery," *Arts Magazine,* October 1978, pp. 106–107.

Siersma, Betsy. *Contemporary Prints: The Figure Beside Itself,* exhibition catalogue, University Gallery, University of Massachusetts, Amherst, 1982.

Starr, Jerold M. "Cultural Politics and the Prospects for Radical Change in the 1980's," in *Cultural Politics: Radical Movements in Modern History,* New York, 1985, pp. 295–333.

Tucker, Marcia. "An Iconography of Recent Figurative Painting: Sex, Death, Violence, and the Apocalypse," *Artforum,* Summer 1982, pp. 70–75.

————. *Paradise Lost/Paradise Regained,* exhibition catalogue, American Pavillion at the Venice Biennale, Venice, Italy, 1984.

Yard, Sally. "The Shadow of the Bomb," *Arts Magazine,* April 1984, pp. 73–82.

Pattern and Decoration

Cohen, Ronny H. "Energism: An Attitude," *Artforum,* vol. 19, September 1980.

Delahoyd, Mary. *Alternatives in Retrospect,* exhibition catalogue, The New Museum, New York, 1982.

Jensen, Robert, and Patricia Conway, *Ornamentalism: The New Decorativeness in Architecture and Design,* New York: Clarkson N. Potter, Inc., 1982.

Kardon, Janet. *Decorative Impulse,* exhibition catalogue, Institute of Contemporary Art, University of Pennsylvania, Philadelphia, 1979.

Kuspit, Donald. "Cosmetic Transcendentalism," *Artforum,* vol. 18, October 1979.

————. *Rodney Ripps' American Landscape,* exhibition catalogue, Marisa del Re Gallery, New York, 1985.

Meyer, Ruth K. *Arabesque,* exhibition catalogue, Contemporary Arts Center, Cincinnati, 1978.

Perreault, John. "Issues in Pattern Painting," *Artforum,* November 1977.

Perrone, Jeff. "Approaching the Decorative," *Artforum,* December 1976.

Rickey, Carrie. "Pattern Painting," *Arts Magazine,* January 1978.

Schwartz, Ellen. "Judy Pfaff: Sculpture May Never Be the Same Again," *Art News,* vol. 80, May 1981.

Appropriating the Past: Neo-Expressionism, Neo-Primitivism, and the Revival of Abstraction

Berman, Marshall. *All That Is Solid Melts into Air: The Experience of Modernity,* New York: Simon & Schuster, 1982.

Buchloh, Benjamin H.D. "Figures of Authority, Ciphers of Regression: Notes on the Return of Representation in European Painting," *October,* Spring 1981.

"Expressionism Today: An Artists' Symposium." Interviews by Carter Ratcliff, Hayden Herrera, Sarah McFadden, and Joan Simon, *Art in America,* December 1982.

Foster, Hal. "The Expressive Fallacy," *Art in America,* January 1983.

Kosuth, Joseph. "Necrophilia Mon Amour," *Artforum,* May 1982.

Kuspit, Donald. "Rejoinder: Tired Criticism, Tired 'Radicalism,'" *Art in America,* April 1983.

Lawson, Thomas. "Last Exit: Painting," *Artforum,* October 1981.

Levin, Kim. "The State of the Art: 1980," *Art Journal,* Fall/Winter 1980.

Moufarrege, Nicholas. "X Equals Zero, As in Tic-Tac-Toe," *Arts,* February 1983.

Owens, Craig. "Honor, Power and the Love of Women," *Art in America,* January 1983.

Paz, Octavio. *Children of the Mire: The Charles Eliot Norton Lectures, 1971–1972,* Cambridge, Mass.: Harvard University Press, 1974.

Plagens, Peter. "The Academy of the Bad," *Art in America,* November 1981.

Ratcliff, Carter. "The Short Life of the Sincere Stroke," *Art in America,* January 1983.

Ricard, René. "The Radiant Child," *Artforum,* December 1981.

Schiff, Gert. *Julian Schnabel,* New York: Pace Gallery, 1984.

Schjeldahl, Peter. "The Real Salle," *Art in America,* September 1984.

ARTISTS IN THE EXHIBITION

I Reappraising the New York School

Painting

William Baziotes
Ilya Bolotowsky
Stuart Davis
Willem de Kooning
Richard Diebenkorn
Sam Francis
Arshile Gorky
Adolph Gottlieb
Hans Hofmann
Franz Kline
Lee Krasner
Joan Mitchell
Robert Motherwell
Barnett Newman
Jackson Pollock
Richard Pousette-Dart
Ad Reinhardt
Mark Rothko
Clyfford Still

Sculpture

Louise Bourgeois
Alexander Calder
Joseph Cornell
Louise Nevelson
Isamu Noguchi
Theodore Roszak
David Smith

II Color Field Painting, Reductivist Painting, and Minimal Art

Painting

Helen Frankenthaler
Sam Gilliam
Ellsworth Kelly
Morris Louis
Robert Mangold
Brice Marden

Kenneth Noland
Jules Olitski
Robert Ryman

Sculpture

Carl Andre
Walter de Maria
Michael Heizer
Donald Judd
Joel Shapiro
Tony Smith

III "The Responsive Eye": Art of Light, Perception, and Movement

Painting

Al Held
Robert Irwin
Agnes Martin

Sculpture

Dan Flavin
George Rickey
James Seawright

IV The Object of Pop Art and Assemblage

Painting

Jim Dine
Red Grooms
Jasper Johns
Alex Katz
R. B. Kitaj
Roy Lichtenstein
Richard Lindner
Robert Rauschenberg
Larry Rivers
James Rosenquist
Ed Ruscha
Cy Twombly

Andy Warhol
Tom Wesselmann
William Wiley

Sculpture

Arman
Richard Artschwager
John Chamberlain
Mark di Suvero
Claes Oldenburg
George Segal

V Return to Realism

Painting

William Beckman
Chuck Close
Richard Estes
Audrey Flack
Edward Hopper
Alfred Leslie
Philip Pearlstein
Neil Welliver

Sculpture

John Ahearn
Duane Hanson

VI Beyond Formalism: Language Models, Conceptual Art, and Environmental Art

Painting

John Baldessari
Robert Barry
Jennifer Bartlett
Mel Bochner
Hans Haacke
Douglas Huebler
Joseph Kosuth
Dorothea Rockburne

Sculpture

Siah Armajani
Alice Aycock
Scott Burton
Eva Hesse
Sol LeWitt
Mary Miss
Bruce Nauman
Richard Serra
Charles Simonds
Robert Smithson

VII *The Art of Cultural Violence*

Painting

Vito Acconci
Nicolas Africano
Ida Applebroog
Jonathan Borofsky
Richard Bosman
Charles Garabedian
Leon Golub
Neil Jenney
Barbara Kruger
Robert Longo
Peter Saul

Sculpture

Robert Arneson
Chris Burden
H. C. Westermann

VIII *Pattern and Decoration*

Painting

Robert Kushner
Kim MacConnel
Rodney Ripps
Robert Zakanitch
Joe Zucker

Sculpture

Judy Pfaff
Ned Smyth

IX *Appropriating the Past: Neo-Expressionism, Neo-Primitivism, and the Revival of Abstraction*

Painting

Gregory Amenoff
Donald Baechler
Jean-Michel Basquiat
Troy Brauntuch
Eric Fischl
Jedd Garet
Jack Goldstein
Philip Guston
Keith Haring
Malcolm Morley
Robert Morris
Robert Moskowitz

Elizabeth Murray
Katherine Porter
Judy Rifka
Susan Rothenberg
David Salle
Kenny Scharf
Julian Schnabel
Sean Scully
Frank Stella
Gary Stephan
Donald Sultan
Terry Winters

Sculpture

John Duff
Nancy Graves
Bryan Hunt
Tom Otterness
Lucas Samaras

262

In dimensions, height precedes width precedes depth; measurements are given in inches and feet.

Vito Acconci (b. 1940)
People's Wall, 1985.
Painted wood, quilted fabric, rubber flooring, mirrored Plexiglas, 96 x 192 x 27".
Carpenter + Hochman Gallery, New York.
PLATE 98

Nicolas Africano (b. 1948)
Whiskey per Tutti, 1980.
Acrylic, oil, enamel, and magna on Masonite, 48 x 84".
Collection Holly and Horace Solomon, New York.
PLATE 104

John Ahearn (b. 1951)
Pedro, 1984.
Polyester castings modified and painted by the artist, 80 x 42 x 18".
Collection Edward R. Downe, Jr., New York.
PLATE 76

Gregory Amenoff (b. 1948)
Deceit, 1983.
Oil on canvas, 94¼ x 76".
Collection Martin Sklar, New York.
PLATE 131

Carl Andre (b. 1935)
81 Cu Fe (The Net of Hephaestus), floor piece, 1981.
Copper and steel, 180 x 180 x ³⁄₁₆"; 41 copper plates, 40 steel plates, each plate 20 x 20".
Paula Cooper Gallery, New York.
PLATE 37

Ida Applebroog.
Wentworth Gardens, 1984.
Oil on canvas, 100 x 100". Two panels: 100 x 33½" and 100 x 66½".
Ronald Feldman Fine Arts, New York.
PLATE 96

Siah Armajani (b. 1939)
Open Door Buffet with Windows, 1984.
Painted wood with mirror and stained glass, 103½ x 65 x 31".
Max Protetch Gallery, New York.
PLATE 87

Arman (b. 1928)
Horizontal Catastrophe, 1982.
Burned sofa cast in bronze, 39¾ x 55 x 26".
Marisa del Re Gallery, New York.
PLATE 53

Robert Arneson (b. 1930)
Doggie Bob, 1982.
Glazed ceramic, 36 x 33 x 21".
Allan Frumkin Gallery, New York.
PLATE 100

Richard Artschwager (b. 1924)
Flayed Tables, 1985.
Polychrome on wood (open), 123 x 52½ x 18¼".
Collection Suzanne and Howard Feldman, New York.
PLATE 54

Alice Aycock (b. 1946)
Fata Morgana (Of Things Seen in the Sky), 1984.
Steel, engine, mirror, neon, 130 x 50 x 70".
John Weber Gallery, New York.
PLATE 90

Donald Baechler (b. 1956)
Die Fahne Hoch, 1984.
Acrylic, acrylic medium, and paper on canvas, 97 x 64".
Collection Tony Shafrazi, New York.
PLATE 141

John Baldessari (b. 1931)
Black and White Decision, 1984.
Black-and-white photographs, gelatin silver prints, 64 x 70¾".
The Eli Broad Family Foundation, Los Angeles.
PLATE 92

Robert Barry (b. 1936)
Word Circle, 1986.
Installation piece, pencil and latex paint.
Not illustrated.

Jennifer Bartlett (b. 1941)
Horizon, 1979.
Enamel, silkscreen grid and baked enamel on steel plates, oil on canvas (20 plates, 1 canvas), 48 x 250".
Collection Martin Sklar, New York.
PLATE 85

Jean-Michel Basquiat (b. 1960)
Gua-Gua, 1984.
Oil on canvas, 80 x 102".
Collection Robert and Doris Hillman, New York.
PLATE 140

William Baziotes (1912–1963)
Phantom, 1953.
Oil on canvas, 30⅛ x 37¾".
Blum-Helman Gallery, New York.
PLATE 11

William Beckman (b. 1942)
Diana IV, 1981.
Oil on wood panel, 84½ x 50⅞".
Hirshhorn Museum and Sculpture Garden, Smithsonian Institution, Washington, D.C.
PLATE 77

Mel Bochner (b. 1940)
Siege, 1984.
Oil on canvas, 100 x 79".
Sonnabend Gallery, New York.
PLATE 84

Ilya Bolotowsky (b. 1907)
Grey and White, 1945.
Oil on canvas, 21 x 33".
Washburn Gallery, Inc., New York.
PLATE 5

Jonathan Borofsky (b. 1942)
2,841,778 Male Aggression Now Playing Everywhere, 1981–83.
Acrylic on canvas, 109½ x 83¾".
Collection Suzanne and Howard Feldman, New York.
PLATE 97

Richard Bosman (b. 1944)
Panic, 1982.
Oil on canvas, 72 x 108".
Collection Robert H. Helmick, Des Moines.
PLATE 99

Louise Bourgeois (b. 1911)
Femme Maison (Woman's House), 1981.
Marble, 48⅛ x 47 x 49⅞".
Robert Miller Gallery, New York.
PLATE 26

Troy Brauntuch (b. 1954)
Floorboards, 1984.
Pastel on cotton, 108 x 144".
The Eli Broad Family Foundation, Los Angeles.
PLATE 138

Chris Burden (b. 1946)
The Pinta, 1982.
Wood, toys, motorcycle, engine, paint, and electronic parts, 30 x 70 x 10½".
Ronald Feldman Fine Arts, New York.
PLATE 103

Scott Burton (b. 1939)
Pedestal Tables, 1979–81.
Copper-plated bronze, 37 x 11 x 11".
Max Protetch Gallery, New York.
PLATE 88

Alexander Calder (1898–1976)
Bourges, 1969.
Painted metal.
Collection Irma and Norman Braman, Miami. Courtesy of The Tampa Museum.
PLATE 3

John Chamberlain (b. 1927)
Lorelei's Passion, 1982.
Painted and chromium-plated steel, 84 x 60 x 35".
Xavier Fourcade Gallery, New York.
PLATE 51

Chuck Close (b. 1940)
Phil, 1983.
Pulp paper on canvas, 92 x 72".
The Pace Gallery, New York.
PLATE 75

Joseph Cornell (1903–1972)
Variétés Apollinaires (for Guillaume Apollinaire), 1953.
Box construction, 18¾ x 11⅜ x 4¼".
Castelli, Feigen, Corcoran, New York.
PLATE 25

Stuart Davis (1894–1964)
Ultramarine, 1943.
Oil on canvas, 20 x 40".

Pennsylvania Academy of the Fine Arts, Philadelphia.
PLATE 4

Willem de Kooning (b. 1904)
Untitled XV, 1975.
Oil on canvas, 77 x 88".
Xavier Fourcade Gallery, New York.
PLATE 15

Walter de Maria (b. 1954)
The Square of the Large Rod Series, 1985.
Solid, custom-ground, and hand-polished polygonal stainless-steel rods, 5-, 7-, 9-, 11- and 13-sided, each 52" long.
Xavier Fourcade Gallery, New York.
PLATE 36

Richard Diebenkorn (b. 1922)
Ocean Park No. 118, 1980.
Oil on canvas, 93 x 81".
Collection Martin Z. Margulies, Miami.
PLATE 24

Jim Dine (b. 1935)
Blue, 1980.
Oil on canvas, three panels, overall size 80 x 96".
The Pace Gallery, New York.
PLATE 67

Mark di Suvero (b. 1933)
Untitled, 1980–83.
Steel and stainless steel, 63½ x 64 x 59¾".
Oil and Steel Gallery, New York.
PLATE 52

John Duff (b. 1943)
Macaha, 1985.
Fiberglass and enamel paint, 61½ x 15⅝ x 21¾".
Margo Leavin Gallery, Los Angeles.
PLATE 128

Richard Estes (b. 1936)
Canadian Club, 1974.
Oil on Masonite, 48 x 60".
The Neumann Family Collection, New York.
PLATE 72

Eric Fischl (b. 1948)
Haircut, 1985.
Oil on linen, 104 x 84".
The Eli Broad Family Foundation, Los Angeles.
PLATE 137

Audrey Flack (b. 1931)
Invocation, 1982.
Oil on canvas, 64 x 80".
Louis K. Meisel Gallery, New York.
PLATE 74

Dan Flavin (b. 1933)
Untitled, 1980.
Blue, green, and pink fluorescent light, 168 x 25".
Leo Castelli Gallery, New York.
PLATE 46

Sam Francis (b. 1923)
Persephone, or Painters Work in the Dark, 1979.
Acrylic on canvas, 114 x 228".
Collection the artist.
PLATE 14

Helen Frankenthaler (b. 1928)
Nature Abhors a Vacuum, 1973.
Acrylic on canvas, 103½ x 112½".
Andre Emmerich Gallery, New York.
PLATE 30

Charles Garabedian (b. 1923)
Ulysses, 1984.
Acrylic on canvas, 90 x 66".
Hirschl & Adler Modern, New York.
PLATE 105

Jedd Garet (b. 1955)
Two, 1984.
Acrylic on canvas, 104 x 158".
The Museum of Modern Art, New York, Gift of Anna Marie and Robert Shapiro, 1984.
PLATE 130

Sam Gilliam (b. 1933)
Like Today, 1985.
Acrylic on canvas with aluminum construction, 55 x 67 x 4".
Monique Knowlton Gallery, New York.
PLATE 28

Jack Goldstein (b. 1945)
Untitled, 1985.
Acrylic on canvas, 96 x 62".
Metro Pictures, New York.
PLATE 133

Leon Golub (b. 1922)
Interrogation I, 1981.
Acrylic on canvas, 120 x 176".
The Eli Broad Family Foundation, Los Angeles.
PLATE 107

Arshile Gorky (1904–1948)
Untitled, 1943–48.
Oil on canvas, 54½ x 64½".
Dallas Museum of Art.
PLATE 10

Adolph Gottlieb (1903–1974)
Collision, 1971.
Oil and acrylic on canvas, 90⅛ x 60⅛".
©1979 Adolph and Esther Gottlieb Foundation, New York.
PLATE 20

Nancy Graves (b. 1940)
Circumfoliate, 1983.
Patinated bronze, 46½ x 44½ x 32½".
Collection Leonard and Gloria Luria, Miami.
PLATE 126

Red Grooms (b. 1937)
Ruckus Manhattan: Girls, Girls, Girls, 1976.
Mixed mediums, canvas, fabric, 120 x 168½".
Marlborough Gallery, New York.
PLATE 49

Philip Guston (1913–1980)
The Floor, 1976.
Oil on canvas, 69 x 98".
Estate of Philip Guston; David McKee Gallery, New York.
PLATE 118

Hans Haacke (b. 1936)
Taking Stock (Portrait of Margaret Thatcher), 1985.
Oil on canvas, wood, gold leaf, with photographs, 95 x 81 x 7".
Collection Gilbert and Lila Silverman, Southfield, Michigan.
PLATE 91

Duane Hanson (b. 1925)
Self-Portrait with Model, 1979.
Polyvinyl, polychromed in oil, with accessories, life size.
Collection Maja and Duane Hanson,

Davie, Florida.
PLATE 69

Keith Haring (b. 1958)
Untitled, 1983.
Vinyl ink on vinyl tarpaulin, 120 x 120".
Tony Shafrazi Gallery, New York.
PLATE 139

Michael Heizer (b. 1944)
45,° 90,° 180,° 1985.
Three elements, bronze,
45°: 31 x 29 x 31";
90°: 40 x 30 x 27";
180°: 15 x 21 x 37";
pedestals, 18 x 27 x 40".
Xavier Fourcade Gallery, New York.
PLATE 41

Al Held (b. 1928)
Rome II, 1982.
Acrylic on canvas, 108 x 216".
Andre Emmerich Gallery, New York.
PLATE 44

Eva Hesse (1936–1970)
Ice Piece, 1969.
Fiberglass and wire, 62' x 1".
Xavier Fourcade Gallery, New York.
PLATE 83

Hans Hofmann (1880–1966)
Pastorale, 1958.
Oil on canvas, 60 x 48".
Andre Emmerich Gallery, New York.
PLATE 7

Edward Hopper (1882–1967)
August in the City, 1945.
Oil on canvas, 23 x 30".
Norton Gallery of Art,
West Palm Beach, Florida.
PLATE 70

Douglas Huebler (b. 1924)
Variable Piece No. 70 (in Process), Global Crocodile Tears II: Howard, 1981.
Three photographs, 3 texts; overall
55 x 118¾".
Leo Castelli Gallery, New York.
PLATE 93

Bryan Hunt (b. 1947)
Mysterian (Barcelona Series), 1985.
Bronze and limestone, 58½ x 25 x 19½".
Blum-Helman Gallery, New York.
PLATE 125

Robert Irwin (b. 1928)
Untitled, 1969.
Acrylic paint on cast acrylic, 54" diameter.
The Pace Gallery, New York.
PLATE 43

Neil Jenney (b. 1945)
Them and Us, 1969.
Acrylic on canvas, 58½" x 11'3".
The Museum of Modern Art, New York,
Gift of Louis G. and Susan B. Reese, 1985.
PLATE 106

Jasper Johns (b. 1930)
Dancers on a Plane, 1979.
Oil on canvas with objects, 77⅞ x 64".
Private collection, New York.
PLATE 66

Donald Judd (b. 1928)
Untitled, 1979.
Cor-ten steel, 48 x 119 x 119".
Collection Martin Z. Margulies, Miami.
PLATE 38

Alex Katz (b. 1927)
Lawn Party, 1977.
Oil on canvas, 78 x 144".
Marlborough Gallery, New York.
PLATE 56

Ellsworth Kelly (b. 1923)
Untitled, 1983.
Cor-ten steel, 39⅜ x 94⅛ x ⅜".
Leo Castelli Gallery, New York.
PLATE 39

R. B. Kitaj (b. 1932)
The Ohio Gang, 1964.
Oil and crayon on canvas, 72⅛ x 72¼".
The Museum of Modern Art, New York,
Philip Johnson Fund, 1965.
PLATE 62

Franz Kline (1910–1962)
Yellow Square, 1952.
Oil on canvas mounted on Masonite,
64¾ x 78¾".
Collection Dr. and Mrs. A. Castellett,
Darien, Connecticut.
PLATE 22

Joseph Kosuth (b. 1945)
Fort! Da! No. 2, 1985.
Duratrans photo process, 72 x 120".
Leo Castelli Gallery, New York.
PLATE 95

Lee Krasner (1908–1984)
Celebration, 1957–60.
Oil on canvas, 92¼ x 184½".
Robert Miller Gallery, New York.
PLATE 13

Barbara Kruger (b. 1945)
Untitled ("Your Fictions Become History"),
1983.
Photomontage, 120 x 96".
Annina Nosei Gallery, New York.
PLATE 109

Robert Kushner (b. 1949)
Ride, 1985.
Cast paper, 3 panels in one frame:
43¾ x 85".
Holly Solomon Gallery, New York.
PLATE 114

Alfred Leslie (b. 1927)
Birthday for Ethel Moore, 1976.
Oil on canvas, 108 x 132".
Collection the artist; courtesy Oil and Steel
Gallery, New York.
PLATE 73

Sol LeWitt (b. 1928)
Eight-Unit Cube, 1976.
Painted aluminum, 120 x 120 x 120".
Collection Martin Z. Margulies, Miami.
PLATE 79

Roy Lichtenstein (b. 1923)
Cosmology, 1978.
Oil and magna on canvas, 107 x 167".
Private collection, New York.
PLATE 64

Richard Lindner (b. 1901)
Hello, 1966.
Oil on canvas, 70 x 60".
The Abrams Family Collection, New York.
PLATE 60

Robert Longo (b. 1953)
Friends, 1985.
Charcoal, graphite, and dye on paper,
plastic, steel, 191¾ x 189 x 7".

Metro Pictures, New York.
PLATE 108

Morris Louis (1912–1962)
Beth Lamed, 1959.
Acrylic on canvas, 90¼ x 150".
Andre Emmerich Gallery, New York.
PLATE 31

Kim MacConnel (b. 1946)
U-Totem, 1984.
Acrylic on cotton, 96 x 108".
Holly Solomon Gallery, New York.
PLATE 111

Robert Mangold (b. 1937)
Four Color Frame Painting No. 1, 1983.
Acrylic and pencil on canvas, 111 x 105".
Collection Martin Sklar, New York.
PLATE 33

Brice Marden (b. 1938)
Number Two, 1983–84.
Oil on canvas, 84 x 109".
Collection Martin Z. Margulies, Miami.
PLATE 34

Agnes Martin (b. 1912)
Number 14, 1981.
Gesso acrylic and pencil on canvas,
72 x 72".
The Pace Gallery, New York.
PLATE 45

Mary Miss (b. 1944)
Screen, 1984.
Painted aluminum, 76 x 96 x 72".
Max Protetch Gallery, New York.
PLATE 89

Joan Mitchell (b. 1926)
Flying Dutchman, 1961–62.
Oil on canvas, 78¾ x 78¾".
Xavier Fourcade Gallery, New York.
PLATE 16

Malcolm Morley (b. 1931)
La Plage, 1980.
Oil on canvas, 72½ x 98¾".
Collection Martin Z. Margulies, Miami.
PLATE 134

Robert Morris (b. 1931)
Untitled, 1983–84.
Painted Hydrocal, pastel on paper,
88 x 72 x 3½".
The Eli Broad Family Foundation, Los
Angeles.
PLATE 145

Robert Moskowitz (b. 1935)
Stack, 1979.
Oil on canvas, 108 x 34".
Collection Mr. and Mrs. Raymond Nasher,
Dallas.
PLATE 132

Robert Motherwell (b. 1915)
Wall Painting No. 4, 1954.
Oil on canvas, 55½ x 73¼".
Collection Elliott and Bonnie Barnett,
Fort Lauderdale, Florida.
PLATE 8

Elizabeth Murray (b. 1940)
Simple Meaning, 1982.
Oil on two canvases, 107 x 96".
Collection Jerry and Emily Spiegel,
Kings Point, New York.
PLATE 123

Bruce Nauman (b. 1941)
Perfect Door, Perfect Odor, Perfect Rodo,

265

1972.
Neon and glass tubing, three sections each:
21½ x 28¾," edition of three.
Leo Castelli Gallery, New York.
PLATE 94

Louise Nevelson (b. 1900)
Mirror-Shadow IV, 1985.
Wood painted black, 105 x 128 x 33".
The Pace Gallery, New York.
PLATE 17

Barnett Newman (1905–1970)
Onement VI, 1953.
Oil on canvas, 102 x 120".
Weisman Family Collection,
Richard L. Weisman, New York.
PLATE 23

Isamu Noguchi (b. 1904)
Basin and Range, 1982.
Mihara granite, 17 x 14 x 49," with wooden
pedestal.
The Pace Gallery, New York.
PLATE 27

Kenneth Noland (b. 1924)
Across, 1964.
Acrylic resin paint on canvas, 97 x 126".
Andre Emmerich Gallery, New York.
PLATE 29

Claes Oldenburg (b. 1929) and
Coosje van Bruggen (b. 1942)
*Cross Section of a Toothbrush with Paste,
in a Cup, on a Sink: Portrait of Coosje's
Thinking–Model*, 1982.
Aluminum, painted with acrylic,
134¼ x 54¼ x 15⅛".
Leo Castelli Gallery, New York.
PLATE 65

Jules Olitski (b. 1922)
Exact Origin, 1966.
Acrylic on canvas, 110 x 85".
Andre Emmerich Gallery, New York.
PLATE 32

Tom Otterness (b. 1952)
Frog and Robot, 1985.
Cast bronze, 34½ x 41 x 41".
Collection Mrs. Emily Fisher Landau, New York.
Courtesy of Brooke Alexander Gallery,
New York.
PLATE 143

Philip Pearlstein (b. 1924)
Two Nudes, Bamboo, and Linoleum, 1984.
Oil on canvas, 96 x 96".
Hirschl & Adler Modern, New York.
PLATE 78

Judy Pfaff (b. 1946)
Untitled, 1984.
Mixed mediums, 68 x 99 x 35".
Collection Leonard and Gloria Luria,
Miami.
PLATE 112

Jackson Pollock (1912–1956)
Banners of Spring, 1946.
Oil on canvas, 33 x 43".
Private collection, Connecticut.
PLATE 9

Katherine Porter (b. 1941)
La Libertad, 1980.
Oil on canvas, 84½ x 88⅝".
Private collection; courtesy of David McKee
Gallery, New York.
PLATE 127

Richard Pousette-Dart (b. 1916)
Presence, Genesis, 1975.
Acrylic on canvas, 96 x 111".
Marisa del Re Gallery, New York.
PLATE 19

Robert Rauschenberg (b. 1925)
Kite, 1963.
Oil and silkscreen on canvas, 84 x 60".
Collection Mr. and Mrs. Michael
Sonnabend, New York.
PLATE 1 (frontispiece)

Ad Reinhardt (1913–1967)
Red, Green, Blue and Orange, ca. 1948.
Oil on canvas, 60 x 30".
The Pace Gallery, New York.
PLATE 6

George Rickey (b. 1907)
Two Lines, Oblique, 1967. Executed in 1969.
Stainless steel, 25'h., 2/8.
The Lannan Foundation, Palm Beach,
Florida.
PLATE 47

Judy Rifka (b. 1945)
Five Nudes with Still Life, 1984.
Oil on two linen panels, 96 x 108 x 9".
Archer M. Huntington Art Gallery, The
University of Texas at Austin,
Archer M. Huntington Museum Fund, 1985.
PLATE 135

Rodney Ripps (b. 1950)
Mountain (The Guardian), 1985.
Encaustic and oil on linen, 104 x 74".
Marisa del Re Gallery, New York.
PLATE 116

Larry Rivers (b. 1923)
*The Continuing Interest in Abstract Art:
Now and Then*, 1981.
Acrylic on canvas, 76⅛ x 80½".
Marlborough Gallery, New York.
PLATE 55

Dorothea Rockburne (b. 1934)
Capernaum Gate, 1982–85.
Oil paint and gold leaf on gessoed linen,
92 x 85 x 4".
Xavier Fourcade Gallery, New York.
PLATE 86

James Rosenquist (b. 1933)
Eau de Monet, 1985.
Oil on canvas, 78 x 54".
Mr. and Mrs. Martin Bucksbaum,
Des Moines.
PLATE 61

Theodore Roszak (1907–1981)
Skylark, 1950--51.
Steel, 99" x 60 x 16"
Collection Mrs. Florence Roszak, New York.
PLATE 12

Susan Rothenberg (b. 1945)
A Golden Moment, 1985.
Oil on canvas, 54 x 48".
Collection Eli and Edythe L. Broad, Los
Angeles.
PLATE 121

Mark Rothko (1903–1970)
Blue and Gray, 1962.
Oil on canvas, 79¼ x 69".
Weisman Family Collection, Richard L.
Weisman, New York.
PLATE 21

Ed Ruscha (b. 1924)
Virtue, 1973.

Oil on canvas, 54⅛ x 60".
Leo Castelli Gallery, New York.
PLATE 57

Robert Ryman (b. 1930)
Department, 1981.
Oil on aluminum, 59¾ x 59¾".
Collection Rhona Hoffman, Chicago.
PLATE 35

David Salle (b. 1952)
Wild Locusts Ride, 1985.
Oil and acrylic on canvas with fabric,
75 x 104½".
Collection the artist; courtesy Mary Boone
Gallery, New York.
PLATE 136

Lucas Samaras (b. 1936)
Chair with Four Figures, 1983.
Bronze, 33⅛ x 17½ x 19½".
The Pace Gallery, New York.
PLATE 144

Peter Saul (b. 1934)
Subway II, 1982.
Acrylic on canvas, 78 x 106".
Allan Frumkin Gallery, New York.
PLATE 101

Kenny Scharf (b. 1958)
Sajippe Kaaka Joujesh, 1984.
Oil on canvas, 127½ x 151½".
Tony Shafrazi Gallery, New York.
PLATE 142

Julian Schnabel (b. 1951)
A Private School in California, 1984.
Oil and modeling paste on velvet,
120 x 108".
Collection Edwin L. Stringer, Q.C., Toronto.
PLATE 124

Sean Scully (b. 1945)
Narcissus, 1984.
Oil on canvas, 109 x 96".
The Edward R. Broida Trust, Los Angeles.
PLATE 120

James Seawright (b. 1936)
Mirror VII, 1985.
Fiberglass-reinforced cement and glass
mirrors, 90 x 90 x 4".
Collection the artist, New York.
PLATE 48

George Segal (b. 1924)
Blue Girl in Front of Black Door, 1977.
Painted plaster with wood and metal,
98 x 39 x 32".
Collection Leonard and Gloria Luria,
Miami.
PLATE 63

Richard Serra (b. 1939)
Carnegie, 1984.
Cor-ten steel, 53 x 24 x 24".
Larry Gagosian Gallery, New York.
PLATE 80

Joel Shapiro (b. 1941)
Untitled, 1985.
Bronze, 9'9" x 11'1" x 6'.
Paula Cooper Gallery, New York.
PLATE 42

Charles Simonds (b. 1945)
Pod II, 1983.
Clay, 7½ x 24 x 24".
Castelli, Feigen, Corcoran, New York.
PLATE 81

David Smith (1906–1965)
Circle and Ray, 1963.
Steel painted white, 119½ x 29¼ x 22½".
Collection Irma and Norman Braman,
Miami. Courtesy of The Tampa Museum.

Tony Smith (1912–1980)
Throwback, 1966.
Painted welded steel, 63 x 150 x 74".
Collection Martin Z. Margulies, Miami.

Robert Smithson (1938–1973)
Untitled, 1968–69.
Glass and mica, 26 x 20 x 20".
John Weber Gallery, New York.

Ned Smyth (b. 1948)
Expulsion, 1985.
Mosaic, stone, and glass on plywood,
84½ x 97 x 5½" overall.
Holly Solomon Gallery, New York.

Frank Stella (b. 1936)
Brazilian Merganser, 1977–80.
Aluminum and mixed mediums, 120 x 84".
Collection Martin Z. Margulies, Miami.

Gary Stephan (b. 1942)
Out, 1984.
Acrylic on linen, wood, 113 x 136".

Collection Irma and Norman Braman,
Miami.

Clyfford Still (1904–1980)
1955-D, 1955.
Oil on canvas, 117 x 111".
Marisa del Re Gallery, New York.

Donald Sultan (b. 1951)
Forest Fire, October 28, 1983.
Mixed mediums, 96 x 96".
Blum-Helman Gallery, New York.

Cy Twombly (b. 1928)
Nina's Painting (first version), 1969–70.
Oil and graphite on canvas, 98½ x 118".
Collection Martin Z. Margulies, Miami.

Andy Warhol (b. 1930)
Mona Lisa, 1963.
Acrylic and silkscreen enamel on
canvas, 128 x 82".
Blum-Helman Gallery, New York.

Neil Welliver (b. 1929)
Final Venus, 1984.
Oil on canvas, 96 x 96".
Marlborough Gallery, New York.

Tom Wesselmann (b. 1931)
Bedroom Painting No. 28, 1970–72.

Oil on canvas, 93¾ x 100½".
Museum of Art, Fort Lauderdale, Florida.

H. C. Westermann (1922–1981)
Battle to Death in the Ice House, 1971.
Wood, rope, glass, mixed mediums,
32 x 26 x 20½".
Allan Frumkin Gallery, New York.

William Wiley (b. 1937)
Imp Your Deck Oration on the Level, 1983.
Acrylic and charcoal on canvas, 96 x 108½".
Collection Harvey and Judy Gushner,
Philadelphia.

Terry Winters (b. 1949)
Lumen, 1984.
Oil on linen, 101 x 68".
Sonnabend Gallery, New York.

Robert S. Zakanitch (b. 1935)
Hoedown, 1983.
Acrylic on canvas, 109¾ x 85¾".
Robert Miller Gallery, New York.

Joe Zucker (b. 1941)
Successful Pirates, 1979.
Cotton, acrylic, Rhoplex on canvas, 60 x 96".
Collection John Solomon, Los Angeles.

267

Dallas Museum of Art, Dallas, Texas
Hirshhorn Museum and Sculpture Garden, Smithsonian Institution, Washington, D.C.
Archer M. Huntington Art Gallery, The University of Texas, Austin, Texas
Museum of Art, Fort Lauderdale, Florida
The Museum of Modern Art, New York
Norton Gallery of Art, West Palm Beach, Florida
Pennsylvania Academy of the Fine Arts, Philadelphia, Pennsylvania

The Abrams Family Collection, New York
Elliott and Bonnie Barnett, Fort Lauderdale, Florida
Irma and Norman Braman, Miami, Florida
The Eli Broad Family Foundation, Los Angeles, California
Eli and Edythe L. Broad, Los Angeles, California
The Edward R. Broida Trust, Los Angeles, California
Mr. and Mrs. Martin Bucksbaum, Des Moines, Iowa
Dr. and Mrs. A. Castellett, Darien, Connecticut
Mr. Edward R. Downe, Jr., New York
Mr. and Mrs. Howard Feldman, New York
Mr. Sam Francis, Santa Monica, California
Adolph and Esther Gottlieb Foundation, New York
Mr. and Mrs. Harvey Gushner, Bryn Mawr, Pennsylvania
Maja and Duane Hanson, Davie, Florida
Robert H. Helmick, Des Moines, Iowa
Mr. and Mrs. Robert Hillman, New York
Rhona Hoffman, Chicago, Illinois
Mrs. Emily Fisher Landau, New York
The Lannan Foundation, Palm Beach, Florida
Leonard and Gloria Luria, Miami, Florida
Martin Z. Margulies, Miami, Florida
Mr. and Mrs. Raymond Nasher, Dallas, Texas
The Neumann Family Collection, New York
Mrs. Florence Roszak, New York
Mr. James Seawright, New York
Gilbert and Lila Silverman, Southfield, Michigan
Mr. John Solomon, Los Angeles, California
Jerry and Emily Spiegel, Kings Point, New York
Edwin L. Stringer, Q.C., Toronto, Ontario, Canada
Mr. Richard Weisman, Los Angeles, California
Weisman Family Collection, Richard L. Weisman, New York

Brooke Alexander Gallery, New York
Blum-Helman Gallery, New York
Mary Boone Gallery, New York
Carpenter + Hochman Gallery, New York
Leo Castelli Gallery, New York
Paula Cooper Gallery, New York
Marisa del Re Gallery, New York
Andre Emmerich Gallery, New York
Richard Feigen Gallery, New York
Ronald Feldman Fine Arts, New York
Xavier Fourcade Gallery, New York
Allan Frumkin Gallery, New York
Larry Gagosian Gallery, New York
Hirschl & Adler Modern, New York
Monique Knowlton Gallery, New York

Margo Leavin Gallery, Los Angeles
Marlborough Gallery, New York
David McKee Gallery, New York
Louis K. Meisel Gallery, New York
Metro Pictures, New York
Robert Miller Gallery, New York
Annina Nosei Gallery, New York
Oil and Steel Gallery, New York
The Pace Gallery, New York
Max Protetch Gallery, New York
Holly Solomon Gallery, New York
Tony Shafrazi Gallery, New York
Sonnabend Gallery, New York
Washburn Gallery, Inc., New York
John Weber Gallery, New York